Pages loose
11-14-91

J

9

N

DE

OCT 0 9 2001

THE
DRAWING
BOOK

To Laetitia

The Drawing Book was edited and designed by
Dorling Kindersley Limited, 9 Henrietta Street,
London WC2E 8PS

First published in the United States in 1981 by
Holt, Rinehart and Winston, 383 Madison Avenue,
New York, New York 10017

Published in Great Britain under the title
DRAW: How to Master the Art

Library of Congress Cataloging in Publication Data

Camp, Jeffery.
 The drawing book.

 Published in Great Britain under title ''Draw—how to
master the art''—T.p. verso.
 1. Drawing—Technique. I. Title.
NC730.C25 1981 741.2 81–6277
 AACR2

ISBN: 0-03-059888-5

First American Edition

Printed in Italy by A. Mondadori, Verona
1 3 5 7 9 10 8 6 4 2

THE
DRAWING
BOOK

Jeffery Camp

Foreword by David Hockney

Holt, Rinehart and Winston
New York

CONTENTS

FOREWORD

David Hockney
drawn by Jeffery Camp
from a photograph
by Peter Schlesinger

Everybody learns to write. We are taught to write by copying marks, and even when we copy marks we all make them individually, we all have different kinds of handwriting. Within a year or two of being taught to write, things happen to our handwriting and personal ways of making marks develop very quickly. That's the way, really, you learn to draw. And in learning to draw (unlike learning to write) you learn to look. It's not the beauty of the marks we like in writing, it's the beauty of the ideas. But in drawing it's a bit of both — it's beauty of ideas, of feelings and of marks — and I think Jeffery Camp shows this marvellously well. He dwells a great deal on how the marks are actually made.

This seems to me the most comprehensive book about making marks into something on pieces of paper that I have seen. It worries about mediums, how to make the marks and how you then relate these to your eye or your feelings.

I would say that anybody can actually learn to draw quite well, just as anybody can be taught to write. We are all taught to fiddle with a pen enough to write a complicated squiggle, which is what writing is, and if you can do that, all the manipulations are learned. Then you teach yourself to see and to feel what you see. Drawing is a more interesting way than writing of passing on feelings about the world you see, the world you feel about, and much more interesting than the common method at the moment of taking photographs, because it is closer to how we actually feel. Photography just can't compete with drawing as a method of expression, as a method of feelings, as a method of telling people about things. I have never seen a photographic portrait, for instance, that was as good as a painted or drawn one. The best of them, anyway. There is no comparison. Yet the number of people who take portraiture seriously outside of the camera is very small. Before there were cheap cameras, people used to draw. Now if they draw less and take photographs all the time, there are areas of experience which are being completely lost to them.

I've come to the conclusion that drawing should be taught very seriously everywhere, in all schools, not just in art schools, because if you can draw, even a little bit, you can express all kinds of ideas that might otherwise be lost — delights, frustrations, whatever torments you or pleases you. Drawing helps you to put your thoughts in order. It can make you think in different ways. It naturally gives you a sense of harmony, of order. The longer a visual education is not treated seriously, the bigger the effect will finally be.

Jeffery Camp's book is special because it seems to me that it deals with two things very well. Straightaway they are very visible in the book. One, which is very important and often underrated, is delight and pleasure in the medium you are using. There are many uses of medium here, and the book makes many suggestions. You might find drawing in mass much easier than drawing in line, for example, but this probably depends on the way your mind works, and unless you try different things out visually you might never know quite how the mind works visually. The second is copying. The old academic method of teaching people to look very carefully at the human figure is a good way to teach looking, but copying is a very excellent way. I've become more and more convinced of this over the last few years.

Copying is a first-rate way to learn to look because it is looking through somebody else's eyes, at the way that person saw something and ordered it around on paper. In copying, you are copying the way people made their marks, the way they felt, and it has been confirmed as a very good way to learn by the amount of copying that wonderful artists have done.

About twenty years ago the idea of copying was completely abandoned in art education in Britain; it was not suggested at all, even as a way of learning. Somehow painting and drawing had become about personal expression, almost a therapeutic way of expression that made them perhaps go too inward, losing feelings of the ordinary things about them. But of course we all do copy anyway. Most art students at work today are copying, even if it is in rather an indirect way – though it would be more honest if we said they are copying. They copy ways of making marks that other painters use, they copy ways of putting on paint, they copy ways of making lines – but without acknowledging it. If you acknowledge what you are doing, you learn more from it. One shouldn't be afraid of being influenced. If you are influenced by something because it has attracted your eye or your mind, and if you begin to deal with it, you quickly sort out what it was that attracted you to it and it can be made into something. If you avoid the influences or pretend they are not there . . . frankly, they will always be there, not dealt with.

I think this is a marvellous book. It should stimulate many people. Even if you just pick it up to look through it, it means that there's something attracting you. And if you act on your feelings and do something about them with the help of the book, it will open up a vast world as interesting as suddenly hearing somebody playing an instrument and finally learning of the wonderful world of music. Drawing to me is an even more wonderful world, that can be, that is, open to everybody. Not completely perhaps, because to draw marvellously is very hard, just as to play the piano marvellously is very hard. A lot of people learning to play the piano know inside themselves that they are not going to be Rubinstein. Well, you may know that you are not going to be Rembrandt or Ingres, but not everybody has to be Rembrandt or Ingres. And the fact that you might know more about yourself at the end if you do this means that you have added yourself to Rembrandt and Ingres. And that makes it worthwhile. That's what it's all about.

David Hockney

7

INTRODUCTION

This book is designed to be like breaks of days. Think of the double pages as double doors. Push them lustily. Each double page presents the experience and the material for a period of drawing. Each time the pages open, your abilities in drawing (however latent and dormant) will break out and flower, and you will be affected – unable to prevent your drawing hand from moving sympathetically with mine or furiously, angrily, determinedly against it. Opening these pages one by one, how could you fail to change, as I changed, drawing and writing them? Break free from habit. If writing is mightier than the sword, then to write and draw has more power than cracking atoms. The ultimate aim is for you to be able to draw anything present in the visible world or in the imagination, with no more inhibition than you had as a child.

Use a native skill
We are all able to draw. When we were children, we did not hesitate. Seizing the crayon, we attacked the paper with passionate intent, lying on our noses, nose on the nose we were drawing. There was no difficulty. Nothing was impossible. Later, as adults, pencils were more for writing, less for drawing. It was then that we began to fear to draw the sun! The activity of drawing is as natural as walking, breathing, writing, loving or hating, and when a map or diagram is needed, we draw immediately. It is only the thought of the grandness of drawing which inhibits. You draw at every turn: when you steer a car, throw a ball, dive in a pool, gesture to a friend, cast a fishing line, net a ball, shine a torch or caress a body. You have been drawing every day of your life.

How I began
My life began at Lowestoft, a town blown hard by North Sea winds. I was a student at two art schools and at Edinburgh College of Art. At the two art schools began my enormous knowledge of what not to do. They taught me madly. The curricula of those days embraced everything: how to sharpen a knife, copy a saucepan, lay a watercolour wash and bind a book. We studied historic ornament, colour theory, anatomy and (very demanding) the plotting of the reflections and shadows in multiple fountains in measured perspective. The list could continue. . . When I finished being a student, I knew a little about everything. Since I began teaching in art schools, including nineteen years at the famous Slade School in London, I have learned something from almost a thousand students. Many famous painters learned by copying from Masaccio's Brancacci Chapel frescoes. His influence was immense. He did not know the paintings of Poussin, Seurat and Picasso. I do. Styles increase in number every year to tax the visual digestion. I know many more ways art can go wrong than Masaccio did. I have produced over fifteen hundred paintings and twelve thousand drawings. (I am boasting only of making bonfires with many of them!)

A new way of learning to draw
This book is unique to date in showing ways of learning to draw by the age-old method of copying. Early in this century, it is partially true to say, the teaching of art lost its way. It was thought possible to learn to draw by drawing a figure and having it corrected by a teacher. In practice, while the student became dexterous, art often passed him by. Art is inspired by nature, yet art also grows out of art. Drawing a nude from Poussin and then drawing the body of a girl sunbathing in the same pose will bring us close to creation. The extent of creative transformation is always surprising. Once the material is under one's hand, copying is both physical and thoughtful. Copy to experience the glory of art and to help you learn to draw. Draw for deep pleasure and awareness and in order to communicate in fine style. In this book, the copies I have so truculently made from great artists are not intended as imitations but as attempts at realization of the great works which, by their resemblance and insufficiency, will make you rush to look at the originals again, and make you wish to do your own copies.

Seeing is conditioned
A mother and child and a fisherman stand on a cliff by the sea. A tiny disturbance in a vast speckle of waves is seen by the fisherman as a shoal of mackerel. He does not see a thistle. The mother sees the thistle – her child has a prickle in his mouth – but the shoal of mackerel is invisible to her. Neither fisherman nor mother notices that the sea is the same colour as the thistle. The artist, a universal eye, sees all these things. See to draw; draw to see! Five senses involve us in the world. The experience and examination of the visible world, with sensual involvement, brings its own rewards. We know of the ears for which music is noise, the finger-licking tongues hooked on artificial flavourings, and of touch and the touch of doctors. Our senses enable us to grow. Drawing can open the door and raise that useful extra eyelid which, like that possessed by certain lizards, is in humans the inhibiting, cribbed, confining, narrow-browed, vertical-thinking curtain eyelid of conformity.

It is never too early or too late to begin
Van Gogh did his main work within a ten-year period. Matisse was thirty before he did original work. Raphael died at thirty-seven, Seurat at thirty-two. Poets often write better when young. Bonnard and Rembrandt painted self portraits magnificently when old. Titian's finest paintings were done when he was almost ninety. If your hand wobbles, if you feel old, sick or nervous, draw, because your ideas will find their form as surely as they do when you speak. You will communicate with or without skill. It is just like when an old folk singer, the only person alive who remembers a beautiful song, sings it in a cracked voice and moves us deeply. It is as valid as any polished rendering. Despise gimmicks. Do not seek knacks for making drawings happen. You do not need papers of massive weight and all grades of pencil, from 6B to 9H, to draw well. Wherever I believe exotic methods make art marvellous, I have tried to show the process. But, extravagantly, I know that if you make marks with the nearest dirty point on a piece of waste paper with a bright thought, the result will be positive and a joy forever.

Rembrandt self portraits will follow you round the capitals of the world with that curiously wise way of looking. If his face had been thin and sharp-boned, with a small, uptilted nose, perhaps he would not have painted so many. Copy Rembrandt self portraits if you can from youth to old age. Or copy this one of him as an old man. London has more than any other town – over a dozen. The Rembrandt at Kenwood House is particularly fine. If you are under the spell of those stricken, compassionate, heroic, relentlessly searching-eyed, bravely painted heads, you will find four of these self portraits in Berlin, six in Paris, five in New York, six in Vienna, three in Florence and three in Dresden. Below, Laetitia is looking at the actual picture in the National Gallery, London.

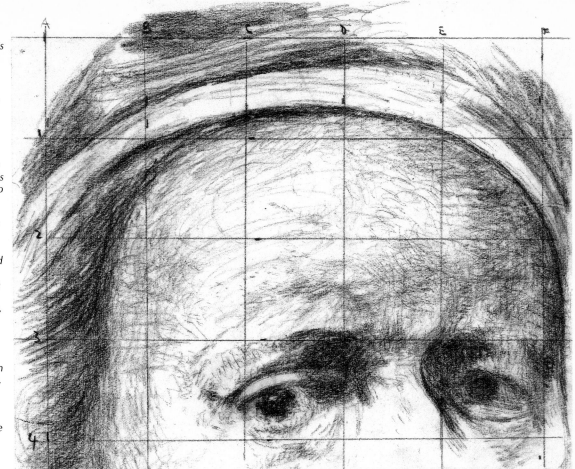

After Rembrandt

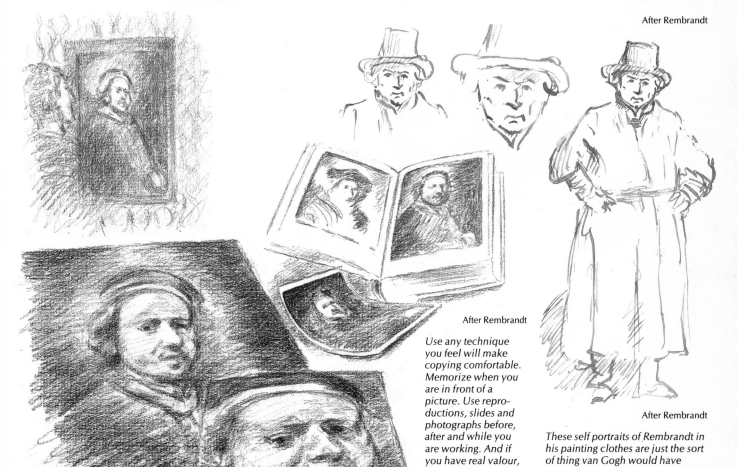

After Rembrandt

Use any technique you feel will make copying comfortable. Memorize when you are in front of a picture. Use repro-ductions, slides and photographs before, after and while you are working. And if you have real valour, draw it again entirely from memory when you have finished direct copying.

After Rembrandt

These self portraits of Rembrandt in his painting clothes are just the sort of thing van Gogh would have studied. The few marks which make up the features can easily go astray, but make the marks with a pen and as much determination as you can.

11

Rembrandt's "Self Portrait"

A painting by Rembrandt of his own face seems so near and real that any kind of tampering, by copying for instance, embarrasses. He is not dead and it takes a cool nerve to come to grips with such a large nose. To draw it would be as impolite as pulling it. The nose is valuable in establishing contact between the viewer and the subject. Rembrandt placed an excreting dog in his etching of "The Good Samaritan", to make it look real. In some paintings, a glistening highlight is used to make a head present, but here the beautiful protuberance of the nose is all that is necessary. For Jimmy Schnozzle Durante, W.C. Fields and many comedians, a large nose has also been a boon.

The circle of the iris of the left eye is surrounded by convex arcs and is compared with a circular dark, made by dotting at the meeting of eyebrow and nose. The right eye is surrounded by concave arcs.

After Rembrandt

It is possible to see a Rembrandt in many ways, but it is often rewarding to look for concentric circular forms. As you dot closer to the frame, the circles and ovals become increasingly flattened.

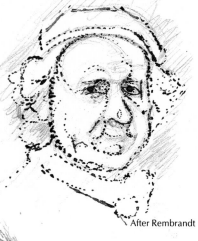

After Rembrandt

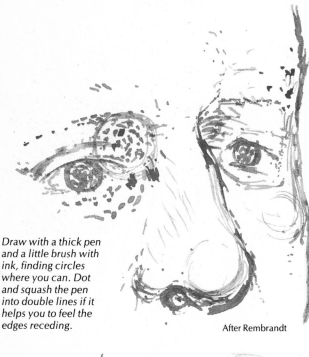

Draw with a thick pen and a little brush with ink, finding circles where you can. Dot and squash the pen into double lines if it helps you to feel the edges receding.

After Rembrandt

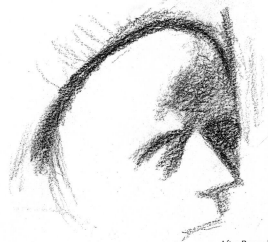

Here, rather extravagantly, I have tried drawing the forms as teardrops. It is slightly like an Arcimboldo.

After Rembrandt

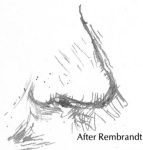

After Rembrandt

Draw coarsely, as if the pen was drawing thick paint being trowelled on.

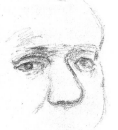

After Rembrandt

Draw it smoothly with a small point. See the nose as an elegant swan shape.

After Rouault

Rouault was plainly influenced by Rembrandt in this self portrait. The nose triangle contrasts with the oval of the forehead. The bun-shaped Rembrandt forehead (left), drawn in line and dots, is made by me to resemble it as much as possible.

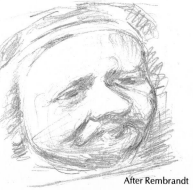

After Rembrandt

Draw from an upside-down, foreshortened photograph. Even distorted this way, flattened by the medium, the magic does not lose its actuality. But generalizing from a photograph the right way up is easier.

After Rembrandt

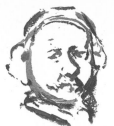

After Rembrandt

Thinking of brush drawings by Rembrandt, brush him in as economically as possible.

Using all the means at your disposal – chalk and charcoal, scribble and hatching – build the image as generously as you can. Be prepared to lose your way. Be prepared to make a mess if you must. And if the result turns out to be rather too dark, you will nevertheless have travelled all over a remarkable image.

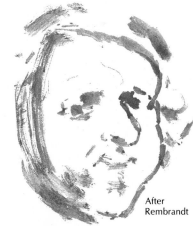

After Rembrandt

Use a rough brush and a small pointed brush, thinking of Japanese Sumi.

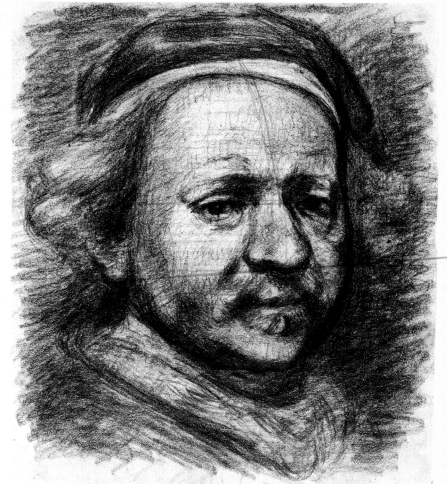

After Rembrandt

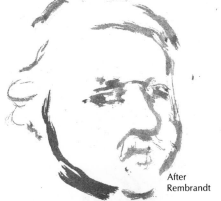

After Rembrandt

Brush round with a fluid slickness, thinking of Manet's brush drawings.

With a rough paper and soft conté crayon, form the bun shapes of forehead, cheeks and chin, maintaining the pear shape of the nose. In the course of your drawing, you may decide that one eye looks resigned and the other looks tormented. You will find that on every visit to London's National Gallery, the portrait will change. Perhaps there really are a great many Rembrandts on top of each other!

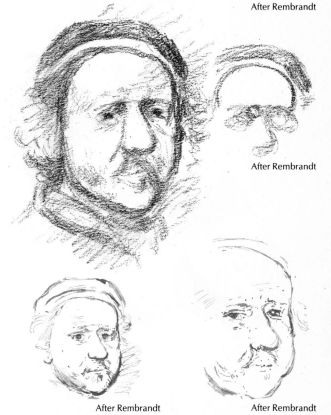

After Rembrandt

After Rembrandt

After Rembrandt

After Rembrandt

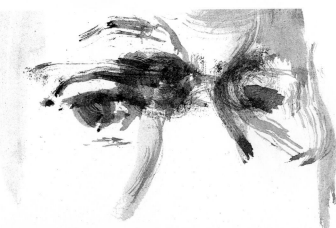

With a good look at Japanese brush drawing and a half-dry, soft, long-haired brush, try a vigorous drawing with Chinese ink.

Draw with a pen nib which will give swelling lines, thinking of Rembrandt quill pens.

Do several. The appearance changes every time you draw him.

Art Follows Art

To copy a copy by a great artist of another, equally great, painter is learning in a very high class way. Copying is wonderful and you can choose the finest teachers. Consider this page: Velasquez is there as director; Picasso is at his beck and call, painting the director in four versions; El Greco and Cézanne are on hand, demonstrating hands; and Rubens sets Cézanne and Delacroix prancing with the naiads. First, draw from the Rubens, using conté crayon with rich, tonal modelling. Rubens was good at making Roman bas-relief sculpture lifelike, by swelling the forms and making them less orderly. These girls are splashing in the waves. Then draw from Delacroix and Cézanne. Delacroix travelled through Flanders especially to see Rubens' paintings and recorded his excitement in his journal. He copied the most contorted nude. I have copied it in conté crayon. Try to keep the energy flowing. The last resemblance I have traced to this Rubens is of a painting of nudes all awash by Delvaux. Picasso was also adept at contorting bodies so that, as here, buttocks and breasts, faces and features, could all be shown at once.

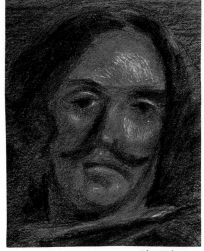

After Velasquez

Copy from the head of the painter in "Las Meninas", using black and white chalk.

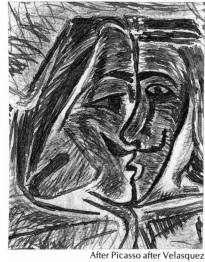

After Picasso after Velasquez

Picasso copied from "Las Meninas" over and over again, sometimes copying his own copies, sometimes including himself and even his own children. Four examples are included here. The one copied above was painted in August, below left in September, below centre on October 2nd and by October 3rd, when the picture copied below right was painted, Picasso had tamed Velasquez thoroughly.

After El Greco

After Cézanne's copy of a magazine illustration after El Greco

After a magazine illustration after El Greco

Here are examples of how an artist can learn from and make use of past art. Cézanne copied from a magazine illustration of an El Greco. Draw the style adjustments.

After Picasso after Velasquez

After Cézanne after Rubens

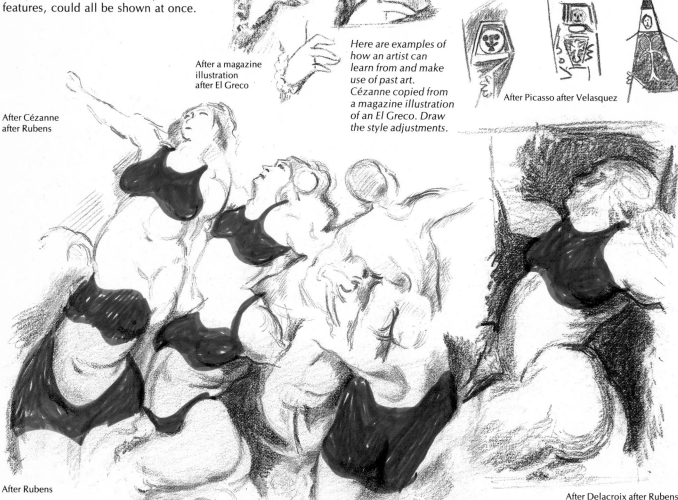

After Rubens

After Delacroix after Rubens

It is possible to appreciate a great deal about style by copying these three artists who span the years. Delacroix is broader and rougher than Rubens. Cézanne absorbs the rhythms and reconstitutes them in an eccentric way, distorting and suppressing the volume. The result is energetic. Cézanne was inspired by Tintoretto. Traditions are like fish swimming in schools, coming and going.

The "Last Supper"

Leonardo's "Last Supper" and "Mona Lisa" are the world's best-known pictures. The portrait looks like overworked varnish and the Supper has almost dissolved on the wall. As a result of the condition of the wall, the painting began to deteriorate soon after it was painted. It has been retouched so many times and looked at by so many eyes that it is worn out. Each generation of viewers feeds its stains with its own beliefs. The image comes and goes on the wall and the gestures seem unalterable. The general pictorial arrangement has a monumental grandeur. Copy some of the beautiful preparatory drawings. They are as clear and alive as the day they were done. The schematic copies Rembrandt made served to give him confidence when planning groups of figures seated at tables, as in "The Syndics" and "The Conspiracy of the Batavians".

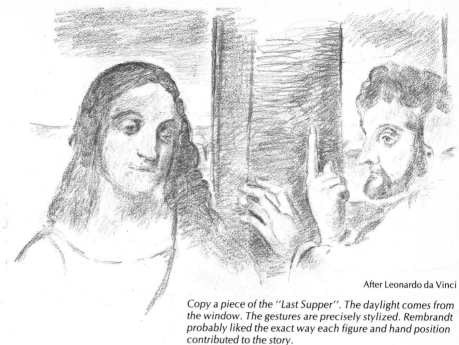

After Leonardo da Vinci

Copy a piece of the "Last Supper". The daylight comes from the window. The gestures are precisely stylized. Rembrandt probably liked the exact way each figure and hand position contributed to the story.

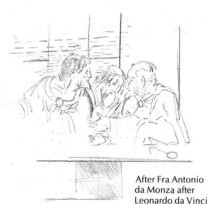

After Fra Antonio
da Monza after
Leonardo da Vinci

The engraving from which Rembrandt did his copies. Rembrandt had a large collection of art from which he was conveniently able to copy.

The two versions right and below are extremely wild, as indeed is the engraving. Copy the Rembrandt on the right with conté crayon. Draw the version below with a flexible pen or quill, dilute ink and hard paper. Draw vigorously. To digest a Leonardo, you need a splendid Rembrandt flourish.

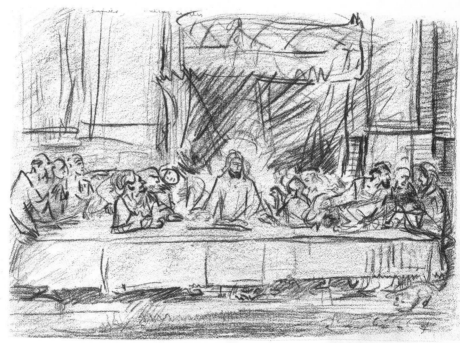

After Rembrandt after Leonardo da Vinci

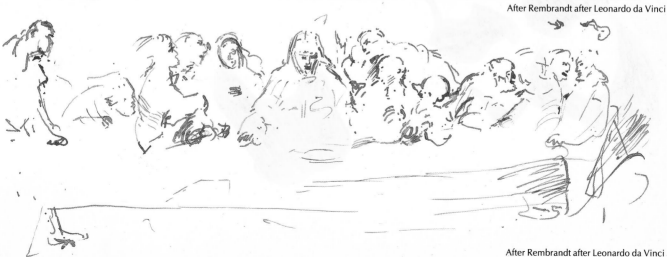

After Rembrandt after Leonardo da Vinci

Van Gogh's "Sunflowers"

Van Gogh, excited by his little yellow house in Arles and at the prospect of being visited by Gauguin, painted six pictures of sunflowers to decorate its rooms. An abundance of passion went into these paintings, overflowing into a human relationship more overpowering than Gauguin could bear. Look at the paintings and, with your life enhanced – perhaps by having read Vincent's letters to his brother Theo, written at the time – look at van Gogh's drawings. Then attempt to interpret his paint marks as ink marks, to equal the richly worked paint – make stabs for seeds, swaying rhythms for petals, strong, thick lines for the stems and static hatchings for the backgrounds. Draw bravely. Take risks. Use reed pens, quills, wide-nibbed pens, brushes, whatever seems comfortable, and two bottles of ink, one full strength and one half-strength.

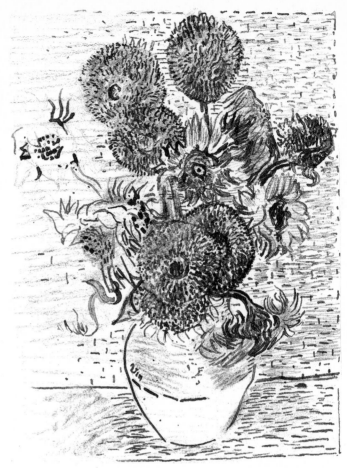

After van Gogh

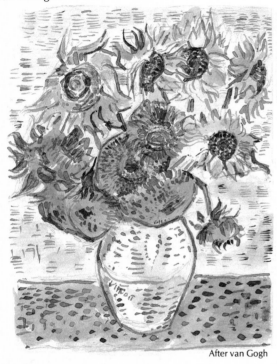

After van Gogh

The rich patterns of pen textures make clear what Matisse meant when he said: "Decoration is at the same time expression." Matisse owned a van Gogh drawing of haystacks. The vertical/horizontal marks of the background were taken over by a later Dutchman, Mondrian, during his middle period.

As I copied, I became aware of the symbolic nature of the flower paintings and of how involved with the sun the painter was. Gauguin's influence can be seen in the tightness of their design. Later, Gauguin did a portrait of van Gogh painting sunflowers.

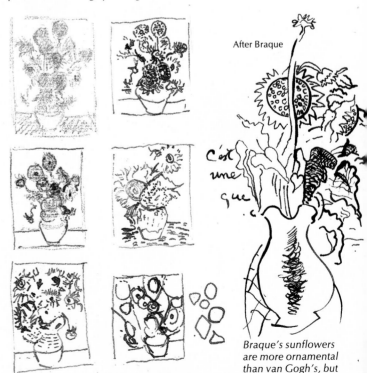

After Braque

Braque's sunflowers are more ornamental than van Gogh's, but heirs to them. Copy with a thin pen and a thick pen and Indian ink.

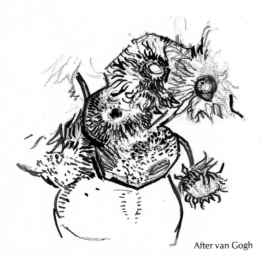

After van Gogh

This detail, copied from the drawing above, emphasizes the fierce way in which ovals are compressed within interlocking polygons.

Diagrams of the formats of the sunflower paintings. The six paintings resemble each other in a decorative way, being central and concentric, with diamond or lozenge formats.

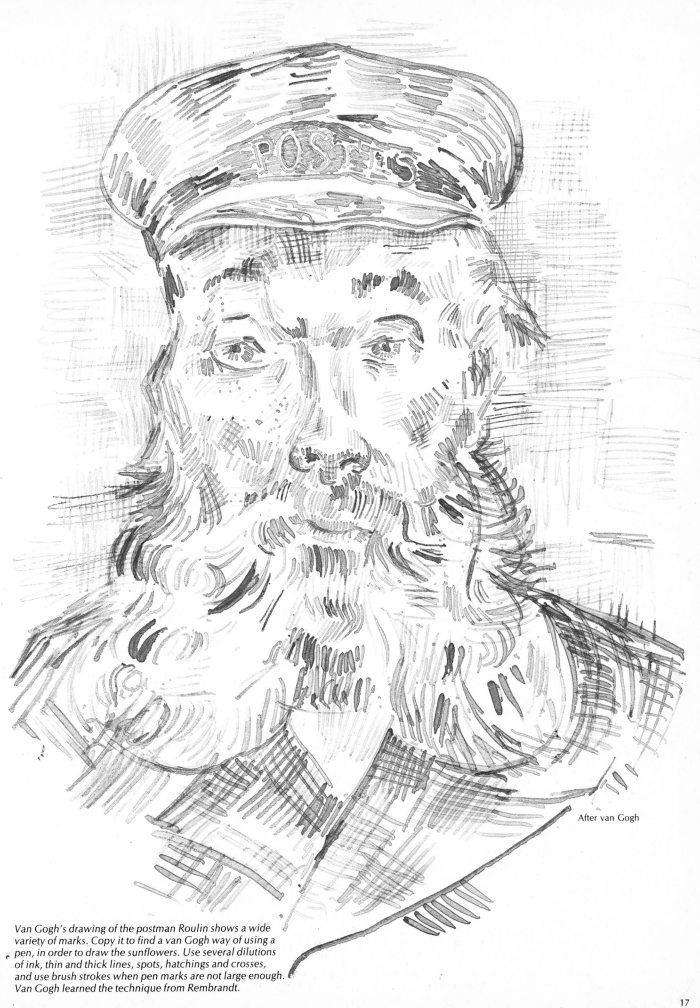

After van Gogh

Van Gogh's drawing of the postman Roulin shows a wide
variety of marks. Copy it to find a van Gogh way of using a
pen, in order to draw the sunflowers. Use several dilutions
of ink, thin and thick lines, spots, hatchings and crosses,
and use brush strokes when pen marks are not large enough.
Van Gogh learned the technique from Rembrandt.

MEDIA

It used to be fashionable to say, "The medium is the message". For the artists I admire, the message is paramount. Their medium is always at the service of their ideas. An idea can exist in the mind without a medium, be mind-born without settling on a method for expressing it (for only telepathy communicates without a medium and telepathy has not affected the history of art). But once it exists in the mind strongly, it seeks its perfect language for communication: sounds, words, shapes, lines. . . If the drawing medium is right, the embodiment, the substance of the idea is secure.

Finding the right medium

Unlike a tailor, an art store will not measure your ideas and sell you supplies to fit your needs exactly. It may take years to find the right blend of media for you alone. For this reason, it is useful to know about a lot of materials. Examine everything. Try out as many as you can – the range is enormous, baffling and exciting. Obtain catalogues. If an item is available at an office supply store or other kind of shop, it may be cheaper – and the range will be different. For instance, angling shops have fly boxes of many kinds which are convenient for holding gouache and water-colours, and, to be specific, light folding stools. They also sell large umbrellas. (The Impressionists always seem to have worked in the shelter of mammoth umbrellas.) Smooth writing paper, pencils, pencil sharpeners, pens and erasers can be obtained from stationers.

The intimate use of materials

The drawing media extend the body. The affectionate, tight extension of the psyche through the arm and hand to the drawing instrument is where a medium weaves its spell and makes the wonder begin. The most intimate marks are those made by fingers; the least intimate are those produced by computers. Soft and human are the drawing marks of fingers on clay (look at Donatello terracottas and Rodin bronzes) or the amorously scraped drawings on the smooth sands of beaches. Like a kiss, a pencil scribble by Bonnard caresses the paper and strokes the eye of the beholder. The prehistoric caveman's hand, used like a stencil spattered on the cave wall, makes him seem at home. Intimately immediate too are the fingerprints in happy colours by Miró and the papers, torn and grubby with sweat, erasure, drawing pin holes and paste marks on the last cut-outs by Matisse. All these bring the onlooker into close contact with the artists in a special way. This intimacy is part of the life of drawing.

Watch artists at work

Movies which show artists actually at work are exciting. Look, for instance, at Matisse in trilby hat and overcoat, sitting opposite and close to a small boy whom he draws at arm's length. Giacometti, Hockney, Picasso, Monet, Stanley Spencer, Pollock, Miró and Chagall are all photogenic and marvellous to watch. Sometimes their heads move as fast as birds and their hands propel their chosen media with sure, rapid movements. It can be like watching a solo violinist performing a sonata by Bach.

What to use for copying

When you study a drawing by copying, it is not essential to work in the same medium used for the original. Indeed, it is difficult to obtain certain materials now. Where, for instance, do you obtain mountain chalk? And Michallet paper (Seurat's paper) is no longer available in Britain. It is not good to imitate, but when copying, it is sometimes part of the enjoyment of making contact with a work of art to do the study using similar materials. Conté crayon would be no more like Titian's black chalk than a grand piano is like a forte piano. Modern papers rarely have the hand-made roughness of old papers and unless you make your own,

they lessen the chance of approaching the responsive touches which Goya achieved in chalk or brushed ink.

The media used by artists

An artist must find the medium appropriate to his idea. For Chopin, it was the piano; for Käthe Kollwitz, black chalk. Odilon Redon drew in charcoal, but later learned lithography and revelled in the blacks which greasy crayons on stone could produce. Degas changed from oil paint and pencil to charcoal and pastel, which allowed lines to be more emphatic. Goya did brush drawings at first; later he used black chalk. The common pencil has been a delight to Uglow, Claude Rogers, Ingres, Balthus, Blake, Giacometti, Matisse and Constable. They used it as Leonardo and Dürer had used the silver point (which tarnished to a darker tone) – for precise drawing. Edvard Munch did wood-cuts using planks; Matisse cut into coloured paper; Picasso cut newsprint. R. B. Kitaj revived the use of pastel and made a new, poignant ballad (a "Lyke Wake Dirge") for people bruised as beaten roses at sunset; a golden paper supported pastels for Odilon Redon, whose drawings burn with mystical music. Picasso gouged into lino and made an intransigent medium come alive – he could have made even potato-cuts or, that impossible medium, scraperboard into high art. Schwitters made art from trash, Lanyon from jetsam; Cohen finger-printed colours; Rauschenberg transferred reproductions by rubbing and silk-screening; Jasper Johns used encaustic (hot wax paint); Hockney uses coloured pencils and prints with coloured paper pulp. Degas made monotypes; Braque used sand, cork and tobacco; Gris – wallpaper; Calder – wire; Klee – burlap; Duccio – gold; Coldstream – a pen; Patrick Procktor – watercolour; Pollock – enamel drips. Appel and Bratby did "Tubism" – they drew with paint exuded directly from the tube. Picasso drew with a torch, other practitioners with smoke and fire and powders. Kenneth Martin made mobiles of metals. Sometimes artists use surprising methods – Gauguin and Chirico used oiled charcoal; Ernst rubbed paper to obtain the pattern of grained wood; Henry Moore used greasy crayon as a resist with watercolour; Rembrandt used the handle of the brush to draw into paint. Peter Sylviere uses black velvet for his deepest black, by collaging it in some pictures. Sometimes artists use mixed media. Klee used, entrancingly and metaphysically, ink, wax, watercolour, pastel and oil paint all in one drawing. In his last paintings, Kandinsky used coloured sands which were also used by North American Indians. Bernard Cohen, an admirer of their culture, has introduced spore marks (hoof, paw and claw marks) into his paintings. Since Klee, Kandinsky and others at the Bauhaus and since Cubism, an enormous range of media is used. It is not Cohen's use of unusual materials but his way of applying acrylic or oil paints by combing and spraying that would have been surprising before this century. In the history of transitory fashions, some sewed sacking, cut and pierced canvas or shot paint, and Yves Klein made paint-covered girls writhe against canvas to the sound of cellos. Recent practitioners plough, mark, mow and lay out with sticks the earth we live on, cut, paint or tie up their bodies, alter food or colour the sea. The choice of medium was once traditional; now new media can delight or confuse artists.

The five main media

If sky-writing, earth art or neon-tube bending do not demand your services, a pencil can be more intimate. The five main media exampled on the facing page have been our companions through the ages. They respond to our lightest touch, are vehicles of our love, extensions for communication; and although common and cheap, they can make the finest poetry. They are: brush, pen, pencil, charcoal and black chalk.

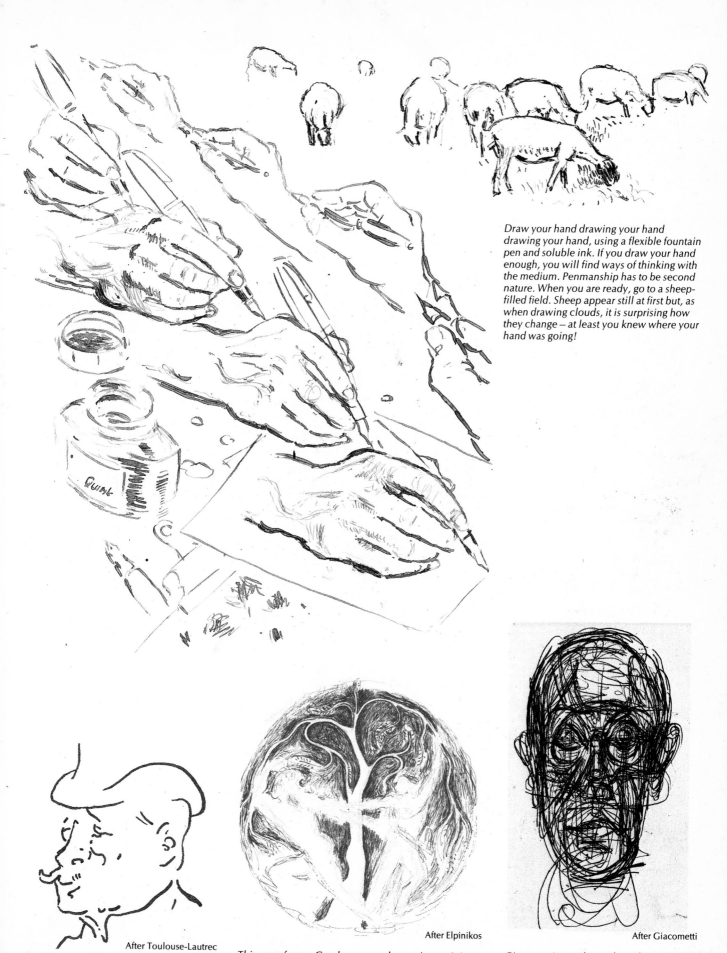

Draw your hand drawing your hand drawing your hand, using a flexible fountain pen and soluble ink. If you draw your hand enough, you will find ways of thinking with the medium. Penmanship has to be second nature. When you are ready, go to a sheep-filled field. Sheep appear still at first but, as when drawing clouds, it is surprising how they change – at least you knew where your hand was going!

After Toulouse-Lautrec

Lautrec would not have liked it – subtlety is impossible with a marker, but it has other qualities.

After Elpinikos

This copy from a Greek cup was done using an 0.1mm stylo tip pen. This is the narrowest line obtainable with these pens. They make it easy to encompass the tiniest details while they keep flowing.

After Giacometti

Giacometti was almost the only great artist to use a ballpoint pen. It was exciting when first invented and he probably enjoyed its speed – like drawing on ball bearings.

Natural Pens

I call the pens illustrated here "natural pens". After the steel balls and nibs, hydrocarbons, fibres and needles, they are as sympathetic as flutes. For the artists of the past, the quill was an instrument for writing and drawing. Children learned to write with a quill and their styles matured naturally through the years. (Letter-writing was also a serious activity in the past.) Leonardo mixed drawing and writing continuously and with almost the same rhythms. Sharper than a sword, the pen enabled him to inscribe devilish inventions for mowing down soldiers, to examine a beetle or draw a flower. The warm quality of a natural pen becomes apparent if you copy Goya's signature; diluted Chinese ink will make the fluctuations of thickness more evident.

Bamboo pens are like tougher forms of reed pen and wear rather better.

Reeds for pens are taken from marshland and must be over two years old.

A reed pen with two splits makes very ornamental marks.

The feather makes a variety of very precise marks.

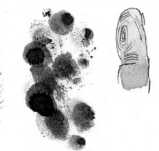

Fingertips or whole hands will make sensuous touches.

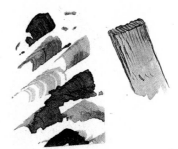

Wood can be cut to any shape and makes pale or dark marks. Bamboo is good.

A match will make square marks.

Quills make beautiful, soft marks, as can be seen in old drawings and documents.

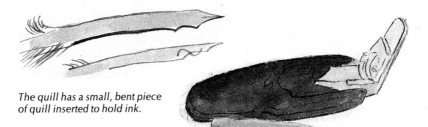

The quill has a small, bent piece of quill inserted to hold ink.

An antique pen-cutter and knife combined. It not only cut the quill to a point but also split it.

Cut quills or reeds with a sharp knife or a razor blade.

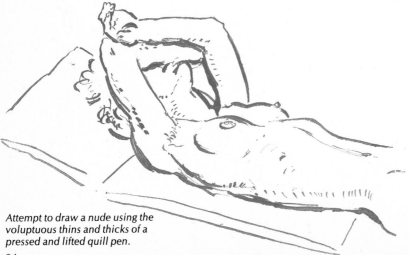

Attempt to draw a nude using the voluptuous thins and thicks of a pressed and lifted quill pen.

After Goya

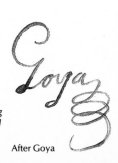

Only after a lot of practice will you be able to compete on a technical level with Goya's signature. Using a quill (above) or a reed (right), try out some flowing curlicues.

After Goya

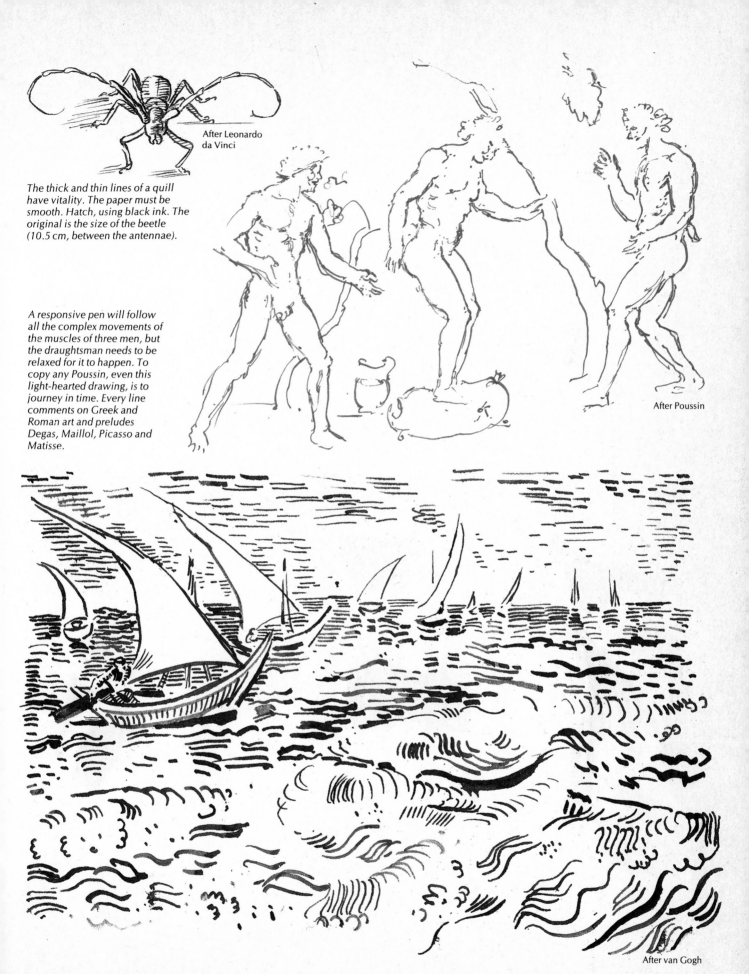

After Leonardo
da Vinci

The thick and thin lines of a quill
have vitality. The paper must be
smooth. Hatch, using black ink. The
original is the size of the beetle
(10.5 cm, between the antennae).

A responsive pen will follow
all the complex movements of
the muscles of three men, but
the draughtsman needs to be
relaxed for it to happen. To
copy any Poussin, even this
light-hearted drawing, is to
journey in time. Every line
comments on Greek and
Roman art and preludes
Degas, Maillol, Picasso and
Matisse.

After Poussin

After van Gogh

Van Gogh made reed or bamboo pens describe his feelings about the sea
with active bursts of vigorous calligraphy. When he did drawings of
fields of corn he said the wind made undulations like the sea. Reeds and
bamboo are cut in the same way as quills. Bamboo may be bought at
gardening shops. Use these pens upside-down for thinner lines. Use a
brush if you need fat lines.

Crayons and Inks

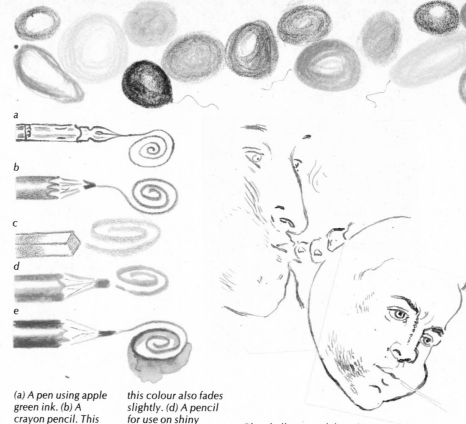

Feminists in an Agitprop playlet in a film by Varda sang of pregnancy and balloons. Balloons are marvellous subjects for displaying the variety of coloured inks, crayons and crayon pencils. Half blown, a balloon is opaque and seems solid. Blown larger, the other side and its background are seen and lights are reflected from its surface. All these differences of colour, shine, weight and shape can be drawn with coloured wax crayons (in stick form), coloured wax pencils, or even soluble coloured pencils. The balloon blown to bursting point is almost as transparent as a soap bubble. It accepts only the most delicate touches. The vulgar approach of a point is almost enough to burst it. Draw it fully blown, then again as the shining extraterrestrial body loses air; then draw it as it sags and saddens into wrinkled rubber. Finally, draw its burst shards. Crayons and coloured pencils can be dry, waxy, greasy or soapy. The ones which are hard have the minimum amount of wax in them and are the best to use, unless you are doing wax resist drawing with diluted ink or watercolour. Some pencils are specially made to write on shiny surfaces. Copy from the wax crayon drawings by Picasso, Hockney, Oldenburg, Allen Jones and Henry Moore.

a

b

c

d

e

(a) A pen using apple green ink. (b) A crayon pencil. This colour fades slightly. (c) A colour block – *this colour also fades slightly. (d) A pencil for use on shiny surfaces. (e) A soluble coloured pencil.*

Blow balloons and draw your cheeks. Balloons blow back. Trumpeters and glassblowers have special cheeks. Ink in the cheeks of a zephyr from the "Birth of Venus".

After Botticelli

After Hugo van der Goes

The belly of the serpent follows suspiciously closely the line of the belly of Eve (drawn in burnt umber ink). Considering how central and symbolic is the pregnant body, it has been very little painted. Modersohn-Becker, van Eyck, Picasso and Piero della Francesca painted it movingly.

After Cranach

Although not pregnant, the nudes of Cranach have swelling bellies, to show how desirably fruitful they were. Draw with bistre ink, which is brown and made from charcoal.

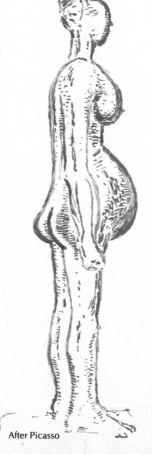

After Picasso

After Epstein

This strong, Expressionist sculpture – African, Vorticist, pregnant and large – shocked in its day. Brown and crimson ink were used.

Draw from this sculpture using green ink. Picasso has separated all the round parts of the body, which has made the creative roundness of pregnancy very clear.

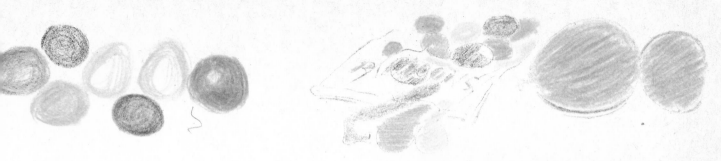

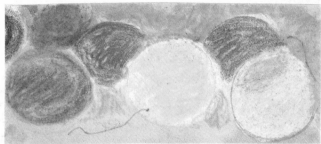

Four inks, unmixed, can be colourful. The permutations possible are considerable, like a bell-ringer ringing changes on four bells. Test-scribble in inks and crayons on paper. Cut with scissors and keep one set of samples in a dark drawer and the other in a sunny window. After two weeks, compare them.

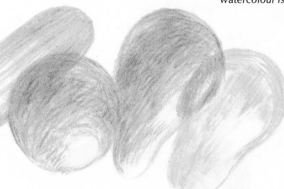

Draw the balloons as if you were painting them, with a greasy crayon or clear carnauba wax or bleached beeswax. Diluted ink or watercolour is repelled from the waxy areas.

Draw balloons on white paper with wax crayon pencils, watching the weight, shadow, transparency and colour.

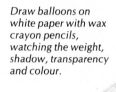

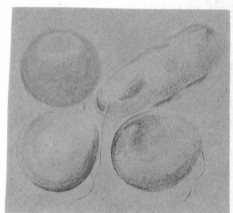

Balloons are brightly puffed for parties and respond to exuberant, dashing, spiral crayon scribbles.

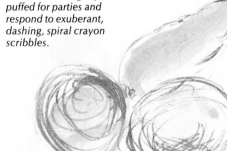

Draw balloons with coloured wax crayon pencils on white and on buff paper. Slight changes of paper colour make large differences of effect.

Draw delicately on buff paper these sad, deflated and burst balloons, using coloured pencils and ink.

Coloured inks are often fugitive. Wash your nib or brush in water between colours, as the borax is not good for them.

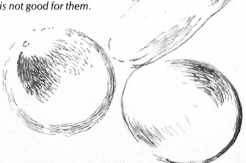

After Miró

One of the few representations of a balloon in painting. The string joins a blue area to a red area. A detail, using soluble coloured pencils and ink.

Green ink over crimson ink goes almost black for the balloon cadaver.

The last dreg of the party, done in crayons.

Charcoal

Early cave-dwellers drew with charred sticks. Charcoal is made from twigs of willow or vine (myrtle, walnut and birch are less usual). Scene-painters' charcoal is thick, like firewood. Charcoal lines can be erased with a cloth and redrawn fast. In a period when orchestration had become thick and blended in texture, Stravinsky allowed each instrument to sound clearly with its true voice. Degas and Matisse did this for charcoal, and made it bright and clear. Matisse's changes of mind are visible and the final marks are marvellous conclusions. Charcoal is the drawing medium most like painting. It can be removed with a rag or putty rubber or, very precisely, with an India rubber or an eraser pencil. If charcoal is fixed thoroughly, only a typewriting eraser will extract pale marks from the darkness. Fixing charcoal should be done carefully, at a distance, and in a number of light applications – otherwise the drawing is blown away or dissolved. Bomberg taught in opposition to methodical, tasteful English drawing. He advised using charcoal because it prevents niggling, is painterly and can be used broadly, with passion. Auerbach and Kossoff shared a few of Bomberg's ideas and drew compulsively. Auerbach drew and rubbed until the greyed paper broke into holes.

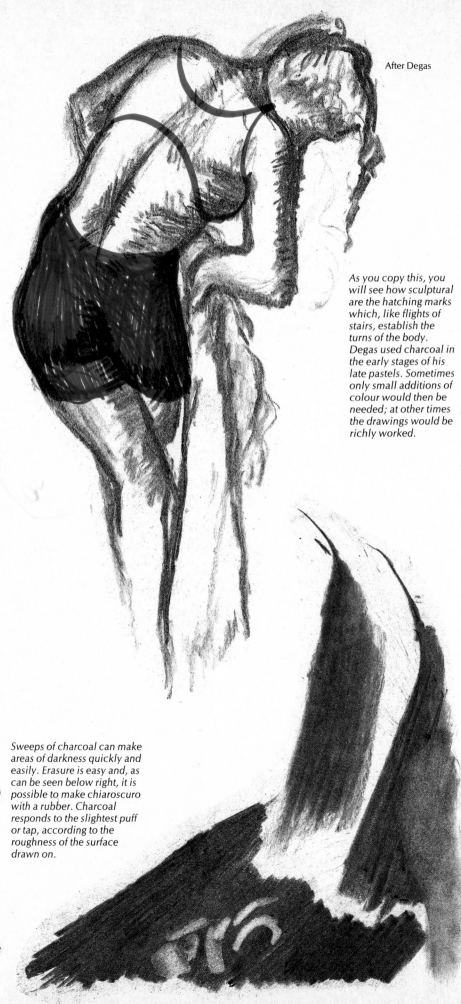

After Degas

As you copy this, you will see how sculptural are the hatching marks which, like flights of stairs, establish the turns of the body. Degas used charcoal in the early stages of his late pastels. Sometimes only small additions of colour would then be needed; at other times the drawings would be richly worked.

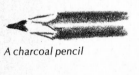

A charcoal pencil

Conté and lithographic crayons in various grades

A box of charcoal sticks

Vine or willow charcoal

Scene-painters' charcoal

Compressed charcoal

Sweeps of charcoal can make areas of darkness quickly and easily. Erasure is easy and, as can be seen below right, it is possible to make chiaroscuro with a rubber. Charcoal responds to the slightest puff or tap, according to the roughness of the surface drawn on.

Charcoal dipped in linseed oil needs no fixing, but it no longer has the softness of charcoal.

Sharpen charcoal with a craft knife or sandpaper.

Used on its side, charcoal makes marks like van Gogh's brush strokes.

Compressed charcoal has little of the airy quality of natural charcoal.

A conté crayon pencil gives a very dense black and will make small marks.

Conté crayons come in square sticks in three grades of hardness.

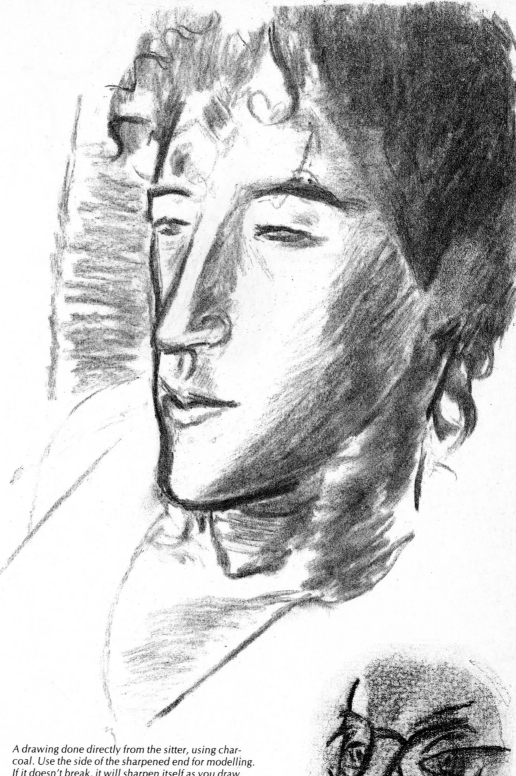

A drawing done directly from the sitter, using charcoal. Use the side of the sharpened end for modelling. If it doesn't break, it will sharpen itself as you draw.

A Matisse self portrait copied on a large sheet of open, rough, "wove" paper. Notice how the forms are adjusted to accommodate the stick-width marks. Copy Gaudier-Brzeska's chunky drawings. Picasso and Constable also used charcoal, as did the Romans and ancient Egyptians.

After Matisse

29

Pigments and Chalks

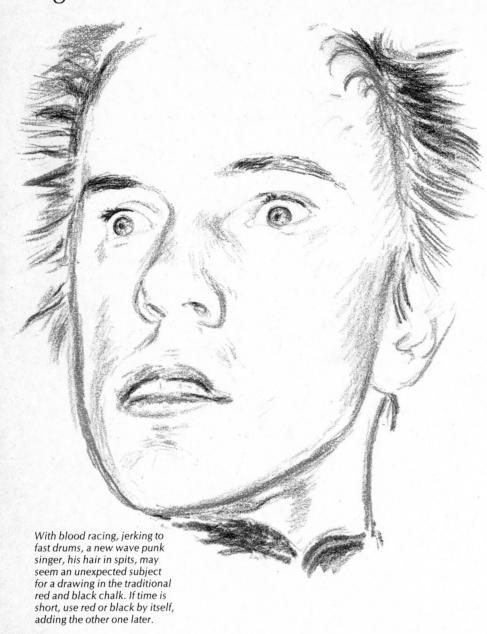

With blood racing, jerking to fast drums, a new wave punk singer, his hair in spits, may seem an unexpected subject for a drawing in the traditional red and black chalk. If time is short, use red or black by itself, adding the other one later.

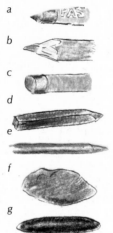

a
b
c
d
e
f
g

a. Red earth pastel
b. Red conté pencil
c. Venetian red pastel
d. Red conté crayon
e. As a thick porte-
 crayon or clutch
 pencil refill
f. A lump of sanguine
g. A hand-made pastel
 of Caput mortuum

Black is simple on buff paper.

White is cooled.

Black over white is warmer than white over black.

Black and white mix to a medium grey.

White over black is bluish.

White over red makes it cooler.

Red is warmer when rubbed.

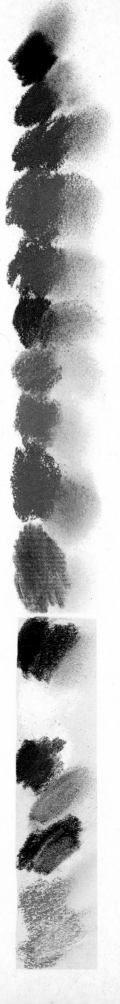

Tiny capillaries beneath the skin create tender, delicate complexions and rosy glows all over the body. Sanguine, white and black chalks will also work miraculously on golden paper in the hands of a master. Rubens, Watteau, Leonardo and Michelangelo did not seek to imitate the pinks or sunny tans of their sitters, but the warm red chalks enabled monochrome drawings to be made presentably rich for a client or be a useful suggestive reminder for the artist's later use. Watteau filled books with such drawings for use in paintings. Titian used black chalk vigorously; the gestural marks, like brush strokes, made the act of drawing seem like painting. Experiment with papers: the insides of Manilla envelopes, Ingres or other rag papers and with papers coated with diluted acrylic medium mixed with very fine sand, marble dust or pumice. The terms crayon and chalk are broad and imprecise. A square or round stick of dye or pigment mixed with a lot of wax is a crayon. A conté crayon is a mixture of pigment with gum and a trace of grease. Lithographic crayon is black, soapy and waxy, as are the coloured oil pastels. Van Gogh and earlier artists used mountain chalk which, like sanguine, was taken directly from the earth. These had no wax or grease in them. Neither have blackboard chalk or pastels. Pastels can be made with pigment mixed with a three per cent solution of gelatine or with gum tragacanth rolled into sticks and allowed to harden. Certain pastels and pastel pencils are obtainable which have the texture of charcoal. Chalks and pastels need care in fixing. Spray lightly several times.

Saturnine and sure-handed, Leonardo drew himself with a hard sanguine chalk. This copy was done with left-handed hatching by my right hand! The slightest smudging of sanguine chalk sends it orange. Erasure is therefore hazardous. Leonardo had an iron control. Parchment and paper were expensive and every mark made on them was done with care.

My dried blood – the colour resembles Caput mortuum.

The Etruscans made wall paintings using black and red. Like the cave painters of Altamira and Lascaux, they used the materials to hand – soot and red earth. Wax, fat or blood albumin probably helped to make the pigment stick to the walls. It is worth looking at Egyptian wall drawings. The lines are drawn with a brush but very few colours are used. Both Cocteau and Picasso did decorative wall drawings.

Copy the flautist, using the thicks and thins made by the points and conical ends of the sticks. You will become aware of the intensity of this notation – the delicate vibrant touches of a concentrated short-hand for later use in paintings. Three crayons were used on buff paper – red, black, and white for heightening.

After Leonardo da Vinci

After Watteau

Oriental and Western Brushes

Brushes can be any size, from a whitewash brush to the miniature brush – a hair divided into four parts – used for painting a tiny picture for the Queen's dolls' house. But I find those made from pure red sable will do most of the things I want of them. It is usual for art stores to have a pot of water available with which to test the points, because watercolourists are often more discriminating when choosing sable brushes than oil or acrylic users. (It is difficult to keep points for long periods in these media, anyway.) Brushes are made from the hair of many animals, including deer, horse, camel, squirrel and badger. Sable brushes are Kolinsky, which is Siberian mink; fitch brushes are polecat. An Oriental inscription brush is made of two parts

rabbit and eight parts goat hair. There is also one made of chicken feathers. The Egyptians used a reed with its fibres macerated at the end. The rare brush Cennino Cennini had was of miniver, or ermine. Japanese and Chinese brushes have beautiful handles. Sometimes the hairs are supported solidly up to the tip by a cone. Although they are all good when used with ink, they can be disappointing if you hope for the spring of sable. Each kind of hair is intended for a particular use. The brush strokes set out below are a part of the beautiful and traditional visual language of brush marks once used in China. Those in the centre of the page are techniques for broad leaves.

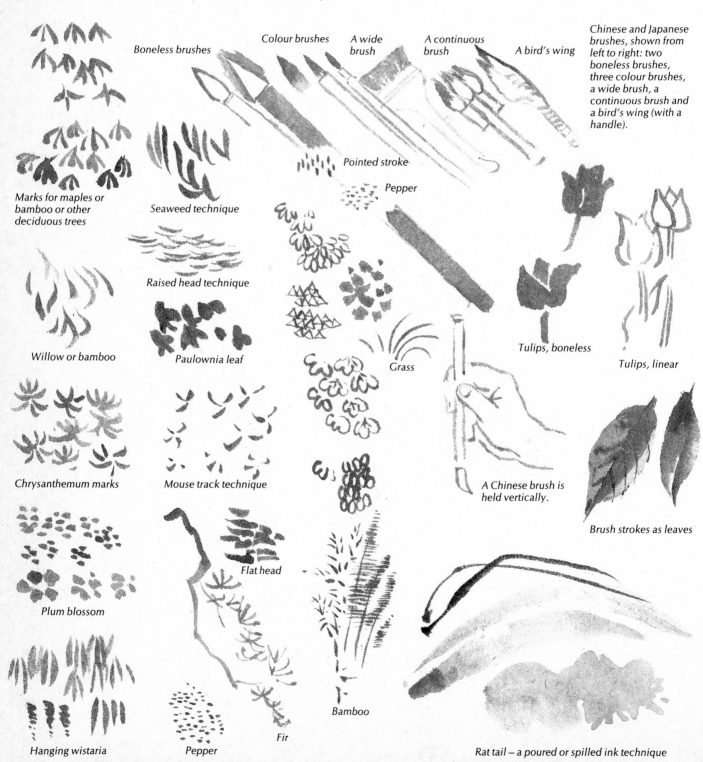

Boneless brushes

Colour brushes

A wide brush

A continuous brush

A bird's wing

Chinese and Japanese brushes, shown from left to right: two boneless brushes, three colour brushes, a wide brush, a continuous brush and a bird's wing (with a handle).

Pointed stroke

Pepper

Marks for maples or bamboo or other deciduous trees

Seaweed technique

Raised head technique

Willow or bamboo

Paulownia leaf

Grass

Tulips, boneless

Tulips, linear

Chrysanthemum marks

Mouse track technique

A Chinese brush is held vertically.

Brush strokes as leaves

Plum blossom

Flat head

Hanging wistaria

Pepper

Fir

Bamboo

Rat tail – a poured or spilled ink technique

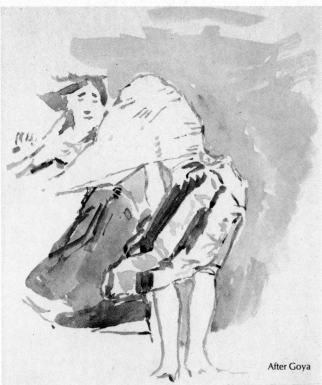

After Goya

Using diluted Chinese ink, freshly rubbed on a stone with purest water, copy one of the intimate brush drawings to be found in Goya's notebooks. Every touch makes the wind gust more. East and West meet in great brush drawings.

A red sable in a quill. Sizes, named in order, are: lark, crow, small duck, duck, large duck, small goose, goose, large goose, extra small swan, small swan, middle swan, large swan and extra large swan.

A flat brush

A rigger or striper

A writer

A hog hair brush

A round, red sable brush. Less springy brushes are made of ox and squirrel hair.

Fan brushes are available in hog bristle or sable hair.

A spotting brush

Blenders and wash brushes are usually made of badger hair.

With a bristle brush, ink, gouache or diluted oil paint, draw with a semi-wet brush. There are various alkyd extenders for use with oil paint, as well as alkyd paints. Find the right roughness of paper and wetness of brush. The results can be rewarding, because then drawing becomes like painting.

A pocket sable

A sponge

A shell for mixing

Wells for diluting watercolours and inks

The items above and on the left, together with some tubes of watercolour, bottles of ink, blotting paper, a sponge and some water, constitute the main requirements for brush drawing in the West. They are not as beautiful to contemplate as the Oriental materials below.

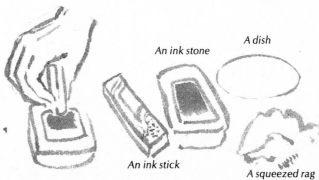

A dish

An ink stone

An ink stick

A squeezed rag

The materials for rubbing up ink and the slab of ink itself are inspiring, when one thinks of the centuries of wonderful drawings and paintings these simple materials have helped to create. Here, left to right, are: an ink stick being rubbed on the stone with water, an ink stick, an ink stone, a dish of water and a damp rag.

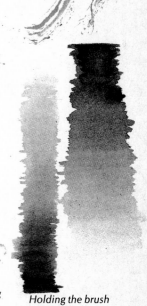

Holding the brush vertically, moving horizontally and vertically, make gradations from water to blackest ink.

33

Flowing Brushes

Licked brushes keep their beautiful points and saliva has a special cleansing action, but some colours are poisonous, so wash your brushes continually by wiping them with a damp cloth. Red sable brushes have springy hairs and, when bound and set in quills, seem to be made with better points than those in metal ferrules. Nothing will fray the temper more than a brush which fails to keep its point, and such a brush will hamper the work done with it. Use it for erasure and buy a better one.

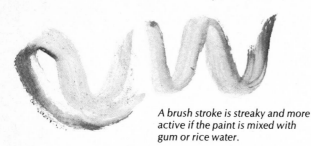

A brush stroke is streaky and more active if the paint is mixed with gum or rice water.

Hold a brush vertically, and a pondlike pool of colour will form. Raise or lower and move your brush and a rivulet will flow. Practice flows using the tip of a brush and barely touch the paper.

A spring will suspend a brush in water.

A brush stroke begins with a point, swells, then finishes with a point.

Sponges and blotting paper are useful for controlling the depth of colour and tone, and for erasure.

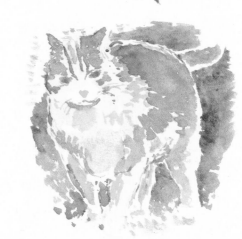

A rising progression of brush strokes

Suggest a fine cat with little blobs. Move from the nose outwards. Much of the line is in the liquid edges of the brush strokes. With a hair or two of sable, mark delicately his whiskers as they radiate.

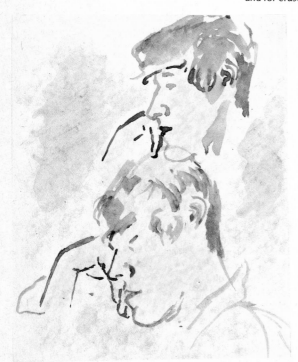

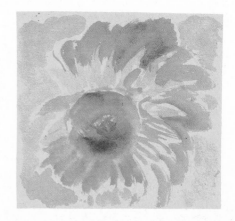

Drawing with an almost vertical brush needs a precise, delicate control. The heads are drawn with a brush and Chinese ink; the tinting is with pastel and watercolour.

A brush can add colour to pencil drawings. This is useful in a sketchbook.

Make a dancing play of brushed marks. The curving zizags of the background will oppose the saw teeth of the petals.

Practice a full repertoire of dabs in front of a tree full of apples. Japanese paper is responsive to the lightest touch. In China and Japan, there is less difference made between drawing and painting, or indeed between these and writing. It may help if you think of it as brush-writing your way round the tree – calligraphing a letter about summer's change to autumn and about how all branches move towards twigs, narrowing at the end but supporting apples on stalks and even birds. Using blobs for apples or leaves seems less like drawing and more like painting than when you make the brush tip outline structures and shapes, which seems more like drawing. I suppose it depends on how great is the emphasis on line. Both methods are used in this drawing of an apple tree.

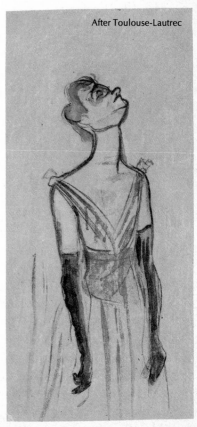

After Toulouse-Lautrec

Watery puddles of colour move only at their sharp edges. Warm colours and contrasts come forward. Light lines are left between areas of colour. The legs are drawn with dark outlines. Pattern triangles lie flat. The lines are economical and much depends on the suggestive qualities of the dabbed water. People on couches and beds should never be allowed to go undrawn. Posing is so comfortable and the drawings can be so good.

A long-haired brush, called a writer or rigger, will hold enough liquid to make long, expressive marks. When these marks accumulate, drawings become more like paintings. Lautrec sometimes made elaborately overlapping brushings to mass up his portraits. Degas would draw with turpentine and oil paint.

Erasure

The word accidentally dropped in conversation which ruins a friendship cannot be erased. Some conversationalists thrive on making insults which they then retract, making every friendship begin with a fight. Able draughtsmen, like statesmen, know ways of avoiding mistakes or of making them work to their advantage. Degas, Matisse, Picasso and Giacometti drawings are often worked over erasures which display the temporal succession of marks made when arriving at an image. Little visible erasure was permissible before this century. If revisions are inspired, they are as moving to behold as the successive states of Rembrandt etchings. In some cases, redrawing is deliberately used to suggest seriousness. When it is automatic or unnecessary, it is as boring as when, in the Sixties, displaying the process was a fashionable way of showing awareness of abstract art. Showmanship is often made possible by erasure. Copying can help to distinguish eloquence from slickness.

a. Pumice
b. Sandpaper
c. Steel wool scouring pad
d. Scouring brush
e. Pencil and ink rubber
f. Hog hair brush
g. Razor blade
h. Typewriting eraser
i. Scalpel
j. Paper cleaner
k. Typewriting eraser pencil
l. Pounce wheel
m. Cloth
n. Rubber-ended pencil
o. Putty rubber
p. Kneaded bread
q. Correction fluid
r. India rubber
s. Sponge
t. Titanium white gouache

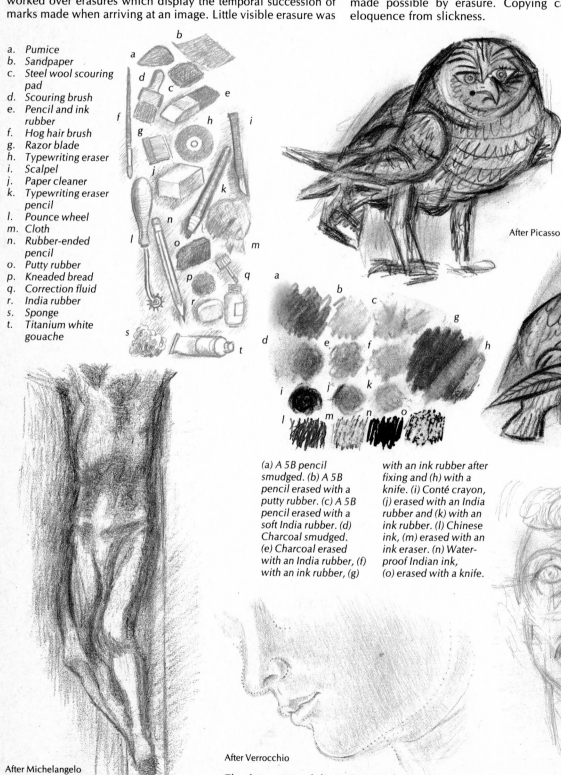

The owl is drawn with smudges and the rubbings out are left visible. In the lower version, done two days later, the wing is redesigned and made with increased virtuosity.

After Picasso

(a) A 5B pencil smudged. (b) A 5B pencil erased with a putty rubber. (c) A 5B pencil erased with a soft India rubber. (d) Charcoal smudged. (e) Charcoal erased with an India rubber, (f) with an ink rubber, (g) with an ink rubber after fixing and (h) with a knife. (i) Conté crayon, (j) erased with an India rubber and (k) with an ink rubber. (l) Chinese ink, (m) erased with an ink eraser. (n) Waterproof Indian ink, (o) erased with a knife.

After Michelangelo

Changes throughout are left visible as in the other late "Crucifixion" drawings. Unless you are as skilful as Leonardo, draw and erase and let rightness prevail.

After Verrocchio

The cleanest way of eliminating mistakes was to use a paper cartoon. Only the ultimate decisions were pounced (pricked and dusted through) on to the painting surface. Verrocchio thinned the nose and removed the double chin of the Madonna.

After Giacometti

Giacometti takes a small soft rubber across his marks, as if drawing with it. The resulting smudges are more a part of his style than the effect of rectifying mistakes.

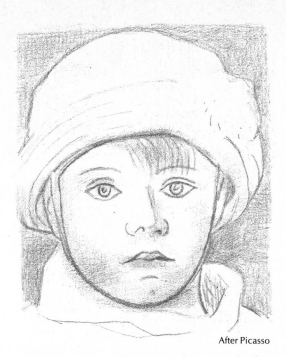

After Picasso

A canvas cleaned with solvent was redrawn very simply with a small brush. We cannot guess how many redrawings were necessary.

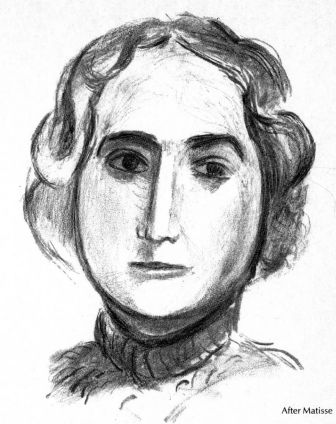

After Matisse

Matisse said of his work at one period that, like tying a cravat, if it did not come out right, it must be discarded and a new start made. He was a great artist and showman. Erasure was part of his style. It enabled him to present the image being formed and a virtuoso performance, all in one drawing.

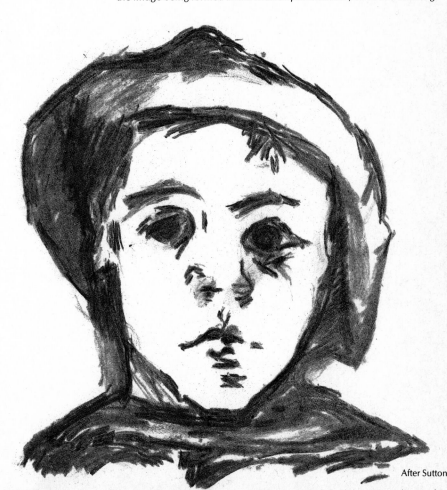

After Sutton

Self portraits and ink force us to perform with polish, though ink can be erased with typewriting erasers or by dabs of correction fluid or other white paint.

Philip Sutton takes many new sheets and eventually discards the failures. Continual practice in front of the subject means his marks are in the position he intends, with panache.

Coloured Papers

Coloured papers, like coloured beds, change the colour of anything put on them. Pink beds turn nudes green. Some juxtaposed colours hurt the observer, making vivid, painful contrasts. If those as sensitive as Mozart faint at the sound of trumpets, some associations of strong colours can be handled only at optical peril. Coloured papers come in many shades and textures. Cut shreds from the edges and put them in a sunny window for ten days. Some will fade badly. Papers prepared by brushing, sponging or streaking them with watercolour are often attractive, especially when used with body colour or pastel. Towards the end of his life, Matisse had papers specially painted for him with gouache, making them bright and streaky. Cutting with scissors, he could work in colour. Try cutting into different hues and seeing how they react when placed against each other. The laws of contrast apply. Complementary colours set each other off. Close tones "buzz," especially red and blue. Colours which do not have the same ratio of dark to light found in a rainbow are often discordant. For example, violet is dark compared with yellow in a natural spectrum. A discord which can sometimes be delicious occurs if brown is placed against a violet-blue. Other effects are less predictable, such as colour drift, where a bright surrounding colour moves into a small neutral area, instead of that area turning by "simultaneous contrast" to a complementary colour.

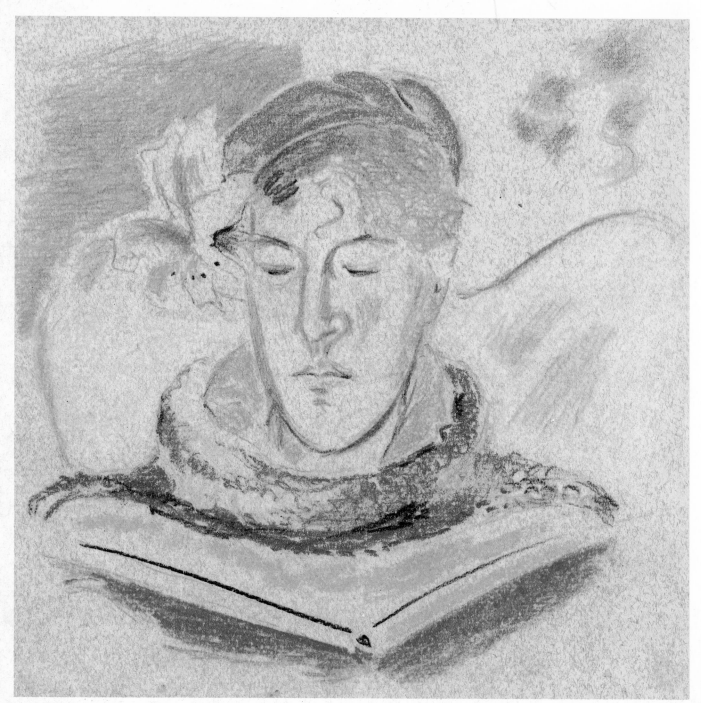

Laetitia reading. I used pastel pencils on yellow Ingres paper. Its hairy texture makes a pleasant vibration, reducing the tone without subduing the vitality. Every pastel mark is affected by the base colour. A broken colour is affected in a different way from a solid colour. Marks made on coloured paper react with the colour of the paper. In some ways, this is simpler than working with white paper, because white is all colours and some colours seem more simple and solid than white. But if the paper is a very bright colour it may be demanding or limiting.

Always having been a
sculptor and a great
colourist, Matisse felt
he was carving in light
and colour at the same
time. Paint some paper
blue with beautiful
streaks and cut it to
make a figure.

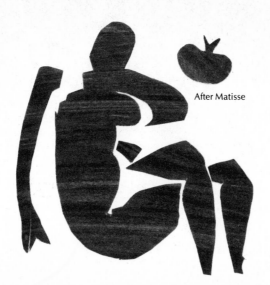

After Matisse

Yellow bananas drawn
on yellow paper. Even a
cream crayon goes cool
over yellow. The rough,
woven appearance of
the paper gives a
smooth texture easily, if
you fill up the weave.
The flesh can thus be
made smooth in contrast
to the background.

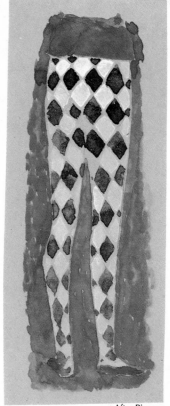

After Picasso

A variation on a harlequin from
Picasso's Rose Period. He often used
gouache on buff paper. Copy a
Picasso from this period, using a
coloured paper with body colour. If
you mix gum arabic with pigments,
the colours have strength, brilliance
and a beautiful eggshell texture.
Vuillard mixed them with glue.

The opaque left-hand
line is white conté
crayon. The trans-
lucent white ink line
is modified by the
coloured papers it
passes over.

Hastings Castle on pink paper. The pink is visible through
the granular greys, making an airy, optical effect. Optical
effects of this kind are sometimes called "film colour", as
is the blue we look at if our eyes are closed or when we
look at the sky.

39

Grey Papers

Black and grey days affect our spirits. Black and grey papers support our drawings and affect them considerably. Chalks move well on black and grey Ingres paper. White ink travels easily on smooth paper which has been sponged or brushed with black gouache – the slightly granular texture takes the ink well. Use fixative if you find the pen dissolving the gouache. With waterproof-inked paper, the coating does not dissolve. There are several commercial black papers: some are white papers coated with black, which are attractive; in others, the black dye is integral. Drawing with dark lines on white paper is a clear language to which we have become accustomed since infancy. White lines do not function in the same way. We see them far less easily. It is slower to read a typescript printed white on black than black on white. White lines are gleams, X-rays, ectoplasm, wires and traces. Dürer and his pupil, Hans Baldung Grien, hatched with white and black lines and the meshes worked convincingly to make heavy, rounded forms. Picasso and Matisse cut white lines as linocuts and Munch made white lines in woodcuts.

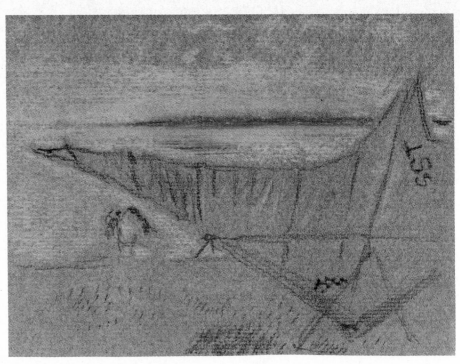

A hang-glider on cliffs overlooking the sea at sunset. Pinkish Ingres paper can be stroked with white conté crayon to suggest the softness of evening. The darks are in black conté crayon. As evening comes on, the birdlike kite turns into something more like a bat.

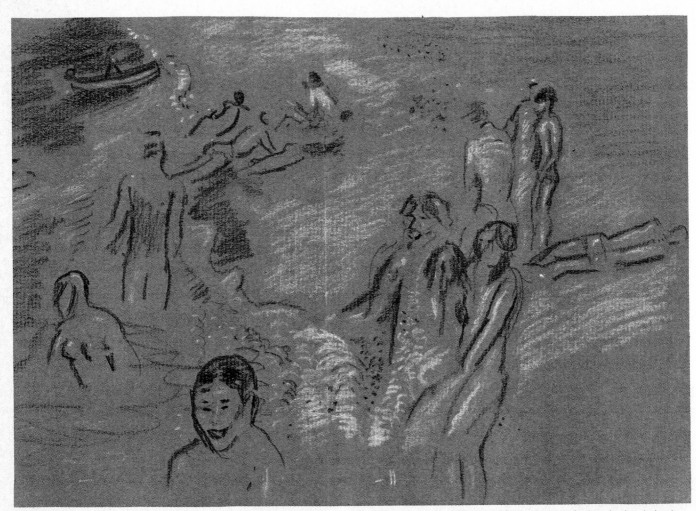

Draw bathers as firmly as you can on grey Ingres paper. It is much less dazzling than white paper on a bright day, and you can use white chalk to heighten. Hatch over the ribs of the paper to make fine, broken lights for the shimmering heat of the beach. A different jerking mark depicts the foam.

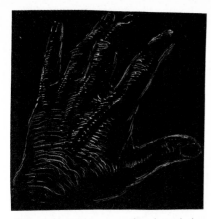

Draw delicately your own hand, on dark paper with white ink and a mapping pen. Shake the bottle frequently. The result may look rather negative.

A white and a dark line diagrammed to show that the black line looks more linear than the white.

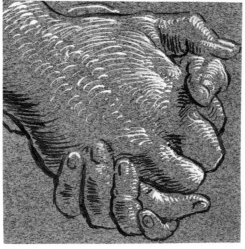

After Dürer

Almost unbelievably wild, like an engraver who has drunk too much, the black lines are pulled around the forms with a bounding passion. It needs intoxication of a kind to draw well with white ink lines.

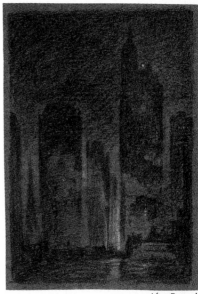

After Pennell

The lights of New York, made dreamy with smoke. The towers melt into the gradated darkness. Touch in with white chalk and ink.

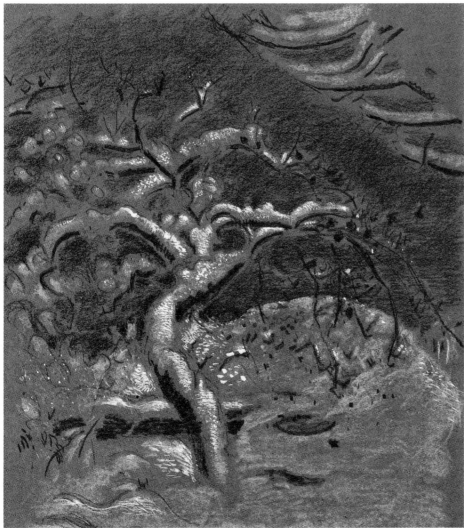

Lights at night can be marked on black and grey paper with white conté crayon, by the light of a torch (or a car dashboard light).

A combined torch and pen is obtainable for use in the dark. Use symbols on white paper for the complicated lights by the sea.

Use white and black conté crayons to draw snow on an apple tree. Where it needs more clarity, draw with a pen and white ink. It became more and more decorative as I tried to make it as clear as the snow. Sometimes it is difficult to be light enough on grey paper. The drawing shows well that if a black line is made on grey paper it remains a line, while a white line becomes like snow. It might be interesting to try to reverse this by making the darks vague and the lights linear.

Dabs of masking fluid can be put on each point, and dark watercolour or ink may be washed over the whole sheet – then the city lights will shimmer above the river.

41

Pale and White Papers

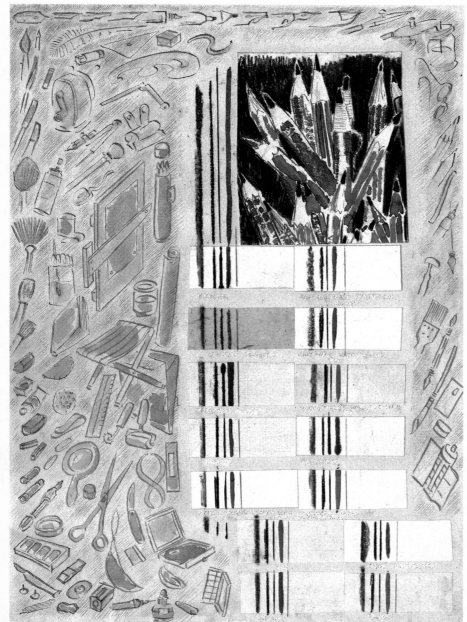

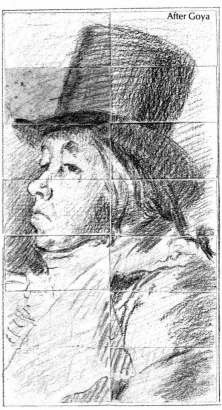

After Goya

Lines made with charcoal, conté crayon, pen, brush and pencil on fourteen different papers (left) show how different surfaces affect media. I used conté crayon and the same papers to copy the Goya self portrait (above).

In the left-hand column of each group, the papers used were (top to bottom): blotting; Japanese textured; Japanese mulberry; Ingres; Ivorex board, filled with china clay for smoothness; bank; airmail.

In the right-hand column, the papers used were (top to bottom): rough-surfaced; heavy hand-made watercolour; rough-surfaced, hand-made watercolour; not surfaced, mould-made watercolour; cartridge; thin, hot-pressed hand-made; bond.

Like bread, paper was never white in the past. Vellum and parchment were a warm colour. How dazzled and surprised the Old Masters would have been by our cool papers, treated with whiteners and fillers, such as china clay, to make them shining white and smooth. Intuition will help you when buying paper. If it tears easily, it is probably inferior. Cartridge is the commonest art paper and is fairly durable, but it contains wood pulp and is not suitable for watercolour. Rag, cotton and esparto papers are good for the line media; so are the papers used for lawyers' documents. Bank is a thin, hard paper. Blotting paper and filter papers are durable and non-yellowing but, like Japanese papers, are very absorbent. Thick watercolour papers do not cockle when wetted; they are watermarked and, if held to the light, the brand name and sometimes the words "Hand-made" become visible. They can be remarkably expensive, heavy and thick, and should be made of flax rag fibre. Certain sheets are called "outsides" and these are cheaper. You can make paper at home with an outfit which is sold for the purpose, and this can be pleasant as the paper will contain only your chosen ingredients. Colours or dyes can be introduced at the pulp stage, or the paper can be given washes of watercolour afterwards. Some of the wood pulp papers yellow badly and the chemicals used in pulping and repulping wood cause a rapid breakdown in the material. Newspaper suffers photochemical changes and quickly goes brown and brittle. Many Cubist collages have had their tonality and colour completely changed by light. Victor Pasmore's collages of the Fifties have also changed considerably. Paper is a fragile material. It is subject to rapid decay if it gets damp, because fungi thrive on the glue size it contains. Some papers contain acids which affect them badly. Yet papers have supported paintings by Dürer, Degas and Cézanne. Engineers' drawing boards are made to keep paper flat. Battened and slotted, they have ebony edges. Thin plywood and even pieces of cardboard are also useful as drawing boards. They are light and may be used with clips. To stretch paper, wet it and stick its edges with gummed paper to the surface of a drawing board. The paper will then have a fine, slightly absorbent texture and will not wrinkle when wetted. By selecting your papers correctly and by stretching and coating them, it is possible to make the surface you are working on absolutely right. The colour and texture of paper are a large part of what is to be looked at in many drawings.

TECHNIQUE

We gasp at cleverness, at the man balancing on one finger on a flagpole. Details amaze. Long brush strokes, smoothness, finish, calligraphic bravura are a part of drawing and are as able to capture an audience as a virtuoso violinist in the throes of a concerto. Rubens painted before an audience in his studio. Turner painted at Royal Academy varnishing days. While Tintoretto, Rubens, Manet, Dufy, Hals and Matisse were great performers, Chardin, Carpaccio, Balthus and Magritte made no show of their skill. But skill can conceal skill. Cleverness is only clear if the language is understood. Copying can help us to distinguish superficial slickness from the aware skill of a master.

When you were young
When you drew as an infant, was there a favourite colour in your big box of crayons? Was your sheet of paper limitless? Your way of working now you are older need not be much different from the one you enjoyed then. Perhaps drawing is the youthful elixir which spans the years. The state of mind you are in when you draw is important. Prepare for discipline. Breathe correctly. Let the spirit move the fingers. Become intent enough to lose yourself. Lines are like breaths. Hold your breath for a long line – be poised like a singer taking a long top note. Draw another line. Bring muscle tonicity to it. Make it full of fire.

Practice for tonic draughtsmanship
Push-ups can be part of serious training; shelling prawns demands manual dexterity; and snooker requires the exact coordination of eye, hand and brain. The exercises in this section have been prepared for your serious trial, using balls, cardboard triangles, cassettes and Möbius strips. Once you have practiced enough to be sure of the clear expression of your ideas, you need only practice to loosen up. Drawing only requires a continuance of exercise if you are a virtuoso artist.

Document your life by drawing
Carry less paper money; substitute drawing paper. Register your experiences. Make memoranda – a visual diary. Record your life. Draw whatever you encounter to soothe your nerves. Inscribe your delights. Drawing books can encapsulate such very special essences: Gwen John, for instance, drawing in a church, sketching her cat or trying out designs for a nun's portrait; or Sickert, recording in a notebook an intimate assignation in a London theatre box. If you carry a 2B clutch pencil with its own eraser and a few postcards, you are completely equipped. Sketch-drawing was central to the activity of Vuillard as he explored the richly patterned interiors of his milieu, to Bonnard as he walked in the garden, and to Constable who, like a meteorologist, put time and date, day by day, to cloud displays in his tiny sketchbook. Turner's sketchbooks are beautiful dream records of golden journeys, of revelations in mountain passes, of epiphanies in faraway places.

Lines which decorate and define
The main element in drawing is line, and although there are drawings made almost without lines (see p.66), line is like the spine in the body: central to draughtsmanship. Line is versatile and various, and in a way approaches closer to music than most other visual elements. There is a pleasure to be had from pure, clean lines which show objects of a certain banality – a jug or a cup in Ben Nicholson's early drawings, which resemble voices singing unaccompanied in clear air. There are lines which form labyrinthine patterns, as manuscripts do when, winding in mazes, they endeavour to protect holy writ from the devil – all manner of animals, birds, flowers and men are strap-worked in. The ability of a line to decorate and define at the same time was understood by Matisse as he wound his harems of delight in the shape of black ink arabesque performances. Lines are drawing and to know about drawings we must examine them, line by line.

Ordinary working lines
There are the lines which will have no pages especially devoted to them. They are not thick, thin or incisive. They are the ordinary lines in between. They are the lines for the artists who take the middle way of reason. Passion is in some mysterious way distilled from ordinary lines by John Lessore, who makes no show of cleverness or extravagant, exotic patterning or bravura. Sickert also used ordinary pencil lines and made serious, secure surprises. Lucien Freud strokes his powerful imagery with ordinary pencil lines, yet they are gritty and angry against ordered design. He worries every contour and crevice, like a dog worrying a sheep. Though to begin with, Freud made well-ordered paintings – possibly under the influence of Cedric Morris and then the early Miró – now his lines are made to sweat.

The eloquence of lines
It is almost impossible to make a line keep still. Any fluctuation or inequality and the line goes bounding along. Equal lines will move less vividly than swinging, fluctuating or gestural lines. Artists whose special temperaments incline them to what is loosely called a classical style (nothing to do with Greece or Rome) tend to draw slow moving lines. Gris' portrait drawings are still and definite; so are those of William Roberts. Léger's equal lines flow like slow rivers. On the other hand, Patrick Procktor's lines are tender and thin for striplings and delicate flowers, as seductive as watercoloured charms. But the still, small voice of the thin line is at its most moving in the pencil and watercolour drawings by Gwen John. Picasso has used every kind of line at different periods of his life. The heavy drawings of his classical period contrast with his delicate drawings of ballet dancers. The tiny, delicate lines of early Klee were followed by funereal late angels and skulls done with thick, dark lines. Howard Hodgkin paints wide chords of sensuous colour. The widest lines in art, they evoke sometimes and obliterate at others, like ravishing meals eaten in splendid circumstances and brought to mind by spots and splodge patterns. An eaten meal is an obliteration of the art of the cook. Hodgkin's obliteration is the painted memory of the circumstances of a meal.

Drawing can exist without lines
I do not care to separate drawing from painting and it would not be useful. Seurat used black chalk, but his drawings could almost be thought of as dry paintings. From the glitter of dry painting, dots and spots can be seen to be as much a part of drawing as is line. Some pointillists did drawings using spots. Dots stimulate the eye, just as the plucked strings in a Bartok quartet stimulate the ear. Dots can build realms of vibrating light. In practice, the incomplete understanding of hatching, shade, shading, shadow and the various kinds of modelling is a frequent cause of nasty drawing. Put any of the meshes and darkenings in the wrong places and you have dirt. I implore you to examine the effect of every piece of hatching. Almost as hazardous are tone values. Search out the effects of varying degrees of darkness. Leave nothing to chance. If you lose tone control, it will cause you endless trouble. Tone trouble can make you sad for years. Lastly in this section, perspective – the most dangerous technical tool of them all. Perspective, that marvellous method for making railway lines travel to a vanishing point, will mechanize your delicate sensations. It has enabled wonderful paintings to be constructed in the past. But take the greatest care. It is a tool which is important to understand. The parallel and receding lines of objects as they are angled in drawings act together in perspective, whether you wish it or not, and it is very important to know what is happening in order to control your picture.

Fast, Easy Drawing

Draw with a child or for a child. A child will teach you, free you and applaud you. (If you are a child, join in and play the game with me.) Did you learn the alphabet with an ABC made of coloured pictures? Thomas Bewick and his apprentices printed wood blocks to delight young eyes. Copy a Bewick and, as you are not cutting wood blocks, be free with your lines. The race, for young and old, is to fill in at speed twenty-six lettered squares with images – child's play you think? A for apple, B for bottle, C for cat, D for dog . . . You will fail to win. A child will fill the compartments before you can ink your pen. For the next race, draw anything which comes into your head. The child will probably not win this time. The aim of the game is to free you for drawing. Just as a runner shakes his limbs before racing, your mind can be made free for invention and your hand for production. Scribble-draw whatever you imagine as you go through a dictionary. Draw fast. Then draw faster. Draw from the flickering television as it beams the news. Draw as fast as the advertisements. Draw faster than sport, faster than ice hockey! Draw whatever comes up on TV. Draw in pencil. Do not mind the mess of overlapping. Overlap using a fountain pen – it will travel over pencil. Keep the point moving.

David Jones, the great Welsh watercolourist, saw this bear in the street when he was seven years old. The observation was prodigious. So sad a bear was not child's play. This fine Welsh artist and poet probably did not draw it rapidly, but his Celtic feeling for rhythm made all his mature watercolours free and lyrical.

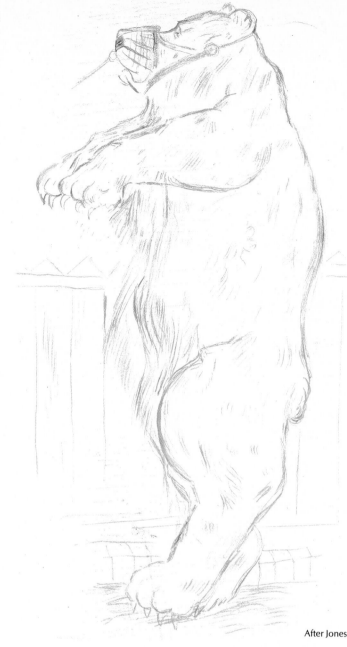

After Jones

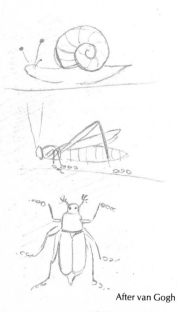

After van Gogh

Vincent drew these insects when he was twenty, to amuse the child of an art dealer he worked for. Draw as if a child has asked you to draw something – a snail, a grasshopper, a beetle or a space shuttle. Van Gogh, in his finest drawings, saw as simply as a child but was never naive.

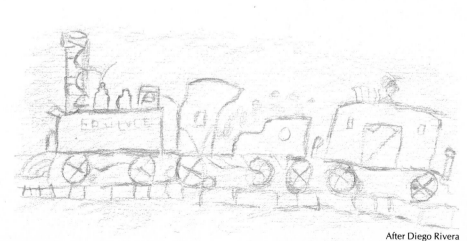

After Diego Rivera

Little Diego made this train move well when he was three years old. It is beautiful and is as logical as any work has to be if the artist is really involved. Copy drawings by children, as Picasso did. Children have ways of thinking which show short cuts to expression, images which can flower in the mind to be mature art.

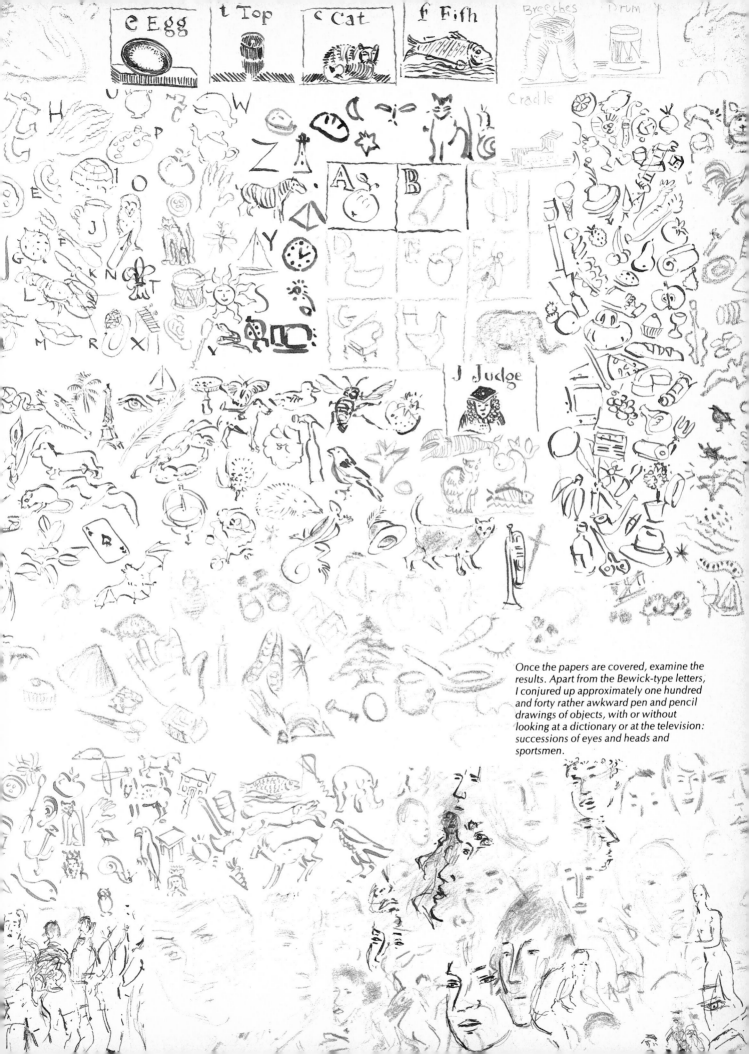

Once the papers are covered, examine the results. Apart from the Bewick-type letters, I conjured up approximately one hundred and forty rather awkward pen and pencil drawings of objects, with or without looking at a dictionary or at the television: successions of eyes and heads and sportsmen.

Scribbling

The board meeting had bored on for hours. When it was over, the secretaries collected the droppings: cigarette tips, ash, papers and pencils. On the papers were drawings – not about international trade, but scribbles and doodles, some very elaborate, some simple, some nervously hatched black, and some plainly led by Eros. So natural had the activity been that most of these businessmen had not known drawing was happening. Most would have asserted that they could not draw to save their lives.

Drawing is the most demanding activity in the world. To do it as well as Leonardo da Vinci, Rembrandt, Rubens or Degas, on a technical level, would require hours of practice. Countless drawings have been done by people as skilful as Leonardo which are meaningless. And some of the world's most beautiful drawings were done without his degree of skill. There are ideas which you alone have and which can only become visible if you draw.

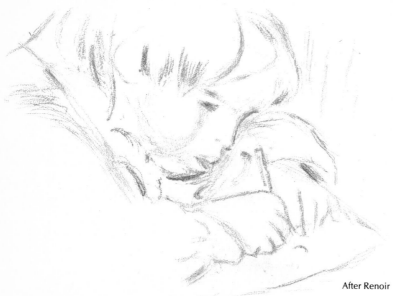

After Renoir

Renoir liked art to look hand-done. His son is drawing intently. The child wants to draw like his father. The painter wants to see as newly as a child. Love allows emulation with no trammel. The technical brilliance of Vermeer is marvellous, but direct expression of this kind requires no polish.

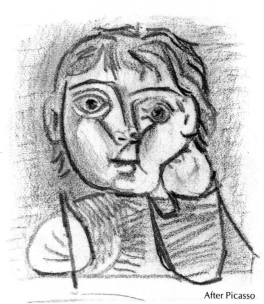

After Picasso

Picasso tried very hard to see with a child's directness. This squat visionary, pencil poised, is Paloma. She is obviously teaching her father how to draw.

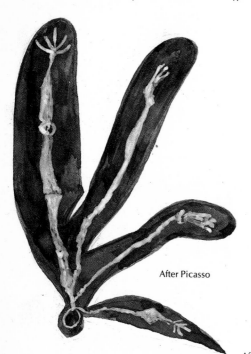

After Picasso

Picasso's Unesco mural is a little like a bouquet of black sausages, more like a sun-whitened skeletal Icarus, set against four funereal black feathers, falling. Artists often identify with Icarus, whose wings melted because he flew too close to the sun. The technique is rough brushing on tiles, done like graffiti.

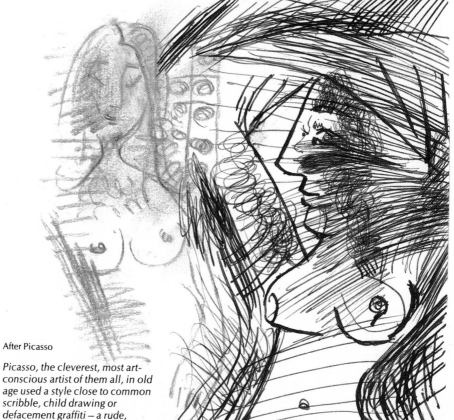

After Picasso

Picasso, the cleverest, most art-conscious artist of them all, in old age used a style close to common scribble, child drawing or defacement graffiti – a rude, direct expression. It is copied from an etching.

A scribble or doodle can grow and even become a convincing image, just as a clipped bush becomes a topiary animal or bird. Try to free your mind, moving the pencil around. Doodles and scribbles are like handwriting without words.

After Utrillo

A naive drawing of three ebullient ladies and a man

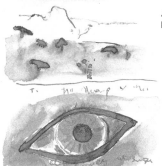

After Lowry

Compared with Utrillo, the figures are well designed but rather thin.

After Klee

A man rowing. Casual and cunning, no one was less naive than Klee.

The great explorer of Africa, David Livingstone, kept a notebook recording his travels. Without being trained as a draughtsman, he communicated vividly and beautifully. Above an elephant's eye, he depicted Tabu Cheu, the white mountain, using pen and watercolour. If the need to communicate is great enough, the means will be found.

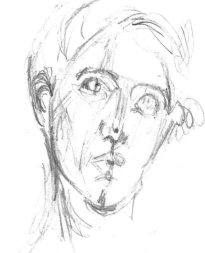

After Livingstone

After Giacometti

The fast scribble is high style drawing. It exploits the lubricant quality of graphite and appears very easy.

After Giacometti

The stabs of graphite suggest a sculpture.

Doodle graffiti are expressive and ubiquitous. Fingers draw in the dust, on cars, on the flat, washed sands of beaches. Aerosols decorate and pollute, exposing obsessions and repressions. Drawings in public conveniences have vitality. Arshile Gorky, Miró, Jackson Pollock and the New York Abstract Expressionists made large-scale works, possessed of doodle-like automatism.

Making a Sketchbook

In the glass cases of museums, the tiny sketchbooks of J.M.W. Turner lie, peaceful after their journeys. His intimate companions when escaping to Wapping or ascending the Alps, they were kept in a capacious pocket when he moored in a gondola on the lagoon of Venice, or heated up as he warmed to drawing the burning Houses of Parliament. Wherever he went, he took a little book of grey, white or orange paper to support and contain his thoughts. To make your own, buy some paper, preferably rag paper, in full size sheets. Smoother papers are also useful. Fold them to give the shape of a sketchbook. You can tear the paper to be rough-edged, if you like; otherwise, cut it. For protection, cut a piece of card, slightly larger, and tie with elastic. Give some of the sheets watercolour washes to tone them; mixtures with a little white are sometimes pleasant to work on. Coloured wax pencils do not smudge and can be washed with colour, but chalky or soft graphite drawings should be fixed or removed as they blur. A sketchbook is often a visual diary. There is a Cézanne sketchbook facsimile which shows his wayward thoughts when not in front of the subject. His little boy, Paul, also drew in it. Study the sketchbooks of Dürer, Constable and Delacroix. Sketchbooks can be – like the notebooks of Beethoven – central to an artist's experience. Treat yours seriously. If you do not have it with you, the back of a chequebook, a gutted envelope, a postcard, a writing pad, a menu or almost anything white will do. Draw everything on one sheet of paper so all the world you see is present as mood and event. If you wish to refresh your memory or make something more permanent, do not change the sheet of paper, lest you destroy the presence. An eraser will remove the pieces of drawing which abstract or spoil the meaning.

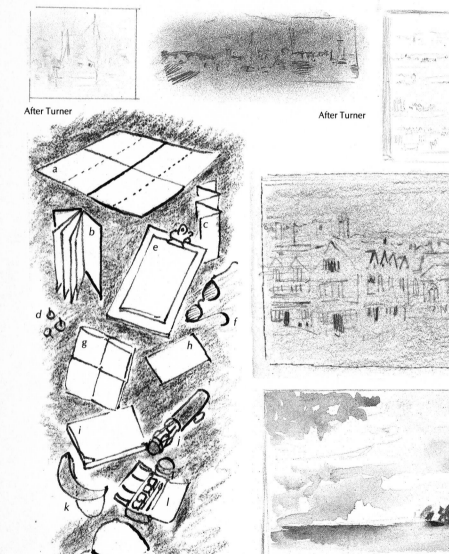

After Turner

After Turner

After Turner

After Turner

Staccato marks make the cows, sheep, windows, battlements or tiny men seen on Turner's journeys. His sketchbooks often had metal clasps which prevented the pages from rubbing together. Some of them look as if they had been dipped in blue-grey watercolour. The rather deep tone enabled him to draw with black chalk and heighten with white, or to use warm-coloured gouache. The effects were magical and achieved with minimum effort.

a. *Paper marked for folding*
b. *Paper folded as leaves*
c. *Paper folded in a zigzag*
d. *Pins*
e. *Clipboard*
f. *Sunglasses*
g. *Paper folded in eight*
h. *Single sheet of paper*
i. *Watercolour block*
j. *Brush container*
k. *Eye shield*
l. *Watercolour thumb box with dipper*
m. *Sunhat*

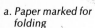

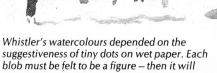

After Whistler

Whistler's watercolours depended on the suggestiveness of tiny dots on wet paper. Each blob must be felt to be a figure – then it will come alive. Dot some distant figures on the beach or in a park.

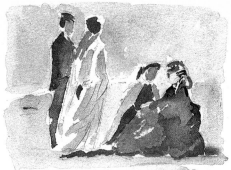

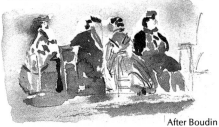

After Boudin

Boudin said that three brush strokes from nature were worth more than two days' studio work. The sedate beachwear is brushed in blobs over a free pencil drawing.

A fast fountain pen drawing of fishermen. Draw the scurry and accept a few bad lines. Clean up later if there is anything too offensive; and if nothing pleases you, discard it in a month's time.

Fishing boat, cliffs and bather on a folded sheet of paper. The pencil has drawn a still, horizontal boat in contrast to the active shoreline and diagonal figure which the seagulls are helping to move towards the sea.

A thick-nibbed fountain pen sketch. Gilman used heavy lines like these, as did Léger. It is necessary to think decisively and draw rather slowly. Dots are safe.

After Bonnard

Bonnard did hundreds of tiny sketches on thin paper, often germs of great paintings. He had a special scribble for every part.

Working with a Sketchbook

Whether you have studied traditional Chinese and Japanese ways of drawing waves or not, in order to make your own sketches true you will have to search imaginatively the real, wild waves experienced by surfers, divers, dolphins and shrimps and feel wet, feel damp, feel the drag of the shingle. Some drawing requires an intuitive leap. Waves move fast, and the clouds which hang so softly in the firmament are deceptive. Approach one with a point and, even as you make the mark, the whole sky changes. The vapours condensing as clouds are eaten into at the same time by evaporation, and it is difficult for a point to shape a cloud – dotting and hatching are too slow. On the beach, the energy is manifested in the marine spectacle. Make any stab at the paper and its vigour will account for some part of the flux. As when a conjurer, casting all his cards into the air, grabs the right one, seize whatever hits your mind hardest, mirroring your mind's daydream. Draw the bright, fast dream and the trace of the movements. Do not examine your catch till later.

Bathers, seagulls and waves – a rough drawing in conté crayon. To draw on the beach you need nerves of steel. Use clips to prevent your papers blowing away. Sit in a folding chair in which you feel comfortable; hide behind dark glasses; wear a big sunhat – the wind blows in your ears. A child, wet from bathing, shivers against you. An ice-cream falls on your hat! Concentrate. If a fine seagull struts towards you, mark him down; do not turn the page. If he pecks or turns, mark it elsewhere. There is space for many beginnings: the coastline in either direction, the wobbling pigeon – throw him some popcorn and draw him bobbing. Mark the tiny wavelets. Watercolour it when you return home.

The sun beats down, making a glittering, attenuated oval on the sea. The girl is lying on the top of high Beachy Head, her body shaped like the Downland hillocks, encountering the sea. The contrast of the jackdaw with the white chalk brings it close. Conté crayon and black watercolour vary the texture. The view does not allow much room for vertical spacing to obtain recession, so a texture becomes extremely important and the vast distances have to be read overlap by overlap.

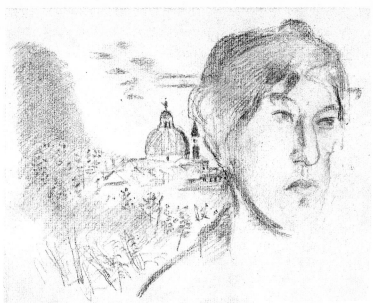

After opening the shutters, Whistler, Sickert, Carpaccio, Bellini or you yourself might, like Turner, have blotched in a gondola, dark on the water.

Domes were probably designed with heads in mind. Anyway, draw the hair shape and chin shape to rhyme with the dome. The flicker of leaves can twinkle as the chalk touches the Ingres paper. The eyes look over Venice. Now copy Carpaccio.

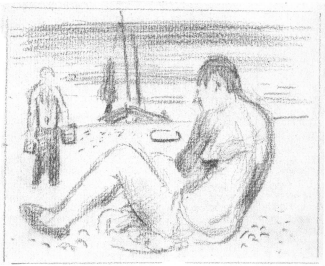

There is time before the plunge to strike in a bather striding through the breakers. Think of Bonnard; his seemingly casual notation contains all he requires to generate a picture.

In this chalk drawing, much depends on the roughness of the ribbed paper. Conté crayon sparkles in the still sunlight; the vertical blocks make slow quietness.

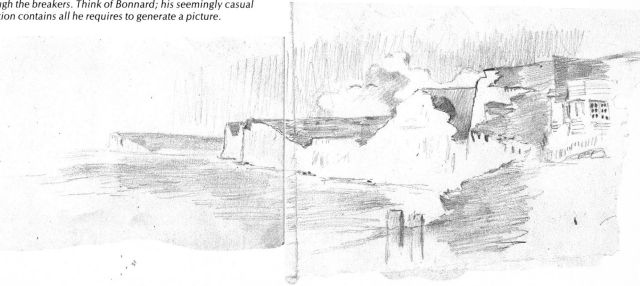

Draw the expanses of chalk cliffs and coastal waters. Light cloud shapes are a more rounded accompaniment. With only the tiniest move along a *cliff edge, every aspect of the view changes. It is possible to follow every crevice, flint and jackdaw with a sharp pencil. Design it as you work.*

Practice Exercises

Drawing is variously heartbreaking, technical, serious or a game. We begin by doing it a little for fun, then want to do better. We practice and consult a book, trainer, coach or teacher. Then we seek prowess and the trainer insists we practice more. Skill in drawing demands the exact co-ordination of all the muscles, bones and nerves from fingertip to brain. Practice enough and the touch will become exact. A sure athletic arm is useful to a draughtsman. A drawn line can be an extension of the life in the body. As a ball player tries many throws, so we must make many marks. This is a sporting art!

Draw a circle freehand and compare it with a mechanical circle. Notice the difference between human and mechanical lines.

Try a fast circle, then draw freely around a compass-drawn circle. Drawing a circle is like making a figure in ice-skating.

Draw concentric circles freehand. *Then test them with compasses.*

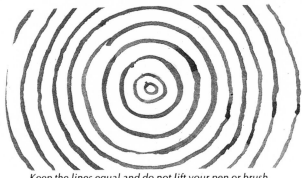

Keep the lines equal and do not lift your pen or brush.

Modelling can be of many kinds. Play with various additions. Invent your own. Some will add solidity clearly and economically; others flatten. Equal darkening will make a circle almost into a flat disc.

Thicken below. *Cross-hatch.* *Speckle.* *Hatch concentrically.*

Thicken below. *Gradate.* *Gradate close to the edge.* *Model by gradating.* *Gradate concentrically.*

A star can be made of long and short arms. But it is difficult to draw one having five equal arms. First draw it in a circle; then by itself. You will be lucky if the last arm fits.

Draw a circle freehand. Divide it equally by five. *Join the points, making a pentagon.* *Five further joins will make a star.* *Now draw it from scratch, without lifting your pen.*

Aim for the still centre. Play at hitting the bull's eye. In Zen, the practice is to strike the bull's eye of a target, having no arrow and a springbow mind. Your target is a square piece of paper.

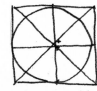
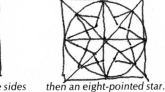
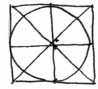

Aim for the middle. Test it with a ruler. *Try for a circle to touch the edges. Check with compasses.* *Join the centres of the sides and make the diagonals . . .* *then an eight-pointed star.*

Transformations

It is important to feel the transformations possible between simple shapes, the basic elements for making drawings. Families of shapes, as when squashed squares become diamonds, make for allied, harmonious juxtapositions – Renoir tended to use ovals, ellipses and circles. When shapes are dissimilar, alien or discordant relationships occur. If the hexagon has started you playing, the whole of Islamic design is available to delight you.

Circles squash to be hexagons, as in honeycombs.

From circle to square in five moves. It is like moving from Oriental roundness to Western straightness.

Circle to cross calling in at diamond

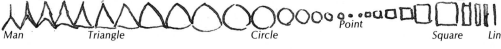

Cross Diamond Circle Hexagon Star Asterisk

Man Triangle Circle Point Square Line

A star is born from a point. It can have three pointed arms but not less. Try losing or gaining an arm on the way to the vanishing point.

The new moon becomes full.

Square to pentagon by way of circle

Power in waves

Draw waving lines oscillating to an exact measure and notice the tense beats which occur between them. Undulating lines obviously make the energy of a van Gogh cornfield or a boar hunt by Rubens, but less obviously they are the life-giving rhythms underlying still subjects, the almost invisible pulse of a Vermeer.

Try an equal zigzag . . .

and an undulating line . . .

then a line moving in arcs.

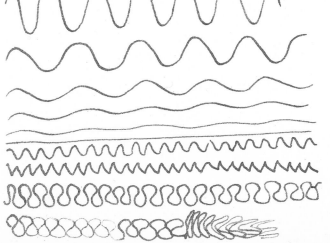

Draw a spiral which returns on itself and a yin/yang sign.

Chinese painters practiced brushing in straight lines, equal in weight and equally divided. Try it with any instrument. I used a pen.

Ball Practice

Drawing squares, circles and cylinders cannot fail to help you learn. This book is not a step-by-step guide to drawing – steps would only be useful if the destination were known. It is for individual journeys and the flights of steps would be as numerous as its readers. Draw a circle enclosed in a square, out of your head. Place a compass-drawn circle in a ruled square opposite your eyes. Copy it. The difference between the two experiences is remarkable. This difference is a mystery which will be with you all your drawing life – although the process is different for everyone. I believe the difference between Goya's feelings when drawing out of his head and those when working from nature was less than it is for many artists. He could combine imagined grotesque subjects with what are apparently closely observed items. Individual temperament affects the drawing of even such apparently simple subjects as a circle, a square or an ellipse.

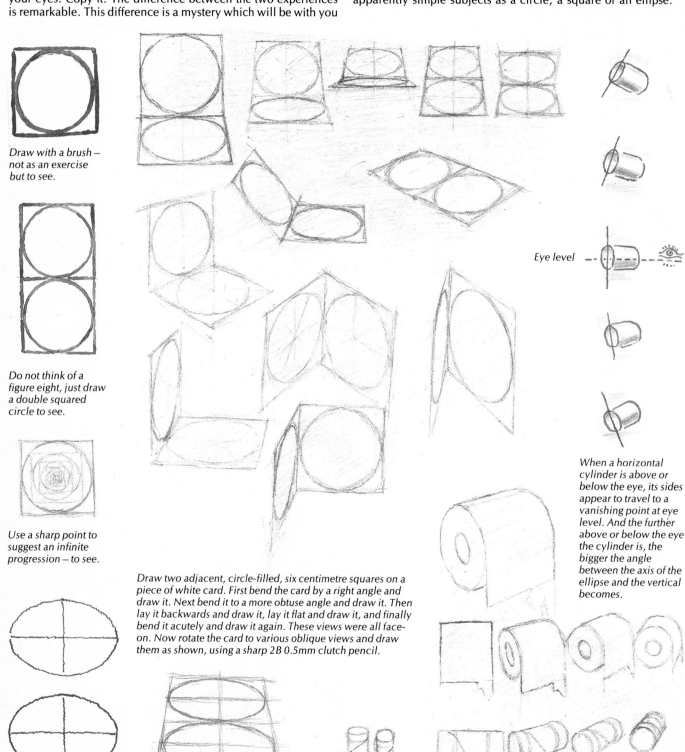

Draw with a brush – not as an exercise but to see.

Do not think of a figure eight, just draw a double squared circle to see.

Use a sharp point to suggest an infinite progression – to see.

Eye level

When a horizontal cylinder is above or below the eye, its sides appear to travel to a vanishing point at eye level. And the further above or below the eye the cylinder is, the bigger the angle between the axis of the ellipse and the vertical becomes.

Draw two adjacent, circle-filled, six centimetre squares on a piece of white card. First bend the card by a right angle and draw it. Next bend it to a more obtuse angle and draw it. Then lay it backwards and draw it, lay it flat and draw it, and finally bend it acutely and draw it again. These views were all face-on. Now rotate the card to various oblique views and draw them as shown, using a sharp 2B 0.5mm clutch pencil.

Draw two geometrical ellipses with equal horizontal and vertical bisections. In perspective, the central lines in the further circle are obviously shorter than those in the nearer one.

A toilet roll combines vertical surfaces and cylinders. It is useful to draw simple forms which we see frequently. The spiral at the core is a complicated conformation when foreshortened. Use a sharp pencil and try for clarity.

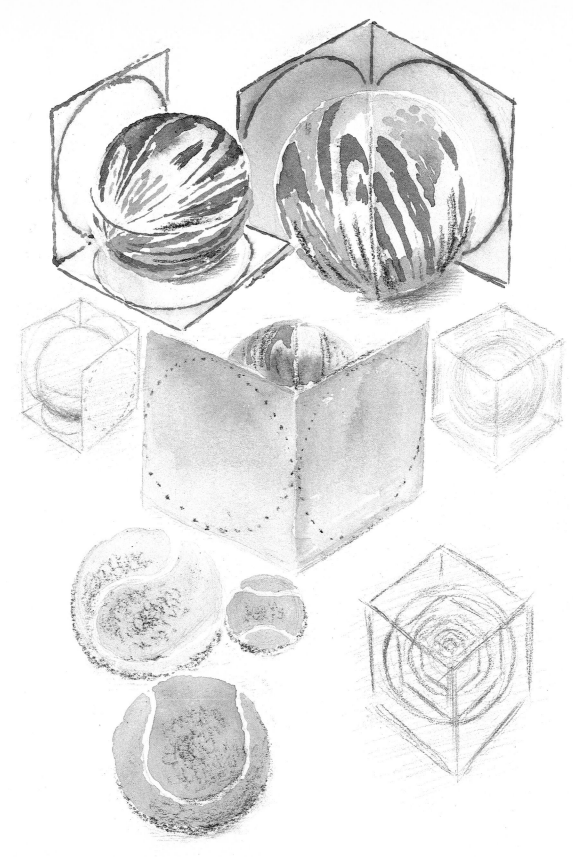

Using a bouncy rubber ball (the circular mould mark is usually visible) and a card with circles of the same dimension, draw the ball as if in a partly made cube. This will make you conscious of the spaces evoked by squares and circles. The two square sides make us think of the other four invisible sides. Draw it with a small sable brush and diluted ink. My ball was decorated with coloured streaks. It is amazing that it looks spherical (the accompaniment of circles and spheres is useful in this.)

Drawing Chinese nests of circles and spheres within cubes (left and below left) helps to exercise the mind to invent structures in three dimensions.

Tennis balls (far left) have an interesting seam line which divides their surfaces equally. Like the spiral of the cardboard core of the toilet roll, the suture makes un-expected convolutions when foreshortened. For eyes to travel along tracks of this kind is simple when we are not actually drawing them. From the two casings of a tennis ball we know that only two parts need be joined together to make a sphere. Use rough chalk to suggest the texture.

Invent your own assemblages for drawing: a spherical ball suspended by a thread in a cube of wires or rods; eccentric cubes which tilt progressively; bouncing balls (spheres with flattening sides); elastic cubes inflating by degrees to become spherical. The mind will invent concretely whatever you demand of it. With discipline, your hand can draw all or any of its conceptions. Discipline is what these trials are about. The drill is performed with simple figures, circles, squares and spheres to make our minds marching-sure. When the marching is in step, then we can attempt to dance. This piece has come full circle and the step-by-step approach is almost a discipline.

Basic Forms

The memorial stone to Friedrich Froebel, the kindergartener, is a cube, a cylinder and a sphere. Froebel taught children to appreciate playing with them. It is amusing to imagine that Bauhaus artists, such as Max Bill and Klee, might have been taught at a Froebel-style infant school. The child in a Froebel kindergarten was given eight blocks, making up a cube. These were allowed to fall apart (analysis) and he was then shown ways of putting them together (synthesis). An infant taught by the Froebel method was taught visually; our education from infancy till leaving university is generally non-visual. Hang a cube from its corner by a piece of thread, spin it and draw the resulting blur. Similarly, spin a cylinder suspended from one edge. It is fascinating to draw the blurs which occur and to feel perhaps, as Cézanne did, that nature is built from basic forms. The exercises on the facing page made clear my shaky hand. Usually I do not mind this if the result is alive (Poussin's last drawings were shaky, yet beautiful), but in this case I would like to have been versatile enough to draw the cassettes with panache, to make a triangle lie down convincingly and draw a line in good order.

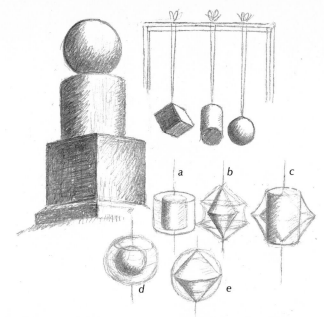

The cube spins with its axis through the centres of opposite faces (a), through the diagonal corners (b), and through the centres of diagonally opposite edges (c). A cylinder rotates on a rod, perpendicular to its central axis (d) and with its axis diagonally edge to edge (e). Draw all these spinning forms. To achieve their different transparent blurrings and weights demands skill and an exact touch. Draw them with fine-as-gossamer pencil lines, modelling the central cores until they seem solid — they materialize as they spin.

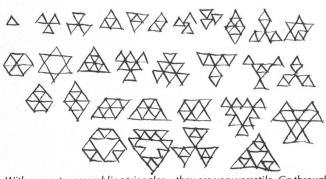

With a pen, try assembling triangles — they are very versatile. Go through all the simple permutations. Do them on graph paper, or triangulated graph paper if you wish. Geodesic domes are made of triangles; so are Kandinsky paintings.

The eight cubes together were assembled as one cube, which was arranged in various ways to suggest common objects. As an exercise, draw cubes assembled out of your head. Use a pen.

A Cézanne letter advised seeing the world in terms of the sphere, cylinder and cone. Draw them with a pencil until they look right — basic forms always look new.

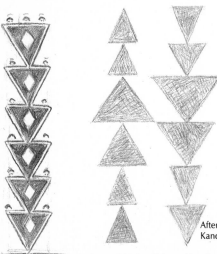

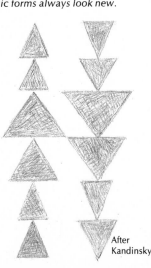

After Kandinsky

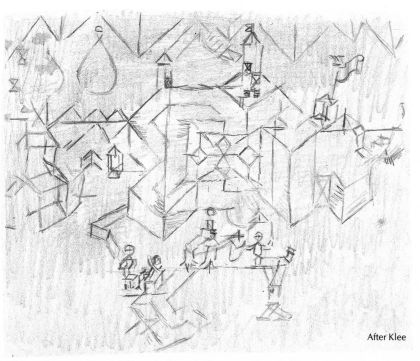

After Klee

Part of a Navajo sand painting

Copy this detail from Kandinsky, hatching some triangles and watching the dog teeth forming.

With a sharp pencil and delicate incisive dashes, copy the sensitive structures with which Klee made his animated world. Triangles will make almost anything. Enjoy the way they touch and crystallize.

Music cassettes will give you music while you draw. Six plastic cassette boxes will be your subjects. Pile them up. Ink them in. Rotate them in sequence. Draw them in sequence. Draw them with assurance in Indian ink. You may not at first be pleased and you may tire. But if you are persistent, the drawings will improve. Finally, loosen up and sketch with bravura. Try drawing naturally cubic salt crystals. After the man-made plastic boxes they seem brimming with life.

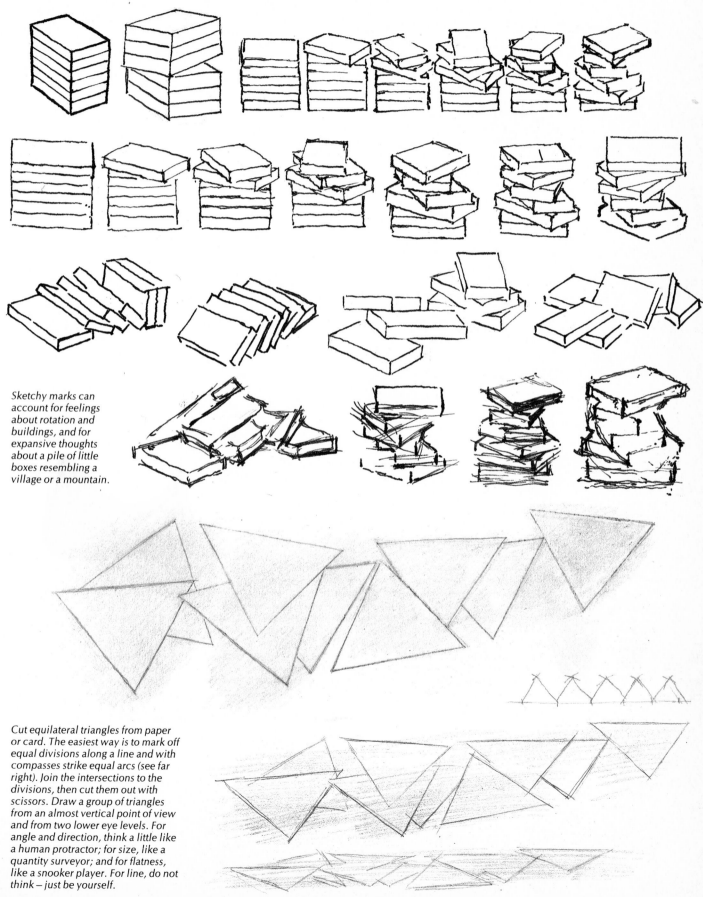

Sketchy marks can account for feelings about rotation and buildings, and for expansive thoughts about a pile of little boxes resembling a village or a mountain.

Cut equilateral triangles from paper or card. The easiest way is to mark off equal divisions along a line and with compasses strike equal arcs (see far right). Join the intersections to the divisions, then cut them out with scissors. Draw a group of triangles from an almost vertical point of view and from two lower eye levels. For angle and direction, think a little like a human protractor; for size, like a quantity surveyor; and for flatness, like a snooker player. For line, do not think – just be yourself.

Ordered Lines

The classical art of Piero della Francesca depended on purity of line and outline. We feel a Sung pot is close to perfection. Human touch and the chance effects of firing made it depart from a purely geometric form, even if this was the potter's aim. We may contemplate an egg, a Brancusi head or the Parthenon, but do not get the same satisfaction from looking at a compass-drawn circle or a billiard ball. Disorder is bad, but rough textures can act as foils to pure forms. For example, Braque uses rough and smooth shapes. Ordering is good. Absolute order is boring. This piece is really all about ordering the disorder of lines and curves.

a ⊙
b ———
c ———
d - - - - -
e -·-·-·-
f ⌒
g ⌐
h ———
i |
j ╱
k 〰〰

The geometric definitions for line and point are: (a) A point has no magnitude but has a position. (b) A straight line is the shortest distance between two points. It has length and position but no thickness. (c) A line is drawn thick (or thin). (d) A dotted line. (e) A chain line. (f) An arc or simple curve – a curve is nowhere straight. (g) A compound curve. (h) A horizontal line is perfectly level, like the surface of still water. (i) A vertical line is perfectly upright, like a plumb-line. (j) An oblique line is neither horizontal nor vertical. (k) Parallel lines are the same distance apart and cannot meet.

Any curve can be made into simple components by slight adjustments. If modified into simple arcs (parts of circles) and straight lines, complicated curves can be simplified to become design material. You can call it "editing" a curve to be classical material. Change a curve so that it becomes a sequence of arcs or straight lines.

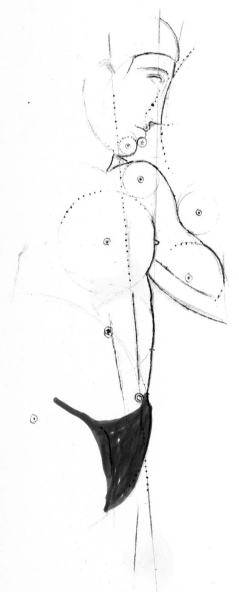

The Greek figures so much art has grown from were made of arcs and straight lines of a felt and measured quantity. They were balanced for a beauty whose measure was an idea of God, and nothing, from top to toe, could therefore be allowed to sag. Examples of the centres of the circles making up the contours are indicated in my diagram.

After Ingres

After Hopper

Look at the controlled outline of an Ingres drawing (left), its indentations connected by my straight dotted lines. The outer line is notched, arc by arc, along its length. By copying a piece of a drawing by Ingres, the curvaceous boldness of the Hopper drawing on the right becomes apparent. Hopper's girl is nevertheless real. Draw from the loosely curved drawing by Hopper and from Ingres, and then from Raphael, to feel the formal difference – as great as that between Milton and Walt Whitman.

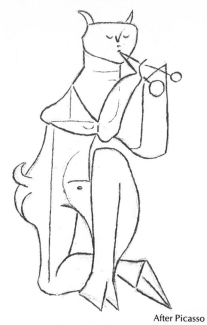

After Picasso

The equal lines of the faun preserve the flatness of an image, made as if from multiple viewpoints.

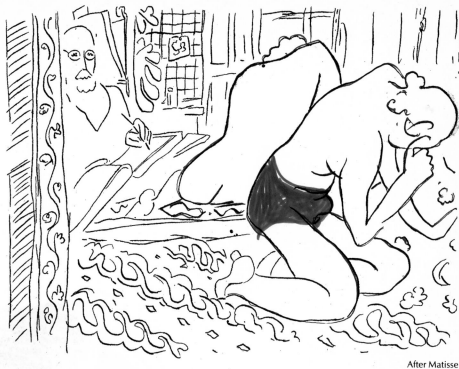

After Matisse

Lay a piece of tracing paper over a reproduction of this Matisse, and do an exact tracing, then a faster and freer one, using Indian ink. You will quickly appreciate that Matisse aims to do as much as possible without lifting the pen. A close tracing of the figure in the reproduction was superimposed on a free tracing of it.

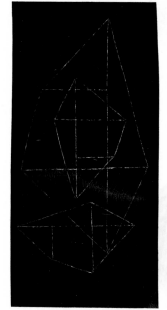

After Klee

After Le Corbusier

Drawn using the wrong pen, the wrong paper, the wrong size, the wrong spectacles – but even if everything was right, what chance would I have had without an architectural training in the use of ruling pens or drawing machines? The master of Modulor understood about quantity and how to use simple, straight, circular, vertical and horizontal lines, and how to use equal lines to draw his own face to be rather like a building.

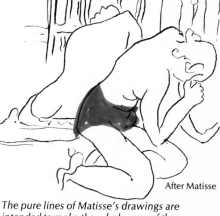

After Matisse

The pure lines of Matisse's drawings are intended to make the whole area of the paper eloquently expressive. Line drawing has to be done almost without conscious thought. It is a virtuoso performance where every mistake or failure of nerve is apparent.

Paul Klee, using a kind of natural geometry, pretended three sticks of a special length were lines. He held them together using a single rubber band. The result (shown directly above) was a figure which was both springy and resembled a yacht. The forces affecting yachts are blowing wind, gravity (which pulls down) and the upward push of the ocean. The sails bend the mast. Klee used the figure three times to paint a mysterious configuration (copied in white ink on black paper above) which, together with other forms, was entitled "Possibilities at Sea".

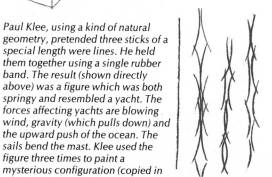

Straight lines made with arcs

Arcs and curves made with arcs

Arcs and curves made with straight lines

After Matisse

I am right-handed but I copied this with my left hand. Use your other hand for drawing, using an equal line. The extra complication makes you think carefully.

Thick Lines

Simple drawings are line drawings. But drawings do not always get more complicated to look at when thickly modelled or shaded. Multiple lines are usually looked at with less acuity than single lines and the effect may be as simple as that of massively thick lines. In a late Degas drawing, one thick contour combines line, modelling and chiaroscuro. Copy with sharp charcoal to see how it is done. The lines which do most may be the strong contrast lines on the light side of the subject. Experimentally, thicken contours on the side by degrees until the figure is almost one thick line. Thick lines comprising many lines resemble wide brush strokes. (See Masaccio frescoes for massive, dark-sided, solid figures.) Rouault's lines are thicker than stained glass leading; they evoke bodies and imprison them. He worked at the thick-line limit of expression. Compare a Rouault with a Chartres window. The early Gothic drawings on jewel-like glass are broken into by armatures and the inactive leading. Rouault uses line for solidity.

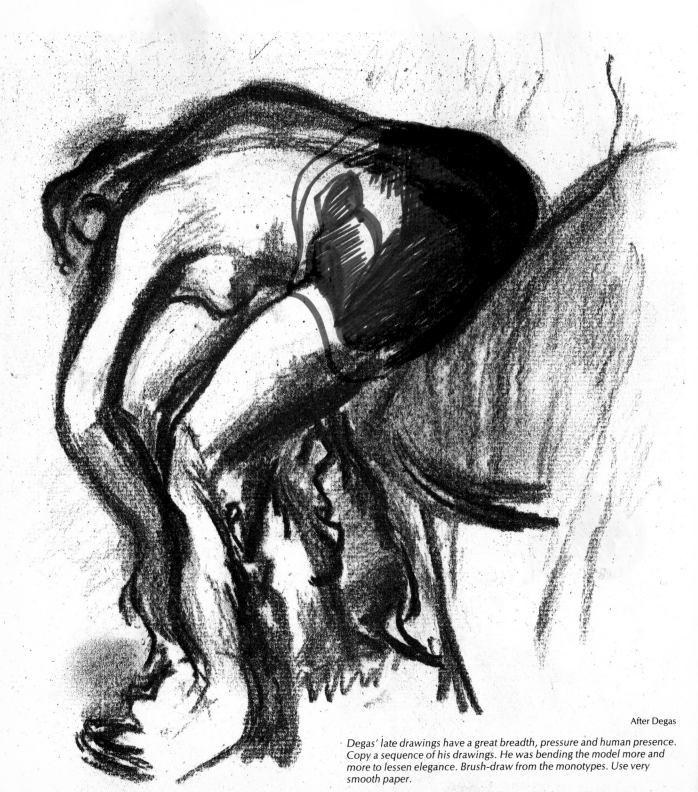

After Degas

Degas' late drawings have a great breadth, pressure and human presence. Copy a sequence of his drawings. He was bending the model more and more to lessen elegance. Brush-draw from the monotypes. Use very smooth paper.

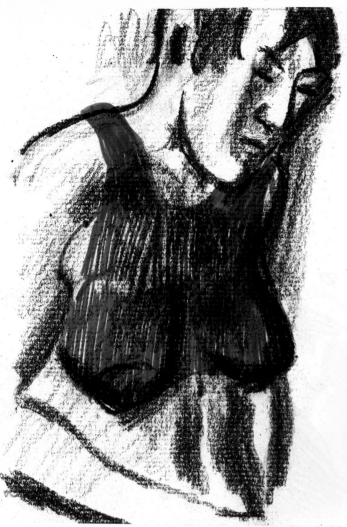

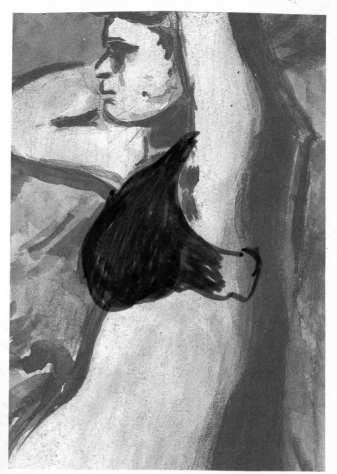

Mystery, sin, beauty and flesh are involved when the religious Rouault uses the widest lines in art. Copy with a fan-shaped sable or bristle blender. Use it to round out the tenebrous forms.

With Degas in mind, draw from a girl, using compressed charcoal on a granular watercolour paper. The dark shade sparkles. Bind and loose it with thick lines.

Thick lines can swell and undulate to make heavy forms, but contours of equal width maintain flatness and often allow colours to work simply.

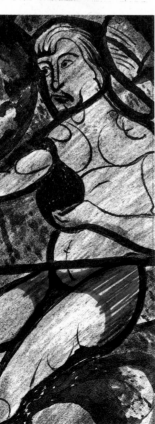

Copy the fine, liquid, serpentine Gothic drawings in the stained glass of Chartres Cathedral and respond to the way the parts of the body are divided and joined. There is a large difference in weight between the thick and thin lines.

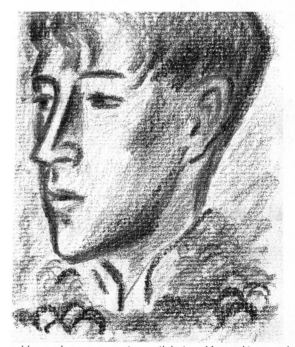

It would seem that a carpenter's pencil designed for marking wood, which has a rectangular lead, might have other uses. As its lead is rather hard, try using it on hard or prepared paper. It sharpens to a pointed oval. It prevents easy, graceful marks. A workmanlike, slightly wooden prose might be what it achieves best. It is sometimes positively said of a drawing that it is "well carpentered", or negatively, that it is "wooden".

Thin Lines

Paper flower-like, poppies emerge, unfolding from thick green buds, like Noguchi paper lampshades or butterflies emerging from chrysalises. When drawing such frailties, you need a hand floating against gravity and a held breath. Hesitate for the crinkle of petal edges. Keep the touch equal. Use a conté crayon and a gossamer-thin trail of carbon pencil. An 0.3 mm clutch pencil on smooth paper can make line-skeins for petals. The poppy is an evanescent structure, changing from crinoline to collapse. The slightest excess weight, the slightest show of energy along the petal fringes, and all is lost. Use an eye surgeon's careful touch. Red poppies are love symbols and a farmer's pest. When drawing, allow your hand to tremble. Controlled shivers crease petals. If the wind is blowing, increase the trembling. Sharpen a 3H pencil. Draw an eye corner, a dead bee, a stamen and tiny ticks by Klee. Sharpen further to draw the wing of a lacewing fly. Make it as pointed as a hypodermic to draw a spider's web. Watch a spider at work. Draw new webs. Spiders never fail – if the web is spoiled they start again. Draw a hand as light as a pick-up. Breathe when you must.

The poppies of summer are landing places for insects. Insects move the pollen. With a light touch we can even draw the pollen in the air. Turn the pencil as you draw and sharpen it continually. Look at Bonnard for poppies, Matisse for anemones.

Using a mapping pen with waterproof ink allows watered ink or watercolour to be used over it. Thin pen and soluble ink lines dissolve to make soft, fragile effects. Think of the pen lines as giving strength to the water.

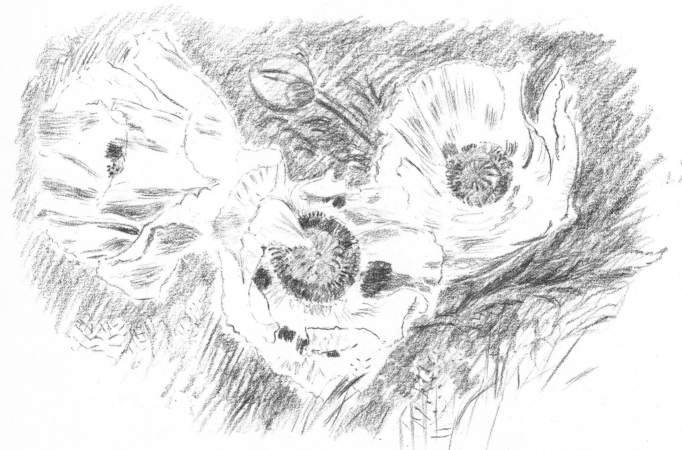

Draw some big poppies. Use a chalk to make a rough, contrasting background. Show the difference between light and heavy weights. Look at the pastels by Redon—they glow richly and wonderfully. Redon makes flowers float on the golden-toned papers he uses, like luminous heavenly bodies, orbs hanging in space. The stalks are minimal. The coloured background contrasts to produce singing pastel blooms.

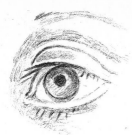

Eyes change their appearance with the weight of an eyelash. Thicken for mascara. Draw with a very sharp conté pencil.

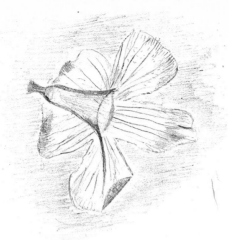

A pressed black-eyed Susan flower. Make each vein move outwards from the vase-shaped centre. Support it with a softly hatched background, which can blend into the petals for weightlessness.

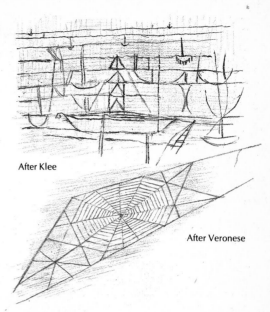

After Klee

After Veronese

Draw with little marks Klee's tiny ships, caught as if between horizontal strands of gossamer. Copied below is a spider's web by Veronese. To be seen clearly from a distance, the lines are drawn thick and unnaturally straight. Draw an actual spider's web. Although each short strand pulls straight, the long stretches are not as continuous and straight as those of Veronese.

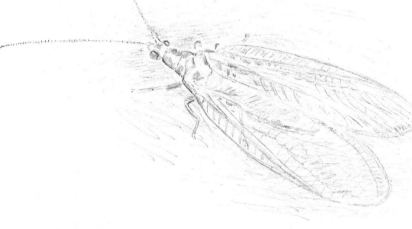

Lacewing flies are attracted to your lighted windows at night. Their filaments are as thin as the sparkle of stars or the shimmer on a phosphorescent sea. Point in the minutiae of

perfectly arced antennae, suspension bridges for fairies. Make the minute eyes strong and the spheroidal eyes clear.

A dead wasp, hook-shaped in death. Use a pen nib, sharp as a sting.

The membrane of an egg is next to the shell. It has strength. Crack a raw egg. Draw it with a very sharp, hard pencil. Train your touch to show the subtle differences in the qualities of broken shell, smooth surface and soft

membrane. For more touch training, hard boil an egg, crack it, drop edible colouring on the cracks and partly peel it. Draw the crackle, the stains, the smoothness and the eggshell texture.

Incisive Lines

Incisive lines are those which appear to penetrate the paper with the drama of an urgent message chipped in rock. At the age of eighty-nine, six days before he died, Michelangelo was smiting the "Rondanini Pietà", hitting and hacking in thoughtful, questioning, furrowing lines, continually changing his mind, much as he had done in the "Crucifixion" drawings. The incisions in the breaking stone are of heroic beauty. In the history of drawing, the lines which have an incisive character are usually the outcome of a training in stone-carving or metal-engraving. Modigliani's lines were incisive. He carved stone and was taught by Brancusi, and Brancusi's forms, simple as eggs, influenced him. As an Italian, he knew Renaissance sculpture. Using a stabbing pencil as if he felt he was chipping stone, Modigliani made a pulsating line which acts in two ways: firstly, the points seem to nail forms to the surface, maintaining picture plane flatness, like the dotted pounce marks to be seen on the contours of forms in frescoes by his favourite artist, Botticelli; and secondly, in an opposite way, the swinging sharp arcs evoke volumes. The incisive lines are close in kind to the lines of Cubism, evoking and governing the solidity of the forms all at once.

After Brancusi

Draw Brancusi's sculpture "The Kiss", in profile and from above. Make carving lines as you draw the converging patterns.

After Brancusi

Brancusi's "Kiss" painted on an egg. The attractions and repulsions in nuclear physics and the dividing egg come to mind. The division between the rounded forms is like a carved incision. Further variations are made for his pillars and plinths (right).

After Modigliani

Use a conté crayon and, possibly with a stony texture in mind, copy the painting of Kisling by Modigliani. Ear, nose and throat are dotted as if with a point chisel and the mouth is shaped like Chinese and Indian sculptures of the Buddha.

After Modigliani

It was years before Diaghilev could bring himself to use the talents of the preening Jean Cocteau. Modigliani, in this portrait, matched Cocteau's elegance and wit with lines as black as lightning and Nureyev prancings of a pencil, keen as a fine claw chisel on pure, white Carrara marble.

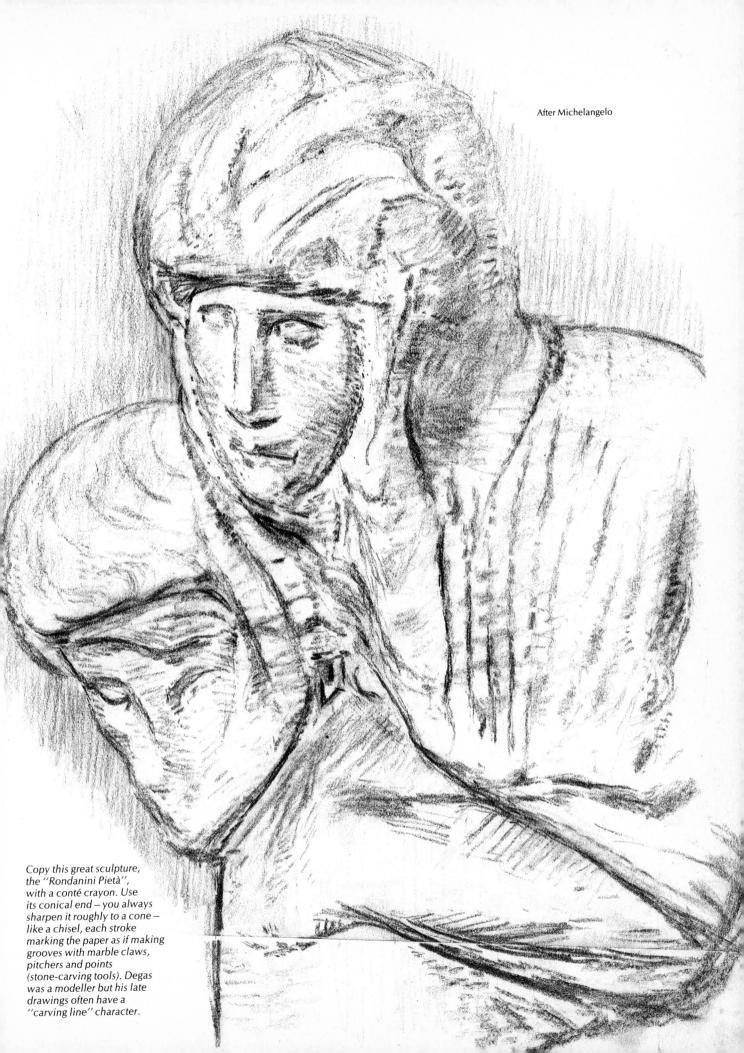

After Michelangelo

Copy this great sculpture, the ''Rondanini Pietà'', with a conté crayon. Use its conical end – you always sharpen it roughly to a cone – like a chisel, each stroke marking the paper as if making grooves with marble claws, pitchers and points (stone-carving tools). Degas was a modeller but his late drawings often have a ''carving line'' character.

Drawing without Lines

Some young artists and many aged ones drew using few lines. They drew with allusive darks and marks which, because of their elisions, you might expect would break down rather than construct forms – and sometimes the counterchange of light and dark is considerable. Masaccio, for example, darkened hollows and dimples with shade and broke away from Florentine Renaissance linear hatching, to inaugurate new ways of painterly drawing. Pushing the pencil or brush into the crevices, corners and dimples of the body is economical and artistically dangerous. As painters grow old, they lighten the boat. Sometimes their sight is less good; sometimes they are impatient; but usually they have found ways of achieving universality with economy. Whatever the reason, Rembrandt darkened hollows as if, like a sculptor-creator, he was pressing his fingers on clay into the places where eye meets nose, nostrils meet cheeks, into the nostrils, into the corners of the mouth and the dimple below.

Bonnard wrote in his little drawing book: "To draw, the hand should glide over the paper as light as a shadow". This thumbnail drawing (the seed of a great painting) was probably done on thin Bank paper with the stub of a 6B pencil, used very much on its side. It suggests shade but was not drawn by the shadows (see p.76). Bonnard's drawings are shorthand sketches, packed with meaning despite having a rough, cursory appearance.

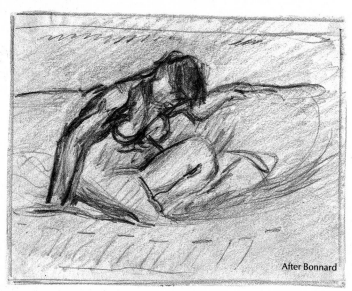

After Bonnard

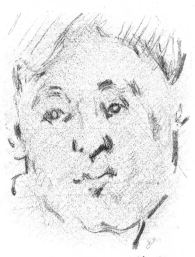

After Cézanne

Cézanne makes carving marks in the valleys. Concave marks move around the eyes, alluding to rather than evoking plumpnesses. The style grew out of his love for Tintoretto and Delacroix drawings.

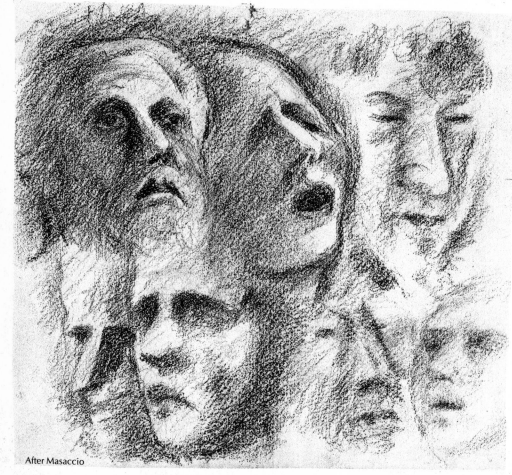

After Masaccio

After Masaccio

Heads can be evoked by smokily rubbing conté crayon or charcoal on rough paper, making hollows and glooms. A piece of a self portrait (bottom row, third from left), the front of Laetitia's face (top right) and various heads copied from Masaccio's Brancacci Chapel frescoes are juxtaposed as examples. Very little line is involved.

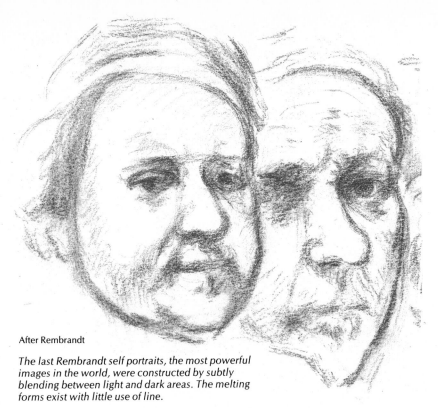

After Rembrandt

The last Rembrandt self portraits, the most powerful images in the world, were constructed by subtly blending between light and dark areas. The melting forms exist with little use of line.

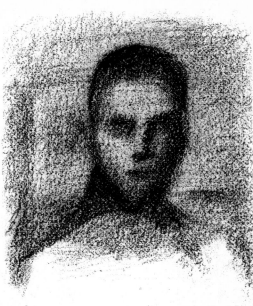

After Seurat

A Seurat drawing looks at first like a rough, blackened piece of paper – dirty, until we appreciate its exactness and luminosity. Conté crayon was stroked by him on Michallet paper. The white speckle is marvellously preserved, making a pointillism of black and white.

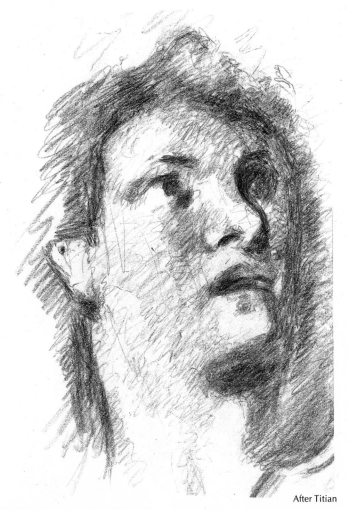

After Titian

Melting darks fill the eye sockets of Orpheus in Titian's "Flaying of Marsyas", one of his last works. The images seem to come and go in the wondrous gloom, appearing as lights and depths. Line is little used. Black chalk was Titian's usual medium.

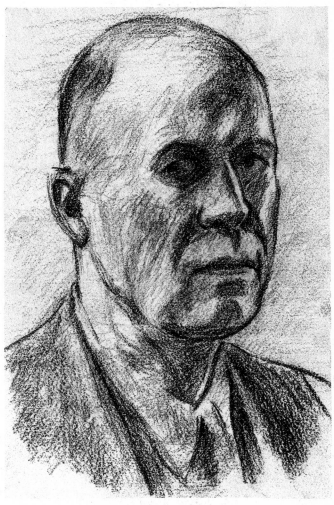

After Hopper

Neither Courbet nor Hopper feared using shadows. Hopper (seen here) had been an illustrator. An improper drawing, judged by classical canons, it yet possesses a solid presence.

67

Dots and Spots

A dash is a short line, a point or dot is less than a dash, a spot is a fat point. Pointillism is a dotting style which began in France. All papers, excepting the smooth, china clay-filled papers, make drawing into pointillism to some degree. Most printing processes and some Pop artists make use of mechanical screens for dotted textures. Giles, the British cartoonist, uses small screened dots brilliantly. Lichtenstein uses large ones. Both Op and Pop Art fizzle with spots. At a distance, most shapes, if repeated at equal intervals, will turn into round spots. Dots are everywhere – as stars and fireworks in Whistler's ''Nocturnes'', as flickering candles and sparkling sequins, on dappled horses, speckled eggs, thrushes and trouts. Spots can be a child's pretty freckles or, with little visual alteration, suggest the angry acne of adolescence or the spotted horror of smallpox. Sometimes dots will be an orchard in spring by van Gogh, sometimes splatters of blood by Bacon or Grünewald.

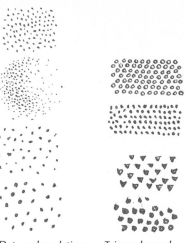

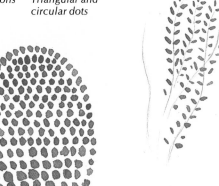

Large and small dots made with smaller dots

Dots and gradations of dots

Triangular and circular dots

Like a special kind of shading, the black stockings darken the edges of the legs. The equal spots flatten the forms, as do the dark edges at the contours. Without gradations the diagram is rendered even flatter by the dots.

A tree from ancient Egypt

Leafy twigs from ancient Egypt

Grapes from ancient Egypt

After Kandinsky

Complicated shapes become spots at a distance.

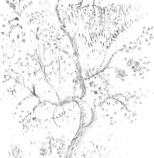

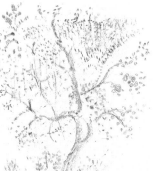

After Grandma Moses

Foliage is made by painting in dots. It resembles embroidered stitches.

After Magritte

A sky of falling men, more like dashes than dots. At a distance, they are almost like raindrops.

After Lichtenstein

All the depth is obtained by overlaying line-bounded areas, one on top of another. Modifications are made by subtly patterning with dots of varying sizes. Charles Ginner dotted drawings area by area with waterproof ink and brushed them with gouache.

After O'Keefe

New York is the most pointillist city in the world. Windows, like star clusters, move to infinity in all directions. Draw with white conté pencil and ink on dark paper.

New York at night. Every point of light suggests a place where a person lives, works, or is driving a car. Car headlights vanish into the distance. Use a mapping pen and white ink on paper which has been given a wash of black waterproof ink. The biggest contrasts are at the bottom of the picture where the dots are further apart.

After Melozzo da Forli

A dotted halo by Melozzo. Gold leaf was often given a texture with a punch, so that it would take the light well.

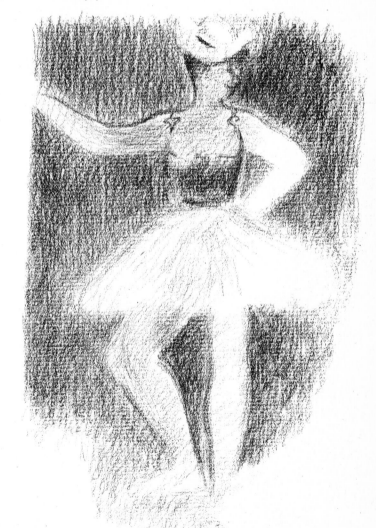

After Seurat

After Seurat

A rare drawing, done purely with lines and dots. The dots model and flatten and suggest light all at the same time.

Much of the textural beauty of Seurat's drawings depends on the granular sparkle which occurs when black conté crayon moves over rough ribbed (laid) paper. Copy on Ingres paper.

Control of Three Dimensions

Seurat said: "Painting is the art of hollowing a surface." Another way of putting it might be to say that painting is the art of plumping up a surface. Either way, it is bas-relief sculptural drawing which is involved. Comparing a Rubens copy of a Raphael drawing with the original will make plain the difference between a fully rounded sculptural drawing and a bas-relief depth sculptural drawing – the shading is much closer to the centre of the forms in the Rubens. For Rubens and Renoir – the volume workers – rounded, cuddly women handled by lustful, masculine men was high tonic picture material. Weight was necessary for the Christian story – the sin-bearing body of Christ,

because He was human as well as divine, had to be made solid. Shading is a misleading word. It means to make darker by hatching or stroking for solidity or for shade or for cast shadows. Modelling (in drawing) is a more precise term. It means shading for solidity. Parallel hatching may be part of shading, of modelling or of shadow. If a flask of water with a little sand is shaken, the sand in suspension will make it appear more solid. Almost any markings between outlines will give solidity. Draw an oval with an equal line. Treat its interior in a variety of ways and watch it become more or less substantial.

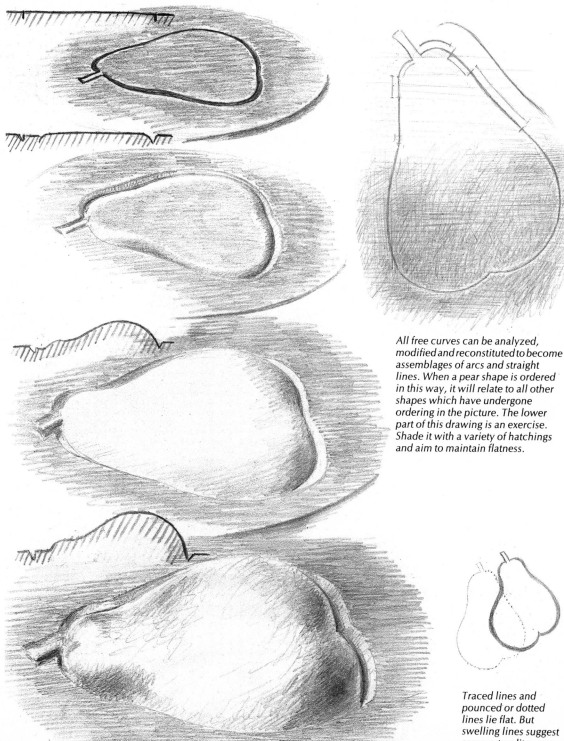

With a flattened dish full of butter, margarine, playdough, modelling paste or clay, fashion a small bas-relief of a pear. First cut round the shape with a thin knife. Then draw what you have done. The shading is within the incision.

Round off the cuts a little. Draw your sculpture on paper. It is only to be as rounded as the section at the side indicates. The shading is close to the incision

Round the sculpture out and plump it up as much as the section shows. Draw what you have done on paper. The shading has moved a little way up the fruit from the incision.

In drawing from a bas-relief, you will gradually find ways of making equivalences for the plumping up or hollowing which has gone on, and will be able to decide whether marks made close to edges, in hollows or on the rounded parts give you the truest, fullest production of forms. This pear is modelled, as can be seen from the section, to be almost half a pear thick. The shading has now moved towards the middle of the paper.

All free curves can be analyzed, modified and reconstituted to become assemblages of arcs and straight lines. When a pear shape is ordered in this way, it will relate to all other shapes which have undergone ordering in the picture. The lower part of this drawing is an exercise. Shade it with a variety of hatchings and aim to maintain flatness.

Traced lines and pounced or dotted lines lie flat. But swelling lines suggest some rotundity, even without any modelling.

After Botticelli

The equal engraver's line, by emphasizing the clear contour, ties the plumpnesses to the surface. It is useful to copy engravings by Mantegna to understand how this is done.

Draw from an African mask. This one, from the Bakongo tribes, is almost in the round – almost a free-standing sculpture. The painted stripe down the forehead and nose, and the stripe across the mouth, are decorative and flattening, The hatching must model for solidity and yet not make it too round. It must be a subtle drawing, a deep bas-relief, almost as deep as the two lowest pears on the facing page. Your hatching has to be versatile: scribble-hatching for the colour of the stripe, richly worked modelling-hatching for the cheek and shade-hatching for the eye holes.

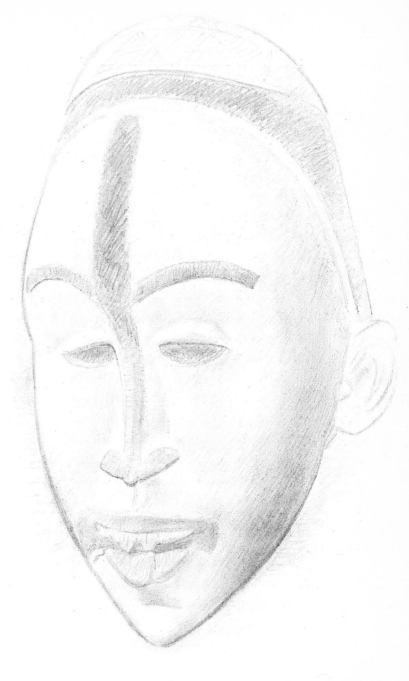

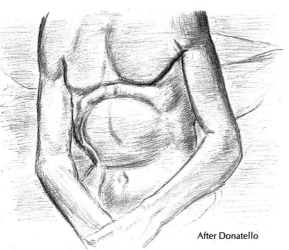

After Donatello

Copy this torso to find out how to control the depth of the relief. Model too far into the contours and you have lift-off – the sculpture will be in the round, and all will be out of control from the point of view of this exercise.

After Donatello

Look at and copy from the bas-reliefs at San Antonio, Padua, or from casts of Donatello reliefs at the Victoria and Albert Museum, London. As you draw, you will see why these panels are among the special wonders of the world – powerful, expressive and humanly concerned. They even contain strongly inscribed perspective lines, whose thrusts seem more energetic than a sculpture of such limited depth could contain and control.

Tone and Recession

Near the sea, our eyes explore the coast-line. Moving compulsively, they tend to follow the sea verge and examine the horizon. Tonal contrasts are made where there are overlaps or breaks in the structure of landscape, as when a headland or cliff meets the sea or a hill covers more distant parts. The tonal contrasts at the edges are progressively reduced, the further away the overlaps occur. In a misty landscape, such a merging of tones is correctly thought of as the result of humidity, as the term "aerial perspective" suggests. But in a pictorial tone value system, the use of tones can be as little related to weather conditions as the tonal devices, rifts and levels used in Chinese paintings. Many landscapes take our eyes for a carefully controlled flight over the hills and far away (as bottom right). In the West, we search for the protuberances. In the East, the clear spaces in between may be the main areas for contemplation. The preparation of a wondrous void is not undertaken lightly.

In these vertical columns, the paper is darkened by equal darkening until black. The first column of squares on the left contains black, white and a middle tone. This middle tone occurs whenever there is an odd number of tones (three, five, seven, nine). Shade some squares, beginning by establishing a middle tone halfway between black and white. The wide column (above right) is a smooth gradation between the two darkest tones above black from the six-squared column.

Squares six, seven and eight from the nine-squared column are placed beside one where a smooth gradation is made between squares six and eight.

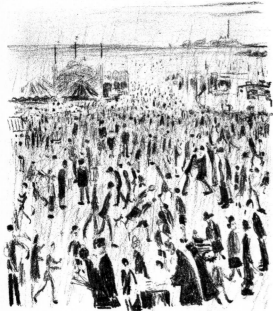

After Lowry

Flats on a theatre stage really are flat; their overlappings suggest recession. In addition, the stage is sometimes raked.

Overlaps of land recede, lap over lap, up the picture.

Three factors control the recession: height in the picture, the diminution of units of known size (men) and the tone values (aerial perspective). Put simply, as Lowry moved up his picture, he made the figures smaller and smaller and less emphatically dark and light.

Thick, dark marks advance.

Tonally, many small marks equal fewer large marks.

Even small marks, if low in the picture, advance.

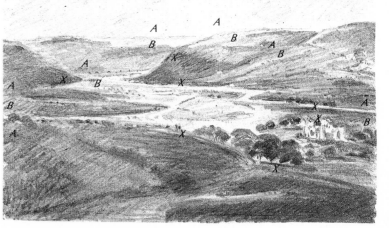

After Girtin

Girtin used areas of equal darkness to connect features in landscape and to make easy paths for the eye to follow. These "passages" may be dark or light — examples are marked AB. Maximum tonal contrasts are marked X.

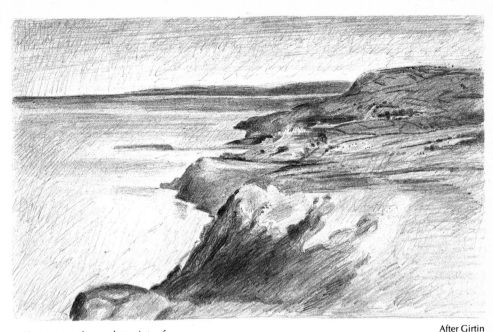

The Chinese use the blank silk or paper as a passage area between hills. European painters use any tone for passages. The Chinese control gradations very delicately, using many patterns of brush stroke.

After Girtin

In the picture above, the points of maximum tonal contrast are in the foreground. Some passages are light, some are of middle tone. In the diagram on the right, arrows suggest where to look in travelling the tonal pathways. Passages frequently cross the main rhythms of the picture (shown by dotted lines). The drawing below the diagram is intended to show a similar kind of landscape formation, whilst reversing the tone value (aerial perspective) system used by Girtin and other Old Master landscape artists.

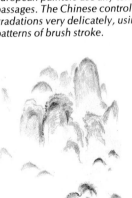

Draw some diagrams after Chinese land-scapes. The one above is a good example of the continuous return to the silk tone. The one on the right is a mere bagatelle to show the process employed.

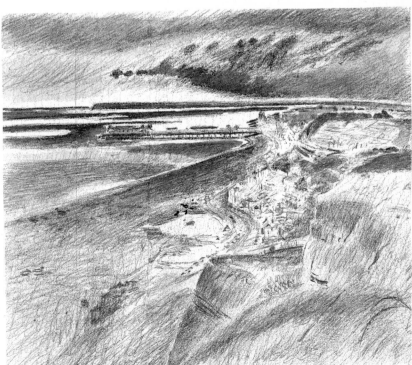

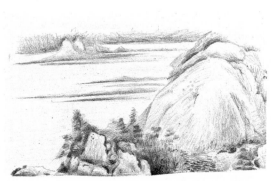

After Wang Chien

The gradations are light above, darkening downwards. The tonal system and perspective are not very different from those of Girtin.

The strong contrasts are placed at the furthest points in the drawing, thus reversing the tonal system usual in English watercolours of the seventeenth and eighteenth centuries. The perspective recession is counteracted by the dramatic contrasts in the distance. If tones are not stated clearly, just as in singing, the effect is a caterwaul.

Perspective

Parallel lines receding into the distance appear to converge at a vanishing point at eye level, which will be the horizon if the ground is flat or you are at the seaside. Unless you are determined to do measured perspective – which is easy although elaborate – it is sufficient to tilt a pencil to the angle of a receding line, to determine where its vanishing point lies. A chair seemed a simple object to show the ways of perspective. In the garden, the chair's seat held a puddle of rainwater and a pattern of leaf shadows camouflaged its shape. Its canvas was stained, its wood weathered and it had not a straight line in it. Why did I choose it? Duchamp hung a Euclid geometry book outdoors, also to be at the mercy of the weather. Perhaps we both feared tight rules. Converging perspective lines may go against your design, receding uneasily. Even the act of tilting a pencil to find directions may be unnatural for you. Piero della Francesca spent the last years of his life making a book on perspective. Wonderfully, in his pictures he was able to combine dynamic symmetry with perspective – a feat of considerable complexity.

The abruptly recessive lines of perspective – which might have made it difficult for you to control your picture or build a sensuous image – *are rendered completely innocuous by the warps, puddles and discolorations of this old chair.*

V.p. (Vanishing point) *Eye level*

V.p.

Here, the lines of the chair are made straight and the receding parallels connected to the vanishing point. Use perspective to check difficult situations, where straight-edged objects fail to be convincing in space. Knowing what perspective does also makes it possible to prevent forms receding when this is undesirable.

A chair and a cat are reflected in a pond. When drawing this, the bank between the chair and the water level must be taken into account. (One has to imagine the water surface as continuing beneath the chair.) Measurements are dropped vertically from various points on the chair.

A rectangle in plan and receding at different angles and inclinations. The various vanishing points are too close to be convincing.

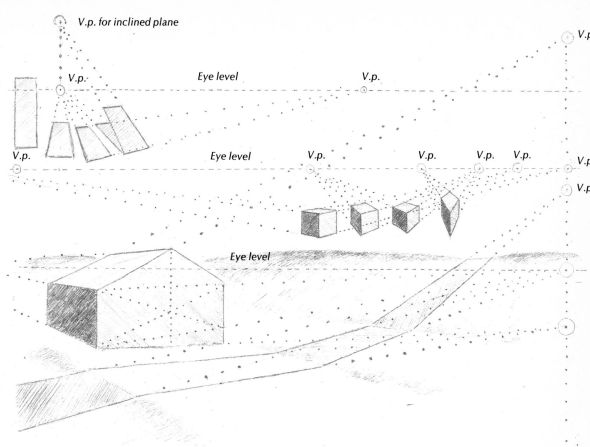

V.p. for inclined plane

V.p.

Eye level

V.p.

V.p.

From left to right, the vanishing points for a cube are brought closer and closer together. The right-hand cube looks extremely distorted.

Eye level

V.p.

V.p.

V.p.

V.p.

V.p.

V.p.

V.p.

The rising and descending parallels of the receding road vanish to points immediately above and below the vanishing point for a horizontal road. The apex of the barn can be arrived at by raising a vertical through the diagonals of its end wall. The barn is built on an incline, so that the left-hand vertical is actually shorter than the right-hand one.

Eye level

An isometric projection of a cube. The orthogonals recede at forty-five degrees and its dimensions do not diminish.

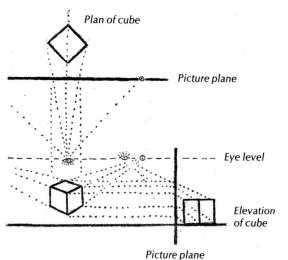

Plan of cube

Picture plane

Eye level

Elevation of cube

Picture plane

The dimensions of the cube are drawn to scale in elevation and plan and taken into perspective. To draw objects in measured perspective, it is useful to obtain a specialist handbook on the subject. The procedures are simple enough in themselves but, as with the computer, the many additions of simple events can make measured perspective complicated. You will need set squares, rulers, ruling pens or hard pencils, tee squares, compasses, dividers, protractors and a good, square drawing board, preferably with a reinforced edge. Drawing machines are also obtainable for those who require them.

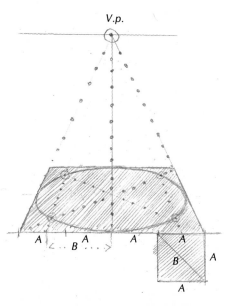

V.p.

A B A A A
A
B
A

When drawing a circle in perspective, you will need to obtain four extra points: A is a quarter of the length of the square surrounding the circle; B is the diagonal of the little square. In this diagram, the circle touches the picture plane.

Imagine a piece of paper to be transparent and held between your eye and a bottle. A tracing will be fairly accurate, but not as accurate as it would be if the paper were concave. The mind can comprehend remarkably our distorted reflections seen in fairground funny mirrors and even interpret oblique views of cinema or television screens. We never doubt the identity of our reflected selves.

Cast Shadows

To draw by copying shadows is the least useful practice, and the most difficult of all the habits of poor drawing to eradicate. Children are close to the ground and to shadows, the aprons of darkness that follow and ape their every antic. When the sun drops, our shadows extend to the distant mountains. If you choose the right shadow shapes or arrange the right lighting, shadows can be wonderful subjects. Pearlstein, the painter of nudes, lights his models with six spotlights which give six shadows. Their penumbrae are even more complicated. Hopper uses shadows to produce strong sunlighting and to move across static surfaces. Shadows make things more present, but also make areas of mystery or insecurity in pictures.

Profile shadows of Laetitia and myself are cast on the window frame. Half of mine, a bogey ghost shape, is at a distance. The sunlight casts the window shape on a bay tree, which is darkened by the square shadow of the house. On the horizon, the sea sparkles and there is a ship visible. The over-lappings disorientate the eye. ''If shadows are useful, put them in; otherwise leave them out,'' said Gauguin. For Constable, chiaroscuro was paramount.

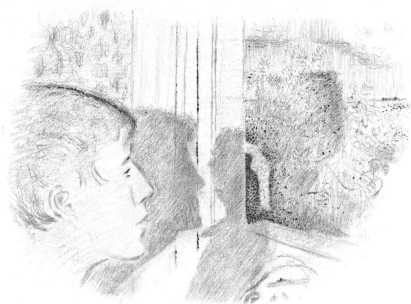

My head, shadowed on different surfaces. Use a mirror to do this.

A mug in sunlight. The plotting of shadows from curves on to domed niches was used as a test in perspective examinations.

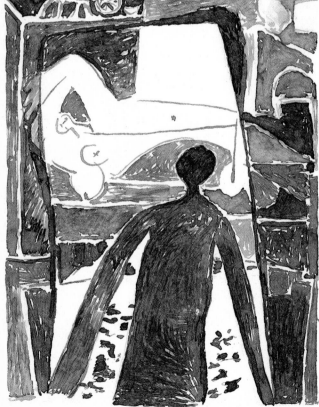

After Picasso

Picasso's shadow is cast on his bed, surrounded by the shadow of the window opening. Because of his style, the shadow is more like a real figure than the one on the bed.

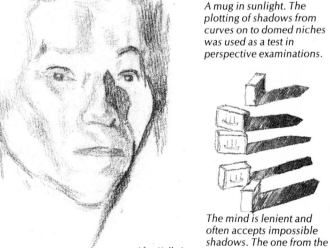

After Kollwitz

The low-lit nose makes a fine dramatic shadow on the cheek. Draw it with a sharp black crayon on Ingres paper. Place a lamp below and at the side of a head. The shadows are rarely what you might expect.

The mind is lenient and often accepts impossible shadows. The one from the top matchbox is wrong. The others were drawn by eye.

A line man casts a shadow on a building. The light is on the ground.

Cut a small mannikin from cardboard. Place it in the sun and draw the shadow.

COMPOSITION

Today, music colleges teach composition; art colleges rarely do. Even as late as the Fifties, the Slade School "Summer Composition" competition was considered an important event in the calendar. In many schools at the beginning of the century, composing with mural paintings in mind was one of the subjects taught. Reproductions of Piero della Francesca were examined and triangles, diagonals and connecting lines drawn to show construction. Students learned how to prepare working drawings in tone or colour, and how to square them up. Stanley Spencer, William Roberts, Edward Burra and others used this method. Roberts even squared up drawings for small pictures; so did Sickert. Burra did not need preliminary drawings, but knew all there was to know about composition.

The jigsaw hangs together
In order for them to fit together, jigsaws have specially shaped pieces. Move any piece, once they are made up, and all the pieces move. Good drawings also fit and hang together but do not usually need so many convolutions. Sometimes the drawings are made of repeated shapes, such as rectangles, like bricks held together with mortar. A compositor sets up type for printing which is horizontal and is set in columns. The layout of a newspaper page is pre-decided to some extent — eight columns, for example, with various headings and compartments. So far, it is mainly horizontals and verticals and the format is predictable. If an advertiser takes half a page, it surprises. Order, measure, habit and a context of propriety make any departures dramatic. There is no rule which is of any value regarding the positioning of objects in pictures, neither is it important to avoid putting the main subject in the middle of a picture. I do not believe it matters much visually where the windows are placed in a building — if they are minutely adjusted to the idea of a great architect, then the magic will occur. This was also true of the beautiful artist-illustrated books which Vollard brought out in France. When the type was juxtaposed with the drawings, the mix was magical.

The grand plan
Composing goes on all the time in art, so why give it a special introduction? Some art is more composed than other art. Crivelli's "St Roch" is more deliberately composed than Hogarth's "Shrimp Girl". Picture-making seems an exact description of composition but is usually used in a dismissive fashion. Picture-making is composing with insufficient urgency. Matisse would refer to his paintings as "decorative". (Decorative must have the word "merely" in front of it before it becomes thoroughly derogatory; but the greatest Western art is often non-decorative.) The great composers will help in particular ways. Look at Seurat's "La Baigneuse", Poussin's "The Burial of Phocian", Piero della Francesca's "The Madonna del Parto". There is a lot to be learned about composition from Seurat, Vermeer and Piero della Francesca, and the big bathing picture by Seurat in London's National Gallery is especially useful. Photographs of details are available and it is possible to see in the original, oil sketches for the river bank. There are books which reproduce the drawings for the bathers and their clothes, as well as specialist books which describe Seurat's theories. Seurat and Piero left nothing unprepared; both used dynamic symmetry in measuring relationships throughout their pictures. This gives the pictures a wondrous, intrinsic beauty of construction.

Without preparation or contrivance
What is art without this careful preparation and design? If it is any good it is done intuitively, and is not usually as complex or as controlled as prepared composition. It can be engaging, even wonderful. It can be the greatest art. But this cannot be taught. Titian's "The Flaying of Marsyas", Hals' late pictures, pictures by Monet, Kokoschka, Rouault, Utrillo, Soutine, Bonnard and Rembrandt, and Turner's "Burning of the Houses of Parliament" are examples.

Looking demands prolonged concentration
The grand structures, such as Raphael's "School of Athens" or Poussin's "The Adoration of the Golden Calf" are massively complicated, three-dimensional machines, containing passages which can only be thought of as sculptural (indeed, much of Poussin is derived from bas-relief). It takes a real effort to search in this complexity. Looking is very difficult and takes a long while to do properly. Looking has to be done on many visits. To look at Poussin drawings, reproductions, photographic details and other related Poussins, such as the "Dance to the Music of Time" (Wallace Collection, London) and "Bacchanalian Revel before a Herm of Pan" (National Gallery, London) demands concentration and far more time than is usually given to looking at pictures. The whole way of exhibiting paintings is illogical. Who would think of trying to listen to one hundred symphonies at a sitting? Yet this number of Cézannes has often been assembled. Copy with a pen, waterproof ink and grey wash from Poussin's drawings and from his paintings of related subjects. Poussin's designs always work both across the surface and in depth; the balance is complex.

The control of the attentive eye
It is not as difficult to look at some art as it is at Mantegna's "The Agony in the Garden". Elsworth Kelly, for instance, is easy on the eye. But when the Mantegna has really been entered by the eye and mind, strangely, the satisfactions increase and, as there is nothing left to chance, the control of the attention is thorough. Within a small rectangle, the onlooker is led about with far greater relevance than in the real world. The sinews of the mind are stretched as paths wind in the rocks. Included are figures who will never speak. Why is the experience so compelling? The mystery lies in the coils of hardest composition.

Details and complicated new techniques
Estes, the Photorealist, does the most complicated pictures since Hieronymus Bosch. He chooses multiple reflections on transparent surfaces. Brueghel, Kandinsky and Klee also included a vast amount of detail which was beautifully composed. The use of sprays by Bernard Cohen in the Sixties was a wonderful innovation. His winding, dancing graffiti of pattern on pattern, the pearls, whorls, icings and fondants of gorgeous colours had not been seen before and showed that composition could float in many ways, opalescent as blown and twisted glass. Matta, Gorki and Miró are also artists who have expanded non-academic ideas of pictorial arrangement.

Disintegrate the integrated respectfully
To say Mozart played billiards might suggest more about how he composed than to talk of keys and fugues. In the pages that follow, I have separated some of the components of some compositions — an objectionable thing to do to any profound work. Like taking a steam engine to pieces, the cogs and wheels only make an ugly heap and the steam escapes to the sky. What did a rectangle matter to Hopper when looking in office windows? What did Velasquez care about a circle in a square when brush-stroking his Venus? What did a triangle mean to Morandi, as he breathed softly so as not to disturb the dust on his bottles? And what did Seurat care about a rectangle if he was creating a house? Composition is love made with geometry.

Pictorial Arrangement

Composition is synthetic arrangement. Selecting from nature is not composing. For a wedding photographer, to include everyone (and no confetti on the bride's nose) is often sufficient. For Vermeer, every form and space in his pictures had to be arranged creatively. A photographer can modify an exposure in the darkroom — Man Ray did this to the limit. Vermeer analyzed the subject using a camera obscura; the synthesis was on the canvas. To see the difference between a manipulated photograph by Man Ray and a Vermeer is to understand where the mystery of composition lies. Laetitia Yhap often watches fishermen handling nets. One day, the performance of her favourites generated instant conviction: a fast scribble, rough and raw beside the boat, stung her imagination into making a careful crayon drawing at home. From this came the picture analyzed here. Musicologists break masterpieces into themes, keys and expositions, and when the harmonious horns have been made into mere handfuls of piano notes, our hearts break too. They do it, and I do it here. The diagrams on these pages show some of the pictorial geometry in this composition. Drawings are ideas; their deeper meanings defy analysis. In *The Analysis of Beauty* Hogarth said that an undulating line would always be more beautiful than an angular one. The Cubists might not have agreed.

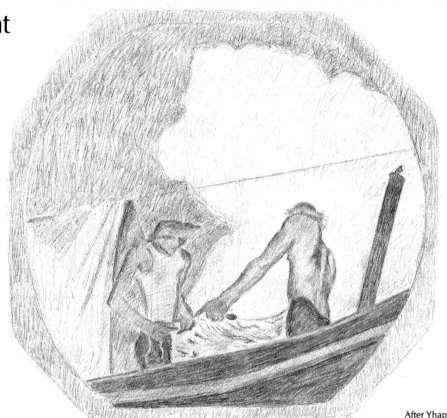

After Yhap

The picture has a low viewpoint. The sea is out of sight. A net looks at the same time like itself and the sea. A rope and canvas make a mysterious triangular exit and parallels fence in the two figures for work, circular in a world disc. The symbolism is continued with a sexual chimney, active like the diagonal arm, all on a Stygian-dark boat — a foil for paradise in the form of a summer cloud, brightly lit, creamily enjoying the penetration of the blue boy and the azure ball of the sky. A geometry is used within a rounded octagonal margin of neutral grey. The image exists within a circle, segmented by horizontal chords, short above and longer below. Within this shape, the diagonal arm is complex and dynamic.

An attempt to show the movements contained. The eye is invited to travel by progressions, following the converging lines and rising angles in the directions of the arrows shown.

Hogarth's serpentine line of beauty was S-shaped like a swan's neck. Matisse called it the "arabesque".

Concentric parallels for structure and confinement. The frame is also four pairs of bending parallels.

Straight lines construct and make for a sense of security. Right angles are right for us because we stand upright, at right angles to the ground. Diagonals make us move to regain equilibrium. Zigzags cause anxiety and are used to illustrate lightning. The cloud, partially a circle, is compared to the world disc or millstone found in Bosch paintings. The ogee movements show the swelling forms contracting actively to their points.

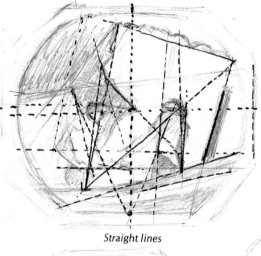

Straight lines

The cloud The world disc

The net as an equivalent for the sea

Zigzags

Ogee movements

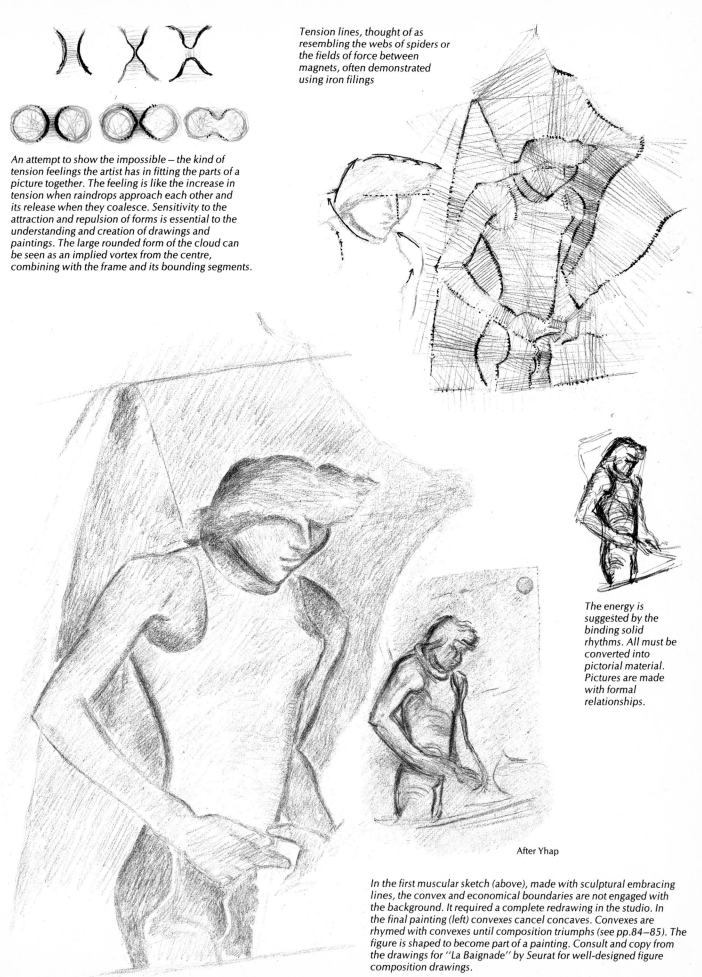

An attempt to show the impossible – the kind of tension feelings the artist has in fitting the parts of a picture together. The feeling is like the increase in tension when raindrops approach each other and its release when they coalesce. Sensitivity to the attraction and repulsion of forms is essential to the understanding and creation of drawings and paintings. The large rounded form of the cloud can be seen as an implied vortex from the centre, combining with the frame and its bounding segments.

Tension lines, thought of as resembling the webs of spiders or the fields of force between magnets, often demonstrated using iron filings

The energy is suggested by the binding solid rhythms. All must be converted into pictorial material. Pictures are made with formal relationships.

After Yhap

In the first muscular sketch (above), made with sculptural embracing lines, the convex and economical boundaries are not engaged with the background. It required a complete redrawing in the studio. In the final painting (left) convexes cancel concaves. Convexes are rhymed with convexes until composition triumphs (see pp.84–85). The figure is shaped to become part of a painting. Consult and copy from the drawings for "La Baignade" by Seurat for well-designed figure composition drawings.

Spacemaking

Cartographers stretched the world to fit goatskins. Artists usually press their subjects into rectangles. If you find this limiting, stretch your format. Many medieval illuminators did this. Today, Anthony Green tries to include his total "intimist" environment – he loves painting his family and friends and their surroundings as much as Vuillard loved drawing his mother in her bedroom, or van Eyck loved painting the details in "Arnolfini and his Wife". Copy this van Eyck. Draw the central space. Travel from the dog upwards, fabric by fabric, to the lovingly clasped hands, and then into the central mirror with its surprise condensation of the event. The "Arnolfini" is one of Green's favourite pictures. To accommodate his subject Green uses carpentry and numbers. There are eight corners to a room. We can only see six. Green sometimes paints eight and his shapes become strange. He adds and subtracts. Sit in your home. Draw your drawing, your knees, shoes, carpet, chairs, cat, friends, window, walls, door. Stretch your format to take in all you wish to depict, detail by detail. Space is elastic. Green can stretch it to the shape of a tent.

A mixture of elevation and plan and bird's eye viewing, copied from the work of the naive painter Alfred Wallis. Wallis makes spaces in ways which resemble the perspective systems of medieval artists. He painted with yacht paint on cardboard. Draw yourself in the middle of a sheet of paper. Then draw your surroundings as a combination of elevation and plan.

After Wallis

From high on the cliff at Birling Gap, Sussex, a free drawing was made and from it the working drawing below. By erasing and redrawing every area, the arrangement was adjusted until the forms were at their most eloquent. The squares helped in transferring it to the canvas for drawing in charcoal (right). The differences in quantity and shape which occur show the continuous attempt to increase urgency and relevance everywhere in the picture. Traditional perspective often makes quantities which are "mean" compared with those felt when we look at vast landscapes.

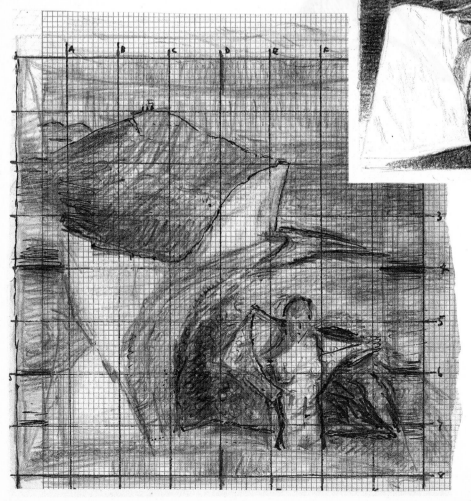

Drawn from an Egyptian painting of a lake surrounded by trees – a combination of plan and elevational views. Do a diagram drawing of your garden as part plan and part elevation. If you have an ornamental pool, put it in the middle and work outwards. Experimenting in this way makes evident the kind of perspective which suits you.

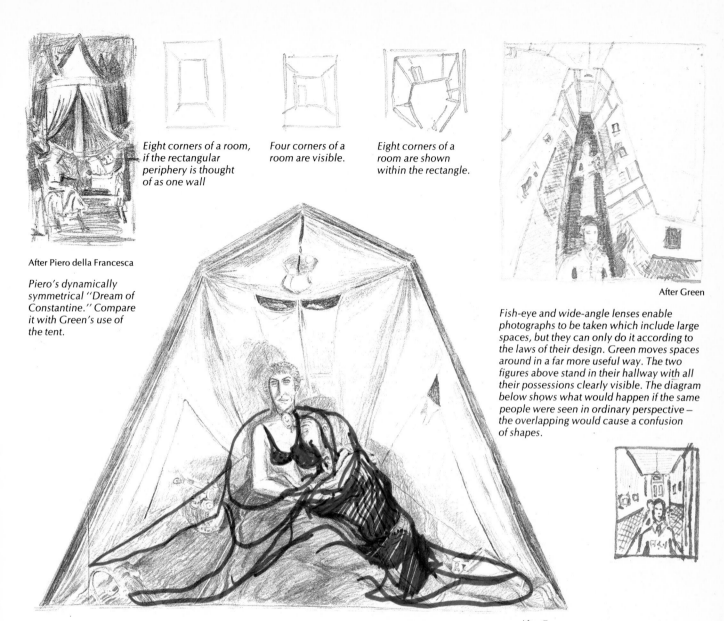

Eight corners of a room, if the rectangular periphery is thought of as one wall

Four corners of a room are visible.

Eight corners of a room are shown within the rectangle.

After Piero della Francesca

Piero's dynamically symmetrical "Dream of Constantine." Compare it with Green's use of the tent.

After Green

Fish-eye and wide-angle lenses enable photographs to be taken which include large spaces, but they can only do it according to the laws of their design. Green moves spaces around in a far more useful way. The two figures above stand in their hallway with all their possessions clearly visible. The diagram below shows what would happen if the same people were seen in ordinary perspective – the overlapping would cause a confusion of shapes.

After Green

In "The Fourteenth Wedding Anniversary: Our Tent", the tent, like immense golden bloomers, contains Green's passionate love-play. Tight as jeans, the relentless pressure of passion engages every corner. The tent is spreadeagled against a blue sky, making a frame for four of the five sides.

After Green

A working "bed" drawing, lined, scaffolded and ready for the constructor to use.

After Green

The painting above right is an invitation to view a living room more intimately. The drawing above left is a working drawing for it. Powerfully obsessive, the idea demands the cutting and shaping of a board to contain it.

Apertures

Just as an architect spends much of his time thinking out where people will walk in buildings, so the artist attempts to work out where eyes will travel in pictures. In practice, he can really only guess (although research has been done to find what movements eyes make when looking at paintings). Eyes may follow diagonal lines or contrasting edges or be drawn towards sparkles of dots, circles, triangles, crosses or bright colours. Where people walk, eyes may travel. An open door invites exploration. Eyes can go where people cannot go: through the windows, out over the sea, into the depths of the firmament, even into the intangible world of the television box. All openings beckon the viewer. Edward Hopper is a master of eye travel control in and out of windows, through doorways, up stairs, even over waves to the horizon.

Rectangular pictures are common.

Old frames were often curvaceous.

Movie directors use hands as a viewing frame.

An old sliding panel viewing frame

A viewing frame with equal or "golden" intervals

Gadgets aid concentration. These have strings.

Viewfinders and binoculars change our seeing.

Proportional grids may be stringed.

After Hopper

After Hopper

For Hopper, windows were useful compositionally. He was almost the only artist to paint views looking into windows. Here he looks both into and out of the room.

Controlling the way we look at the contents, Hopper knows we will look at the centre, at the empty wall. Then, with maximum contrast and with the force of the diagonal, we appreciate the strength of the sunlight. With more sunlight, he leads us up the stairs. Then, because apertures attract our eyes, we move over waves to the contrast at the horizon.

After Magritte

After Magritte

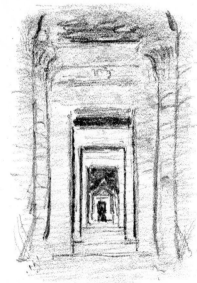

Wonderful things can happen in drawings. The cloud is special because the context is so everyday. Compare it with the Hopper.

The dark doorway is made in a cloudy sky for mystery. Draw a dark doorway until you grip the mystery.

Egyptian rectangular avenues are concentric spacings with wonderful intervals.

Matisse had a room overlooking the blue sea in the South of France. It was the subject of scores of paintings. The curtained windows, the shutters against the sun, the ways out, were infinitely enchanting.

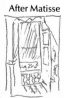

After Matisse

The sea and boats framed by the chimneys and roofs, which in turn are framed by my window bars, which in turn are framed by this book.

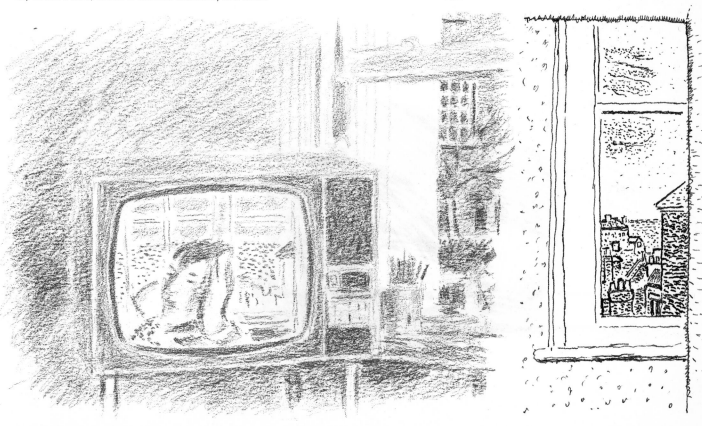

Often called ''the box'', the television on the left is almost as much of a way out of the room as the window on the right. Rectangles are mildly distorted by the screen and by

perspective. Do little drawings of the views from your windows, watching rectangle after rectangle, aperture after aperture, accumulate.

Rectangles and apertures by the sea. A window exit for the eye in my room at Hastings. Use dots and splodges of ink.

Squared Circles

Although I do not forgive books which draw direction lines on Old Masters, if you are not accustomed to looking at pictures in depth, it may help you to become more conscious of the round/square designing which went on in the art of Velasquez. Velasquez – who never lost an image or failed to make a face – painted the first nude rude and real enough to impel a feminist suffragette to slash it several times. Without idealization, the woman's head is portrayed as Venus reflected in a square mirror (captioned below). It is stroked with a surprising amount of design, the roundnesses being played off within the square. The moulding lines of the frame, if prolonged, would seem to point out the body beneath. Structures are made strong by having the squared circle in mind – the round-pegged square hole, the least square in the most square. Find the magnetic geometry of this fluidly painted nude with a searching eye and gently probing fingers.

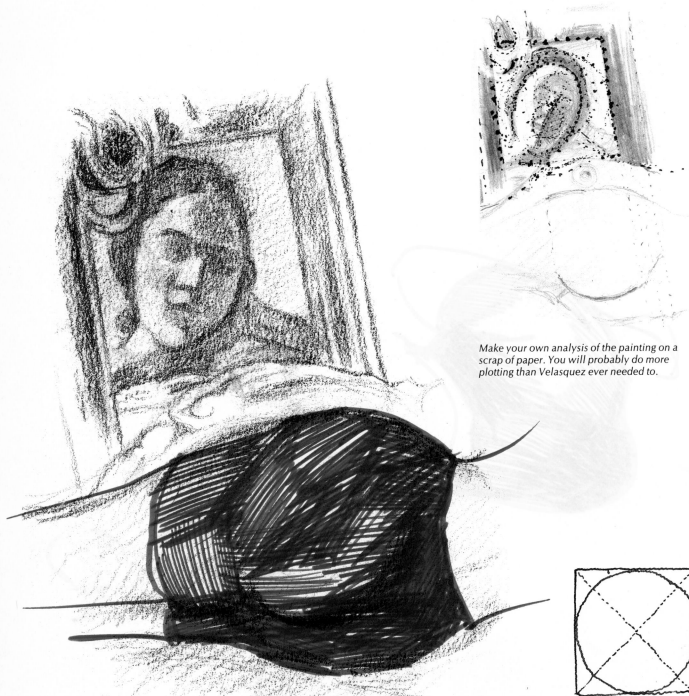

Make your own analysis of the painting on a scrap of paper. You will probably do more plotting than Velasquez ever needed to.

After Velasquez

The rounded forms of the head of the "Rokeby Venus" are enclosed by a square reflection. Using a medium charcoal pencil, shade form against form, looking for orbs and arcs and encountering the gaze of Venus. This is getting close to the design creation of a surprise painting.

A square encloses a circle. Traced as weakly as possible, it still shows its potential. Human beings desire circles and are surrounded by squares and rectangles.

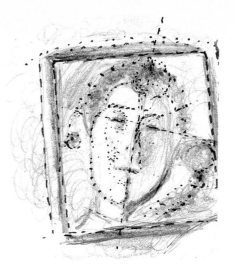

Laetitia's head in a position which slightly resembles the detail from the ''Rokeby Venus'' on the facing page. Arrange a mirror and head and draw the round/square relationship, thinking of the Velasquez.

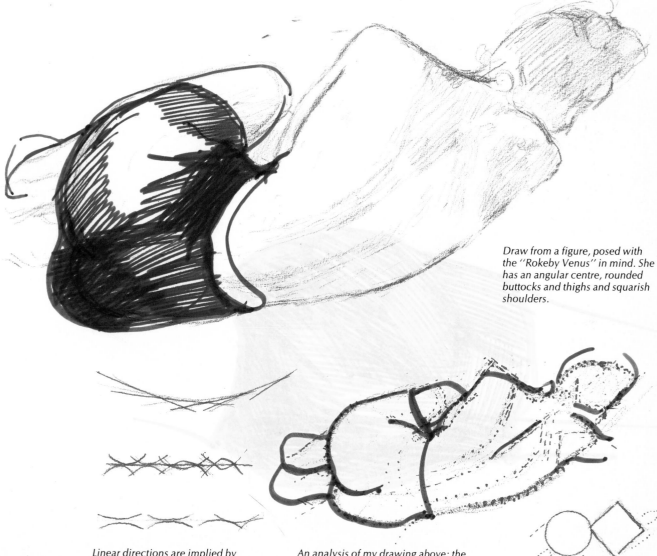

Draw from a figure, posed with the ''Rokeby Venus'' in mind. She has an angular centre, rounded buttocks and thighs and squarish shoulders.

Linear directions are implied by opposing arcs in succession. Arcs may be made by successive straight lines. Thus, roundness becomes straight and straightness round.

An analysis of my drawing above: the dotted lines are arcs, the dashes are for straight lines. Do not force diagrams on great art. Try to coax the codes from them by being sensitive.

A circle and a square pretend equivalence with the figure above.

Triangles

We have triangles in our minds and love to triangulate. We make scalene, right-angled and isosceles triangles. Humans become triangular in vertical rectangular portraits, and still life groups and landscapes become triangles in horizontal rectangles. Japanese cooks make triangular eggs. Gris said the triangle was the strongest shape of all. The pyramids are strong. Geodesic domes are built with triangles. Egyptian male statues have wide shoulders and small waists. Make diagram sketches from Hokusai's "Mount Fuji", Cézanne's "Gardener Vallier" and Piero della Francesca's "Sigismondo Malatesta". Take triangles seriously. Draw them beautifully on their sides and on their points to look at.

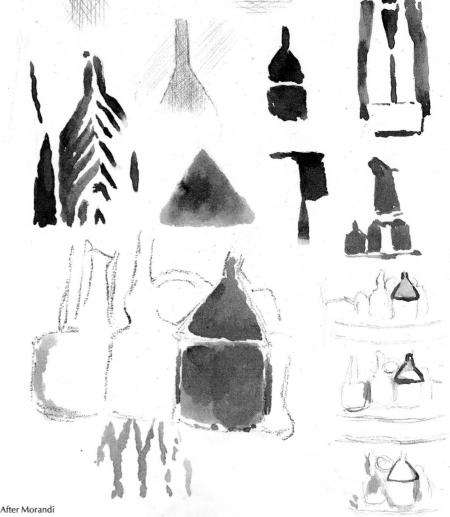

After Gris

Draw a beautiful triangle as a fruit bowl in this late Cubist picture.

After Morandi

With a brush and soft pencil, gently think about triangles making bottles, and bottles becoming triangles, and triangles being the spaces betweeen bottles. Morandi taught etching and loved hatching. His triangles lie as softly on the paper as the dust lay upon his groups of bottles.

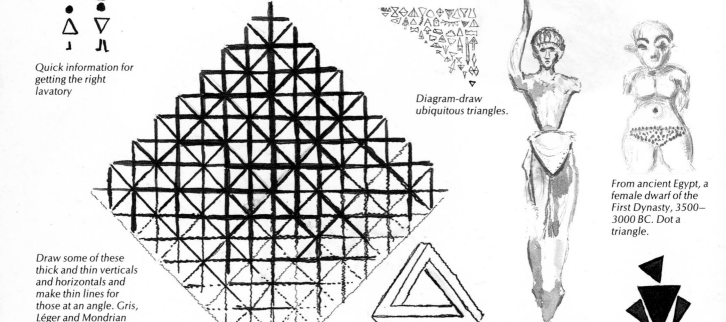

Quick information for getting the right lavatory

Diagram-draw ubiquitous triangles.

From ancient Egypt, a female dwarf of the First Dynasty, 3500–3000 BC. Dot a triangle.

Draw some of these thick and thin verticals and horizontals and make thin lines for those at an angle. Gris, Léger and Mondrian relaxed at night by dancing. Feel the measure and beat as you triangulate.

After Mondrian

The impossible triangle is difficult to draw.

A Minoan statuette from Crete with a golden loincloth

Play with and draw paper triangles.

86

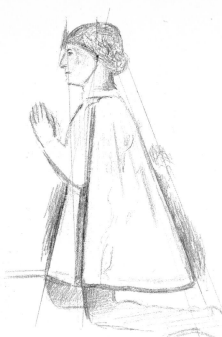

After Pïero della Francesca

Copy with humility the spiritual, triangularly cloaked "Sigismondo Malatesta", kneeling so exactly.

Villard de Honnecourt was a thirteenth-century master mason. His manual gave some rather awkward ways of drawing figures and heads, using triangles and stars made of triangles. These scaffoldings do not fit the figures, and work against the flourish of the pen. Books on drawing often draw triangles arbitrarily on figures, which do nothing useful.

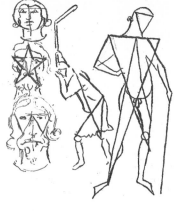

After Villard de Honnecourt

Dürer had many ways of putting a figure together by using geometry. This one was called the triangular method. It gave him a good excuse to point the nipples and it made a splendid way of relating a figure to a simple measure and shape without thinking anatomically or imitatively. Pencil freely some little figures using triangles.

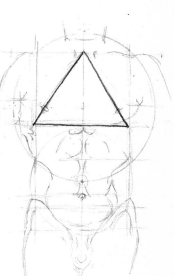

After Dürer

This Cycladic Greek lyre player is triangular of nose and triangular of lyre and sits as triangularly as possible. Three other Cycladic Greek examples with triangular centres are included.

Savonarola's medal portraying the doom he prophesied for Florence

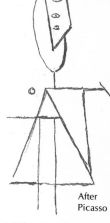

After Picasso

With a pen, draw a triangle and add lines to make a figure.

After Nash

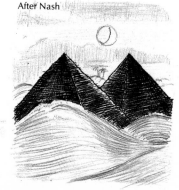

After Klee

On a visit to Egypt, draw a pyramid with the Sphinx in front of it – they comment on the triangularity of each other.

Pyramids in the sea – a Surrealist essay on a strange meeting between wet waves and dry pyramids.

A big triangle is a mountain. A little one is a child's sandcastle. Eyes and Everest climbers are drawn to the apexes of triangles.

Paul Klee's doom-laden, downward pointing arrow has an effect like the dagger above Florence.

Rectangles

Seurat stroked rough paper with black chalk and, although various natural effects can easily be imitated using these media, this was far from his intention. From the first movement of the chalk, his aim was structural. Taut shapes and rhythmical relationships had to fit and work together. In the diagrams on the right, I pretend that Seurat makes a drawing of a house he has seen, on a sheet of Michallet or Ingres paper. Rectangles and part-rectangles are shaded with grey scribbles resembling spiders' webs. These are done by rapidly moving a black crayon; their positioning is crucial. At centre right, moving marks skim up to the horizon. And as the components become more emphatic (bottom right), more webs are spun and a pale oblong, a soft-cornered parallelogram, is made to float in the grey web of sky. The analogy of the web is useful, for spiders' webs are flat. So is a billiard table. Forget the spider. Let me try again. As the balls bounce from the cushions of a billiard table, volleying their way back and forth, they seem to define the limits of the table. In the same way, Seurat's black crayon seems to move between the forms and the rectangular edges, and between one form and another, until the hits and bounces have marked out the edges and limits of every shape. Eventually, all lies flat and glittering, like black fishing nets spread out on the beach to dry.

The component shapes of the exercise (right), separated and flattened so as to be easily visible

The spatial depth is to some extent controlled by "forcing" — exaggerating the tonal contrast between edges. This brings them forward to the picture plane where, if straight, they will lie, as in Cubism, "tied" to the surface.

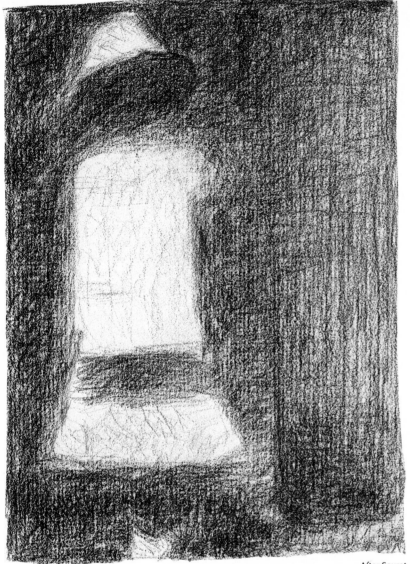

To dismember a masterwork in this way, in order to show the components, would be unpleasant. Fortunately, this is being done to a copy. Light is shown dark and dark light. Make diagram drawings to help you think clearly.

After Seurat

The face is there, but it is not much visible. The granulated darks suggest pointillist painting. The pale areas float in the gloom. The crossing of marks is tense and strong. Copy it to become aware of the perfect placing within a rectangle.

After Constable

A life-size sketchbook page. Constable used tiny sketchbooks and made even smaller drawings in them. Some were smaller than postage stamps and were done in lead pencil, two or more to a page. This mansion by night and day is not as ordered as a Seurat, but Constable has the shapely mind of a great composer.

Draw an attic window. This one is by the sea at Hastings. With conté crayon on rough paper, the speckle gives an effect of strong sunlight. To look into windows, with the sun casting strong shadows, is one of Hopper's favourite devices.

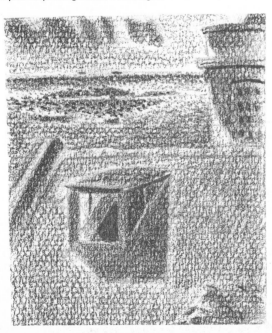

An obvious diagram of the attic window, separating shapes brashly. Draw the attic; cut up and separate the pieces; then glue them together again hard.

Rectangles and triangles go together – for as soon as lines cut rectangles, triangles occur in profusion. The triangle is related to many shapes which comprise the attic window. The family likeness, in other words, is triangular. Here the shapes are thoroughly scattered, like a jigsaw with straight-edged pieces.

Measure and Music

Architecture has been called "frozen music". Gris called his Cubist pictures "coloured pictorial architecture". It was hoped that painting would escape from the jungle of nineteenth-century imitation and that art would be more like music. The subject matter of Cubist still lifes often included composers' names, guitars, pianos, violins and sheet music. But music-related material did not turn painting into music and neither did the beat or quantity of progressions of Paul Klee, although they resembled the bar lines in music. Some hand-written music is calligraphy. The artists of the Twenties felt that painting was getting near to the purity and autonomy of music, and this was important. Later, when all representational matter was subtracted and the work lacked the force and passion of great music, it was evident that visual art, like the novel, needed subject matter if it was to work at full power. Some birds make ordered, symmetrical nests; others are content with a rough heap of twigs. Humans are temperamentally attracted by either order or wildness. Close-cut lawns, neat suits, well-cut hair, clean houses, clean bodies, ritual, classical ballet, and the goose step are examples of the ordered life. The Puritan lives within limits, like the white, white picture. Braque stated that he liked the rule which corrects emotion. Order in art can be achieved in simple ways. Knowing where the middles, quarters and thirds of a picture are, is useful in arriving at harmony. The "golden" proportion, as used by Alberti, Piero della Francesca and Seurat, is simple – the small number is related to the large number in the same proportion as the large number is related to the sum of the small and large numbers – $A : B = B : A + B$. The repetition of simple quantities and relationships of measure can satisfy our feelings for pattern. They bear some relationship to beat in music, metre in poetry and module in architecture.

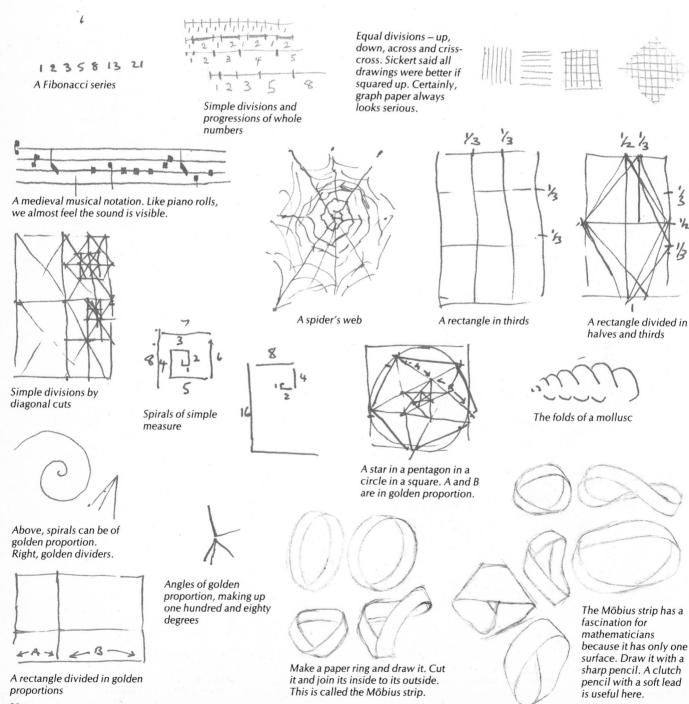

A Fibonacci series

Simple divisions and progressions of whole numbers

Equal divisions – up, down, across and criss-cross. Sickert said all drawings were better if squared up. Certainly, graph paper always looks serious.

A medieval musical notation. Like piano rolls, we almost feel the sound is visible.

A spider's web

A rectangle in thirds

A rectangle divided in halves and thirds

Simple divisions by diagonal cuts

Spirals of simple measure

A star in a pentagon in a circle in a square. A and B are in golden proportion.

The folds of a mollusc

Above, spirals can be of golden proportion. Right, golden dividers.

Angles of golden proportion, making up one hundred and eighty degrees

Make a paper ring and draw it. Cut it and join its inside to its outside. This is called the Möbius strip.

The Möbius strip has a fascination for mathematicians because it has only one surface. Draw it with a sharp pencil. A clutch pencil with a soft lead is useful here.

A rectangle divided in golden proportions

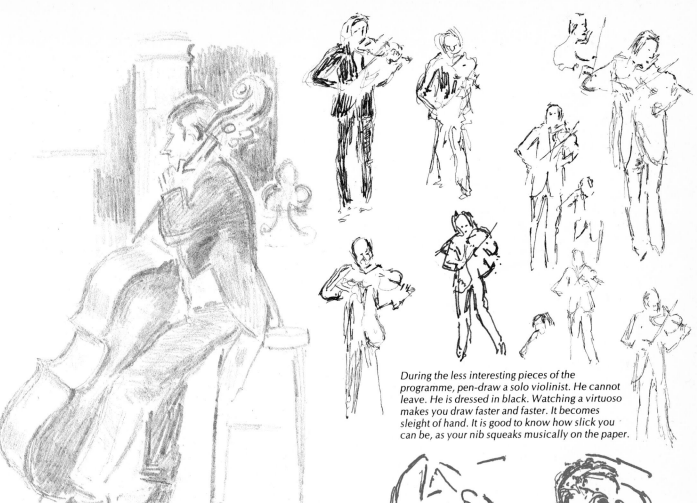

During the less interesting pieces of the programme, pen-draw a solo violinist. He cannot leave. He is dressed in black. Watching a virtuoso makes you draw faster and faster. It becomes sleight of hand. It is good to know how slick you can be, as your nib squeaks musically on the paper.

A double-bass player will keep moderately still, wedded to his instrument. Notice how similar are the rhythms. His waist is like the wooden waist, his back like the wooden back, and so on. The shapes are harmonious to draw, and harmony is, after all, a musical word.

Your fountain pen will stripe-in, spot and scurry across the keys. The winding shadow beneath the grand piano will help to bind it to the player. Picasso, Braque, Dufy, Matisse, Renoir and Degas have depicted pianos, but they have nearly all been upright. The great grand has yet to have its artist.

Pop vocalists often become appendages of microphones, which can be used to alter the face shape. Drawing becomes wild in the strobe-lit shake-up and choices multiply. Electric guitars are of many shapes; usually they are more angular than acoustic guitars.

LANDSCAPE

Visitors converge on Provençal Aix. Mont St Victoire near Aix is a famous mountain because Cézanne painted it. We see places through the eyes of the artists: Venice –Turner; Fontainebleu – Corot; Arles – van Gogh; Arezzo – Piero; New Mexico – Georgia O'Keefe; Dieppe – Sickert; Cookham – Stanley Spencer; Giverny – Monet; Ostend – Ensor; Kragerø and Ekely – Munch; Maine – Marin; Manhattan – Hopper; Le Cannet – Bonnard. It is rewarding to draw in the regions where they worked. Draw from Courbet paintings of rocks and from the real rocks near Ornans. Take your watercolours and home-made or hand-made watercolour paper. Look at some of the hundreds of beautiful Cotmans in Norwich Castle. Travel through East Anglia drawing his subjects – the Norfolk landscape, churches and castles. Travel further. Visit Gauguin's Pont-Aven and Tahiti, Hokusai's Mount Fuji, Lowry's Salford. There are special joys in visiting Aix and Dedham. Cézanne and Constable eye-ravished their landscapes so thoroughly that their views have become our views.

The greatest landscapes ever painted
The rainbow landscapes by Rubens are the most tangible and real creations. The figures, cows, trees, earth and sky are completely convincing. For the first time it became possible to enter a picture and walk in it. Constable's "The Hay Wain" is a little like Rubens' "Chateau de Steen"; they are both weighty works. Rubens achieves substance by drawing, Constable by using a palette knife. "The Lock" and "The Leaping Horse" are other massive structures, rich with paint.

"The Hay Wain" is the most familiar picture in Britain
"The Hay Wain" is in the National Gallery, London. It is printed on calendars and hangs as a reproduction in thousands of homes. It is unlikely that many of its owners know why the cart is in the water, what John Constable thought about art, why he copied Claude or why the picture was revolutionary in its time. Neither do they know that when it was shown in Paris it caused Delacroix to repaint parts of "The Massacre at Chios", nor that the use of greens moved French painting a little nearer to Impressionism. Familiarity with Constable's style has helped to make "The Hay Wain" seem naturalistic. Imitative pictures achieve only superficial resemblance and never "realize" the subject. This is also true of the mechanical flash of natural light on chemicals called the photograph. Realization can only be achieved through style.

Visit Constable country to draw
Dedham is as lush as when John Constable sat listening to the slurping of the water wheel. Remember that Constable said, "Everything changes with light and shade". Soft-pencil-draw the fine Suffolk trees; make them small on Ingres paper. Constable often did more than one drawing on each sheet and used very small sketchbooks. Draw in the evening or at dawn, when long shadows creep and connect long boughs and cows along the river banks. Hatch or blot with a brush as Claude did; mass up the evocative entrancements you feel. It is good to study Constable's sketches and sketchbooks at the Victoria and Albert Museum in London before your expedition. It is good to question the worth of nostalgia, and to examine ways of building on a tradition which involved an art revolution at Flatford Mill under the trees.

Familiarity with the terrain is important to some artists
Stanley Spencer knew every blade of grass, every crack in every brick in Cookham village; Constable loved every rotting plank and dyke at Dedham, but included fewer details; Turner looked carefully but his art was grand and European; Brueghel composed views of great particularity; Poussin studied to make landscapes sufficiently classical to suit his figures, which meant removing any misshapen bushes. Poussin, like Rubens, after a full life of painting figure-filled pictures, became more involved with landscape.

A map is a landscape drawing
Maps are fascinating. They begin as sequences of overlapping photographs in a line from high in the air. These are traced with the aid of a machine. This comes near to a dispassionate way of drawing landscape. A large-scale map of the fields around his home in Gainsborough country was used by Patrick George to show the plan of his landscapes. They are done standing, with a fixed eye position. George marks out exactly, with intuitive liquid marks or shines of pencil, the positions of landmarks such as trees, hedges and farm buildings in sensitive perspectives. His exhibition poster paired diagrammatically the landscape view as he had painted it with the piece of map the view had covered.

Physically explore the land – climb, walk, dig and look
To draw land well you must understand its geography and geology. Fields are supported on soil, clay or rock strata which may flow or break. Sometimes this is visible, sometimes camouflaged with woodland or buildings. Walk through the countryside. Become familiar with each tree and hollow. The recording of walks is the art activity of Richard Long. Peter Lanyon glided over it. Some aspects of it farmers know well – they follow its seasonal changes. George draws with an understanding of farming and represents the events happening before him at measured intervals, even knowing where the tractor will be left on the farm and what position in the picture it will occupy. There is a wildness in landscape which we enjoy. We admire a tulip for its smooth potlike form. A two-leaved seedling tree begins simply. When it reaches a hundred feet high it will have suffered a million shakes and buffets. It is ruggedness we love in the twisted walnut tree. Landscape is long, wide and high. Let artists be your guide: Munch, Courbet, Monet, Pissarro for snow; Gauguin for autumn; Turner and Claude for sky and sea; Girtin and Soutine for prospects; Delaunay for the Eiffel Tower; Seurat for the Seine; Giorgione for a tempest; Brueghel for a stormy day; Vermeer for a view of Delft . . .

Central Design

On the right is the Avenue at the Jas de Bouffan where Cézanne lived. He knew that straight ahead was an obvious way into a picture. A symmetrical weaving of formal webs around a centre can be satisfying. For Cézanne, the avenues around his home were perfect for counterpoint of this kind. Shadows, tree trunks, path, twigs – all were related to the horizontal and vertical. Triangular and circular variations were tied constructively to the rectangle and to the centre. Rubens, Rembrandt and van Gogh did drawings of complicated traceries of twigs and found the simple, stabilizing structure of the avenue invaluable. Alternatively, the centre may be filled symmetrically – roundly, as in the Claude below or with a triangular mass, as in Cézanne's "Mont St Victoire".

After Cézanne

Diagonals to the centre

Orthogonals to a rectangle

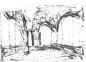

After van Gogh

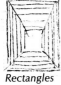

Rectangles reducing

An avenue diagram

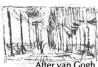

Avenue diagrams

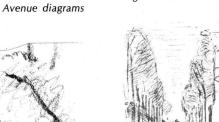

Sketch diagram of an avenue, related to van Gogh's avenues below.

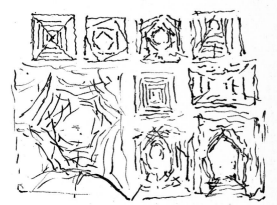

Sketch diagrams of the kind of weblike designing which goes on in pictures. Try a spidery sketch of the underpinning of a favourite drawing.

After van Gogh

A sketch diagram of a pen drawing. Four triangles meet at infinity.

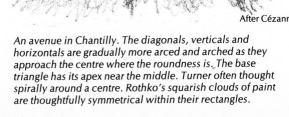

After Cézanne

An avenue in Chantilly. The diagonals, verticals and horizontals are gradually more arced and arched as they approach the centre where the roundness is. The base triangle has its apex near the middle. Turner often thought spirally around a centre. Rothko's squarish clouds of paint are thoughtfully symmetrical within their rectangles.

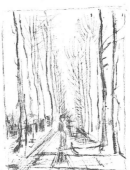

After van Gogh

A base triangle is enclosed by many rectangles within a rectangular format.

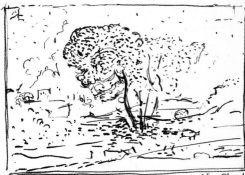

After Claude

Using dots, make sensitive diagrams as you look at paintings. Here the Claude is filled at the centre with foliage. The distance is at the edges in contrast to the central emptiness of avenues.

A central triangle

A round tree overlaps a triangle.

A tree fills the centre.

Conventional Arrangement

Pictorially, a conventional landscape is a balanced arrangement where the obvious points of interest are put in predictable positions of importance. This is done in many pictures by Ruisdael, Claude, Corot, Richard Wilson and Constable. We have seen these arrangements all our lives. The more comfortably familiar the arrangement is, the more complicated other features of the picture can be. For instance, "The Hay Wain" by

Constable is a conventional grouping, but in other ways – in its paint texture and detail – it is complicated. Positively, "conventional" is traditional; negatively, "conventional" is boring. Much of the warmth of Pissarro's etching, below, is the result of this predictable balance. The design is concentric around the central tree. Lozenges, diamonds and triangles and a vertical through the tower to the centre pier of the bridge make for stability.

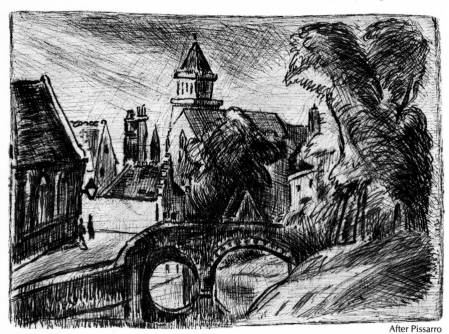

After Pissarro

A diagram suggesting the leaps, delvings and searches the eye makes when looking at pictures

"Quay at Bruges" drawn with crayon, Indian ink and a mapping pen. I overworked it in trying to discover its structure. The ways around and out of the picture are posited in the diagrams.

Where the eye is led. Whether you look for contrasts or mergings is a matter of temperament.

Draw a church tower with a 2H pencil on hard paper. At a distance, receding lines are almost horizontal and perspective loses much of its force. Corot liked to limit it in this way. The lessening leaf and mark sizes are sufficient to take us into the distance.

All is conventional – the components of the English village landscape, so expected, so comfortable, so entirely within walking distance or stone's throw. A river with rushes, a near tree, a middle distance tree, far trees, hill, bridge, cloud, church tower, cottage combine to make this scene even more secure. Shade softly with a conté crayon pencil to give a rich-textured middle tone.

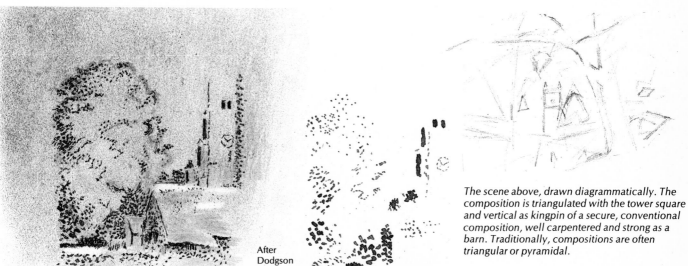

After Dodgson

The scene above, drawn diagrammatically. The composition is triangulated with the tower square and vertical as kingpin of a secure, conventional composition, well carpentered and strong as a barn. Traditionally, compositions are often triangular or pyramidal.

Here is a conventional design and a traditional tone system. A feeling of harmony is engendered by the pale grey paper tone, the middle grey tone, the dotted black on middle grey tone and the black— tones are clearly separated, and the tones making up gradations are clearly declared. Look at Corot from this point of view. Equally placed dots are more static than linked clusters. Dots can turn into stabs and dashes and become dotted lines.

95

Willows in Springtime

Remember how on a special day the sun was sinking in the West against a never to be repeated backdrop of continually changing emptinesses, deep on deep; and the clouds were hanging magically in the firmament with a mysterious feeling of the shutters falling on the vanishing day, tiny twigs trembling and pointing upwards and sprouting with buds, and every bud glittering with tomorrow and becoming springtime. That was the day you had no equipment and frustratedly tore open a matchbox and, with the fudgy marks of a spent match, captured enough information to help you make a drawing from memory at home. Better equipped this time, draw the tree trunks in stages. The big, sharp, close, bright, willow buds are bursting from the yellow, red and green heart shapes to let out fluff, the pussy willow of early spring. A close view of a bud is really surprising; the bursting life is clear. Little dots suggest the thousands of new leaves, seagulls and insects. Tufts of grass may be fluffed with the side of the pencil. Merely moving the pencil up and down will make grass. Pick a leaf to see how it grows. Crumpled lines make last year's dead leaves at the base of the tree. Between the trunks are the houses, contrasting with the twigs making their rhythmic, seasonal, daily pushes up towards the sun against gravity, thicker at the base, thinner towards the sky. The drawing below incorporates a tree trunk in two stages. The one on the right has been modelled more than that on the left.

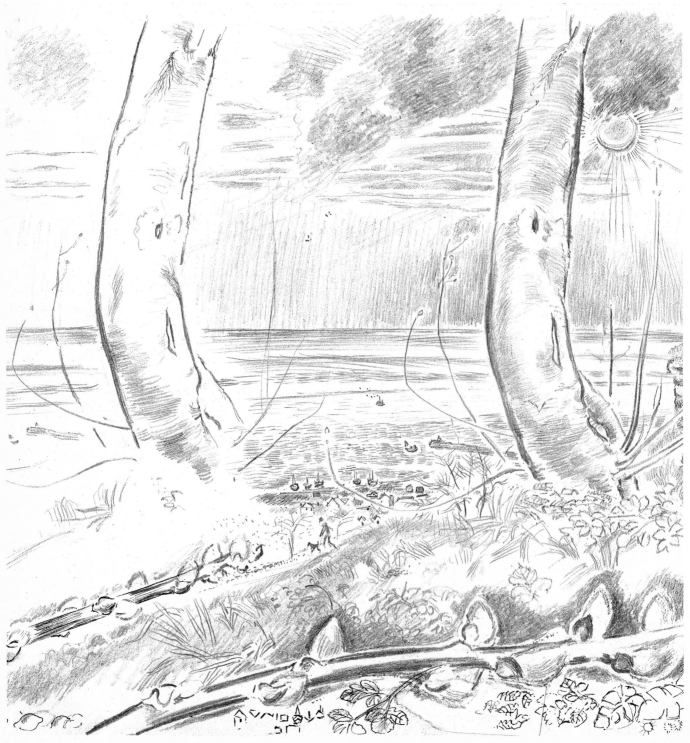

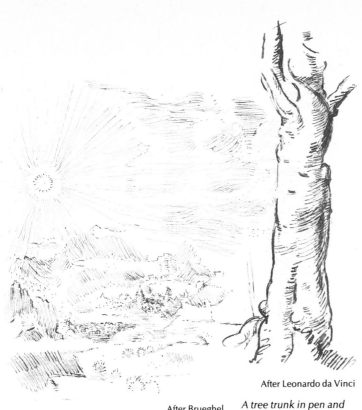

An unfolded matchbox. The serious draughts-man is equipped with poacher-sized pockets and small books, a tiny box of watercolours and a small bottle of water.

A tree trunk and sun, drawn with a spent matchstick. It is amazing how much can be done from a scraping of this kind. The activity of marking causes you to memorize.

A tree trunk. It is more complicated than either the Seurat or Leonardo trunks. Without summer leaves it is simpler to see the structure of a tree. Lichens and crevasses on the tree trunk can be drawn the same size as distant trees, boats and men. The scale is exciting.

After Seurat

Points fashion the measured shape of this study for "La Grande Jatte".

After Leonardo da Vinci

After Brueghel

A sunrise. Copy the tiny marks which lead the eye landmark by landmark to the end of the land, hatching the mountains delicately. Follow the rays to the sun.

A tree trunk in pen and ink, rounded as a figure. Make it robust, with firm sectional hatching and strong outlines.

After Brueghel

A diagram of a cut tree showing its medullary rings.

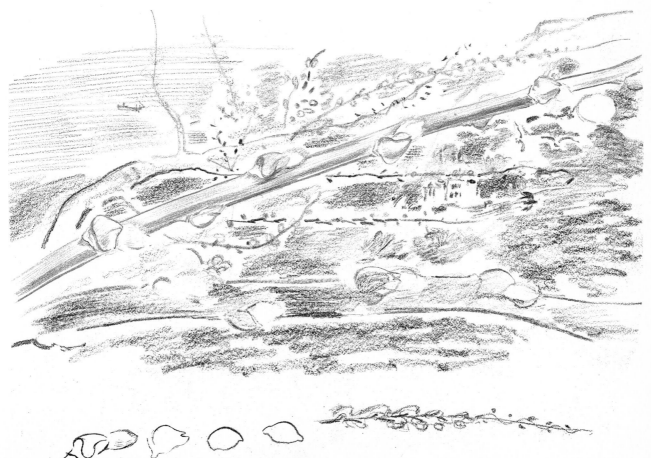

A fishing boat and Hastings harbour with twigs. Use pencil and litho-graphic crayon. The diagrams suggest lozenge or lemon shapes and the progressions of alternating buds on a willow twig. Draw different sized buds ending with dots.

Horse Chestnut Buds

The English village chestnut tree is full of lore. While sweet chestnuts are roasted at Christmas, horse chestnut buds are becoming sticky, brown and shiny as toffee apples. It is a flowery, billowy, pretty, leafy-fingered tree. Its pink and white spikes point upwards like candles on a cake, to become prickly conkers in autumn. It is like having a landscape indoors to draw vases of buds against a window. In a warm, sunny room the buds' bursting time is spread. It is like experiencing two springtimes. Begin with the early-flowering jasmine.

Nut-shaped

Rounded triangle

A Turkish arch

The spaces between buds resemble hour glasses and diabolos.

Buds in winter are balls, tight as nuts. They are built to withstand the coldest weather.

In April, a softer bud is allowed, complicated as an Islamic dome, a beetle-shaped and faceted ogee.

A triangulated circle, supported on an upside-down top to the Parthenon, perched on the electric socket where last year's leaf plugged in. Already the broken heart from autumn on its lost leaf is manure.

The tightest packages sprung for bursting, buds are bombs time-triggered to go off in spring. Draw the buds. Arrange to have several at different stages in a vase, the twigs broken or wedged to point as they did on the tree. You can almost see them moving on a hot day. Draw a lot of buds. Fill the page with buds. Draw a bud every six minutes. Like buds bursting on a tree, you will have twenty in two hours.

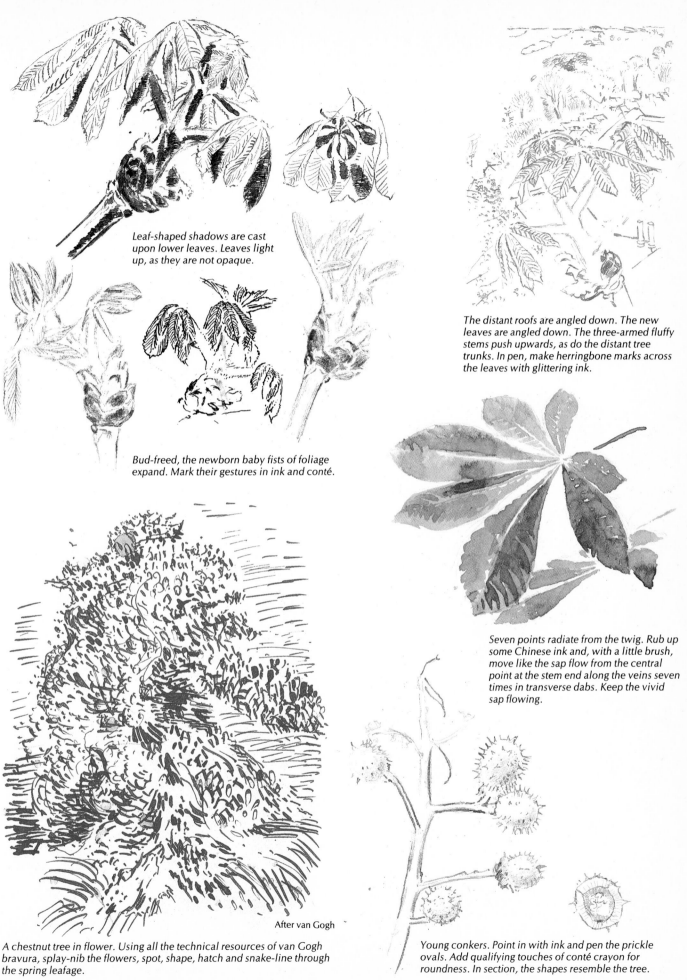

Leaf-shaped shadows are cast upon lower leaves. Leaves light up, as they are not opaque.

Bud-freed, the newborn baby fists of foliage expand. Mark their gestures in ink and conté.

The distant roofs are angled down. The new leaves are angled down. The three-armed fluffy stems push upwards, as do the distant tree trunks. In pen, make herringbone marks across the leaves with glittering ink.

Seven points radiate from the twig. Rub up some Chinese ink and, with a little brush, move like the sap flow from the central point at the stem end along the veins seven times in transverse dabs. Keep the vivid sap flowing.

After van Gogh

A chestnut tree in flower. Using all the technical resources of van Gogh bravura, splay-nib the flowers, spot, shape, hatch and snake-line through the spring leafage.

Young conkers. Point in with ink and pen the prickle ovals. Add qualifying touches of conté crayon for roundness. In section, the shapes resemble the tree.

99

Rich, Leafy Parkland

Soft pastels, compressed and natural charcoal, lithographic crayons, soft 6B pencils, all black media, smearing, crumbling, rich and dark, move over thick, rough, expensive, hard-surfaced watercolour paper leaving clouds of sparkling leaves wherever they go. Art delighted and swelled the pride of rich men of the eighteenth century who employed landscape gardeners such as Capability Brown. Brown planted trees, moved hills, spread earth, dug lakes and marked the sunset horizon with antlered deer which Turner depicted so romantically. Draw some parkland – the trees, pompous and round, or round and slightly flattened at the top, or toppling and glittering around boughs. Horse chestnut, beech, poplar, graceful ash or stout oak, each nibbled by animals to an equal altitude. Draw in sunlight the long cast shadows crossing sheep, grasses and thistles and entering the lake.

After Corot

Corot used tone values with sensitivity. His graded contrasts are secure in space. One of the first to work frequently in the open air, he influenced Pissarro, Cézanne and Monet and was admired by Braque.

After Corot

A romantic evening silhouette. Corot looked at his motifs by moonlight to help him see them simply.

After Cotman

Use a conté crayon on rough paper and watch the sun-drenched pointillism happen. The rich trees are thick with foliage; horses, sheep and cows have eaten the lower leaves; their horizontal bases are parallel to the deep, dark horizontal shadows cast between them.

Cotman probably used a metallic lead pencil. Certainly his darks are darker and less shiny than graphite. Even if the subject was not landscaped, it resembled a Greek sacred grove. (The period was fond of classical allusions.) I used a carbon pencil for the copy.

The landscape which was the site of the Battle of Hastings, with Battle Abbey in the distance. The beech trees cast dark shadows in the moonlight. Conté crayon, white and black ink were used. Ingres paper was given a wash of dilute Chinese ink. The darker textures are supported on the grey wash. The opulent embellishment can only be achieved on larger surfaces. The exceptions are the small, moonlit enchantment pictures by Palmer or the small landscapes of Rouault.

Charcoal swishes to look like strokes of paint. If it is sharpened, it can make tiny, fragile marks and with a cloth it can be blended or removed; it can be drawn into with a putty rubber. Matisse would be forever wiping and redrawing in his search for the right image. This drawing from a sumptuous river landscape overhung with large leaves exploits the medium to the limit. Charcoal, in its dryness, almost seems to dissolve into brushwork. If you draw with it out of doors, take fixative with you and spray by instalments. Remember that charcoal is special; it guards against niggling.

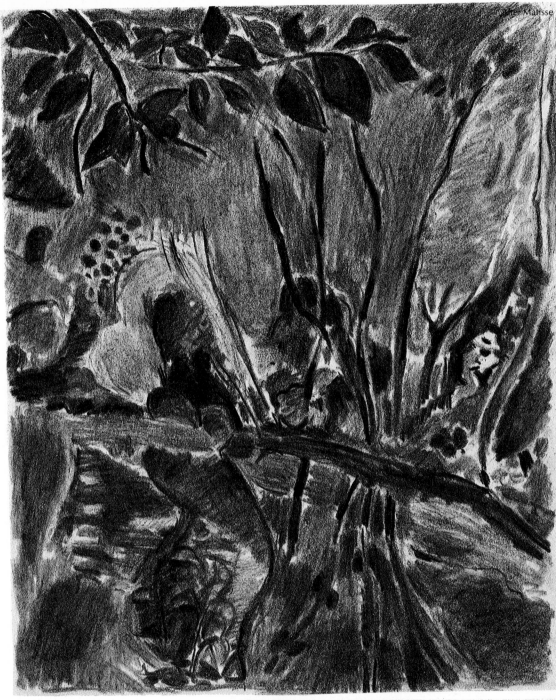

After Matisse

Other textures using charcoal for quick chiaroscuro, below. Experiment with complicated patterns: dab, dot, rub with a finger, hatch, shade, erase with a putty rubber.

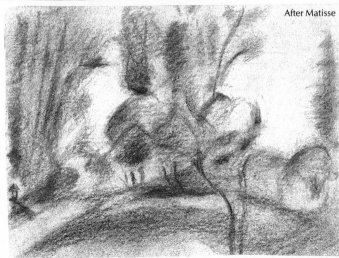

After Matisse

The charcoal was used very broadly. The lavish sweeps make pompous vase shapes out of the trees.

Gardens and Grasses

In winter, the garden of mud and straw seems an impossible place ever again to become a flower-filled delight. Yet the seedsman's garden plan is insistent: here will be lupins, there a lawn, here lobelias and there tall hollyhocks. Scented, bee-humming and hot it will be. The plan names the plants and, as prodigally, van Gogh draws them like a calligraphic tabulation of vegetation. Sometimes he puts cornstalks at the front of his drawings, sometimes irises; always there are wonderful invitations into the middle distance. The foreground of a drawing may be a piece of a large item. In such cases it is usually better for it to be easily recognizable (although out-of-focus photography has accustomed us to quite large areas of "blur"). Blur can occur when wind blows grass or when it is seedy and fine in the middle distance. It is essential to find a way of producing blur efficiently. Hatching is an obvious way; using a dry brush is more hazardous; a pen stroke smudged with a dry finger is taking a chance but good; a wet finger is even more hazardous; dotting and dashing can make grass hum with insects. Tiny marks and flowers in foregrounds can give immensity to large pictures. Titian's "Bacchus and Ariadne" has tiny flowers in the front.

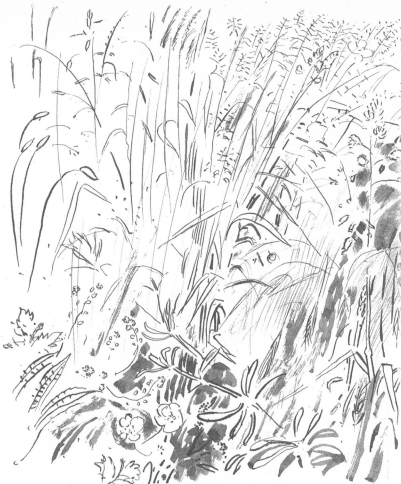

Cowslips, violets and daisies. Meadows are full of marvellous flowers which, placed close in the foreground, will make distant subjects sparkling and new. Use a pen with diluted ink to explore the abundant surprises of the new growth.

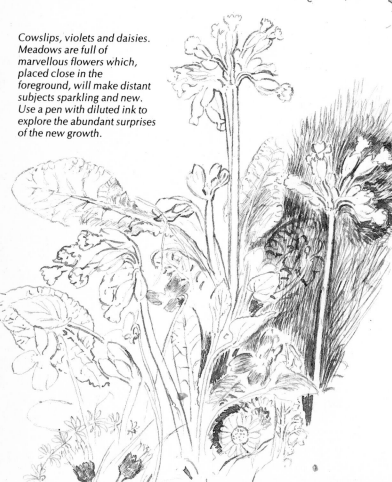

Grass covers the earth in winter. In spring it surges upwards, rich and green. The luxuriance is an invitation for every dog, lamb, horse or child to roll on it. Hay fields fill with grasses, high as knees, high as thighs, high enough for insect-worried love. The tiny, seedy grasses soften the edges of everything. The meadows breathe the perfumes of summer. Draw with diluted black ink, mapping pen and a brush. Van Gogh wrote a letter to his brother Theo describing the life of a Japanese artist: he studies a single blade of grass; this leads him to draw every plant, then the seasons and wide views, then animals, then humans — and life is too short to do the whole.

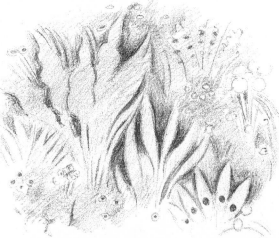

After Fra Angelico

The plants in this detail from Fra Angelico's "Noli Me Tangere" have a serious purpose in setting the mood of the picture. The formalized leaves have large dots suggesting stigmata and are placed close to the feet of Christ.

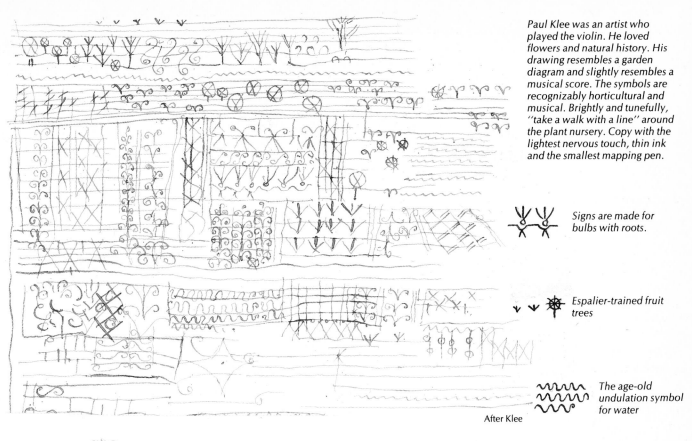

Paul Klee was an artist who played the violin. He loved flowers and natural history. His drawing resembles a garden diagram and slightly resembles a musical score. The symbols are recognizably horticultural and musical. Brightly and tunefully, "take a walk with a line" around the plant nursery. Copy with the lightest nervous touch, thin ink and the smallest mapping pen.

Signs are made for bulbs with roots.

Espalier-trained fruit trees

The age-old undulation symbol for water

After Klee

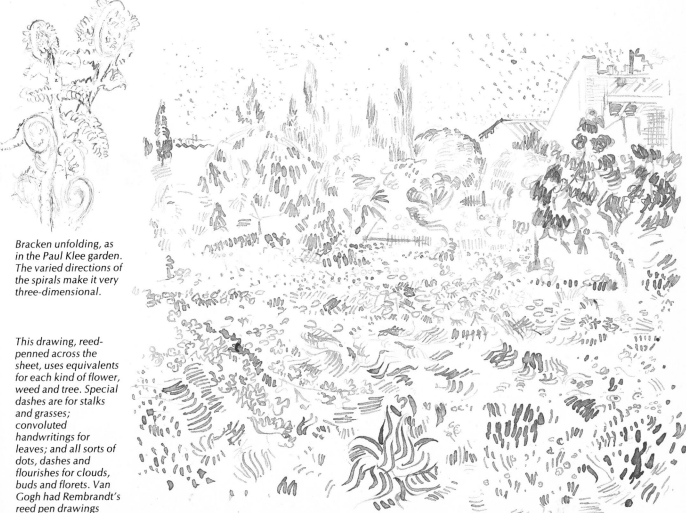

Bracken unfolding, as in the Paul Klee garden. The varied directions of the spirals make it very three-dimensional.

This drawing, reed-penned across the sheet, uses equivalents for each kind of flower, weed and tree. Special dashes are for stalks and grasses; convoluted handwritings for leaves; and all sorts of dots, dashes and flourishes for clouds, buds and florets. Van Gogh had Rembrandt's reed pen drawings constantly in mind.

After van Gogh

Gardens and Wild Flowers

The wistaria in a corner of a sunny garden makes summer breathtaking. Try not to "capture" it or "master" it as some "how to draw" book might urge. Breathe evenly in and evenly out and, with an ink-filled pen, sitting in a comfortable chair, become free of preoccupations, free of spasm, with the best smooth writing paper you can buy. Make only as many strokes as you wish for in its presence. Few or many. The relaxation I suggest is not an invitation to sloth and laze. Real relaxation releases a natural intuitive receptivity, which makes drawing happen without effort.

After Bellini

At the bottom of an extremely violent picture by Bellini, a small, fragile buttercup is placed as a witness and a foil. The lower leaves are made as simple bars. Buttercup leaves are actually very complicated.

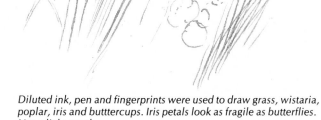

Diluted ink, pen and fingerprints were used to draw grass, wistaria, poplar, iris and butttercups. Iris petals look as fragile as butterflies. Use a light touch.

Buttercups – draw their hazelnut shapes with swelling nib lines.

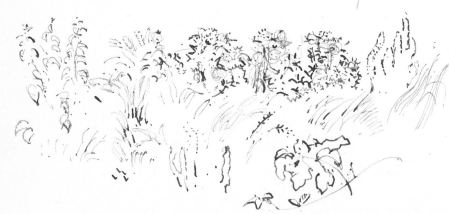

Scribble thistles, docks, nettles and grass. Try to prevent your natural sense of design from making it neater than a weed patch.

Draw with a sharp pencil the acanthus-like buttercup leaves. Convolute both petals and leaves in a similar way.

Language of Trees

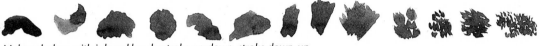

Trees affect us in many ways. When a tree is felled, we fall with it like a heart thud, and its buds, twigs, bark, birds, squirrels, leaves, spiders, woodlice and ants are unbalanced. To find the kinds of expression possible, make blurs and blots with a brush. They quickly resemble trees. Their meaning will depend to some extent on how seriously you do it. Draw and scribble your way through the succeeding pages. Pen-scratch at the thorns – they scratch back. Tear into wet paper with Indian ink for the wind-torn bushes. Solemnify with a pencil the tall melancholy of dark trees, and for death make deep cones of darkness. Next, draw with security plain and simple trees. Stand tiptoe and limn lordly, dignified trees. Leave the earth and aspiringly, with a watercolour-filled brush, draft graceful, lyrical trees. And then, as a happy coda, splash in speckled, twinkling Impressionist trees, full of sunshine; and play with gay pineapple-sprightly palm trees, nutty and bright in Hawaii or nicely shaking at the water's edge in Nice.

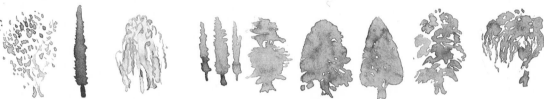

Make splodges with ink and brush: stroke up-down, stroke down-up, finishing with broken spotted splodges.

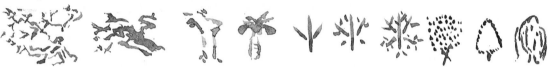

Dapple for birch; spear-dab for poplar; pen-hook and wash for willow; and continue stroking in hornbeam, horse and sweet chestnut, alder, sycamore and willow.

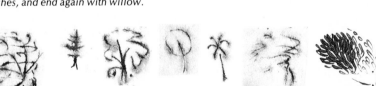

Try marks for wind-torn tree trunks. Three strokes make a tree. Add marks and more marks, then dots, then dashes, and end again with willow.

Little strokes and pen scratches using diluted ink will make fir trees.

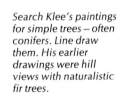

After Matisse

A thick nib and dark ink will make bright contrasts.

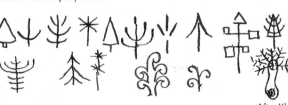

See how pen strokes dissolve and spread on wet paper. End with a splayed nib.

Search Klee's paintings for simple trees – often conifers. Line draw them. His earlier drawings were hill views with naturalistic fir trees.

After Klee

Botanical books of trees show characteristic silhouettes. But each tree is individual and changed by crowding. Sketchily diagram them so you can recognize them.

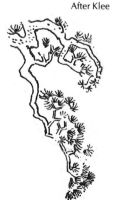

After the Chinese – contortioned, the twig thickness diminishes at each turn.

Stroke-wash, over a splayed nib, lines to make four different kinds of elm.

105

Trunks

When you draw a tree trunk you will probably think of it as being like a human torso. Frazer's *Golden Bough* is full of reasons why you should. Trees are archetypes and overspread us and outlive us. When trees are together at night in a forest, their writhing roots are monstrous and their branches are like great arms ready to crack or split us. Tolkein's trees move in the ground. Hollow trees are spirit exits. The White Goddess is in the hawthorn. The man tied or nailed to a tree images the crucifixion of Christ. Whatever the way you eventually draw trees, you will have to come to terms with anthropomorphism.

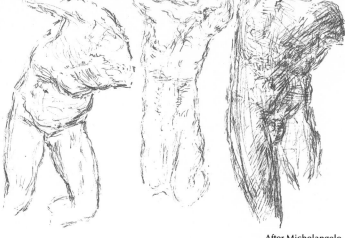

After Michelangelo

After Leonardo da Vinci

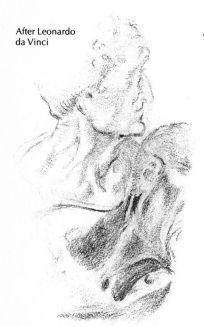

After Brancusi

A three-cylindered male figure is trunked like a tree.

Scratch with a mapping pen to build bodies solid and wild enough to look treelike. He did not paint landscape much – but copy the Tree of Good and Evil in "Adam and Eve" in the Sistine Chapel for a fine snake-bound bole. Sculptors break off limbs as ruthlessly as the winds break off the boughs of trees.

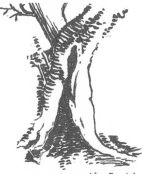

After Bewick

With conté crayon, model these necks which seem rooted into the shoulders.

Pen an eerie, hollow tree opening shaped like a witch.

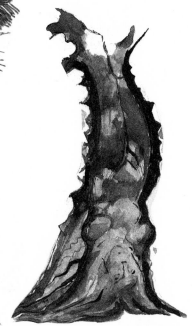

After Blake

Draw with brush and pen the storm-torn tree changing to the form of berserk Cain.

After Blake

Using watercolour, brush and a pen, draw Dante's self-murdered woman upside-down, transformed into a tree thorny with anguish.

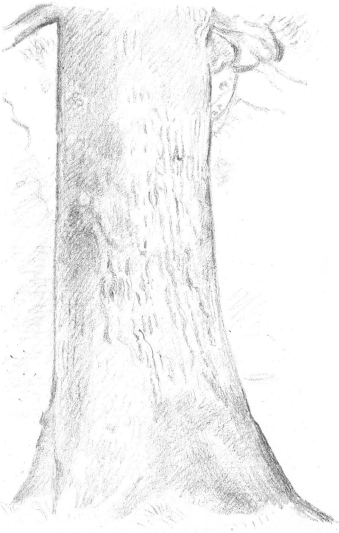

After Constable

Use a medium pencil and copy carefully. It is a substantial confrontation, as with a health-filled torso. The little marks and hatchings make a simple, honest body of wood – firm, strong and true. Constable's was a time when ships and floors were planks and his father's windmill would have been built around a whole tree trunk.

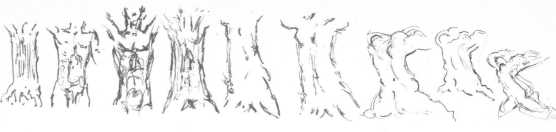

With a pen, try transforming a tree trunk into the body of a young man with raised arms, changing into a tree woman who, blown by a storm wind, becomes a tragic-acting woman.

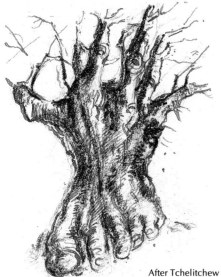

After Tchelitchew

A foot toeing its way into the earth and becoming, with no transition, a grotesque, twigged hand. Make worried markings with a carbon pencil at this itchy image by the Russian-American artist.

After van Gogh

Van Gogh's peasants are made, as are Millet's, to appear rooted in the soil. Like his paint marks, your black pen marks can move like ploughed furrows up the body, a pattern like bark. Maintain the contained toil and energy.

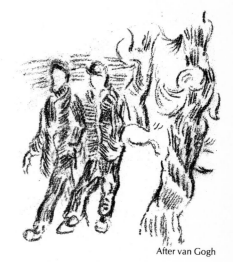

After van Gogh

Copy with black chalk. The figures are rhythmically hatched and marked in ascending zigzags in almost the same manner as the tree trunk. It is a drawing of energy – the Tao, the flux, the life force.

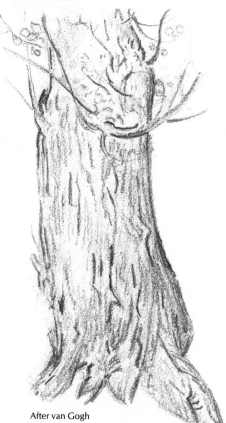

After van Gogh

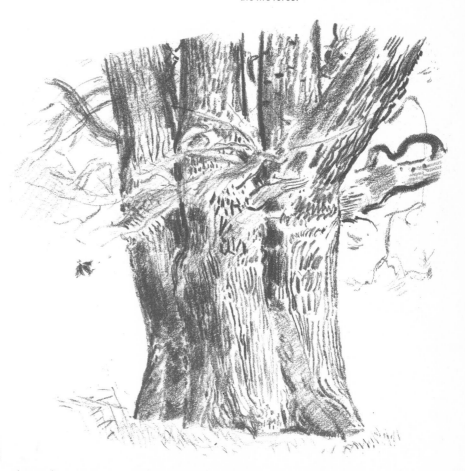

Make angular stabs with black chalk. Compare it with the Constable. It is more vivid and urgently desirous of the sun. The artists' temperaments were very different.

After working at so many transformations I drew a tree directly from nature, resolving not to let a body image intervene. I would not anthropomorphize. The tree is a tree is a tree (Gertrude Stein, remember, insisted "a rose is a rose is a rose"). The result, made of marks, zigzags, lines, hatchings, stabs and strong vertical pushings made up the tree. Its main trunk seemed humanized again!

Trees for Harshness

Although assembled purely for defence, as they say of a jet fighter, thorns in art are cruel. Draw rose thorns. They are made with surgical instrument refinement. Be sure-handed and, with severe concentration, make the stem hard, the thorn base harder and the point of the thorn sharp as a fish hook. Think in terms of triangles, and triangles with tweaked points, and watch the spaces between the tweaks. Leave a little halo around each point. This makes it look sharper. Maintain the long line of the stem, padding out the background to make the rising shaft visible. You will not find it easy to draw the thorn which points directly at you.

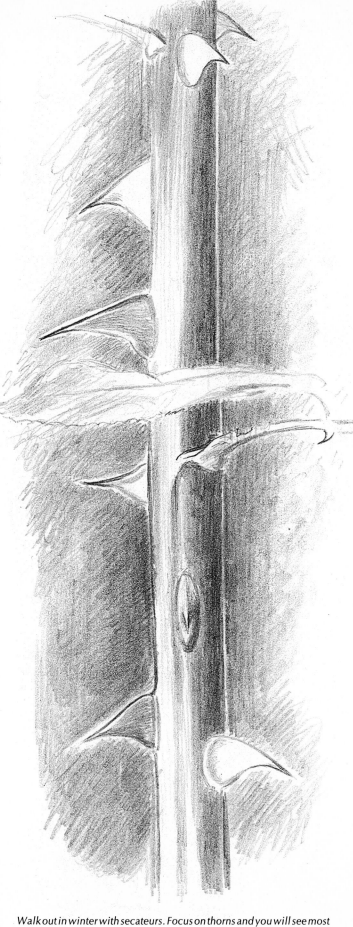

After Dürer

Dürer made this mountain tree as graceless as possible – itchy, worried and unpleasant.

Distinguish between the sharp spines and the plump flesh as you draw a cactus.

Using a pen like a brush by splaying the nib and filling the marks with extra ink, make the blackthorn spines sharp.

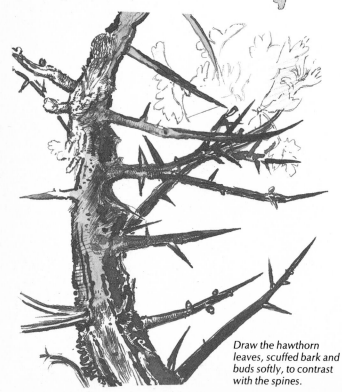

Draw the hawthorn leaves, scuffed bark and buds softly, to contrast with the spines.

Walk out in winter with secateurs. Focus on thorns and you will see most surprising hooks and spines in every direction. Practice drawing thorns. They look wild and fierce, as if determined to fight back at keen winds. Draw their silhouettes to make a winter sunset, wild as a skirl of bagpipes.

After Santi

Draw these beautifully entwined snakes of cruelty with a pen.

After Antonello da Messina

Antonello learned something about cruelty from the Flemish. Draw with a mapping pen and black ink, making the thorns curve smoothly.

After Fra Angelico

After Grünewald

Grünewald's Isenheim altarpiece with its grisly imagery was an influence on the Crucifixion painted for Northampton church by Sutherland. The thorns are made for real scratches and are less ornamental than those from Italy by Fra Angelico.

The "Genius Loci" of Paul Nash

Paul Nash was a poetical landscape painter in the English watercolour tradition of Cozens, Cotman, Girtin and Turner. He absorbed the simplifications of Léger and had a delicate feeling for the "genius loci" in England, where a strangely shaped tree stump, blasted by lightning, or the surprise of unexpected views of the sea would generate surrealist poetry. Sometimes he would write it, sometimes paint it. The larger figures of Samuel Palmer and Blake overshone him.

After Nash

Drawn from a Nash photograph of a ravaged tree root. Copy with a pen and black ink and sense the tortuous death-throe writhing of the cadaver.

After Nash

Nash was affected by Surrealism and found fallen trees strange, dry and dead.

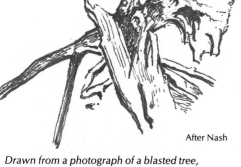

After Nash

Drawn from a photograph of a blasted tree, taken by Nash. He may have remembered the broken trees of wartime. Certain places and forms had a haunting presence for him. With a pen and ink, draw its splintered agony.

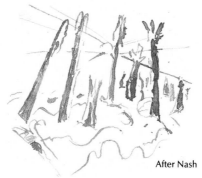

After Nash

Nash would sit with shells bursting around him, drawing the sun sinking over churning mud and barbed wire.

After Nash

In the First World War, trees were torn by shells to stumps with tatters for branches. Their maiming symbolized all that was against life.

Graham Sutherland's Thorn Trees

The Second World War made all the world look vicious. Sutherland did drawings of wind-torn hawthorn trees in Pembrokeshire, Wales. He called them "thorn trees". He knew of Blake's illustrations to Dante and the cruel Crucifixion by Grünewald and the unusual Crucifixion by Picasso. The thorn trees were trees from which crowns of thorns would be fashioned.

After Sutherland

Trees that look as if maimed by a weed-killer.

After Sutherland

A monstrous, cadaverous tree. Draw it black like an etching.

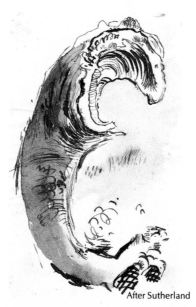

After Sutherland

Draw with pen and wash. The tree bole has been struck by lightning or otherwise cruelly tortured. It seems to howl with suffering.

After Sutherland

Sutherland exchanged his etching needle for a sharp nib, and scratched thorns. Copy this tree with sharp cutting marks and jagged, painful stabbing marks.

Trees for Sadness

Winter oak, cedar, yew and the myth-haunted cypress can be slowly brushed in with dark watercolour or ink. Like the dark keys in music, the dark masses of drooping foliage are used to contain our sad thoughts. The pointed evergreen trees are charged with Romantic mystery. They make up the terrifying wolf-ranged forests of the North, the chill splendour of the "Grand Tour" Alps drawn by Turner, and stand in many grand landscapes. Cézanne succeeded in eliminating the folklore to make strong art from the conical structure of the fir. Altdorfer used dark, complicated evergreens chillingly. Van Gogh's mental torments found expression in the writhing shapes he made from his pine trees. Draw these different trees to experience the varied ways trees can encourage a sad composition.

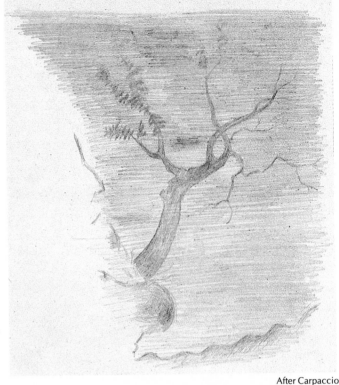

After Carpaccio

This "Agony in the Garden" tree grows from the rock and overhangs precipitously. On the side where Christ prays a few leaves grow. The leafless branches and twigs are carefully composed and resemble cracks in the dark sky. With a pencil, hatch the sky horizontally and draw the twigs clear, sharp and painful, like black lightning.

After Poussin

The most doleful tree in art, from "The Deluge". Lichens and tree bend or hang over a precipice in misery. Copy with conté crayon.

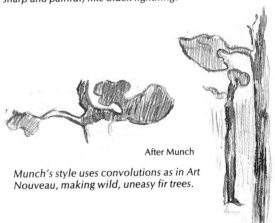

After Munch

Munch's style uses convolutions as in Art Nouveau, making wild, uneasy fir trees.

After Baldung Grien

This skinned, torn tree is the Crucifixion tree in a pietà. Its companion has a horrible wound in its trunk and entrail-like forms are visible within. Mountain trees are often wet and straggly. Lichens hang from them like seaweed.

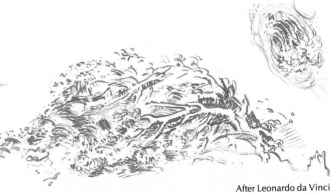

After Leonardo da Vinci

These storm-tossed trees from Leonardo's drawing of the "Deluge" are torn like the dissected arteries of men, the flow of growth seen as from the eye of a storm. The eye was that of a great anatomist.

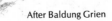

110

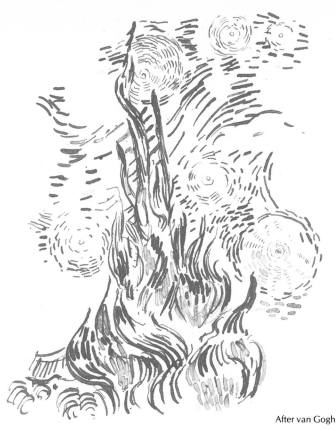

After van Gogh

Rub up some fresh Chinese ink or use other diluted ink and, with a Waverley or other flexible nib, follow the flame-like rhythms of this splendid drawing which crashes dash-drawn concentric lights of stars into the struggling flame shapes of the cypresses.

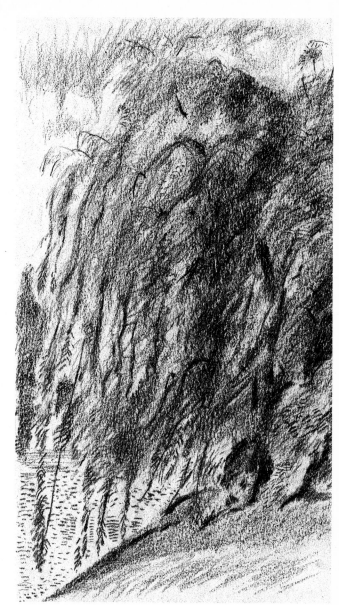

The weeping willow is not as sad as its name suggests. It is saddest in autumn. See that the leaves, wavelets and twigs are differentiated. First let it be merged and shaded as fusion without confusion. Then do a glistening cascade, a green fountain of willow.

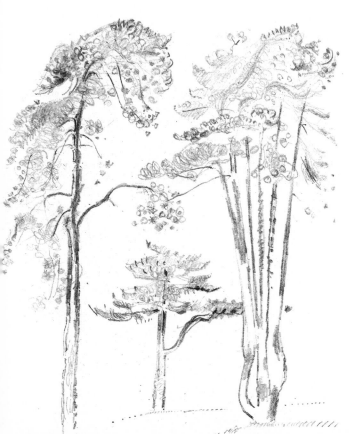

After Böcklin

Soft-pencil-draw fir trees. Sense their vigour. Using dots, circles, conic scribbles, hatchings, tough lines and jerks, embellish their stately verticals. Move your pencil through the needled structures like a crow making a nest. The descending branches will be the sad ones.

Copy with a charcoal pencil the dark sentinel evergreen trees of Böcklin's "Isle of the Dead".

Drawn from a photograph of the cypresses at the Villa d'Este. Cypresses seem naturally funereal.

Trees for Gaiety

In art, figures and backgrounds move against each other relatively. Wave patterns of foliage will alter the kinetic effect of a drawn dancer and, in turn, dancers' movements will change the apparent activity of a background. In the van Gogh drawing of men walking, their action is dependent on the wild tree trunk rhythms which urge them on. If you wish to test this, cover up the trees with blank paper and the figures become rooted to the spot. Palm trees grow in regions of hurricanes, earthquakes and volcanoes but tropical islands enchant us. The hula skirts of our dreams never chafe. Palms pleased Renoir, Dufy, Matisse, Gauguin and Winslow Homer.

After Dufy after Renoir

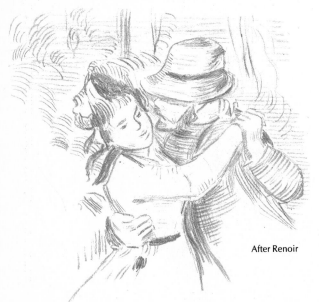

After Renoir

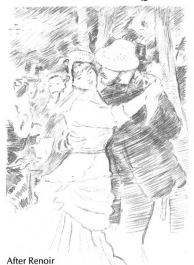

After Renoir

Dufy designed fabric, was a Fauve, practiced a decorative Cubism and made wonderful flurries with a freely moving brush. Only in France perhaps could so much delight be expressed in copying Renoir's great picture of good living. Renoir had painted porcelain. They both had at their fingertips brushes tipped with delight. Follow the delights with best red sables bound in quills, with flowing paint. Delight might be the accompaniment of trees. Dufy used colour brilliantly; unusually, he did monochromes in bright colours, sometimes about music.

Suzanne Valadon was the model for this lusty "Country Dance" painting. Copy Renoir paintings with a pen. The little curling brush marks translate into curling hatchings. Caress his well-loved world.

Draw with a mapping pen from Renoir's etching, using dynamic oblique hatchings across the drawing to make it move.

After van Gogh

Van Gogh's last drawings are frantic, exultant, urgent, at times even buoyant. The round rhythms you must draw with black crayon to be similar for both men and trees.

112

After Hockney

The adventure of visiting Los Angeles made these palm trees of vividly arranged brush strokes gay as daylight. Appreciate the intervals and hone the lissom limbs of the palms, edge-perfect as Egyptian inscriptions.

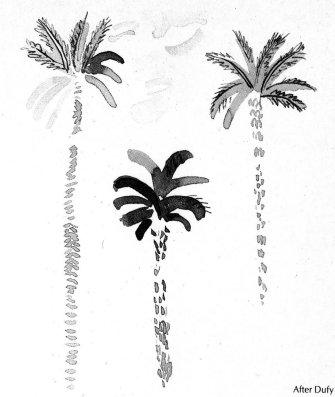

After Dufy

Dufy made super-class French confections of palms on palmy days to wave nicely all along the Côte d'Azur. Dab outwards with watercolour. There is no need to count the leaves.

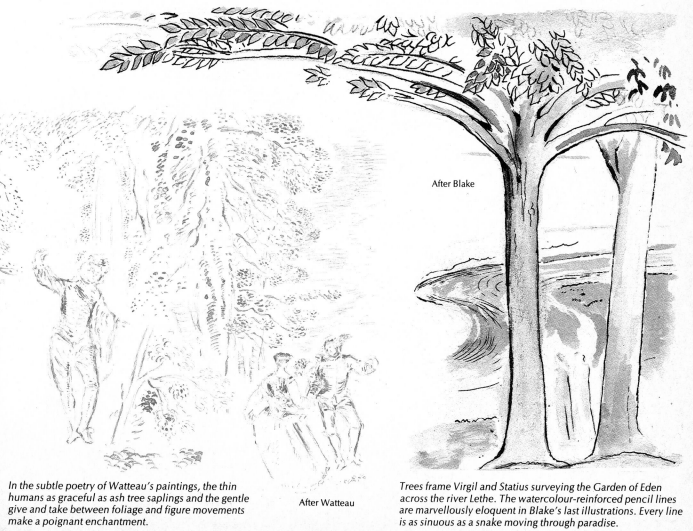

After Blake

In the subtle poetry of Watteau's paintings, the thin humans as graceful as ash tree saplings and the gentle give and take between foliage and figure movements make a poignant enchantment.

After Watteau

Trees frame Virgil and Statius surveying the Garden of Eden across the river Lethe. The watercolour-reinforced pencil lines are marvellously eloquent in Blake's last illustrations. Every line is as sinuous as a snake moving through paradise.

113

Autumn

All summer you sought true shapes for trees in full leaf. You watched the spaces between leaves with the alertness of a Japanese bamboo painter, making silhouettes as cleanly as Cotman, Hiroshige and Constable; billow-clumping leaves as roundly as Rubens; searching for spine-like trunks and twigs in the mass of green vegetation. Now it all falls around you – the winter rigours are past, the budding spring, the maturation of summer. Be comfortable in autumn. Take a folding chair into the woods. The wasps are too surfeited for stinging. Not too hot, not too cold, you will be softly sunned as the brown leaves fall across clouds. The fall sadness is suffusing like cellos. Breathe gently and flick in little marks with a crayon. Soon a leaf trembles on the paper. Drawing is a natural activity. Draw without effort. Use Ingres or pastel paper and with a soft, sharp carbon pencil draw the dry fallen leaf. Crackle it in. Bound around the acorns. Acorns make oak trees seem enormous. If you find the oak tree too large (it is fifty times the height of your paper, six hundred times the size of an acorn), draw the acorn instead.

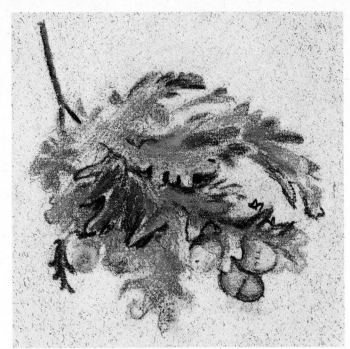

Take brown artist's pastels and with deliberation, on heavy buff Ingres paper, make the green vitality of summer retreat in each leaf, rough and dry. Clip the paper to a board and take a tin of fixative with you.

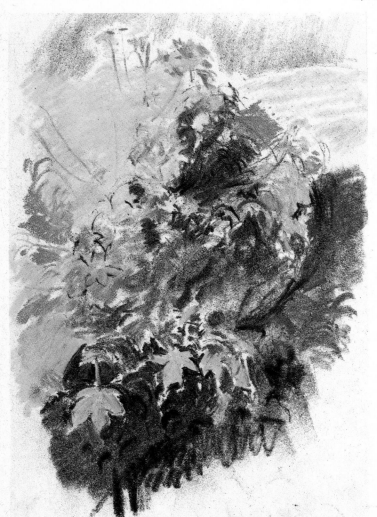

With pastel pencils, make last canary yellow chirps for after summer against some sharp deep greens. Fix between opposing colours where you do not want sullied colour. Experiment with umbers paired with cadmium and lemon yellows, with sparks of viridian for contrast.

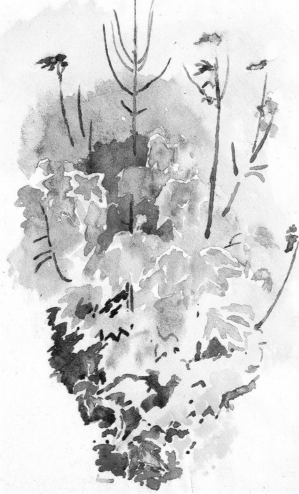

Take a sable brush and watercolours. Sycamore leaves occur if you spill viridian into the centres of warmed, lemon yellow leaf shapes. Draw the twigs and cut in the leaf edges with viridian dulled by mixing with Indian red. Watch the intervals.

Draw your apple-full tree, there in the garden, gleaming, glowing, tempting. A golden paean of praise, summing up summer, reflecting in spherical opulence the lower suns of autumn. Its greying billows of leaves are like beds for fruity cherubs flown from a Rubens garden of love. Pastel pencils seduce the eye. Use no more than eight. Make a red mark for the edge of a rosy apple. Dab some orange against it. Fleck with yellow. Baste with dark green. Suppress with grey. Bite with black and with flourishes of soft greens to complete your gold-balled tree.

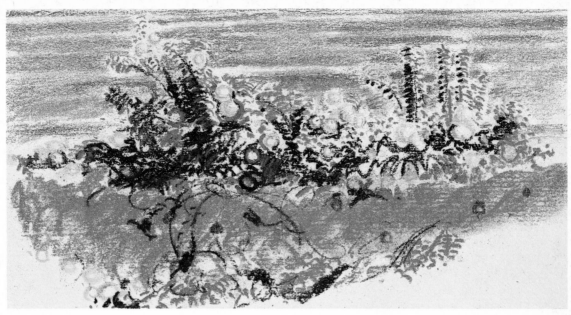

In the low evening sunshine, the twiggy baby larches lit from behind make an almost shadowless surrounding to your autobiographical shadow, mysteriously present and seeming more solid than the background. Use pale pastel pencils on grey Ingres paper, with light airy touches for atmosphere.

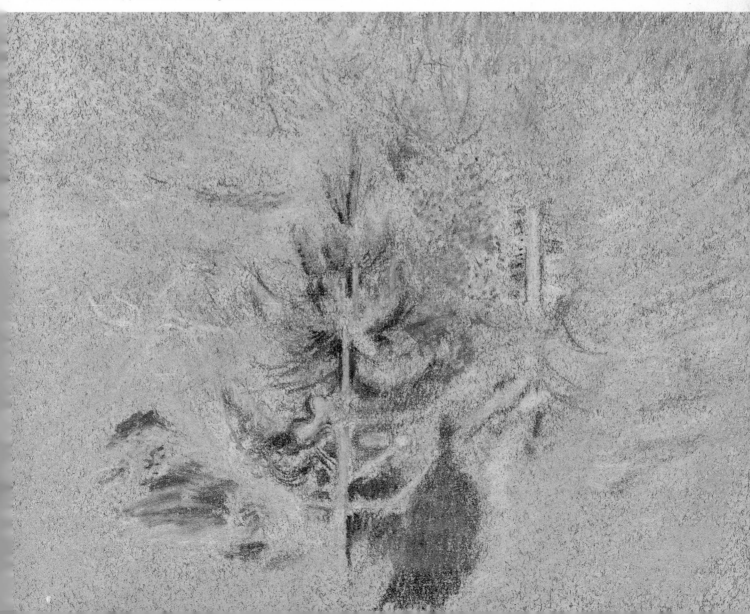

Spring Blossoms

The Japanese celebrate spring with a picnic eaten beneath flowering almond and plum trees. Their delight in the display of blossom after dry, dead winter was chipped out on wood blocks and then printed in coloured inks on thin paper. A bright commemoration of the event, it was pleasing to everyone. A true art for all, a substitute painting, the raised wood lines were made to resemble brush strokes. The prints were expendable enough to be used to wrap up goods exported to Europe. When they arrived in Paris they changed the art of France magically and, like biological washing powder, absorbed the browns of the academies. For van Gogh, the browns and bitumens of Rembrandt and of his teacher Breitner drained away as he looked at Impressionist colour and at the clear areas of colour in Japanese prints. He copied them and used them in backgrounds to test the purity of his new use of colour. His drawing also was changed. The imitation of brush marks in Japanese prints often resembled the marks made by reed or bamboo pens. Rembrandt had worked with reed and brush. Van Gogh loved drawing the orchards in different darknesses of ink and making every kind of pattern from the twigs, blossoms, gnarled trunks and grasses.

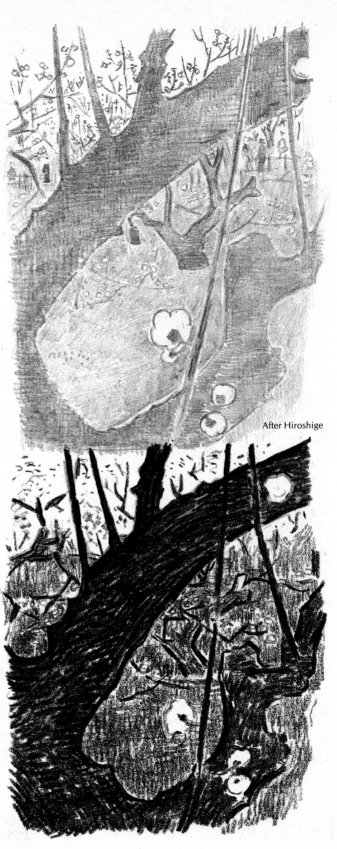

After Hiroshige

A sample of brush marks. They are not so much like the marks in Japanese prints as those in the sample below.

A sample of pen marks. These stabbing marks resemble the woodcut marks of Japanese prints.

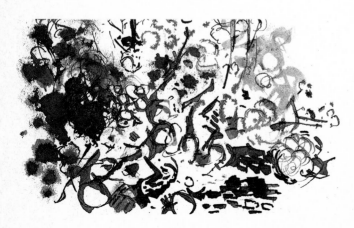

Sample marks and fingerprints in full strength and diluted ink, and lines drawn on wet paper. Try to find a technique to parallel the exuberance of spring. Samuel Palmer drew the abundance of orchards in Kent.

After van Gogh after Hiroshige

When copying Hiroshige, van Gogh roughs it up, making clouds of blossom for a background in place of the delicate Japanese gradations, fierce jagged marks and broken rhythms in place of the long perfected arcs of twigs in the musically enchanting design of the print. The roughing up was done for the same reasons as Rubens had for bloating a nude when copying a Titian. In both cases the artist wanted earthiness and presence. Van Gogh's impatient and urgent temper was also a factor.

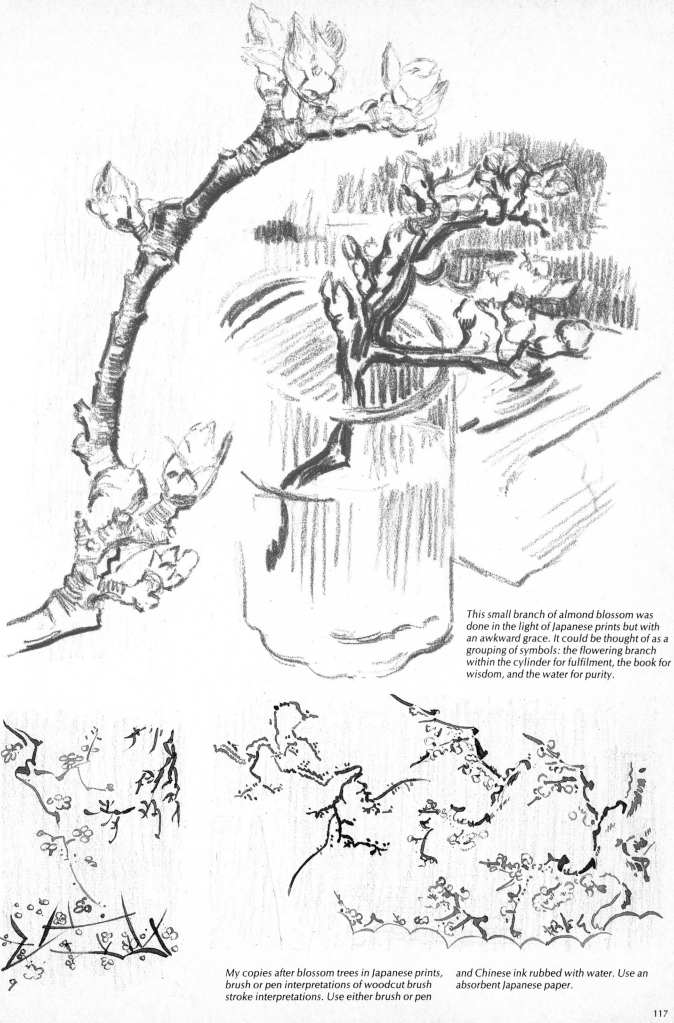

This small branch of almond blossom was done in the light of Japanese prints but with an awkward grace. It could be thought of as a grouping of symbols: the flowering branch within the cylinder for fulfilment, the book for wisdom, and the water for purity.

My copies after blossom trees in Japanese prints, brush or pen interpretations of woodcut brush stroke interpretations. Use either brush or pen and Chinese ink rubbed with water. Use an absorbent Japanese paper.

Trees and Happy Colours

Marks of yellow beside pale blue give, at a distance, a luminous grey.

Yellow and blue rubbed together give a green which is more subdued than either colour by itself.

Marks of yellow beside marks of pink will give a brighter orange than when they are rubbed together.

Pink and yellow rubbed together

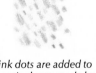

If pink dots are added to the optical grey made by dotting with blue and yellow, the grey will turn pinkish.

After Monet

Even when times are terrible, sunlight often makes people happy. The Impressionists believed that almost anything in the open air was transformed by light into a wonderland. They chose pleasant subjects. Monet used close tones and simple colours, juxtaposed rather than blended, to obtain daylight effects. Using pastel pencils in very few colours – derivatives of red, blue and yellow – copy the Monet trees above, drawing without much blending on a rough paper. Hire a punt or rowing boat, lie back on cushions and, beneath the willows, watercolour-in separated dabs of pure primaries, washing your sable in the sunny green water and glancing at the minnows beneath the waterlily leaves. Monet had a floating studio – a houseboat. If happiness results from working at what you want, then Monet was happy.

Red
Blue Yellow

In general, the primaries with white give off light and a feeling of happiness. Van Gogh was fond of primary colours, as were Monet and Pissarro.

Violet Orange
Green

Mystical artists seem to prefer this other triangle. Van Gogh used it for the "portrait" of Gauguin's chair – probably because Gauguin was a Symbolist.

R
V O
B Y
G

The two triangles together make up the spectrum. Violet is darker than red and red is darker than orange.

Transcendental Trees

Matisse cut convoluted seaweed or philodendron leaf shapes. The edges are long and "buzz" or react actively with the colours they overlap. Look at his *Jazz* (a collaged book) and at Middle Eastern books which might have influenced him, such as the palace album of Topkapi Sardy from Istanbul, with its virtuoso cut-paper design: "Moss Roses, Lilac, Tulips, Carnations, Violet and Blue Periwinkle with a Dancing and Singing Woman". Drawings with scissors are made of edges and adhesive. Pressed leaves are more distorted than we at first believe. Copy them and the different character of Matisse's flatness will become evident.

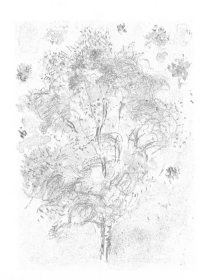

Birch trees have black on white bark, which has been used as a surface for drawing on. Their tiny leaves glitter through the summer brightly. Pencil-dot the foliage and watercolour-dot to make the shape. Poplars make a similar natural pointillism and on sunny days seem to vibrate with happiness.

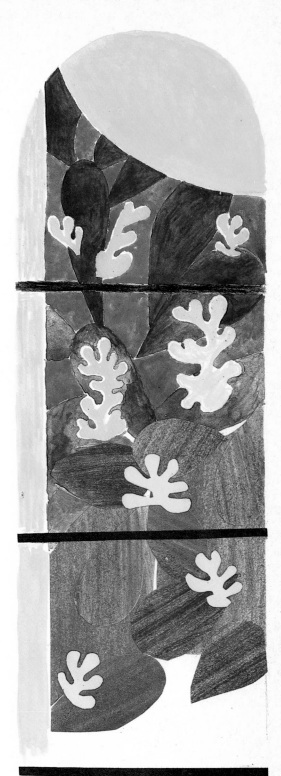

<div align="right">After Matisse</div>

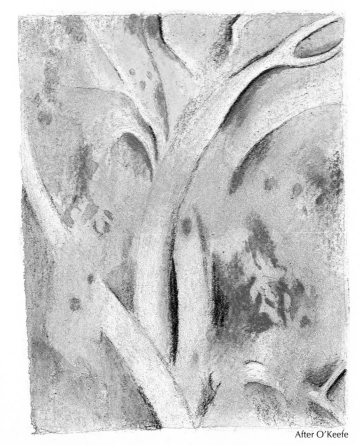

<div align="right">After O'Keefe</div>

Georgia O'Keefe saw the morning light making bright, white birch trunks resemble the bleached bones she liked to see and paint in the desert. The autumn leaves resemble the colour of rock and desert. The arcs oppose one another in the centre. Copy with pastel and watercolour.

A detail from the "Tree of Life" in cut paper, a design for the stained glass window in Matisse's Chapel at Vence. The pools of coloured light fall on the floor of the interior. The black of the brush-drawn ceramic mural, "The Seven Stations of the Cross" (also at Vence), acts as a foil, a marvellous extra colour, to the colours of this page, as does the small tree by Klee.

<div align="right">After Klee</div>

<div align="right">119</div>

Sycamore Trees

Sycamores have pale rough trunks and display abundant foliage. The leaf is convex at the stalk end, becoming concave towards the tips. The lively arabesque is repeated in the shapes of the foliage clumps. Draw them with a fine-nibbed pen and watered ink and let them flow in swoops. Trees have special characteristics of growth and shape. Once you have found their key shape, it becomes easier to draw them. The sycamore is more concave than the apple tree and the foliage is denser, making deeper shadows.

The swatches of lines rising diagonally thrash against each other to make active contrasts with the static horizontals and verticals of the ground and trunks. Use a pen and watery ink. Patches of shade and clusters of leaves make similar shapes.

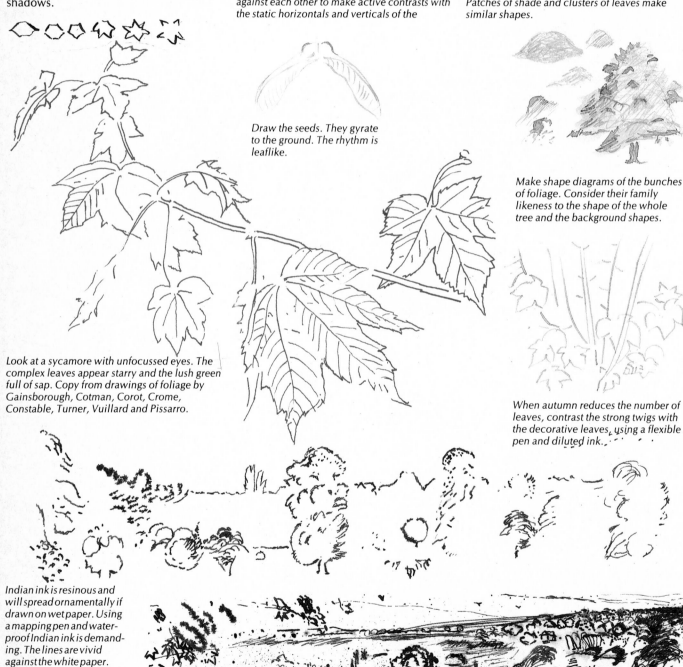

Draw the seeds. They gyrate to the ground. The rhythm is leaflike.

Make shape diagrams of the bunches of foliage. Consider their family likeness to the shape of the whole tree and the background shapes.

Look at a sycamore with unfocussed eyes. The complex leaves appear starry and the lush green full of sap. Copy from drawings of foliage by Gainsborough, Cotman, Corot, Crome, Constable, Turner, Vuillard and Pissarro.

When autumn reduces the number of leaves, contrast the strong twigs with the decorative leaves, using a flexible pen and diluted ink.

Indian ink is resinous and will spread ornamentally if drawn on wet paper. Using a mapping pen and waterproof Indian ink is demanding. The lines are vivid against the white paper. Graphic artists dot around their complicated subjects. Spattering can modify hard areas and give scale. Draw a distant landscape, picking out sycamores.

Apple Trees

The Tree of Good and Evil was a pomegranate, but in art it is an apple which Eve eats and which is the prize from the judging Paris. The apple tree is full of love and buds, blossom, apples and birds. It is not too big to grow comfortably in a picture. Draw it with Chinese paintings of plum blossom in mind. Be ravished like van Gogh by orchards. Flourish a wide-nibbed pen and grey ink among the flowering branches.

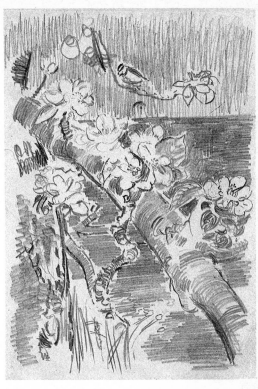

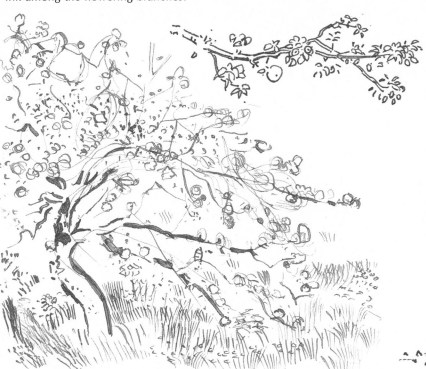

Tits and apple blossom. Move close until the flowers take up most of the paper. Use a carbon pencil on a smooth paper which has been coated with white watercolour. The granular dark hatchings will make the blossom luminous.

It is mysterious in drawing apple trees that an assortment of hooked lines will, if things go well and the touch is sufficiently urgent, be recognizable as an apple rather than a plum tree.

Something of an apple shape is felt about an apple tree, however gnarled its life in the weather has made it.

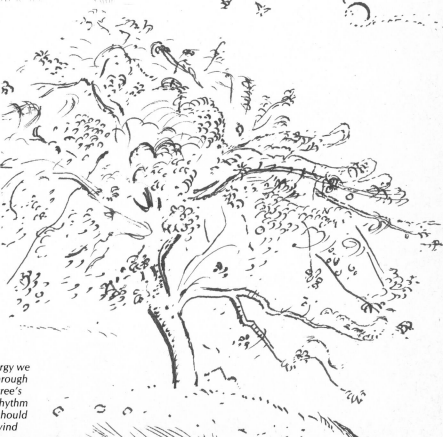

Rapid pen strokes made an equivalence for the energy we feel in the growing tree and for the wind blowing through it. The pen gestures you make should respond to a tree's resistance to the wind, its movements, the growth rhythm sensed through the trunk and along the twigs, and should also indicate with occasional swishes the gusts of wind across the leaves. Small birds should enjoy moving through the branches.

Sky

Look up at the limitless blue. TV provides a satellite view of sky, like foam on coffee – a view which would have intrigued Constable. He wrote about the weather on the backs of his oil sketches of clouds. The sky can be many things. A sheet of paper will be a featureless sky, a blue sheet a summer sky. Van Gogh sometimes painted skies green to match the fields. The direction and strength of the wind is a matter of life and death to hang-glider pilots as they hang and soar in the firmament. Their high-pitched colours, silky fabrics, glittering helmets, wires and shines, harmonize with the sky. To achieve depth in simple skies, birds, kites, insects, flags, smoke, aeroplanes, rain and rainbows can all be used to mark out spatial distances. Progressions of line, mark and size, tonal gradations and colour sequences can all help to make a small piece of paper suggest vastness. In art, clouds can be enormous vortices, as in Altdorfer, or very solid, as in Permeke. Turner used some of the tiniest touches in art and, with a fingernail and a sharp knife, made great depths with watercolour.

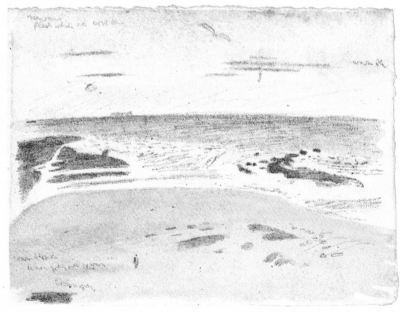

The thin stratus clouds hang over the sea like waves. The drawing was coloured in later with watercolour – the colours were written in on the drawing.
Commit the items to memory as you write in the colours. They can be the colours of paint or made-up descriptions, such as ''milky amethyst with flecks of bitter chocolate''.
Disciplined in memorizing, we only need to scribble and look, or just look . . .

A mixture of mackerel sky, cumulus and cirrhus clouds

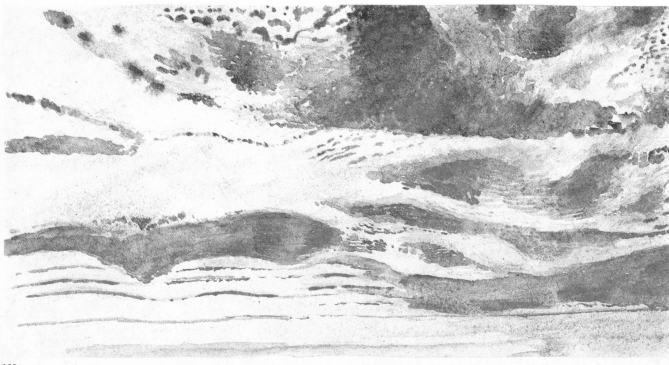

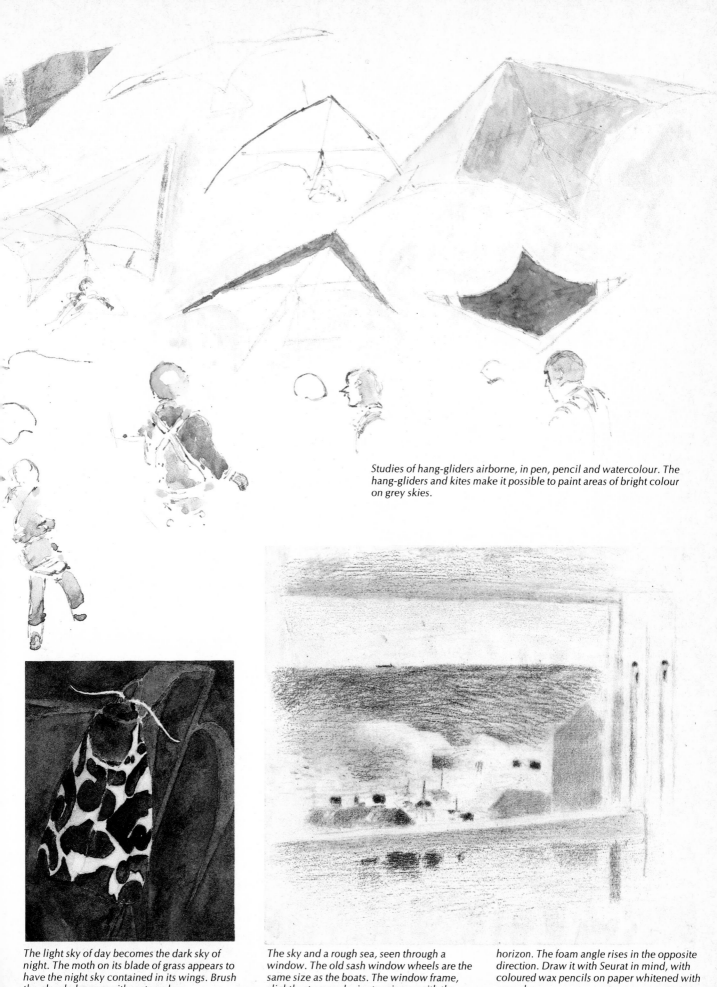

Studies of hang-gliders airborne, in pen, pencil and watercolour. The hang-gliders and kites make it possible to paint areas of bright colour on grey skies.

The light sky of day becomes the dark sky of night. The moth on its blade of grass appears to have the night sky contained in its wings. Brush the clouded moon with watercolour.

The sky and a rough sea, seen through a window. The old sash window wheels are the same size as the boats. The window frame, slightly at an angle, is at variance with the horizon. The foam angle rises in the opposite direction. Draw it with Seurat in mind, with coloured wax pencils on paper whitened with gouache.

Snow

When Richard Hamilton depicted Bing Crosby in his picture "I'm Dreaming of a White Christmas", based on a film negative, light and dark were reversed. Snow also throws light into unexpected places. Awake at dawn to all things strange: blanked windows, an overwhite ceiling, an apple tree mocking us with false blossoms of snow – its boughs of torn blacks looking like photographs harshly printed for advertisements, its twigs like solarized photographs. Snow leaves dark gaps or stripes where it has melted which resemble lines but which do not delineate. In this way a substantial house covered with snow might have a dark stripe crossing it. It looks light as a cloud and an actual cloud goes sailing by looking grey and heavy as a battleship. Snow is exciting. It makes puzzles and enchantment from what was usual. We look at lines which are not part of our style repertoire. White paper looks grey. The seagull usually camouflaged by its gentle gradation from grey above to white beneath is all dull against the bright snow. The first marks of a dark pencil make the paper full of snow.

After Hamilton

A film lead in an 0.5 mm clutch pencil was used to suggest the smoothness of a colour film negative. Draw the head of a friend sitting in the sun and lit by snow. Lighting from below is interesting. Experiment using a spotlight at floor level. The effect can be supernatural. Georges de La Tour lit his figures from strange angles, often using candle flames.

After Munch

Draw the apple tree at night. Walk into the dark orchard and memorize the strange flowers of snow supported by grotesque, dark clawlike branches. Black conté crayon was rubbed on the paper, fixed, and blobs of white ink were used for snow.

Copy the wonderful starlit snowscape with its writhing branch and shadow shapes – possibly the shadows of the artist and companions, like Art Nouveau phantoms – using conté crayon, black and white, on grey paper.

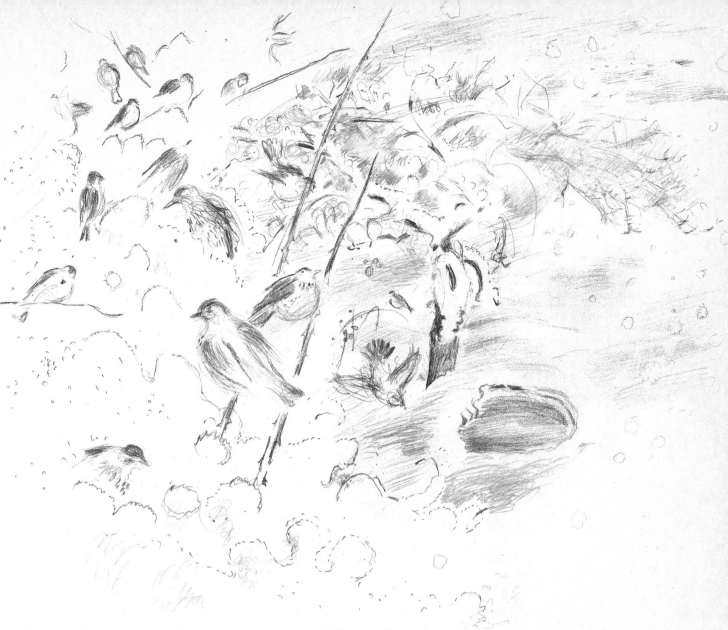

Take some white paper (Chinese white watercolour will make it whiter) and a 2B 0.3 mm clutch pencil. Stab with the pencil. The snow amasses around every dot and dash. The white paper is composed of snow. Move the pencil faster, faster. The birds are knocking the snow from the twigs. Flurries of wind are changing everything. The staccato marks are made in a wild cancellation of expectation. Random marks are often the most convincing.

After Munch

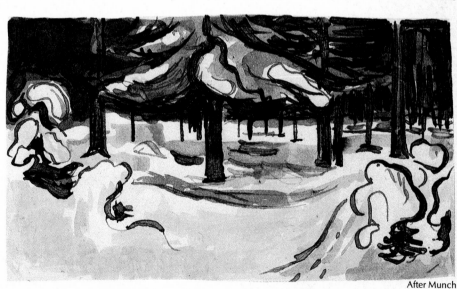

After Munch

The long, dark Norwegian winter, expressed in a thumbnail sketch copy of "White Night", a snow-filled woodland by Munch. He lived with snow and made pictures at arm's length in his outdoor studio.

Using a brush and ink and a pen, draw the writhing undulating snow shapes. Munch did a large number of woodcuts; sometimes the wood grain conformations suggested ways of drawing and painting meaningful counterchange areas, islands of light and dark. Draw from Brueghel – the great painter of ice and snow. Pissarro, Monet, Courbet, Millet, even Cézanne, also did snow pictures.

Shell Rhythms and Sky Dragons

Leonardo da Vinci suggested looking at stained walls as an aid for inventing figure compositions. The most unrelated objects can act as stimulants for art. But the small things found at the edge of the sea somehow equal the large forms surprisingly. A mussel shell can suggest the colour and form of a seascape and even look more like the sea than the view of the sea itself. A mussel imbibes tides day by day and is part of the seaside rhythm. The flows of water seem to have layered themselves to become its shell.

The pastel pencilled razorshell resembles the sand and shingle shore; the watercoloured mussel suggests the sea and sky.

Move the crumbly marks of a pastel concentrically to make an oyster shell.

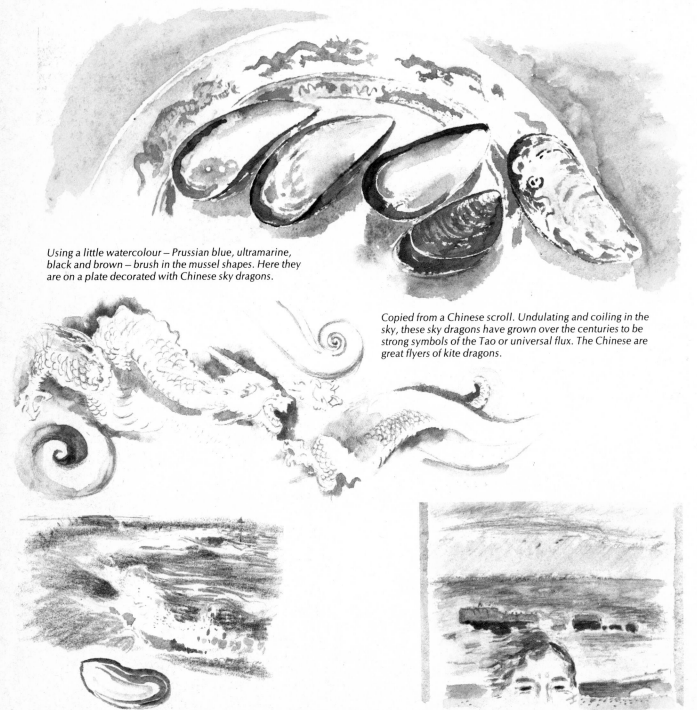

Using a little watercolour – Prussian blue, ultramarine, black and brown – brush in the mussel shapes. Here they are on a plate decorated with Chinese sky dragons.

Copied from a Chinese scroll. Undulating and coiling in the sky, these sky dragons have grown over the centuries to be strong symbols of the Tao or universal flux. The Chinese are great flyers of kite dragons.

A mussel-shaped bay. Suggest it, on the spot, with pastel pencils. Watercolour touches can be added later.

Hastings harbour with two eyes in mussel colours. Carry a tiny watercolour box.

We know the sea is large. In perspective, the sea beyond the breakwater on the paper is only half a centimetre high. The deckchair takes up much more space than this. If we feel that, in justice to the mighty ocean, we must have more of it we can: 1. make the sea area bigger; 2. make the deckchair smaller; 3. use the deckchair to allude to the sea; 4. introduce a person whose striped shorts will allude to the sea – but with 4. we are straining things. The shorts are more person than sea, a giant dwarfing the sea still further. The seaside commotion is confusing; all goes dazzlingly fast. Draw with a swing, from the safety of a deckchair. Focus on another deckchair, making visual excursions from it.

After Klee

Klee named his pictures only after completion. He and Kandinsky thought of painting as being like music. Simplistically, the horizontals would be staves and the dark spots notes. Investigate the shapes and decide whether they make up boat-shaped shore sections with sun and surf lines, with blue tides and waves.

Waves breaking along the shore resemble the striations of mussels.

The striped shorts have a more watery flow than the warm blue sea in the background. Beachwear, bright with pattern, can be used to comment on surroundings. Look at everything to discover its kinetic effect.

Waves and Seas

Waves are affected by wind and by land screening. At times, strange beats and streaks form on the water. Rocks and sand-banks change the appearance of the open sea. Alfred Wallis held up a glass of water and said it was like the colour of the sea – a pale green. Matisse said his experiments had led him to paint it black in the sun. The sea must be pre-designed in the light of experience or the result will be chaos. Blake's symbol of chaos was the sea. Using a wide-nibbed pen and diluted ink, move the liquid into the distance following the hollows of the waves; mark the transverse lines connecting the ridges of the waves parallel to the horizon. It is as if an immense Scottish tartan undulated as it floated on the water, subject to tide and wind. If you prefer rough, smudging suggestive marks to a hard pattern, smudge until you get it right for your style. A Bonnard wave looks different from a Hockney wave. I taught Benjamin Britten's butler to draw. In return he showed me how Ben had taught him to play waves on the piano. Britten's genius for conjuring the sea out of musical instruments was only equalled by that of van Gogh for conjuring the sea out of reed pen marks. The undulation which is the wave keeps its form until wind or rocks strike it or until a sandbank or beach forces it upwards. It then turns over. Although all seems formal and controlled as one looks, the finding of equivalent patterns for the various motions is not easy, until you allow your mind to flow freely like water. Brain waves are needed for extracting wet waves from the great gush.

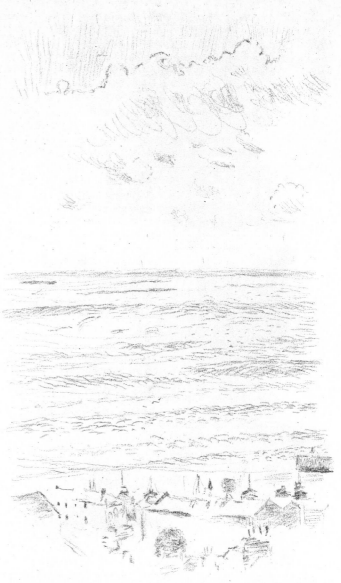

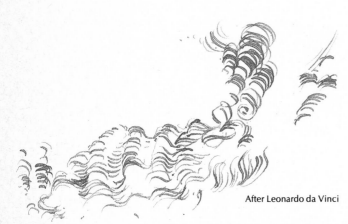

After Leonardo da Vinci

Leonardo made a crescendo of oscillating calligraphic patterns in this "Deluge" drawing.

Lines of wavelets approaching the small fishing boats on the beach at Hastings. The lines suggest the horizontal stretch. It is always difficult to portray a sufficient spread to equal the mighty ocean. Here it is done with the limitation of a vertical format.

A raw use of a charcoal pencil. A Chinese might find it more difficult to accept such a rough form than Bonnard would have done. Treat the whole schematically, tightening the marks as they depict the rocky cliffs.

The sea beneath a pier, seen with Chinese wave patterns in mind. Piers are good vantage points for researching wave shapes. Do diagram drawings moving from near plan to distant views.

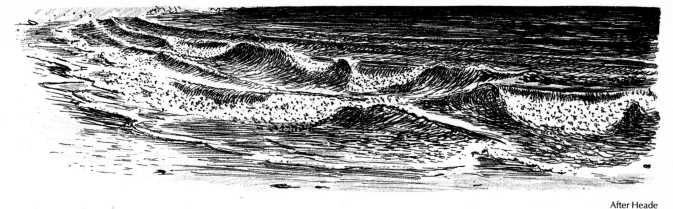

After Heade

A perspective view of breaking waves which are parallel to the shoreline of a bay.

After Hockney

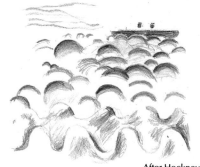

After Hockney

The smooth gradations between declared tones are maintained perfectly in Hockney's paintings of clear water.

Hockney uses the Egyptian undulating symbol for water. The liner makes its way across a sea whose waves are as round as human bottoms.

Small ripples on wavelets on large surging waves. It is sometimes useful to think of wavelets as resembling fishing nets lying on the water.

The Chinese wave patterns take many forms. Copy them and compare them with the conformations of real waves.

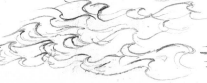

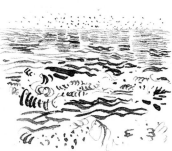

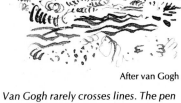

After van Gogh

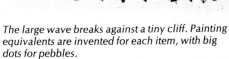

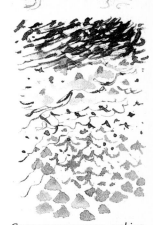

The large wave breaks against a tiny cliff. Painting equivalents are invented for each item, with big dots for pebbles.

After Braque

Van Gogh rarely crosses lines. The pen plays with thicks, thins, dots and even with brush dabs.

Cameras copy waves, making them solid ice, glistering green toffee or postcard blue. Any pen mark made by hand looks more real.

Undulating Chinese waves with a dragonlike rapacious feeling to them. Draw with a pen, maintaining the Tao flow. McComb and Hockney understand flowing water. Copy from "The Water Theme in Chinese painting" by Robert J. Maedas.

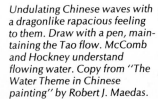

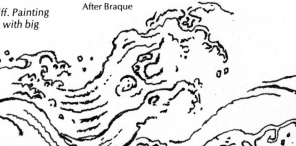

Nocturnes

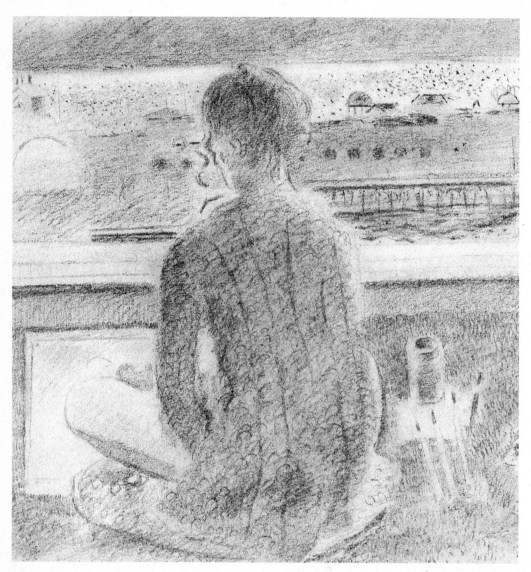

When evening falls, the tone range in landscape is gradually reduced until the range of tones possible on paper is actually able to equal it. To make a drawing take on a nocturnal mood, it is necessary to prevent these limited tones appearing like daylight. You will need to be resourceful, even experimental. Making a drawing as dark as night is not difficult. You just shade thoroughly until the subject is swathed in darkness. But be careful not to end up with an opaque, impasted black. Blacks only look well if light twinkles through them like starlight on wintry black nights. To make a middle grey drawing of evening or night is not so simple. If nothing else works try using the close to middle tones and make textural and pattern differences separate the forms. Cushion your accents with clouds of soft shading. The merging and emerging of forms is natural to the nocturnal experience. Design well with soft edges.

For the drawing on the left, conjure the forms out of rough, hard watercolour paper, using a 5B graphite pencil, and a lithographic crayon pencil for extra darkness. Ingeniously separate sky, hair, woolly cardigan, pier and carpet, keeping the edges well disposed, without daytime tonal contrasts.

Winter days can be dark and nights long. At the fade of light, magic takes over. The cloud traceries of sunset will correspond to soft scribbles of chalk on paper washed with watercolour. The close tones of evening can be spotted, rubbed and hatched to differentiate them. The darkness demands a rich repertoire of texture. The darker the area, the more legible must be the marks with which it is drawn. Darkness in drawing can be wonderful. Redon, Degas and Rembrandt move their darknesses with mysterious force. Grey paper can be darkened with black ink or black chalk and heightened with white crayon, white ink or white gouache. It is economical in effort but the darks will not have the sparkle of a Seurat drawing, where the white paper glitters through. Piero della Francesca's "Dream of Constantine" is a sharp-edged night picture. Seurat's many drawings use little variation of texture but wonderful intervals, edges and gradations. Hopper invented a new nocturne – the voyeurist's peep into lighted windows at night.

Fishermen hauling nets at daybreak – the sun is breaking through dark clouds. The drawing must be sharp in the darkness. Black chalk can be used with black watercolour to make darkness quickly. Be rough – you can always clean up by erasing later. If the light is poor, draw diagrams on white paper and work from memory afterwards. Lights, stars, moons and reflections can be marked with a pen on white paper or with a knife tip on scraperboard.

Facing page, top
The varied illuminations after dark can be more surprising than those of day. Here an electric light shines on the paper whose reflective surface illuminates the head. Other heads are reflected by the night-dark windows of the room. Exploit every texture that a scraping, scratching, scribbling, hatching conté crayon can give you.

Facing page, bottom
A subdued nocturnal seaside townscape from the cliffs of Hastings. Fix between applications of black chalk. The working of the surfaces is quite arduous but the sparkle achieved by using rough paper is the reward. Erase with a hard typewriting eraser after fixing, if things go wrong, or use it as part of your technique. Lights can be taken out with a knife.

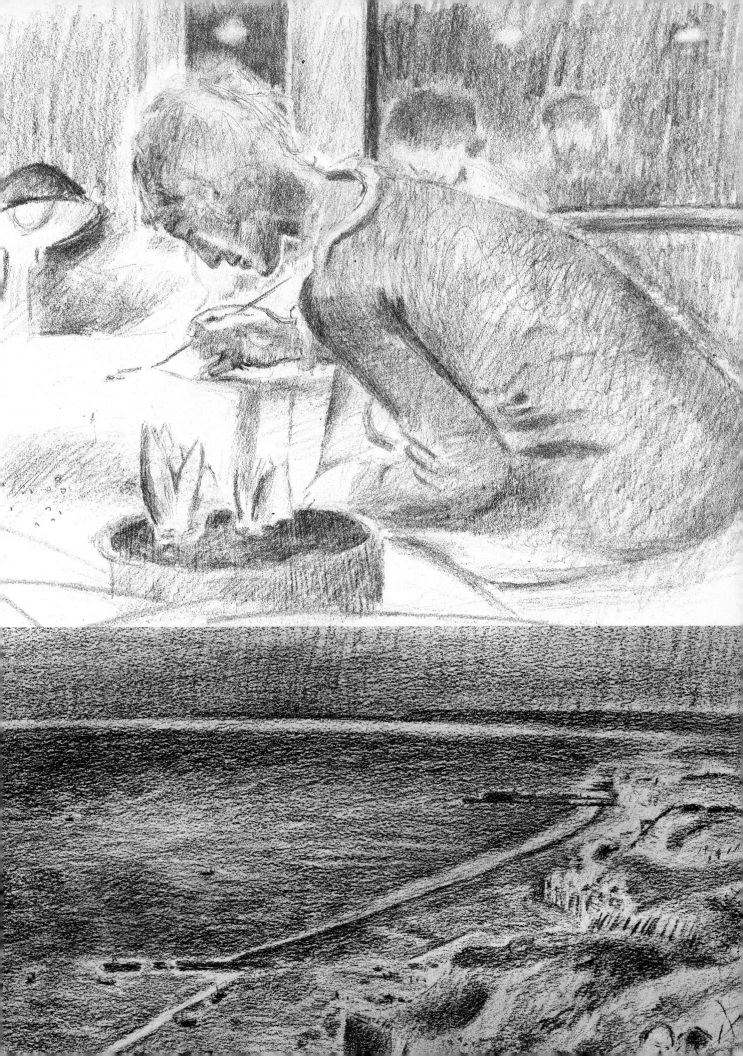

Cliffs and Rocks

With a black chalk, draw the fissured and stratified blocks. Hawthorns and brambles and grasses grow in the surface soil; seagulls wheel.

Using a pen and chalk, dot and mark your way from the grass and thrift in the foreground, wave by wave along the sea edge, as if you were one of the seagulls.

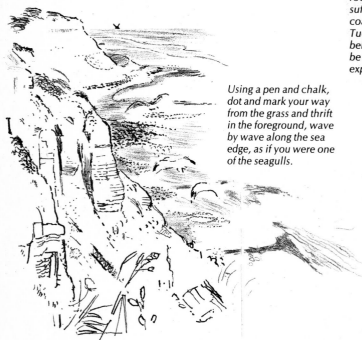

Rock-a-Nore is aptly named for this study of rock. There is never sufficient paper to pack a coast into. Be cunning. Tuck the distant headland behind the large rocks, but be careful that the sea edge explains what is happening.

If you draw a rock cliff at this distance, the whole structure is clear. The big space jump from the seaweed to the horizon is continued and controlled by the horizontal strata lines.

Along the coast near cliff edges faults appear. Frost and rain cause the rock to fall in chunks into the sea where, after years of pounding and knocking in the waves, it becomes rounded as pebbles and sand. This is ballast, and with cement and water it becomes concrete. Sand melts to become glass. Glass and concrete are ingredients for skyscrapers. The fissures have become air and lift shafts, the stratifications – floors, and caves – the windows and doors. Rocks are mysterious. Think of the faces in the rocks by Mantegna, Lot's wife, the floating rocks and people made of rock by Magritte, the roundels of Yves Tanguy,

caves, labyrinths and burial barrows. Broken windows are unnerving. Breaking glass is nerve-shattering. Cutting glass involves tension. The cleaving of large diamonds is intensely brow-tightening. Draw a broken window. The sharp edges make you feel that you might cut yourself: there is a strain in drawing it. In the film *Repulsion*, Roman Polanski used the sudden appearance of cracks in the walls of a living room to demonstrate the unhinging of the main character. Some cracks have charm, as in old mortar-filled walls. Draw some cracks. Use a brush and watercolour, with Cézanne's Bibemus Quarry in mind.

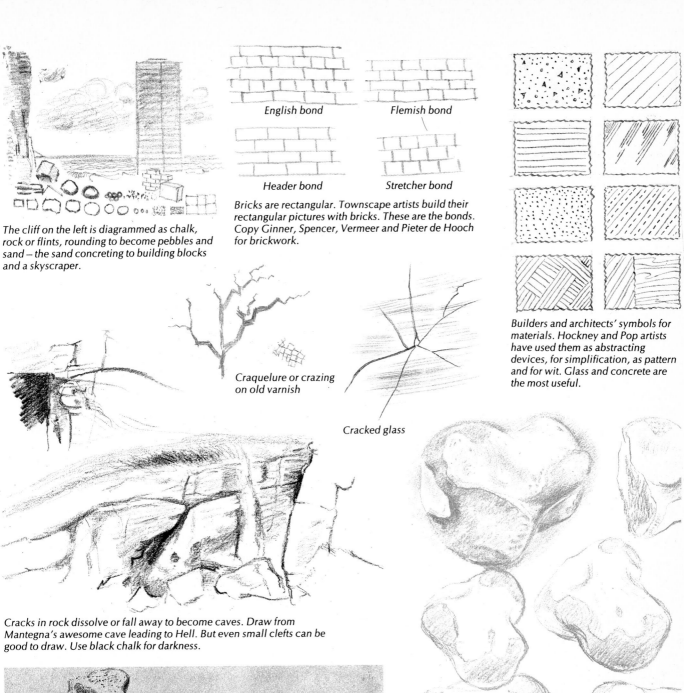

The cliff on the left is diagrammed as chalk, rock or flints, rounding to become pebbles and sand – the sand concreting to building blocks and a skyscraper.

English bond

Flemish bond

Header bond

Stretcher bond

Bricks are rectangular. Townscape artists build their rectangular pictures with bricks. These are the bonds. Copy Ginner, Spencer, Vermeer and Pieter de Hooch for brickwork.

Craquelure or crazing on old varnish

Cracked glass

Builders and architects' symbols for materials. Hockney and Pop artists have used them as abstracting devices, for simplification, as pattern and for wit. Glass and concrete are the most useful.

Cracks in rock dissolve or fall away to become caves. Draw from Mantegna's awesome cave leading to Hell. But even small clefts can be good to draw. Use black chalk for darkness.

Draw from a flint. Pretend it is immense by placing it close to you. Draw a girl and make her fit with it, soft against hard. Differentiate the textures, using conté crayon.

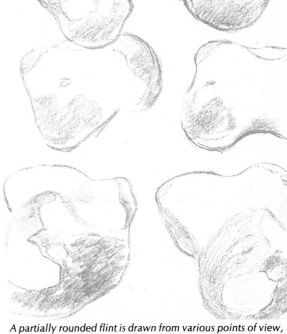

A partially rounded flint is drawn from various points of view, concave and convex, as an exercise. When you have drawn eight or more, draw from memory.

Cities and Protections

Narrowest in a human being is the marrow in his bones. And coating his bones, in succession, are muscles, guts, blood, fat and skin. Coating these are various protections – stockings, tee shirts, leathers, wools and fur coats. Other rotund protections for the vulnerable body were caves, igloos and round mud and grass huts; straight-sided coverings were log cabins, tents and temples. (Japanese houses were measured out in mats of equal size – an Eastern modulor.) And finally, the hardest-looking protective environment of all, the high-rise city block. In the beginning, men tried to protect themselves from wild nature. Now the city dweller seeks relief from jagged nerves by escaping to the country cottage. Buildings can be drawn hard or soft. Ingres drew them hard; Bonnard drew them soft. The drawings of cathedrals by Rodin look hand-done, as if the great sculptor imagined them to be clay in his hands. Draw London from a window at roof-top level. The skyline of vertical chimneys, columns, towers and spires makes crosses with the cranes and windows. London's skyline is more varied than that of most cities. Oscar Kokoschka painted London from one of the highest windows. The skyline, high in the picture, became unimportant; the city was spread out before him like a tapestry. The river Thames moving up the picture was its theme.

After Dufy

A drawing of an imaginary cathedral. Lightly play with skeins of pencil marks. The fast, lissom scurries of line suggest the next great Parisian sculptor – Giacometti.

Diagrams of man's protecting structures: igloo, caravan, grass or mud hut, tent, temple, cathedral, villa and high-rise block

After Rodin

Sometimes the complexity of a subject seems overwhelming. The sky-scrapers of New York are full of windows. Dufy's version may not be definitive but it is a good response.

The varied structures of a bridge over the Thames and the Fire Tower are exciting to draw. London seems man-made and remarkably hand-done – ugly, yet beautiful. Draw roughly until you are able to separate the different structures. It is often best to start with a window or an ornament (such as the golden ball on top of the Fire Tower) and then work your way along the skyline.

The small fishing town nestles against the rocks. The size of house is right for human beings. Le Corbusier tried hard to make his architectural module relate to human proportions, but it was a long while before people wished to live in his vast block of flats at Marseilles.

Buildings in the Old Town, Hastings. Draw some distant buildings first.

William Gillies was my teacher. He was a Scotsman who had studied in Paris. Edinburgh was early in having a Munch exhibition and, like Norway, Scotland in the snow is beautiful and wild. Art Nouveau rhythms were useful to both artists, and made it possible for Gillies to draw this little village in thaw with rapid curls of the pencil. He was obviously moved by its isolation. Winter always inspired him. The trees and houses are treated alike, bound together with lines which resemble the edges that occur beside burns when snow melts.

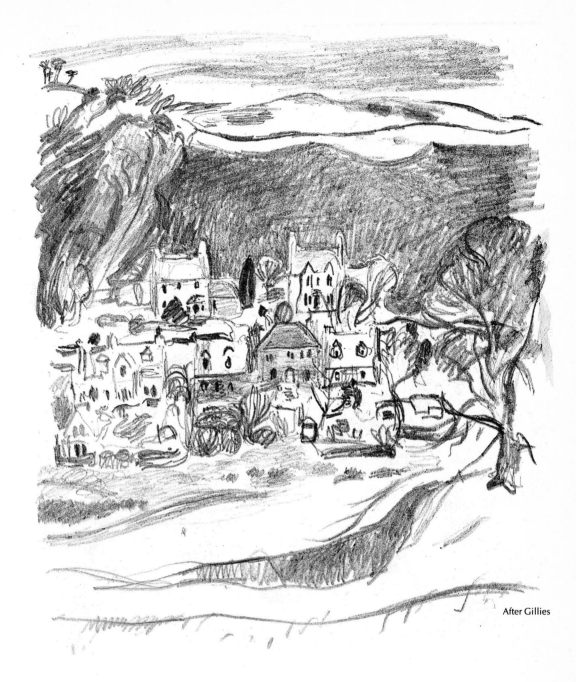

After Gillies

The skin-tight jeans form a common protection for the modern body, which knows it can quickly retreat to a centrally heated environment if chilly. The sea wall behind the figure has to be curved like a wave to be effective.

After Munch

A diagram to show how the underlying rhythm binds together the buildings and trees. Soutine is another artist who does this.

Homes

You probably know the way its windows open, the height of its porch, the weight of a shingle. Some buildings remain houses and never become homes. It is a good thing to draw subjects which are part of your close environment. To learn to draw the body, we study it piece by piece. Buildings can also be thought of as having features. Begin with some windows. They can involve a lot of overlapping, especially if they are old sash windows. First, draw the outer moulding, the frame and the thickness of the wall, then maybe a sun-blind or curtain; finally, there are the shadows cast within. Obviously, it is necessary to find a way of suggesting windows simply, if they are at a distance, and it is useful to be able to keep verticals vertical. If the windows are a long way off, reasonably placed dots are a sufficient indication.

After Hopper

Here is a collection of diagram-scribbled windows. Draw a few architectural features: roofs, windows, doors, steps, porches, chimneys, walls, wall textures, fences, garden gates and paths. Drainpipes can be very dominant.

Draw doorway porches – like small tunnels they lead you towards the building. The Hopper has a square ''country and western'' appearance. Compare it with the Regency, round-arched aristocrat above.

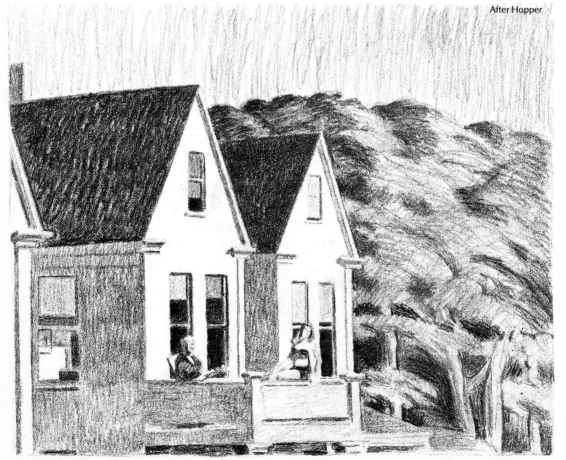

After Hopper

Hopper almost makes his pictures out of the hard shadows cast by a bright sun. From the ground and the pale plank surfaces, light is reflected upwards to make the shadows dark above and light below. Windows are important in Hopper pictures. They are often open, and the blinds, curtains and apertures make clear shapes from the falling sunlight. Draw the window at the extreme left to understand how precisely engineered is his arrangement. Rectangle surrounds rectangle. The shadow from the blind falls carefully across a framed picture on the wall within the room. Unless you are prepared to take enormous pains lining up the windows and doors of your drawings of buildings, it is best to suggest them using a natural style. I find it difficult and against my natural inclinations to draw the straight lines of architecture straight.

Flags

Gusty, punky or still are flags. Some artists paint pictures like large signatures, loyal to themselves, showing off, as some nations do when flying flags. Flags are splendidly clear and bring us to attention. Drawing wind-blown flags trains the mind to make a fast analysis of quickly moving, apparently simple shapes by intuitive leaps. With no wind the flag is vertical and still. A little waft and the design becomes visible. Move the line just a little for a real waft. Push more for urgency. Leave gaps for impetuosity. Make jabs for fast gusts. A flag is a monitor of the invisible airs that caress and buffet us. It is often rectangular. It can be construed in many harmonious permutations within a rectangular picture. Flags are proclamations of heraldic bright colours — tokens which, like bird song, like carillons, like fanfares, like waving hands, declare that we live in the world.

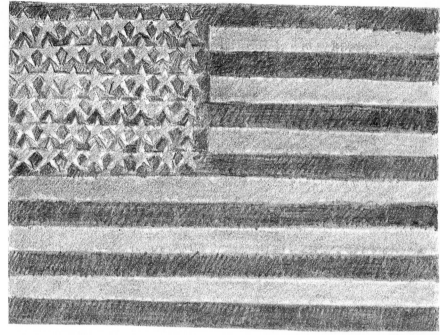

After Johns

A flag can emphasize stillness. There it hangs, vertically, between heaven and earth.

After Giorgione

Jasper Johns' painting of the US flag is done in encaustic (painted with melted wax). It makes a rectangle, flat and not allowed to fly, like the side of a factory: a monument to the United States — still forever. This assertion of the picture plane as a very present and true subject, free from trompe l'oeil, was new and dramatic.

After Oldenburg

The US flag is firmly bitten into the mind, and as an image will survive rough treatment. Claes Oldenburg, using bent wire-netting, plaster and muslin, dribbled it with tempera paint — a commentary on patriotism. Pop for America.

Banner waving in Japan, throwing coloured powder in India, making smoke screens, as in air displays, and throwing confetti and streamers — all make the invisible air seem tangible.

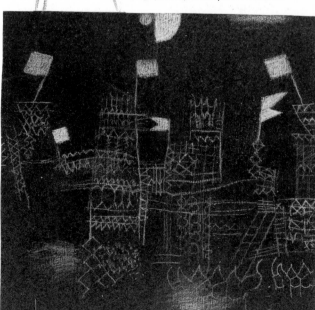

After Klee

Flags seen at night can seem unattached. It is the weightlessness of flags which, combined with a free choice of colour, tone or pattern, makes them a frequent device in art. Here, the dreaming imagination creates flags blowing all ways.

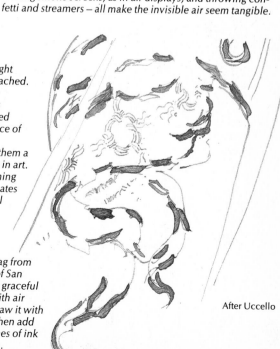

Uccello's flag from "The Rout of San Romano" is graceful and filled with air currents. Draw it with a pen, and then add active touches of ink with a brush.

After Uccello

HUMAN FIGURES

Loneliness in art can be found in Matta, O'Keefe, Friedrich, Lowry, Munch and Bacon. The last four can paint desperate loneliness using figures. The pop-eyed stare of the youth falling to Hell in Michelangelo's "Last Judgement" is an image of solitary despair. In absolute desperation there is no companionship possible. Girtin, Monet, Cézanne, Cotman, Chardin, Braque, Gris and Morandi often painted without including figures, but their pictures have human content. Only in the purest, cleanest, coolest, abstract arrangements can art be neither lonely nor human. Just as the Bible and Shakespeare are packed with figures, so is grand drawing. It is as impossible to have it free from mortals as to have a novel without characters. Broadly speaking, drawing figures to a design is a demanding activity.

The art class

In the past you learned to draw by going to an art school. Male models posed naked for men students and partly clothed for women. (For Eakins' classes, naked female models wore masks.) Teachers corrected the drawings, mainly for accuracy, and in anatomy classes they taught bone and muscle positions by marking them on a male model. The model on a throne was an actor on stage. He was put in a pose, draped, and his position marked with chalk by the teacher. The student checked the pose. Italian models knew how to hold poses taken from Renaissance painting – cliché poses, in the eyes of later artists. They have been supplanted in London by beautiful girl and boy models who sit or stand in simple poses. Models are more expensive now and the art schools employ them less. It is sometimes useful to employ a model privately. Art schools can sometimes give addresses or advice. Friends and relatives will often agree to sit. Make them comfortable; entertain them with TV or music. It is almost possible for two people to draw each other at one time.

Anatomical alternatives

Rembrandt painted Dr Tulp at a dissection, raising the muscles of a forearm and showing their connections to the hand and fingers. It is useful to know the workings of the body when these affect the external appearance. Corpses may only be cut up by arrangement. Life-sized colour photographs of dissected body parts can be found in books. In medical museums you can study dissected portions of bodies preserved in formalin-filled jars. You will need a serious anatomy book. Medical anatomies are sometimes useful, also books of X-ray photographs. Drawing skeletons is always worthwhile. Concave bone supports convex flesh. Knobs of bone cause bumps at the joints. The curious relationship of the armature to ourselves as sculptures in flesh and blood is endlessly intriguing. Cézanne had an écorché figure and a shelf full of skulls in his studio.

The sensual involvement of drawing

We live in our bodies and our bodies control us. If a tooth aches, the mouth becomes a canyon, the tooth is raised like a skyscraper and pain, like a highway full of screaming cops, tears from ear to ear. In pleasure, the body expands beyond the universe and the penetrating, central sunburst colours everything we think about and look at. So many things can affect our sense of being: bathing and sunbathing, coldness, the feel of hair or grass, vibrations, being wounded or massaged, tightness of clothing, belts, leather, the beating heart, breathing, excretion, weight, sweating, goose pimples, drilling sounds or those by Chopin, smells of horse or human dung or the perfume of hyacinths. Our physical and emotional state changes our sympathies and the extent to which we are able to enter events outside ourselves. I believe that in all good drawing the draughtsman enters the subject he draws. Empathy can be as involved and as various as the subject matter of art. The spirit is in and out of the body. When Rembrandt depicts Rembrandt, this is an obvious projection. When the crippled Lautrec draws dancing, his mind's body dances with the dancer. The capacity of an artist to work with empathy varies. When looking at a van Gogh, most people appreciate the quality of his empathy.

The body in pieces

Confidence comes with the continual practice of drawing bodies, and it is easier to draw them piece by piece: an eye, a nose, then a mouth. This is how they are presented on the following pages. An eye, a nose and a mouth is not a smile, but if you practice enough you will make them smile. Practice hard. It is worthwhile.

The ultimate incentive

An incentive encourages hard practice. Rubens had a goal— having seen Michelangelo's "Last Judgement", it was nothing short of wanting to be able to paint the human body in any possible position – upright for Heaven or naked, upended and falling goaded by devils to Hell, a swirling serpentine deluge and flight of bodies. Draw figures in black chalk from your head in as many positions as you can invent. After this, choose something from Rubens' three pictures in Munich called "The Fall of the Damned", "The Fall of the Angels" and the large "Last Judgement". Copy with black ink the body deluges in these, the most body-filled pictures ever painted. In the lowest depth of Hell in the "Last Judgement" (right) is a mouth, open and screaming, as in an early Francis Bacon. A goal for the figure draughtsman is now clear: Paradise above, Hell below and, between them, the human body. In the art of Signorelli and Michelangelo the body is used to express everything, and very little except the body is used to express anything.

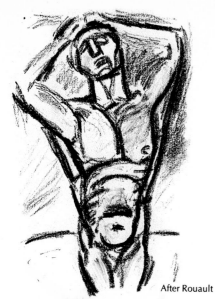

After Rouault

After Léger

Rouault's figure for "Miserere" has an interlocking jointing like that of Matisse. They both studied under Moreau. Draw it with chalk to feel the tension.

Léger's mannered compartments have a fine clarity. Copy with black ink until the contrasts crackle.

Draw from Greek vases. The surface markings are used decoratively. Tune in to the bright, sexy rhythm. Make the lines flow. Use a pen or a tiny brush.

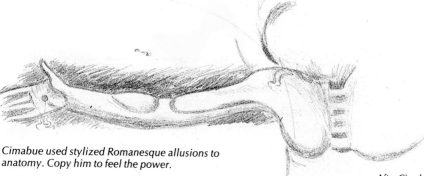

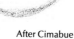

Cimabue used stylized Romanesque allusions to anatomy. Copy him to feel the power.

After Cimabue

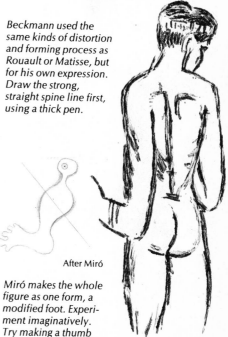

After Klee

Copy freely with a pen the little pieces of Klee's "A Fallen Man Feels in Pieces". The compartmented man is dismembered, scattered and distraught. Play with the idea.

Beckmann used the same kinds of distortion and forming process as Rouault or Matisse, but for his own expression. Draw the strong, straight spine line first, using a thick pen.

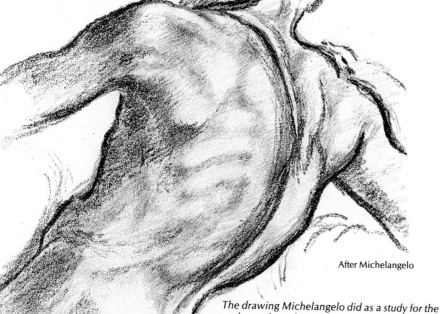

After Michelangelo

After Miró

The drawing Michelangelo did as a study for the nude youth on the ceiling of the Sistine Chapel, copied by me in conté pencil. On it was super-imposed my copy of the nude in the painting. This was done with a black chinagraph pencil. The difference between the two Michelangelos is illuminating. While keeping much of the information present in the drawing, he works up the forms considerably in the painting.

Miró makes the whole figure as one form, a modified foot. Experiment imaginatively. Try making a thumb become a figure.

After Beckmann

Life Room

Eighteenth-century France demanded "history painting", extolling patriotism and stoicism as virtues. David studied models posing stoically with sword and shield. Rembrandt and his pupils drew from nudes. The nineteenth century invented the life room. Removing clothes was daring. Most of the great artists of this era started beside the model's throne, surrounded by casts of ears, noses and antique sculptures. Even if nudists prefer being called naturists it is easier to see bodies now. If you want to draw a motionless body, hire a model or attend an art school. An old teacher may "correct" your work and use fine old clichés, such as: "Position the head above the standing foot"; "Look for the relationships"; "Look for the clues"; "Draw sight-size"; "Do not paint with the pencil"; "See it round, draw it flat"; "Do not start with the head"; "Start with the head". The experience of working for hours at one pose can be important. Images build up in the mind. Profile and frontal views help this to happen.

All the marks Dürer made in his many investigations of human proportion were beautiful. Copy the marvellous lines, points and intersections made to indicate the bone hollows, nipples, armpits, head lengths, centre lines and verticals.

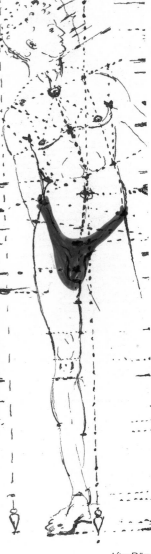

After Dürer

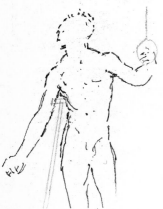

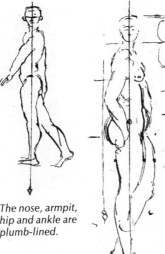

Supporting crutches and rings were used in the past. Fees are higher now but models are often reluctant to hold difficult poses.

The nose, armpit, hip and ankle are plumb-lined.

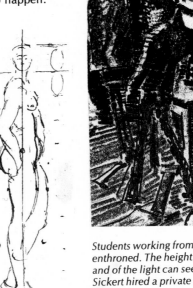

Students working from a model enthroned. The height of the figure and of the light can seem artificial. Sickert hired a private house to teach in; it was more intimate and the windows were vertical.

After Dürer

A beautifully placed central line. Dürer marked head lengths vertically.

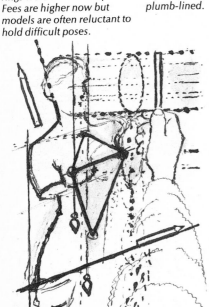

The "Venus de Milo" undergoing linkages. Measure your chosen distances with a vertical pencil at arm's length and with one eye closed, moving the pencil up or down. The plumb-line confirms that the eye is above the nipple and a pencil is placed parallel to an imagined line joining the nipples.

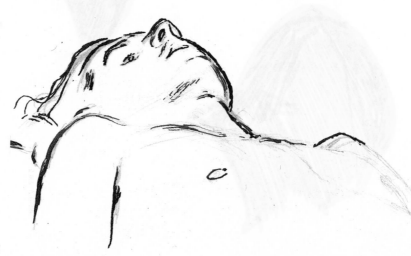

Models become faint, bored or entranced. The position is marked with chalk before the first rest. Positions of chairs and easels may also be marked. My drawing was done close to the model, from a low viewpoint, using two eyes.

Donkey, heater and easel. The radial easel is made to hold one drawing board above another and will tilt backwards or forwards and fall over rather easily.

Drawing board, throne, screen, drapery and mattress

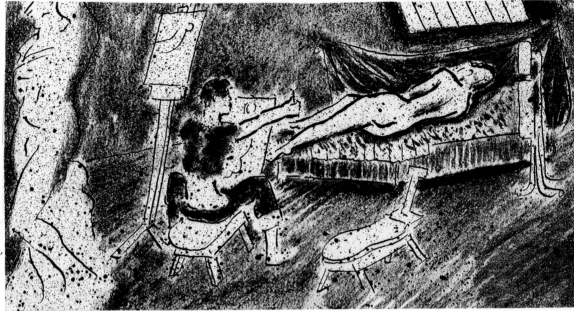

Short poses are sometimes arranged for the last part of the day. This could lead to slack, slick or free drawing. Gaudier-Brzeska and Rodin would have found no pose too short.

Measurements limit the transforming imagination, making it possible to draw plainly without embellishment. It was part of the "Euston Road" attitude which, while it intended prose, often discovered poetry. For William Coldstream and Graham Bell, their exquisite responses to the subjects in front of them were "tuned up" by measurement. Find out about check marks, plumb-lines and space-frames, but also make sure there is no other way for you, for half-hearted measuring can be a crutch, a dotty habit. Life rooms can be used today as positively as when van Gogh, Cézanne, Degas, Seurat or Matisse used them. Their furniture, temperature and smell change little from year to year.

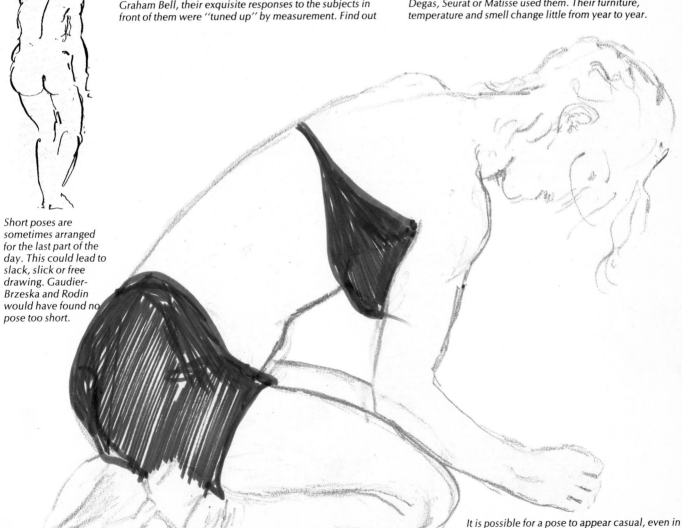

It is possible for a pose to appear casual, even in a life room atmosphere. Models are sometimes asked to wear vests, stockings or even hats. Here, the girl wears shoes and socks for an informal conté crayon drawing.

Hair

Lines happen easily when we draw hair. Hairs grow continually to a predetermined length for every part of the body. It is almost as if nature herself is drawing lines. The lines which are used for hairs must be made differently from the lines used in modelling, shading shadows, and for contours. To make this plain, draw the hairs of a hairy man's body with strokes of a crayon. Do not add other lines. You will find the marks will suggest a substantial figure. If modelling is added, it should be applied in a different way (for example, by hatching in one direction). Shadow and contour lines should also be clearly differentiated. The hair we draw is often the art of a hairdresser, but whether dishevelled, windblown, dark or blonde, waving enchantingly or lusty on pectorals, hair is always wonderful in helping us make lines. Look at and copy Degas' pastels of girls having their hair combed and look particularly at Greek, Roman, Chinese and Egyptian sculptures. Their freedom from colour and tone makes the study of the stylization of solid hair forms easy. It is also good to look at the hard-edged hair shapes in Japanese prints, the dark hair of Anthony Green, and the Indian ink extravaganzas of Beardsley.

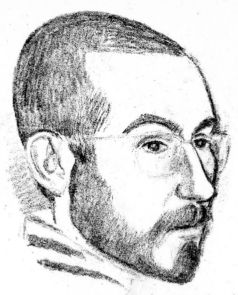

After Green

Strong contrasts are useful to set off the delicate elements in a drawing. (For El Greco, ruffs set off beards.) Anthony Green's beard and hair show off the dark eyes bowed by dark eyebrows. Build the face with strokes of conté crayon, watching the shapes as you make them, until every area is as well designed as a Japanese print by Sharaku.

A small copy of a detail from a self portrait by Anthony Green. The frown marks, hair shapes and features make up and control the solidity of the image.

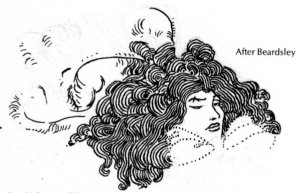

After Beardsley

Placed purposely close to the Green are these two examples from Japanese prints. Notice the tonsure and hair shapes and draw the sharp oriental contrasts.

In the dim lighting of the time Beardsley's contrasts of black and white must have been vivid. This drawing was probably done standing at a desk by the light of candles. Taking Indian ink and the whitest paper, make convolutions of parallel strokes, thinking of the white spaces left as being white lines equal to the black lines. It almost has the "buzz" of Op Art.

 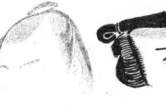

Experiment by making diagrams of blown hair, using pen and brush and watercolour. The off-balance placing of the darks, the line directions and the repetitions vibrantly suggest gusts of wind.

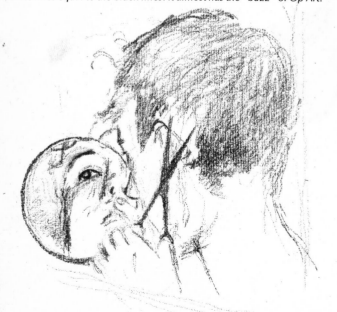

Draw a girl cutting her hair. Use a conté crayon on Ingres paper. The wide part of the stick will cover the dark area easily and a few sharper lines will make the hair's life and growth visible. The variations of design possible using a small mirror are infinite. Here the frontal eye is included in a back view.

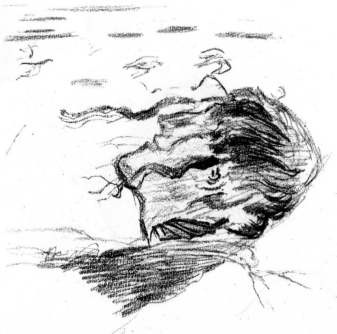

It needed undulating crayon strokes, zigzags and wave-shaped progressions to render the flux of water, seagulls and curls in this drawing of Laetitia's hair blown by a sea breeze.

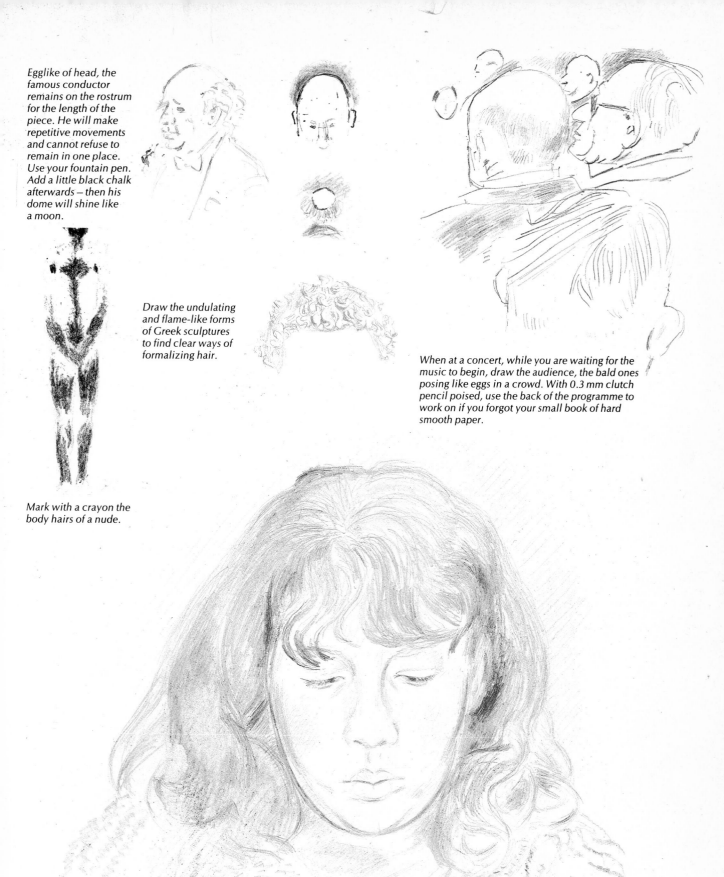

Egglike of head, the famous conductor remains on the rostrum for the length of the piece. He will make repetitive movements and cannot refuse to remain in one place. Use your fountain pen. Add a little black chalk afterwards – then his dome will shine like a moon.

Draw the undulating and flame-like forms of Greek sculptures to find clear ways of formalizing hair.

Mark with a crayon the body hairs of a nude.

When at a concert, while you are waiting for the music to begin, draw the audience, the bald ones posing like eggs in a crowd. With 0.3 mm clutch pencil poised, use the back of the programme to work on if you forgot your small book of hard smooth paper.

The glowing chestnut hair of Melissa by me. Ask someone with beautifully flowing hair to sit for you. Then, using a soft pencil, draw with a combination of hatching and long, rhythmical swish lines until the hair is realized solidly. See that the darks are luminous by allowing the light to show through from the paper, even in the darkest passages. Leave highlights unworked. But if an area has become too dense, erase with a shaped putty rubber or typewriting eraser pencil. These can make lights which are almost linear.

Forehead

For those with no hair, the forehead extends upwards. Draw a bald or a shaven-headed man. The bare skin has a holy appearance because a shaven head is a requirement of many religious orders. Use a pencil to study the way the scalp follows the frontal bone upwards and keeps close to the form of the skull. Could it be that a forehead displays the owner's life in bands of thought, sutures of pain, channels of concentration, vales of sorrow, lines of seriousness, deviousness, deceit, as wrinkles of laughter or seams of sarcasm? Perhaps deep lines are made by whisky, laughter or hate; furrows, deep and equal, result from hard work in all weathers; and jagged indentations are the nervy traces of city slicker machinations. Lines are like type settings in an unknown language. Shade the maze with a pencil; make the horizontal and vertical movements marvellous. Let them be warp and woof, the loom of life. Treat the forehead respectfully – the Indians mark it with a red spot.

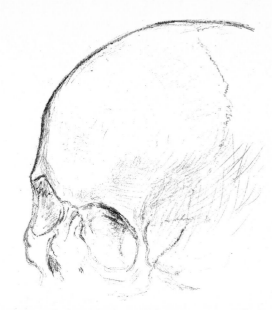

The skull is thick above the eyes and the more it retreats, the more like that of an ape it becomes. The skull has been an important subject for draughtsmen. Its hardness makes it demanding. The pencil should be sharp and hard. The flesh follows the bone closely. If the support structure of any form is understood, the external form can be drawn more securely.

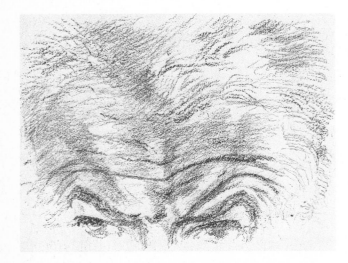

In a mirror, with conté crayon on watercolour paper, draw your own forehead. Scowl a little in a raking light so that it can be shaded darkly, then treat the forms as you would a landscape of hills and lines of clouds. The more you frown in concentration, the more rugged the terrain and the wilder the weather become.

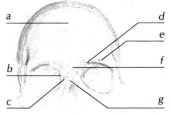

Frontal parts of the skull

a. Frontal bone
b. Lacrimal bone
c. Frontal process of maxilla
d. Frontal notch
e. Supra-orbital foramen
f. Nasion
g. Nasal bone
h. Glabella

| Calm | Philosophical and surprised | Worried | Concentrated or angry |

Make small diagrammatic drawings and see what effect different markings on the forehead produce. The labelling is arbitrary.

Draw the forehead – from below the nose gets in the way and from above the hair gets in the way. Always draw the nearest pieces first, underlapping the forms as they recede from you.

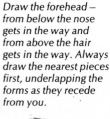

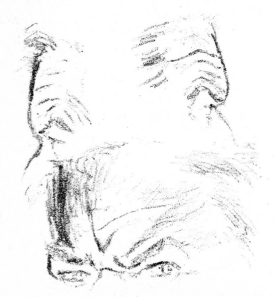

I did this with a sharpened lithographic crayon on smooth paper and scowling as satanically as possible. The wrinkle lines shaped like seagulls must be treated carefully so as not to break up the simple form of the forehead. See that frown lines do not become section lines or contour lines. You will need two mirrors if you are to draw in this way.

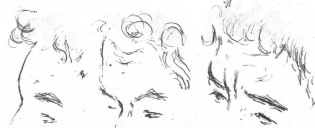

Make a placid brow become a frown in three stages. As you draw the forehead, the owner must act a frown in three stages.

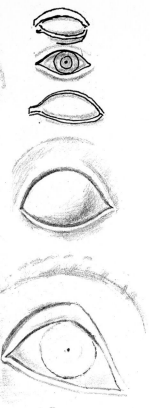

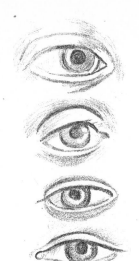

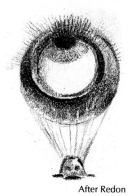

After Redon

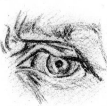

After Botticelli

Draw the beautiful, simple Botticelli almond eyes. It is clear why one of the first lavish books on him was Japanese.

Extemporize freely in the wake of Redon's symbolic, bodiless, floating balloon eye. It carries a skull. It is from a lithograph. Copy it, using a lithographic crayon pencil which has an individual, soapy, waxy quality on paper.

Eyes in African masks gave artists working after 1900 confidence in using unusual forms. Draw them and find what degrees of deformation your style can embrace without losing touch with reality. Paintings can be made simple by using mask-type eyes. Matisse often did this.

Copy eyes from Greek sculpture. The effect is mysterious. We have become accustomed to blank eyes in sculpture. Originally, the eyes were inset with coloured minerals and the figures coloured. John Davies is a present-day sculptor who makes coloured eyes to gaze poignantly from his time-free heads.

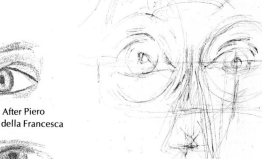

After Piero della Francesca

After Giacometti

After Dubuffet	
After Picasso	
After Brauner	
After Miró	

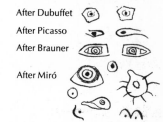

Copy eyes from recent artists, seeing what signs are useful to you. A "target" eye by Miró might lead you to a monstrous delight. Draw with waterproof ink and a Gillott pen.

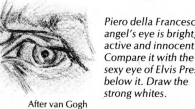

After van Gogh

Draw the pain-filled eye of van Gogh to see how the angular rhythms create the torment.

Piero della Francesca's angel's eye is bright, active and innocent. Compare it with the sexy eye of Elvis Presley below it. Draw the strong whites.

Staring his girl in the eyes, Giacometti drew fast with the novelty of the day – a ballpoint pen. Try one for drawing round an eye.

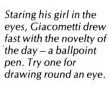

See how the eyeballs are sunken in the sockets of the plaster death mask taken by Clouet of Henry II of France. Copy it (above right), together with the St Dionysius by Thomas Weissfeld, which also has deeply placed eyes in sockets. Look at a skull. There is only a little flesh between the skin and the skull in these drawings.

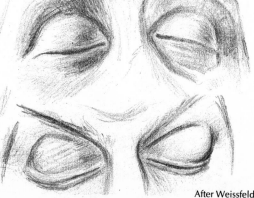

After Weissfeld

These eyes from ancient Egypt are as mysterious as the Sphinx. They are very clear images and not "evil eyes", so safely copy them hard and black.

Copy the entranced Buddha eyes looking forever from the long slit eyelids, like a planet between thin gaps in floating clouds. Draw with a carbon pencil.

Ears

The ear hole is at the centre of a vortex of cartilage and flesh and is also at the centre of the profile head. Whelk-like if dissected, the ear cores its way to the brain, labyrinth leading to labyrinth. Shakespeare killed Hamlet's father by pouring poison into his ear and so made the play mysterious from the beginning. The golden wig helmet from Ur (see facing page) incorporates a stylized ear made of concentric levels surrounding a central hole. Copy it with a hard pencil to see how convincing an equivalent ear of this kind can be. Freely copy from Japanese prints and from Modigliani's simplified ears, then draw from your own ear using one or more mirrors. The ear must be made to grow naturally from the face and not look like an appendage. A little anatomy might help you. The outer ear has no bones. The cartilages are curious forms with complicated names. The antihelix, helix, tragus and lobule will be enough to remember. Recent artists have tended to pass over ears or make them look like jug handles. Matisse, Léger and Giacometti often left them out and Picasso made simple signs for them. Pollaiuolo, a Florentine artist and a keen anatomist, drew ears with fine vital lines only slightly less lyrical than the musically rhythmic ears by Botticelli. These artists took ears seriously and to copy seriously from them is rewarding.

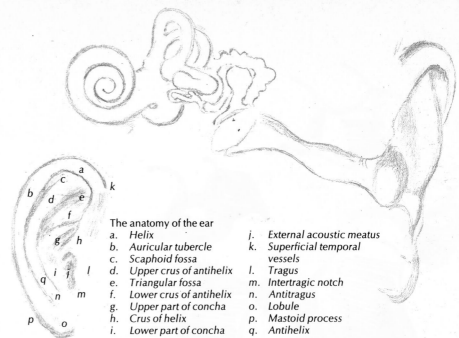

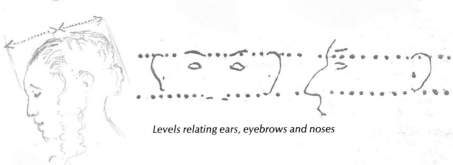

The anatomy of the ear
a. Helix
b. Auricular tubercle
c. Scaphoid fossa
d. Upper crus of antihelix
e. Triangular fossa
f. Lower crus of antihelix
g. Upper part of concha
h. Crus of helix
i. Lower part of concha
j. External acoustic meatus
k. Superficial temporal vessels
l. Tragus
m. Intertragic notch
n. Antitragus
o. Lobule
p. Mastoid process
q. Antihelix

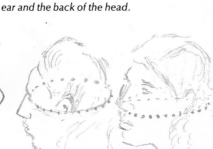

Levels relating ears, eyebrows and noses

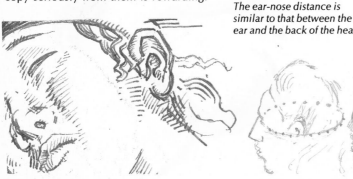

The ear-nose distance is similar to that between the ear and the back of the head.

Imaginary sections through the head are useful in correctly positioning the ears.

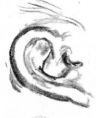

If you can see into the nostrils, the ear will be above the eye.

An ear drawn with charcoal – it must be sharp.

Think of ears as growing from the head, as well-rooted plants grow from the ground. The arrows suggest possible directions of growth.

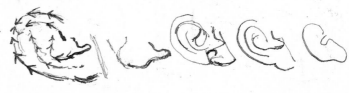

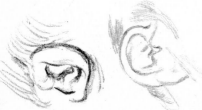

Draw someone's ear from above and below. Ears always surprise.

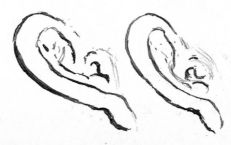

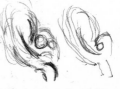

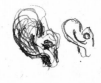

Draw freely with a fountain pen. Separate the parts. Play with the shapes and scribble them together again.

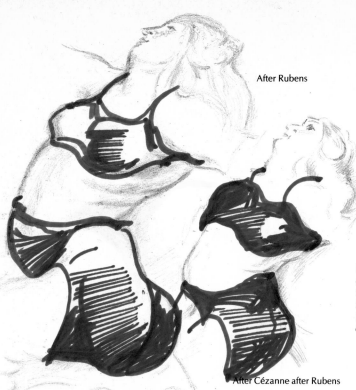

After Rubens

"The Triumph of Bacchus". Rubens' Bacchus is easier to draw than the nubile figures by Renoir because he can be flabby. Model his belly with a carbon pencil.

After Rubens

After Cézanne after Rubens

In this Chinese Buddha, each form is full and no form is bloated. Draw from sculptured Buddhas as if you were drawing Sung pots.

My copy of Rubens' naiad from the "Arrival of Marie de'Medici at Marseilles" in the Louvre. Close to the limits of distortion, plump and erotic, she was copied by Delacroix and by Cézanne. Copy with a conté crayon from each of them to see what modifications were made. Your engagement will be with the power of a great tradition. (See also p. 14.)

A comic postcard

A pot belly seems to accompany the consumption of alcohol.

The world-famous prehistoric statuette, "The Lespugue Venus"

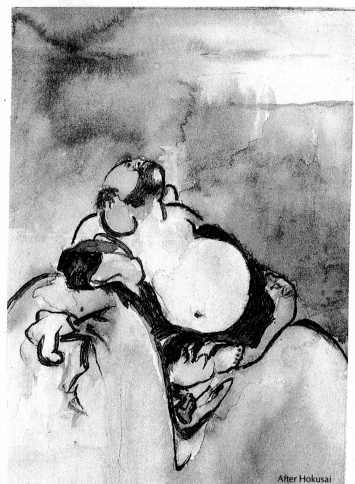

After Hokusai

Hotei, god of good luck, on his sack. Copy him using black watercolour, leaving a light, round belly, thinking of a rising sun. Draw with a brush, making terse writing marks.

After Renoir

A very plump nude – Renoir made his nudes rounder and plumper as he got older. Use compressed charcoal, making the fat forms move concentrically round the central hip. Renoir never slackened the rhythm; the fat is always youthful and never flabby.

After Gillray

In Gillray's voluptuaries, the line is very thin and swells to be very thick, a caricaturist's line.

Open and Closed Poses

We remain in some ways like animals. We feel at risk on our backs. Woodlice (a) or hedgehogs (b) roll into balls, protecting their fronts. Beetles (c) become frantic if upside-down. We are most secure when we are face to face as baby and mother or with a lover (d). Plato's *Symposium* treats of an imagined two-backed being which, halved to make a man and a woman, would always try to become whole once more (e). When standing, we are more watchful and feel safer facing the danger (f) We bow in subjection (g). Praying hands seal the palms together (h). Stanley Spencer's figures pray with the palms facing heaven (i). Hands clench in terror (j). A handshake presents vulnerability to another (k). The body closes into a ball if we squat (l). It is tightened like a spring when we bend it back (m). It is at its most vulnerable when spreadeagled (n). It is prone to be ordained as a priest (o); bent to be beheaded (p) or guillotined (q); stretched to be crucified (r) or tortured (s); laid out to be operated upon (t) or as a Mexican sacrifice (u). Etruscan ladies must have enjoyed picking up their utensils when the handles were in the form of naked young men with tautened backs (facing page). They have a break of day vitality.

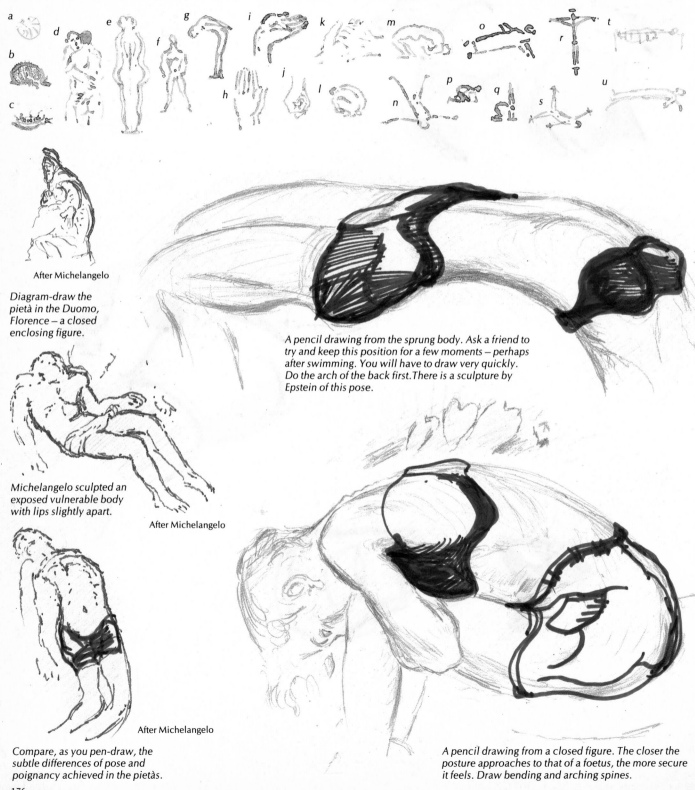

After Michelangelo

Diagram-draw the pietà in the Duomo, Florence – a closed enclosing figure.

A pencil drawing from the sprung body. Ask a friend to try and keep this position for a few moments – perhaps after swimming. You will have to draw very quickly. Do the arch of the back first. There is a sculpture by Epstein of this pose.

Michelangelo sculpted an exposed vulnerable body with lips slightly apart.

After Michelangelo

After Michelangelo

Compare, as you pen-draw, the subtle differences of pose and poignancy achieved in the pietàs.

A pencil drawing from a closed figure. The closer the posture approaches to that of a foetus, the more secure it feels. Draw bending and arching spines.

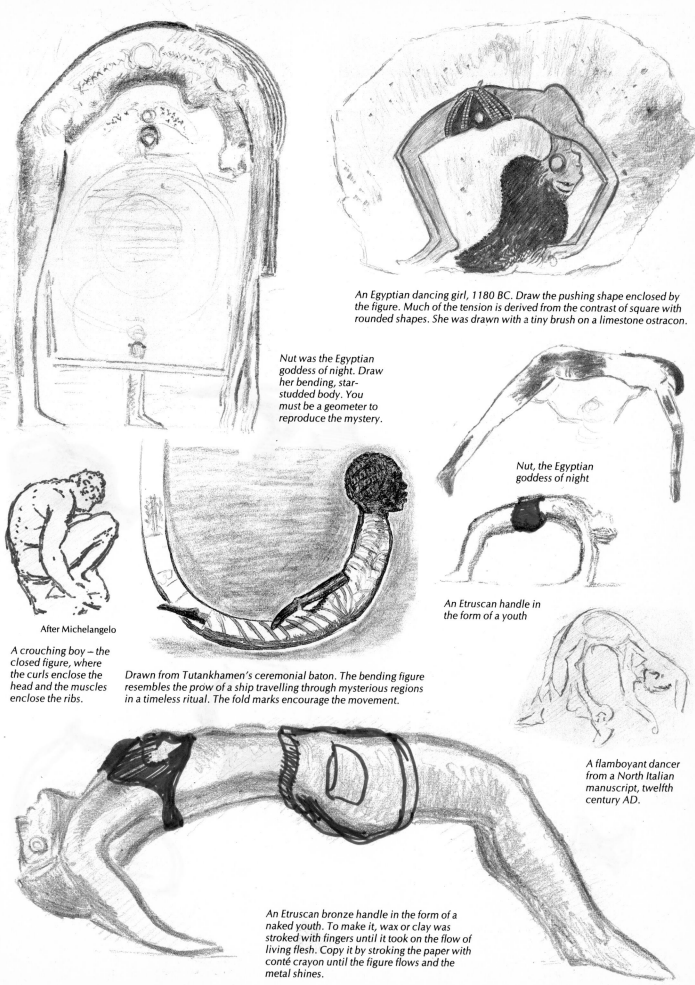

An Egyptian dancing girl, 1180 BC. Draw the pushing shape enclosed by the figure. Much of the tension is derived from the contrast of square with rounded shapes. She was drawn with a tiny brush on a limestone ostracon.

Nut was the Egyptian goddess of night. Draw her bending, star-studded body. You must be a geometer to reproduce the mystery.

Nut, the Egyptian goddess of night

After Michelangelo

A crouching boy – the closed figure, where the curls enclose the head and the muscles enclose the ribs.

Drawn from Tutankhamen's ceremonial baton. The bending figure resembles the prow of a ship travelling through mysterious regions in a timeless ritual. The fold marks encourage the movement.

An Etruscan handle in the form of a youth

A flamboyant dancer from a North Italian manuscript, twelfth century AD.

An Etruscan bronze handle in the form of a naked youth. To make it, wax or clay was stroked with fingers until it took on the flow of living flesh. Copy it by stroking the paper with conté crayon until the figure flows and the metal shines.

Gestures

The English dictionary is full and rich with words. Italians use a lot of gestures for communication. Minute differences in the position of a finger or angle of an arm change the messages transmitted. These many movements of the body were what the Renaissance figure painters used for making their stories plain. Poussin lived in Rome and would have been familiar with the eloquent Italian conversational movements. Try some gestures in front of a mirror, sketch-diagramming them as you perform. To feel each action as you draw in your own body and be aware of its expressive potential is good. This is real empathy. Drawing involves thinking like an actor, understanding the mime of life: the studied, stylized display of the Noh play, the throwaway flourishes of the method actor. Sit in a car parked in a crowded place, or in the corner of a bar. Draw the attitudes people adopt. Make lines through the body. Do not bother with the features, but be very precise about postures and movements. Concentrate your research. Looking at the bearing of the bodies may lead you to a lineament or a wink, an eyelash flutter or a pointing finger, even to a fingernail, a brandish or a raised nostril . . . indeed, any action made by man can be noted down and used in drawing.

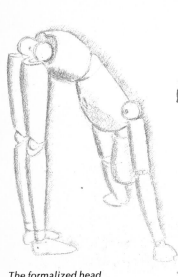

Old lay figures were beautiful sculptures. These new ones are slick mannikins. Draw some positions. Give them life if you can. It is said Tintoretto hung up clay figures to draw from.

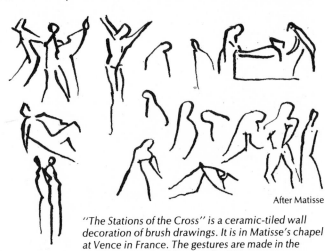

After Matisse

"The Stations of the Cross" is a ceramic-tiled wall decoration of brush drawings. It is in Matisse's chapel at Vence in France. The gestures are made in the simplest way possible yet still tell the story.

The formalized head gruesomely forced against the ground in the war picture "The Charnel House". Picasso learned from Goya.

After Picasso

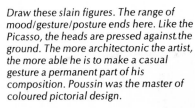

After Poussin

Draw these slain figures. The range of mood/gesture/posture ends here. Like the Picasso, the heads are pressed against the ground. The more architectonic the artist, the more able he is to make a casual gesture a permanent part of his composition. Poussin was the master of coloured pictorial design.

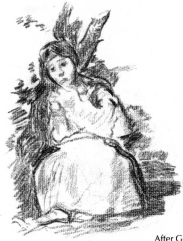

After Goya

An enigmatically sad child. The broken off branches of the tree and the lurch of the pose determine the subtle mood.

After Portinari

An obvious way to show grief is with a shower of tears, but the Brazilian painter may be alone in making a harsh gush of misery this way.

Rembrandt did many schematic drawings of this kind where, in the concentration on lines of posture and gesture, there is some resemblance to the Matisse above. But the Matisse is a final, simple distillation and the Rembrandt is a try out.

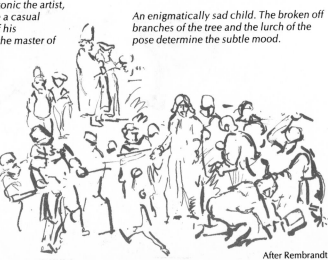

After Rembrandt

After Goya

After Goya

After Goya

After Goya

After Goya

After Goya

A tiny selection from the immense range of human positions in Goya's many drawings (now published in two volumes). The drawings become less happy as Goya grows older, disillusioned and ill. Copy them – from a happy dance with butterfly fingers, through the throes of life, until the ultimate clench of rigor mortis. The original drawings are in brush or crayon as are my copies except where, because of their size, I have used a pen.

After Goya

After Goya

After Goya

Copy with charcoal pencil on rough paper the central head of Goya's "The Third of May", his painting of an execution, with its tilted anguished eyebrows. Below on the left is a sequence of anguished poses from the same work. Chalk them in with black to see how the positions follow each other, telling the story.

Dance

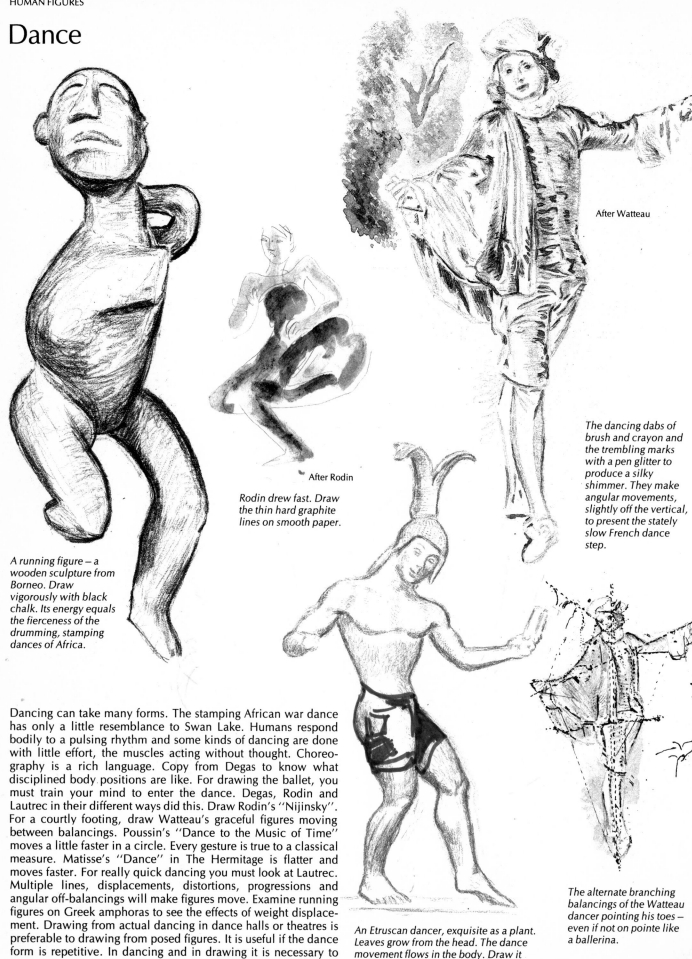

After Watteau

A running figure – a wooden sculpture from Borneo. Draw vigorously with black chalk. Its energy equals the fierceness of the drumming, stamping dances of Africa.

After Rodin

Rodin drew fast. Draw the thin hard graphite lines on smooth paper.

The dancing dabs of brush and crayon and the trembling marks with a pen glitter to produce a silky shimmer. They make angular movements, slightly off the vertical, to present the stately slow French dance step.

Dancing can take many forms. The stamping African war dance has only a little resemblance to Swan Lake. Humans respond bodily to a pulsing rhythm and some kinds of dancing are done with little effort, the muscles acting without thought. Choreography is a rich language. Copy from Degas to know what disciplined body positions are like. For drawing the ballet, you must train your mind to enter the dance. Degas, Rodin and Lautrec in their different ways did this. Draw Rodin's "Nijinsky". For a courtly footing, draw Watteau's graceful figures moving between balancings. Poussin's "Dance to the Music of Time" moves a little faster in a circle. Every gesture is true to a classical measure. Matisse's "Dance" in The Hermitage is flatter and moves faster. For really quick dancing you must look at Lautrec. Multiple lines, displacements, distortions, progressions and angular off-balancings will make figures move. Examine running figures on Greek amphoras to see the effects of weight displacement. Drawing from actual dancing in dance halls or theatres is preferable to drawing from posed figures. It is useful if the dance form is repetitive. In dancing and in drawing it is necessary to move to a natural rhythm.

180

An Etruscan dancer, exquisite as a plant. Leaves grow from the head. The dance movement flows in the body. Draw it with a sharp crayon.

The alternate branching balancings of the Watteau dancer pointing his toes – even if not on pointe like a ballerina.

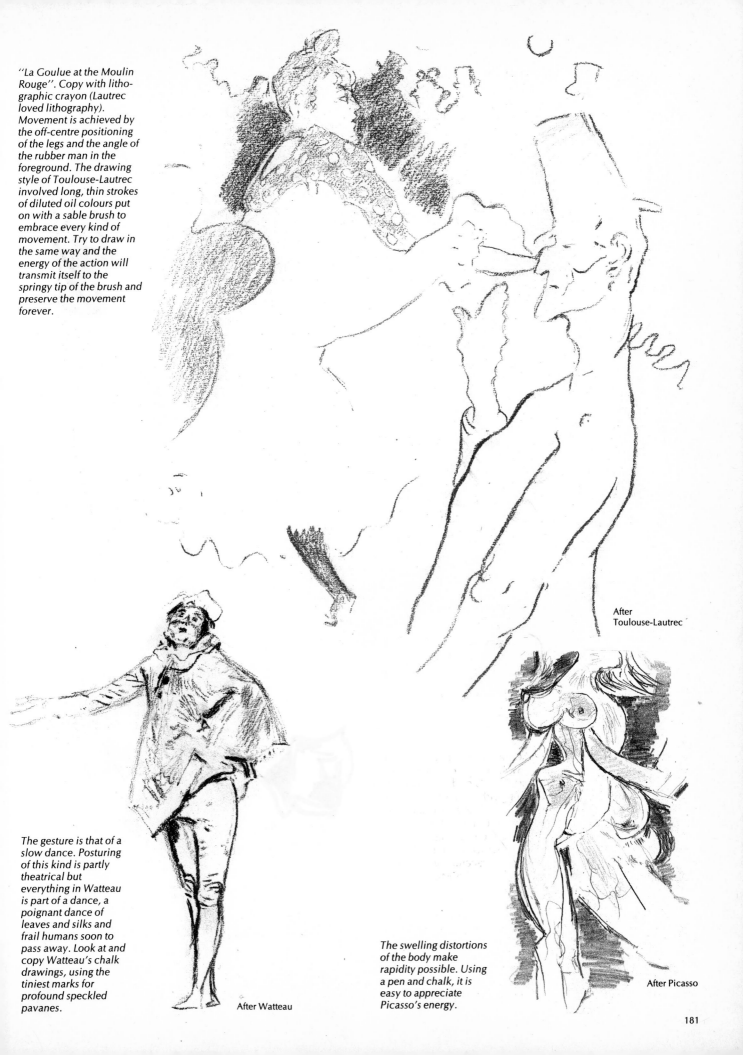

"La Goulue at the Moulin Rouge". Copy with lithographic crayon (Lautrec loved lithography). Movement is achieved by the off-centre positioning of the legs and the angle of the rubber man in the foreground. The drawing style of Toulouse-Lautrec involved long, thin strokes of diluted oil colours put on with a sable brush to embrace every kind of movement. Try to draw in the same way and the energy of the action will transmit itself to the springy tip of the brush and preserve the movement forever.

After Toulouse-Lautrec

The gesture is that of a slow dance. Posturing of this kind is partly theatrical but everything in Watteau is part of a dance, a poignant dance of leaves and silks and frail humans soon to pass away. Look at and copy Watteau's chalk drawings, using the tiniest marks for profound speckled pavanes.

After Watteau

The swelling distortions of the body make rapidity possible. Using a pen and chalk, it is easy to appreciate Picasso's energy.

After Picasso

181

Dance and Free Drawing

Rodin was wrongly accused of making "The Age of Bronze" by casting from a living person. He did not do it, or need to. When he was not doing the hard work of modelling in clay, a girl in the studio would prance or dance, sometimes like Isadora Duncan, sometimes like a classical ballerina, and sometimes she would just move. Then, from memory, and by tracing from one sheet to another, he would draw with a greater freedom than any artist before or since. There is a difference between sketching and fast drawing. Drawing faster than the mind works is disastrous. The haystacks of wrong lines which occur do nothing but annoy. A quick sketch artist will do a worthless recipe fast. Most minds work at a speed which is faster than the hand can move, although Indian tabla players and western pianists must approach speeds where reflex bypasses the brain. Visit a ballet rehearsal or disco, or ask someone to dance for you or move fast for you. Look hard at the moving figure, commit the whole flow of the movement to memory and, in the true spirit of the Tao, draw it with ease in pencil and watercolour. Rodin and Gaudier-Brzeska, both sculptors, and the sculptor-painters Matisse, Modigliani, Picasso and Daumier were fast, often using a single black line. Perhaps working in three dimensions made them able to know their way through and around bodies with a special kind of certainty. Lautrec used intense little swishing brush lines. Bacon used swinging, turning, terror brush marks in his paintings of moving figures. Giacometti knew that the graphite pencil was the fastest medium. Rodin pencil-slipped round the figure fast and filled it with coloured water afterwards. Sometimes he traced from discarded drawings, his pencil scarcely leaving the paper. Rembrandt, Hokusai, van Gogh, Delacroix, Goya, Dufy and Tiepolo all did supercharged fast circuits of the body. There is no need to copy them as fast as they did them – nor any reason why you should not try.

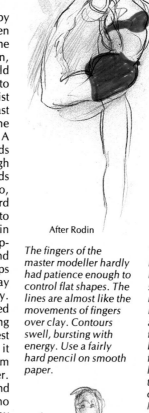

After Rodin

After Rodin

The fingers of the master modeller hardly had patience enough to control flat shapes. The lines are almost like the movements of fingers over clay. Contours swell, bursting with energy. Use a fairly hard pencil on smooth paper.

The watercolour blob manipulated like mobile wax substantiates the line to make a body, slightly like wire but suggesting a dancing figure. Draw from Rodin's small bronzes of dancers with feet held against their heads, for the energy of their handling. And copy his statuette of Nijinsky, following the facets touch by touch around the figure.

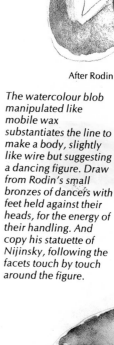

A sketchy figure, ephemeral enough for cursory lines and a few movements of water-colour. Try a similar essay. When there is presence it is finished.

After Rodin

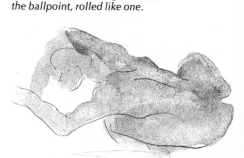

After Rodin

Draw this tensely brushed shape against a pencil line which, long before the invention of the ballpoint, rolled like one.

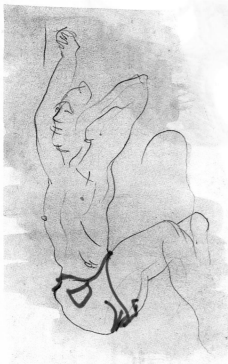

After Rodin

Gaudier-Brzeska might have learned something from this kind of Rodin. The figure is made of liquid lines which make a little poem about the delights of stretching lithe muscles. Copy it with the most vital, vivid lines you are able to evolve, until it becomes an athlete.

After Rodin

Rodin loved to separate pieces of the body or isolate the briefest events as sculptures or drawings. Lines could be faster than moving clay. Roll on your back and draw. Pencil marks are slight but evocative. Gwen John knew Rodin and made tiny pencil-sketched watercolours of fleeting events.

After Rodin

A nubile watercolour blob. Manipulate the liquid against the wire line till it comes alive – tension it like a spring. Rodin's hand power is there to be tapped.

Bath

Be at ease, enter a bath. In its wetness our nerves relax, our wrinkles soften, our pores yawn, our hairs extend and our minds expand. A girl is in the bath. Draw her with empathy; feel the water lapping against your own flesh. Enjoy drawing the water margins encircling the plump islands of breasts, the opalescent suddy lakes surrounding her as she lies there. Draw the melting distortions below the surface. Most of the world is here: soft clouds of steam, water, light and a human being. A bath and a nude is story enough. The subject is splendid. Draw from charcoal drawings by Degas, (his bathers worked hard at sponging) and with scribbling patterns from Bonnard's dream of Marthe in the bath – she practically lived there. Copy the hard, boyish figures hit by shower jets painted by David Hockney in the land where he says they shower all the time.

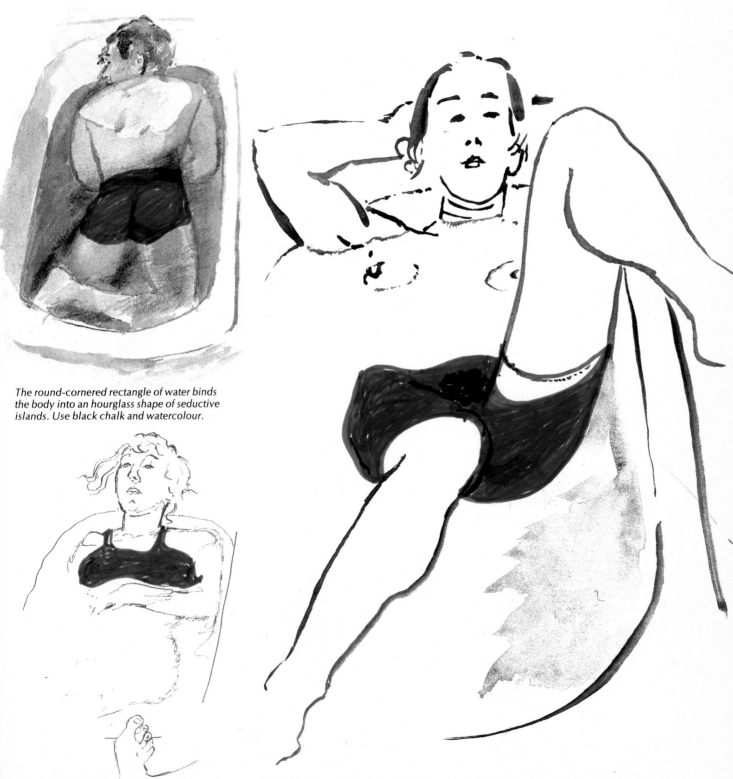

The round-cornered rectangle of water binds the body into an hourglass shape of seductive islands. Use black chalk and watercolour.

Draw with a pen without pause. Fleet intuition will distinguish hair from water, water from flesh, bath from reflection.

A pure brush-tip drawing in diluted Chinese ink. Hesitate and give way for one millisecond of wrong thinking and the drawing is lost. The

paper must be fairly smooth. Look at Zen brush drawing and calligraphy and the brushwork on Greek and oriental pottery.

Sleep

When we sleep we cease to think. Daydreaming becomes deep dreaming. The black velvet night lying over the depths of the sea is there to float in for the calm sleeper. But sleep can be fitful. Storms can cast their streams of lightning over the waters. Dark rainbows span the dark vision. When we die we sleep and then decay or burn. When we sleep we die a little. When we are beset with nightmares and bad dreams our bodies shake in sleep. The night, full of strangeness, goes on without us. Ships pass in the night, moons rise and sink, tides ebb and flow. In the dark nights of winter the black chaos may descend as a chill blank. If you rise early or retire late, a sleeping companion is often available for drawing. The complication of drawing the body can be reduced by the accompaniments of sleep. A pillow can cover a part of the face so that only one closed eye is drawn. Bedclothes can cover with a pattern as much of the body as you wish. Keep a pad and pencil beside the bed.

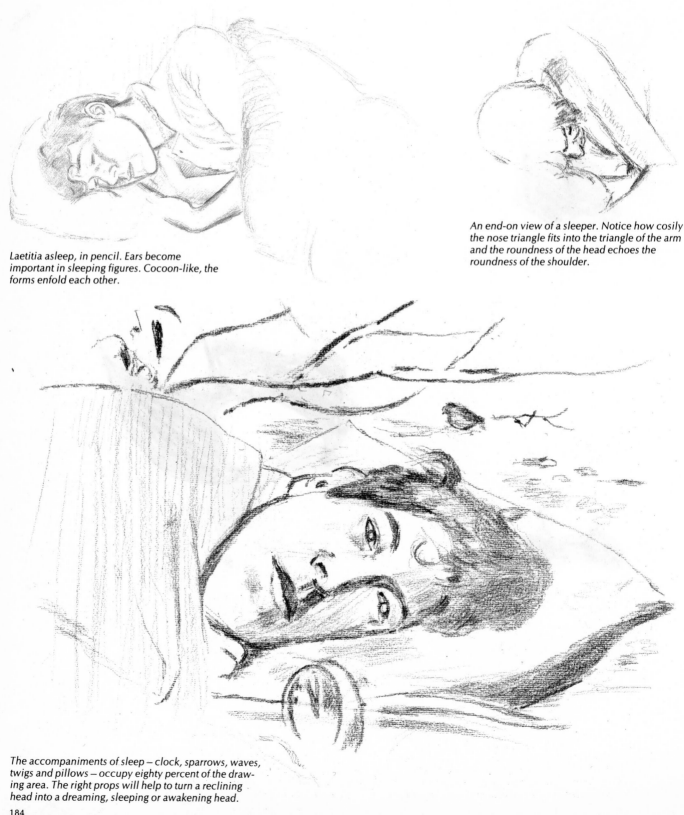

Laetitia asleep, in pencil. Ears become important in sleeping figures. Cocoon-like, the forms enfold each other.

An end-on view of a sleeper. Notice how cosily the nose triangle fits into the triangle of the arm and the roundness of the head echoes the roundness of the shoulder.

The accompaniments of sleep — clock, sparrows, waves, twigs and pillows — occupy eighty percent of the drawing area. The right props will help to turn a reclining head into a dreaming, sleeping or awakening head.

above the sea. The
neck and limbs, violently
even of vertigo.

Foreshortened views from below. Using pen and ink, draw the near forms strongly and overlap the form outlines progressively until a recession is achieved. Small gaps at the intersections will allow the forms to go back. Watch the way the throat enters the underside of the chin.

Venus Supine

Prehistory has its Venus figures, but it is a clearer story after
Giorgione's banana-shaped girl started the series of embodi-
ments of a symbol which has reverberated through time. It is a
simple display. The sexually attractive parts of the body are
placed obviously and in good order. Giorgione balances them

immaculately.
the artist is grea
different guise.
meant Greek d
it is easy to visit

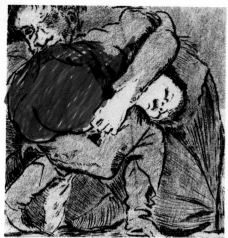
After Goya

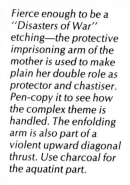

Fierce enough to be a "Disasters of War" etching—the protective imprisoning arm of the mother is used to make plain her double role as protector and chastiser. Pen-copy it to see how the complex theme is handled. The enfolding arm is also part of a violent upward diagonal thrust. Use charcoal for the aquatint part.

The large features of the mother are close to the smaller features of the child. We probably never have security of this kind later in life. Use a sharp pencil on smooth paper to compare the refined edges of the two profiles.

After Millet

Use a bluntish pencil for copying the Millet drawing of a rural occurrence as usual as the daily bread. Eschew slick or elegant lines.

After Rembrandt

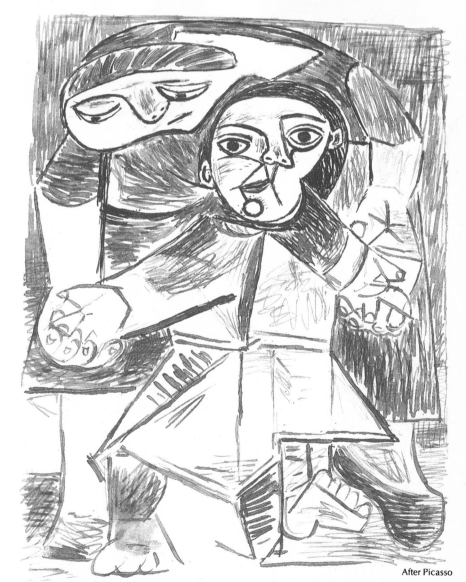
After Picasso

Drawings in ink may be done with quills or reed pens, dabs with fingers or dabs with brushes. Rembrandt always had in mind the Oriental calligraphy in the drawings he owned and the fine handwriting used for documents in those days. This little document has a fast message.

With a large nib and plenty of ink and vigour, draw the young Picasso child tottering on his walk. Draw the staring eyes. You will recognize them as those of the master. The drooping eyes of the mother will continue to worry at his every step through life. The style is a marvellous development of Cubism for humanist purposes.

191

Youth and Age

Copy a part of Gauguin's best-known masterpiece, "Where do we come from? What are we? Where are we going?" It includes, as Shakespeare did, the ages of man. As an exercise, draw the several "ages", making studies from family and friends. Diagram-draw from family snapshots and place those depicted in similar positions for drawing. Compare their profiles for family likenesses. The forehead usually travels forwards with age. In contrast to the lips of a baby which are forward for suckling, old faces sink and sag in folds. But all the eyes will be bright, and who knows the state of the spirit behind the eyes? The frailty of the old recognizes the fragility of the very young. They can both be chubby and make surprisingly rapid movements.

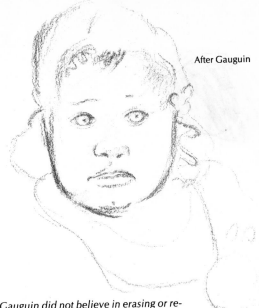

After Gauguin

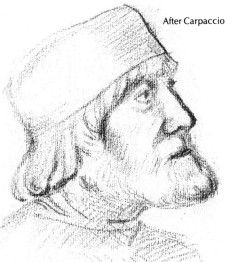

After Carpaccio

Gauguin did not believe in erasing or reworking drawings. The round simplicity had to be achieved in one. Draw the eyes first.

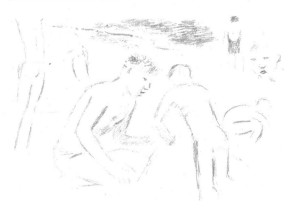

A pen drawing of an old man with a "Punch" nose and large ears. Old ears sometimes seem enormous.

Hatch broadly with a dark crayon. See if you can suggest colour, whiskers, light, shade and structure all at the same time, looking at the surface of a Carpaccio painting. It seems he never needed to repaint — his drawing was so right for use in his painting.

A small drawing of boys building a sandcastle. Children continually repeat the same positions as they play. Start several drawings. It is often possible to continue with a drawing if you encourage a large sandcastle!

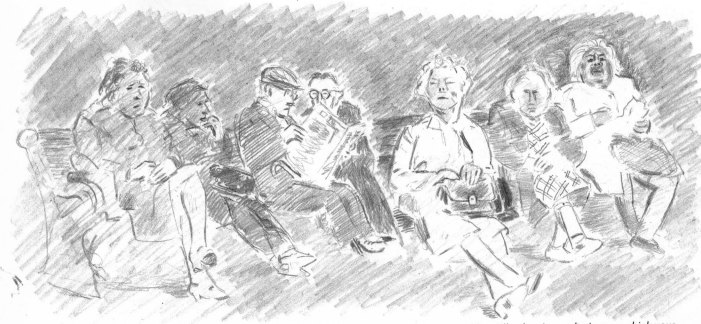

Seven old people sat on a bench on the promenade at Hastings. They thought I was drawing Hastings Castle above them. They were shy: the ladies clutched handbags for protection and the men hid behind

newspapers. Move the pencil rapidly, drawing each piece on which your eye alights. Age groups gather together for protection. Giorgione painted youth, middle and old age for his beautiful "Three Philosophers" in Vienna.

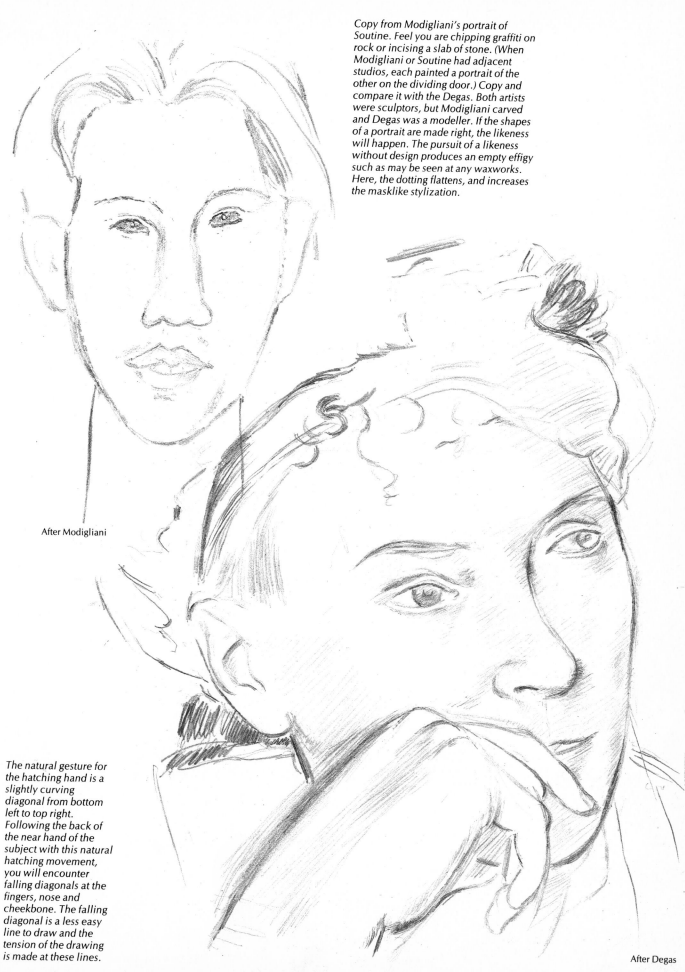

Copy from Modigliani's portrait of Soutine. Feel you are chipping graffiti on rock or incising a slab of stone. (When Modigliani or Soutine had adjacent studios, each painted a portrait of the other on the dividing door.) Copy and compare it with the Degas. Both artists were sculptors, but Modigliani carved and Degas was a modeller. If the shapes of a portrait are made right, the likeness will happen. The pursuit of a likeness without design produces an empty effigy such as may be seen at any waxworks. Here, the dotting flattens, and increases the masklike stylization.

After Modigliani

The natural gesture for the hatching hand is a slightly curving diagonal from bottom left to top right. Following the back of the near hand of the subject with this natural hatching movement, you will encounter falling diagonals at the fingers, nose and cheekbone. The falling diagonal is a less easy line to draw and the tension of the drawing is made at these lines.

After Degas

Sidelit Heads

Picasso combined frontal faces with profiles. These pages are about a full-face countenance. It is an obvious view, which will suffer considerable distortion and masking by shadow without losing its identity or image effect. Because it is symmetrical, one half is enough for its existence. The face can be divided down the middle and lighting can make one half light and the other half dark, and this will still not make it one-eyed. The vertical division to be seen in the line of diagrammed Rembrandts, facing, is at the nose. The nose projects towards you but the straight vertical flattens it. Some of the grand profound edges in painting have been along the central verticals in Rembrandt portraits, where the particles of paint, as pale as light, meet the treacle-dark shadows. Every portrait is a Creation story – the dividing of darkness from light. We love the banality of great art: the low lighting at sunset across the world or across the countenance where the portrayed soul receives the bright light.

Divide a sheet of paper, making one side black using Indian ink. Then draw on the light side with waterproof Indian ink and on the dark side with well-shaken white ink. The vertical at the centre is so exact and parallel with the border lines that any departures from its straightness are clearly visible.

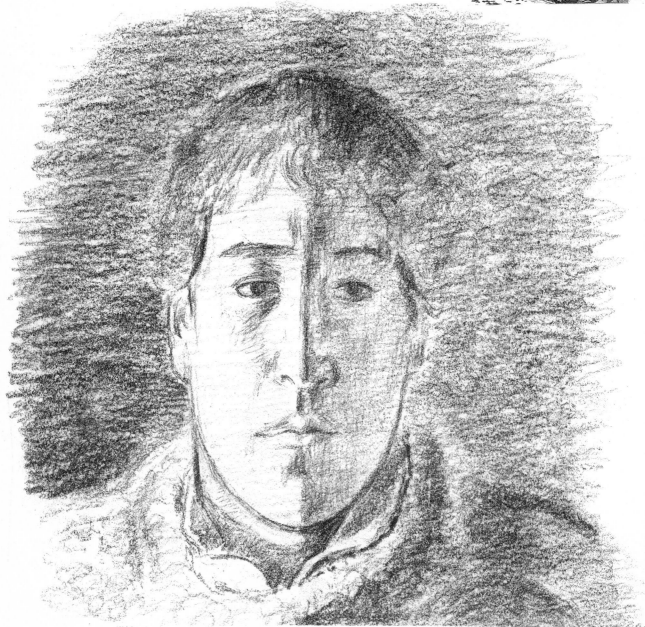

Use conté crayon or compressed charcoal for this exercise. Light your model as exactly as you can, to throw one half of the head into shadow (not blackness). Then stroke your way backwards, making granular marks on rough paper. The eyebrows, mouth and eyes are horizontal. The result resembles a long half moon of light.

196

Like his mother, Rembrandt knows the grave will receive her soon. Sometimes he paints her with a large bible, and it is as if she wears mourning for herself. Draw from the centre. With a well-sharpened black chalk, shade the dark headdress, following the silhouette carefully. It needs a sensitive, exact touch to approach the delicacy of the original. Thick paint does not prevent a marvellous precision in Rembrandt.

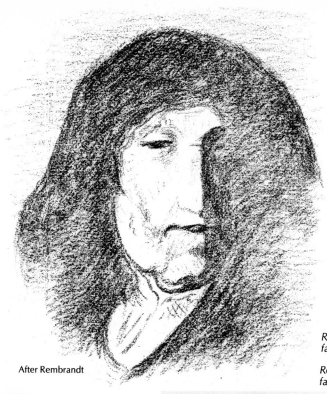

After Rembrandt

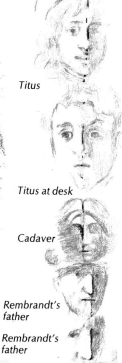

Titus

Titus at desk

Cadaver

Rembrandt's father

Rembrandt's father

Portrait of Agatha Bas

Portrait of old Jew

After Rembrandt

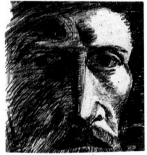

After van Gogh

A self portrait. Van Gogh would have seen Rembrandt's sidelit portraits. Diagram-draw to discover whether the nose caused him difficulty.

After van Gogh

A weaver. The nose makes a cross with the horizontal brow. The loom resembles a pillory for the weaver imprisoned by work.

After Rembrandt

A youthful self portrait with sidelighting

Several examples of the vertical centre in Rembrandt portraits. He often kept the nose as a vertical, even in oblique poses, by inclining the head (see p. 154).

Drawn from Robert Freeman's photograph of the sidelit Beatles on their way to stardom. It is interesting to draw from photographs, which are simplified by processing for the media.

Arrange a mirror and a sidelight and draw yourself. Using Indian ink, make a firm, vertical line and hatch backwards from it until the head accrues. Draw five.

197

Self Portraits

Pissarro was loved by his wife, seven children, by other painters, even by Cézanne who signed himself as a pupil of Pissarro. Look closely at the Pissarro self portrait etching and pretend you are Pissarro, newly arrived home from the fields after standing in mud, painting into the sun. The copper will soon be in the acid. Begin with the round, hooded eye. It is sad and comical to be old but the large white beard is grand. The house is comfortable after the meadow. The children are fine people. You have changed the way the world sees. As you copy the etching, believe you are drawing Pissarro. You will find him remarkably present. His eyes are opposite your eyes.

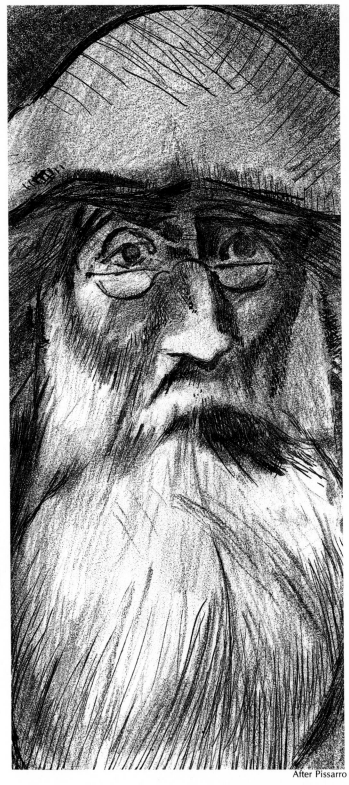

After Pissarro

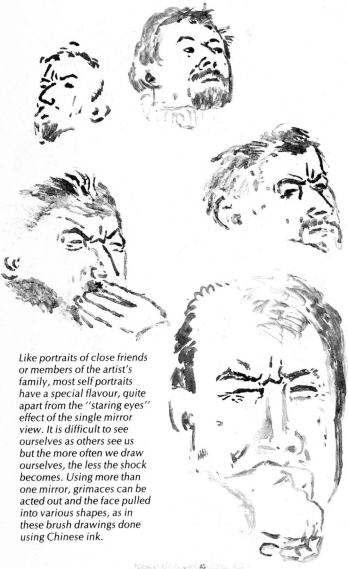

Like portraits of close friends or members of the artist's family, most self portraits have a special flavour, quite apart from the "staring eyes" effect of the single mirror view. It is difficult to see ourselves as others see us but the more often we draw ourselves, the less the shock becomes. Using more than one mirror, grimaces can be acted out and the face pulled into various shapes, as in these brush drawings done using Chinese ink.

A large mirror reflects light on the face when the light is behind the draughtsman.

Three mirrors below and above you

With two mirrors, naked

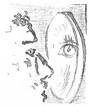

Using a concave mirror

Using a convex mirror

What you see in the chromium of a car

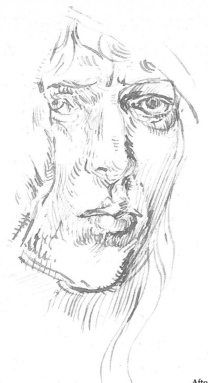

After Dürer

Dürer's ink drawing, done at the age of twenty-one, shows him examining himself with deep concentration. His best-known self portrait was done when he was thirteen years old. My copy was drawn using diluted ink. Building forms within the outlines of a face directly with a pen needs courage, as any mistake is immediately visible.

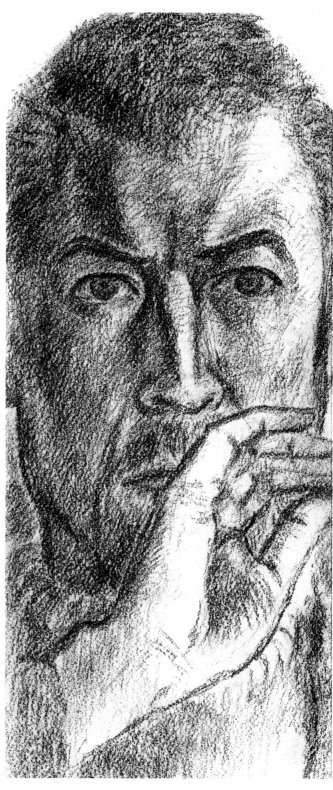

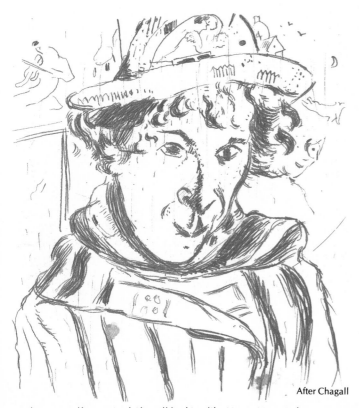

After Chagall

A drypoint self portrait of Chagall looking like Harpo Marx and wearing a hat decorated with memories and dreams. Every scratch on the copper when inked will print and have a special character. Try scratching on paper with a pen or on copper with a needle. Self portraits are opportunities for experiment, trying unfamiliar techniques, and for dressing in unusual clothes.

We can draw ourselves changing with age or altered facial expression. Only in sleep or death do we cease to be possible life models, constantly available for study. As you look at your own mirrored eyes, move the conté crayon over the paper — hard, rough watercolour paper makes a pointillist sparkle even in the darks. The more you work, the thicker and richer the forms become, just as Pissarro's soup needed enough cooking time to reach its full flavour. If you need to erase, fix first then use a typewriting eraser. When you tire of looking yourself in the eye, draw yourself looking up. The forehead rises as the eyes rise, or, when you look down, the cheeks and chin fill out. A turning and tipping head changes its appearance astonishingly. Backgrounds change too. Ceilings, walls, floors or a view through the window — a self portrait out of doors can be the centre of a world.

Faces and Masks

Shakespeare likened people to actors. The attempt to arrive at likenesses is the main occupation of fashionable portrait painters. The struggle to do it by imitating surface effect is usually unrewarding. Witness the many superficial portraits of royalty. Where a painter has designed shapes to make a face, the chance of a real likeness is greater. For our public lives – for professional and social reasons – we assume what we hope is a presentable facial expression, a self-controlled countenance. Cosmetics, beards, dark glasses help the disguise. Only babies, eccentrics, drunks, the ill, mad, dead or sleeping wear natural expressions. The ''presentable'' face is neither completely a mask nor a designed face. It will not make drawing a good portrait easy, but it is partly mask material and however we go about it, drawing a profound portrait which is like the sitter can only be done by modifying some kind of mask.

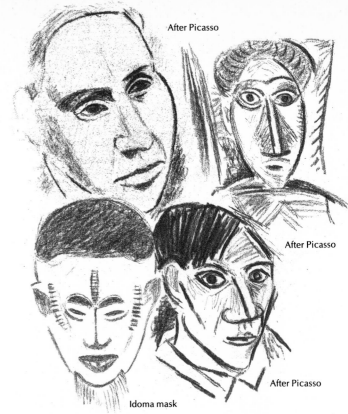

After Picasso

After Picasso

After Picasso

Idoma mask

After Picasso

After Sharaku

Because the Japanese print is already highly stylized, the masks of these faces by Sharaku closely resemble his unmasked faces. Draw them sharply to know the subtle differentiations involved.

The African mask was used by Picasso and Matisse as a device for designing, and delivering the face from illusionism, from imitation, from the waxwork. Picasso's portrait of Gertrude Stein (top) was a fighting breakthrough. He made a mask come alive and made it possible to paint a face using paint to be flat as a mask. Do brush and chalk diagram drawings to understand the beginnings of Cubism.

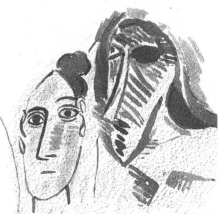

After Picasso

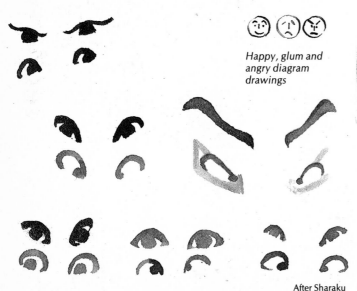

Happy, glum and angry diagram drawings

After Sharaku

Copy some expressive eyes from Sharaku prints with a small watercolour brush and diluted Chinese ink. Make eyes which ogle and gloat or just laugh back at you.

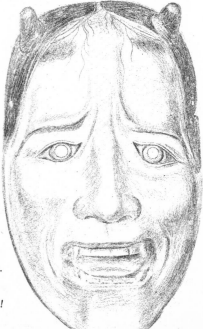

Noh masks are designed for exact expression. Make-up is employed by almost all actors. The natural face is too unreliable for the stage and possibly too unreliable for life! Draw the masks carefully; they are distilled from generations of feeling and thought.

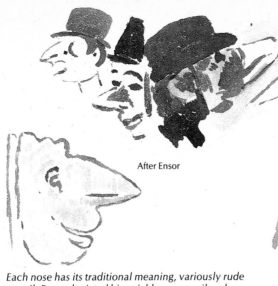

After Ensor

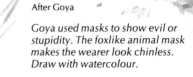

After Goya

Each nose has its traditional meaning, variously rude or evil. Ensor depicted his neighbours as evil and stupid by showing them in long-nosed masks or with long noses. Draw them freely with a brush and ink. Even a very long nose may seem right for a neighbour

Goya used masks to show evil or stupidity. The foxlike animal mask makes the wearer look chinless. Draw with watercolour.

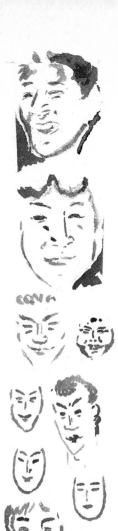

A face almost com-
pletely masked by hair,
hat and dark spectacles

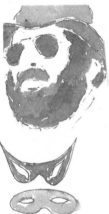

After Goya

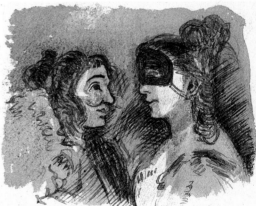

A dark half moon is on a light, waning moon shape. Watercolour it to be mysterious. An eclipse is a moon-masked sun.

Masks for amorous play. Draw with a mapping pen. Masks are unnerving in certain situations. Parties can often become nervy and surrealist.

The masked faces meet each other in the gloom (right). The mystery is deepened by the wash of watercolour veiling the pen lines. Delacroix missed the precision and mystery but this copy was for self-education using "Delacroix style".

Sketch, pen, wash, play with various masks: devilish mask, diamond-studded mask, death mask, gas mask. Think of more.

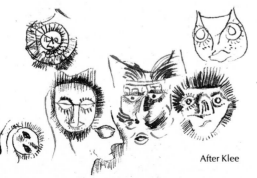

After Klee

Various countenances in a falling procession from laughter to grief. Using a tiny sable brush, try different dabbings with black watercolour to see what kinds of expression occur. Then place them in a similar procession.

Puppet theatre-inspired masks. Copy them with small pen marks. Animal and human heads and probably Klee's own cat were transformed into masks. Klee made a puppet theatre for his son Felix.

After Delacroix after Goya

Humans live briefly, chrysalidded in masks or arrayed in silks like butterflies; they shimmer for a time then die. Draw with a sharpened chalk this pale profile against the small black head. Watteau masks a poignant profundity with silks and satins and the eroticism of the commedia dell'arte.

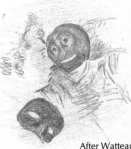

After Watteau

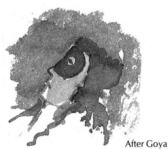
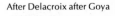
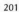

201

ANIMALS

In *The White Peacock*, his first novel, D. H. Lawrence writes of nature and humans with an almost equal passion. Animals abound. In the times of the pit pony, before pesticides, birds and butterflies filled the skies, horses were in field and street. Draw the animals which remain, because animals are good to look at. Broaden your technique to include ways of drawing fur, skin and feathers, and increase your awareness by drawing their variety and degree of resemblance to human forms. This may only be apparent in the skeleton, although so keen is the mind of man to anthropomorphize that there are scarcely any animals whose two-eyed bodies do not suggest human personality.

The giraffe at the zoo

Unless you live in a game park, do not hope for giraffes to wander by. Supposing you feel a giraffe to be wonderful and exotic and worthy of a visit to the zoo, you must go there. Then, as he sways, experience your first momentous encounter. He should really be eating tree tops. Make some scratches and scribbles. Take some colour slides and project them at home. Sketch from a wild animal book at a library. Scribble your way to information. Any scrap of paper will do. Return again to the zoo, to the swaying giraffe. This time have with you a little board, paper, clips and a soft pencil. Do not be distracted if the visitors stare at you more than at the animals. Draw the giraffe. Draw those elements which excite you. If he moves, keep drawing. If your paper becomes filled with lozenge shapes, accept them as what you do. In one drawing you might be involved with the large eyes, leaf-shaped ears and branchy horns; in another it may be the long neck with its camouflage of forest shadow play which receives all your attention. Giraffes are strange animals. Be prepared to accept the wildness of the drawings which occur. If drawing the bizarre does nothing else for us than to make us accept our drawings for what they are (wild by natural response), if we are surprised, there could be no more valuable lesson.

Humans are animal

We identify with mammals and would wave the tails docked by evolution from our backbones in anger or pleasure if we possessed them. Our skeletons resemble a little those of other mammals. It helps us to draw if we feel intuitively that we are the animal we are looking at. We have enough hair left on us to feel, as a personal body experience, the furry qualities of fur as we look at it. Our hairs stand on end, as dogs' hackles rise, when we are frightened. Our hairs become the drawn hairs of the animal as we draw by empathy.

Where to find animals

Animals are wonderful to draw and extremely difficult. Decide how you will find the animal. In the window of the petshop are hutched guinea pigs, a polecat, kittens, parrots, mice. Perhaps it is the rabbit you want to draw. Draw it quickly through the glass, as fast as Bonnard's rabbits, as fast as the rabbits of Matisse. You did not buy the rabbit. Perhaps you will borrow the one next door. Or buy a rabbit from a butcher. Draw the various textures of fur and whiskers with a brush on damp paper or, using pencil or crayon, follow the growth directions in the pelt. Discover how to keep shading for solidity and shading for fur texture clearly different but combined. Find how to harden the touch for the lips and the short hairs of the legs and paws and sharpen a point for the glazed eyes and eyelashes. In forming the nut-shaped head, remember the hare by Dürer. Cats and dogs are noble sitters, generously presenting themselves at the clink of a pet food tin. Spill a little cream on the fur of your cat and she will wash happily, long enough for her elegant stroking licks to be followed with a moist brush and watercolour to make fine hairs, fur and whiskers on damp paper. Or with less contrivance she will curl up in the most comfortable warm place. Cats are probably the most available and the most beautiful animal subjects. Gwen

John, Klee, Hogarth, Balthus and the Egyptians show the range of meaning and mystery they inspire. Drawing cats is comfortable on winter days. Draw the cat on your lap. For a sleek Siamese, take smooth paper and a thin propelling pencil; for a fluffy Blue Persian, rub soft pastel and charcoal on David Cox paper or Ingres paper or sumptuously work gouache or pastel into mounted silk. Dogs today are often well trained and will stay, sit, lie and come to their owners. Draw all these positions and draw them sleeping. Horses are bred for riding, hunting, polo, racing and show-jumping. To draw horses well, have a horse, visit a horse, look at a horse, even ride a horse. Stubbs' *Anatomy of the Horse* and Muybridge's *Animals in Motion* may also help. Cows and sheep move less fast. Visit them in their fields for some quiet drawing. Reptiles are supernaturally still and very fast. A lizard can seem more still than the log it clings to. To draw rare birds needs all the aids, hides and binoculars of the professional bird-watcher. Other birds come to a half coconut. Feathers drawn singly make you conscious of the lightness of birds. Intangible as skies, birds need delicate, airy marks to depict them. Domestic birds are often kept in pens. They are heavier and do not move far. Other ways of learning about animals are listed – the abattoir, battery farm, laboratory, fish shop, butcher's shop and the hunt.

An animals in art index

Having located your chosen animal, broaden your study by copying from art. The collectors of animals for zoos know what jungles in the world to search in for every animal. With a massive knowledge of art, it is possible to find superb representations of almost any animal you want. Horses are everywhere in painting and sculpture. Consider the Chinese sculptures of horses, the horses of St Mark, Venice and look at Stubbs, Pisanello, Poussin, Lautrec, Degas, Leonardo, Verrochio, Uccello. In pictures animals make visual commentaries on humans, for example "Leda and the Swan" and "Europa and the Bull". The dog is man's best friend and most frequent companion in art. In a Titian portrait of a man, the dog increases his stature and virility, reminding the owner of hunting days. Rubens used a pack of hounds to activate a landscape, to show the flux of nature, red with claws. For dogs look at Velasquez, Manet, Goya, Piero di Cosimo, Cézanne and Bonnard. It is easy to find dogs in art but where do you go for an anteater? The following are some examples: Leonardo – an ermine; Courbet – a parrot; Delacroix – a tiger; Dürer – a squirrel; Seurat – a monkey; Bewick – a mole (or almost any animal or bird); Manet – a crow; Ensor – a skate; Courbet – a trout; Dürer – an owl; Brueghel – a monkey; Pisanello – a wild boar; Rembrandt – a lion; Giovanni Bellini – oxen; Botticelli – a peacock; Lu Chin Pu – a bear; Pisanello – a cheetah; Brueghel – a whale; Poussin – a goat. Gothic, Indian, Persian, Egyptian, Chinese and Japanese art is full of beautifully made animals. Carpaccio's murals are painted worlds where men, trees, houses, skies, donkeys, deer, lions, peacocks, dogs, horses, parrots, greyhounds all live together – a fair, mixed, balanced world of living things which we have lost in life but yet may enter with drawing. Trompe l'oeil artists such as the American, Michael Harnett, are very accurate and can be useful to draw from. Chardin combined living and dead animals in his early still life pictures, learning as he worked. Most great artists have made mixtures of birds, animals and humans for special meanings. Men and horses become centaurs. Men and birds become angels and archangels and with claws become devils. Man and bull become Minotaur. Hieronymus Bosch was the greatest breeder of monsters ever. Try copying a lizard man from Bosch. The centaur was a difficult mixture. On the Parthenon it is entirely convincing. Poussin did well. But if you feel inclined to accept the challenge of a lifetime, try joining the top of a man to the body of a horse in a drawing without making it comical.

Cats

It is a privilege to have a cat living with you. The fur disguises the cat's muscularity. Fluffy as the animal may appear, the fluff conceals claws and the ability to spring and kill. Cats are creatures of night and their stealthy movements suggest mysteries. The secret of drawing cats lies in the stroking. Cats like it and you become aware of the depth of hair and the way it lies and the way it can bristle with fury or expand with ecstasy. Begin with the docile pussy, contented paws under chest, tail wrapped around on a lap or another warm place. Draw the nocturnal slit eyes. A pencil will distinguish between the smooth nose, its short hairs, and the longer ones of the forehead. Stroke backwards to the shoulders and then make long strokes for long hairs. It is easier to see the structure in the short-haired varieties. For long-haired cats, combine soft pastels and gouache using a damp, not a very wet, brush. Mixing media can be useful.

Children learn to draw cats by making two circles. A circle in a square swells. If opposing arcs cut it four times, its swelling ceases. The shape left is frequent in Klee's pictures. Sometimes these have cat titles.

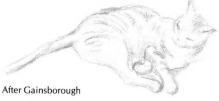

After Klee

After Gainsborough

Draw with ink this slit-eyed ornamental puss with convoluted earlines.

An elegant crayon vitality moves through the stripes and tail. Turn its head crisply to make it ready for play.

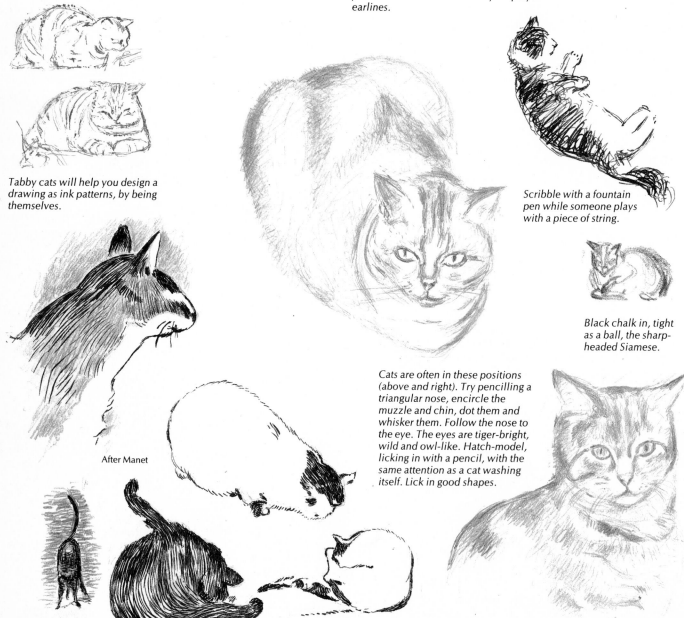

Tabby cats will help you design a drawing as ink patterns, by being themselves.

Scribble with a fountain pen while someone plays with a piece of string.

Black chalk in, tight as a ball, the sharp-headed Siamese.

After Manet

Cats are often in these positions (above and right). Try pencilling a triangular nose, encircle the muzzle and chin, dot them and whisker them. Follow the nose to the eye. The eyes are tiger-bright, wild and owl-like. Hatch-model, licking in with a pencil, with the same attention as a cat washing itself. Lick in good shapes.

Draw with a pen and carbon pencil the black witch mystery cats from Manet's etchings inspired by Edgar Allen Poe. The lowest ones wash themselves. The tail rhymes with the leg.

The little one resembles the cat in Manet's "Olympia". To draw cats you must have a fur-soft touch, a sinewy strong touch and a claw-sharp touch.

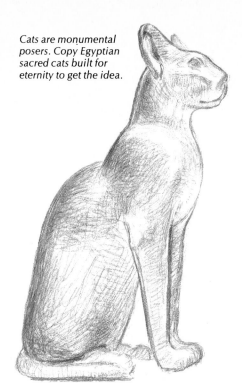

Cats are monumental posers. Copy Egyptian sacred cats built for eternity to get the idea.

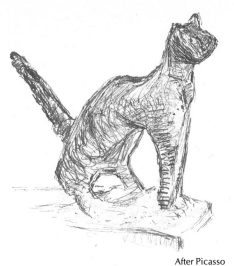

After Picasso

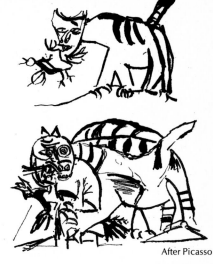

After Picasso

Model with the crayon as if you were handling clay, stroking it around in space, watching – like a cat stalking a bird – that the stealthy, wild cat, coiled-spring tension is achieved.

Cats are wild as tigers and only pretend to be pets. Picasso synthesizes wasp-pattern-boned villains to act out bullfights. Draw them hard with a black pen.

Look at Klee's pictures and diagram-draw in ink the cat shapes whenever you recognize them. They take many forms: cat men, cat women, cat mountains, cats like sacred circles, circles cut by arcs to limit their roundness. Klee was inspired by his cat. Its shape crept into many of his pictures. He was a transforming artist, quite capable of having in mind man, heart, cat, fish, owl, moon and other ideas in one picture.

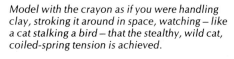

After Klee

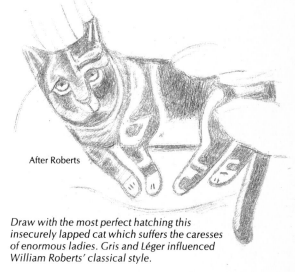

After Roberts

Draw with the most perfect hatching this insecurely lapped cat which suffers the caresses of enormous ladies. Gris and Léger influenced William Roberts' classical style.

The Romantic animal lies relaxed and mysterious, like a wild sunset in deepest Africa. Cézanne took marks from Delacroix whom he admired. Use a small watercolour brush, a free Chinese calligraphy and wash in the rocky background. It is interesting to draw from wild cats, tigers and other big cats at the zoo. Gaudier-Brzeska did fast drawings there.

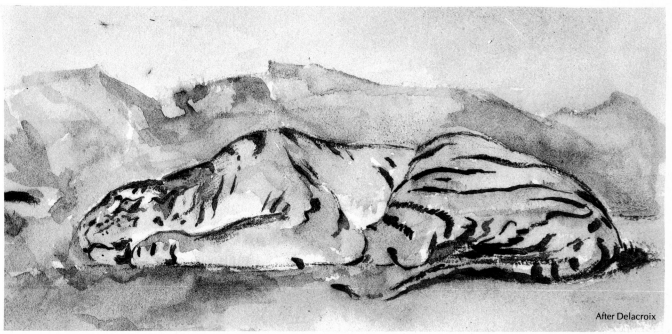

After Delacroix

Dogs

Pat dogs to find out their form – but not with your drawing hand. A Dalmatian is pale so it is easy to see the structure. Draw him well. Refrain from thinking his expression human or disdainful. Use a conté pencil and build up the forms, being careful not to destroy them with a misplaced dot. He is a well-formed, "dog-like" dog. Patting dogs is useful in the same way as stroking cats – you get to know how they are made. Discover from a dog book the anatomy and part names. All dogs have a muzzle, stop, dome and withers. Not all have flews. The "stop" is where the muzzle meets the forehead. Men have bred and modified dogs extravagantly. Many live out of tins and insist upon being "man's best friend". When they wanted a noble portrait, Titian or Velasquez might put a tall dog nearby to give stature and dominance. Wherever there is a dog in art there is a reason, and the dog often looks as if it knows it. Craigie Aitchison's painting of his Bedlington, Wayne, shows the dog nobly posed and accompanied by about forty square feet of a beautiful red paint. The drawn presence results from brushing and rubbing the paint urgently, shape against shape, until the grey Wayne-shape tunes in with Aitchison's vision of his dog. The secret is in the edges.

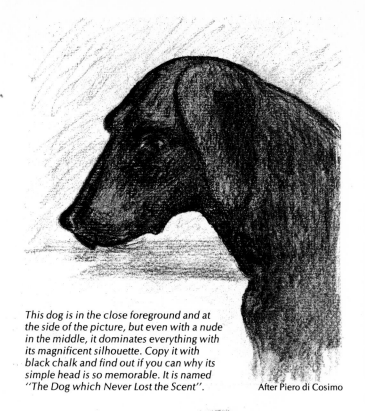

This dog is in the close foreground and at the side of the picture, but even with a nude in the middle, it dominates everything with its magnificent silhouette. Copy it with black chalk and find out if you can why its simple head is so memorable. It is named "The Dog which Never Lost the Scent".

After Piero di Cosimo

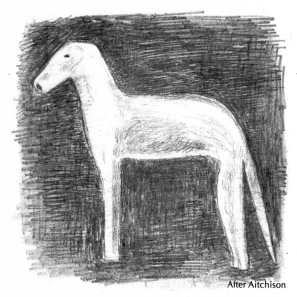

After Aitchison

Unshaded, unmodelled surfaces allow colour shapes to be simple and clear. In copying, make a texture of the backgound areas so that the light image makes its presence felt. If the shape is designed strongly enough, little modelling is needed to make the dog real.

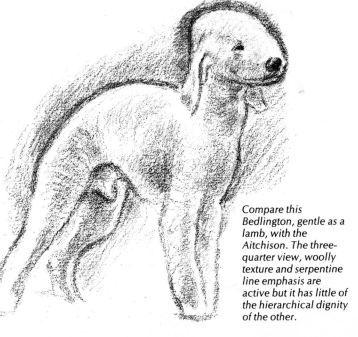

Compare this Bedlington, gentle as a lamb, with the Aitchison. The three-quarter view, woolly texture and serpentine line emphasis are active but it has little of the hierarchical dignity of the other.

Scribble-draw dogs to see how varied they are. They make all kinds of arrangement possible in pictures. Think of the tiny dog at the bottom of a Goya full-length portrait, or Picasso's dab-dot Dalmatian.

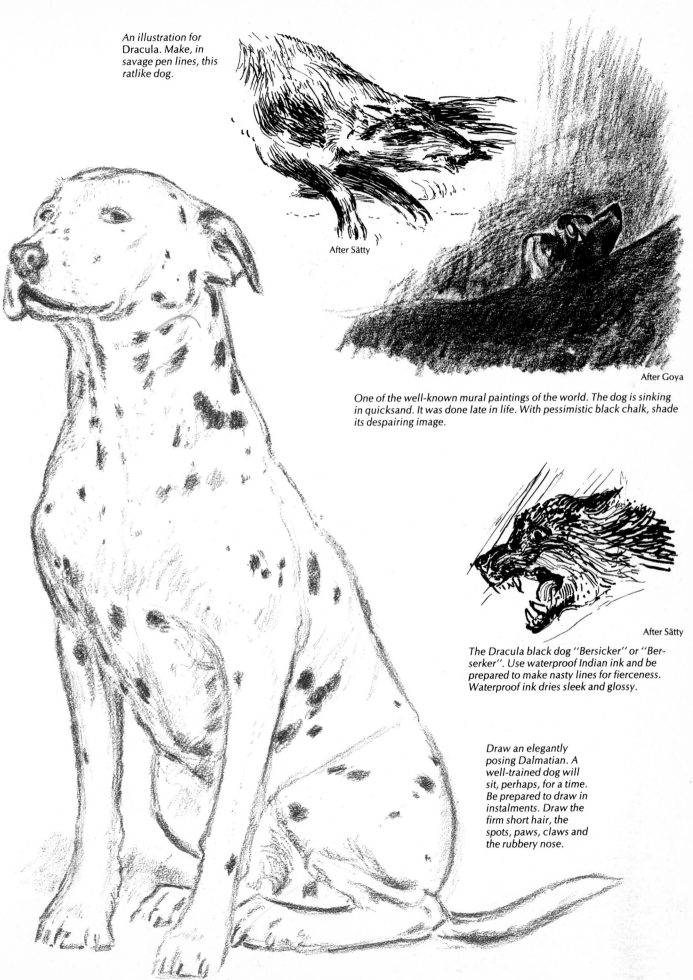

An illustration for Dracula. Make, in savage pen lines, this ratlike dog.

After Sätty

After Goya

One of the well-known mural paintings of the world. The dog is sinking in quicksand. It was done late in life. With pessimistic black chalk, shade its despairing image.

After Sätty

The Dracula black dog "Bersicker" or "Berserker". Use waterproof Indian ink and be prepared to make nasty lines for fierceness. Waterproof ink dries sleek and glossy.

Draw an elegantly posing Dalmatian. A well-trained dog will sit, perhaps, for a time. Be prepared to draw in instalments. Draw the firm short hair, the spots, paws, claws and the rubbery nose.

207

Horses

A horse is a special animal. It makes possible the silky finery of the sport of kings and the grand equestrian portrait. It confers nobility. Copying from art is essential for drawing horses. Degas is the most useful artist to copy. For him, the horse was part of the Parisian street scene and the racecourse and he was one of the first artists to have had the advantage of knowing by photography the way a horse galloped. If you approach a horse in a field with a sketchbook and no preparation, you will be sorely tried. The legs seem to point all ways and the animal, which seemed still, rapidly becomes a baffling mover. Toulouse-Lautrec could brush in horses from babyhood, but he lived in a family of horse-riders. Stubbs, a sure master of the horse, dissected so thoroughly that his drawings are still used in veterinary colleges.

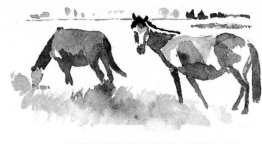

Monochrome watercolour and a sable brush will suggest the sleekness and rhythm of the horse, and even the sunlight and shadow if you allow it to happen. Slowly moving horses are useful to start with. Copy with a slow sable brush the beautiful rounded bodies of the horses in Uccello's "Routs of San Romano".

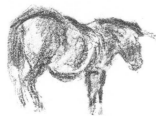

A pony scribbled with a conté crayon. The dark marks must make the shape, solidity, fur and tone of the animal.

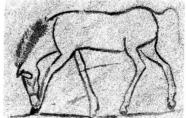

A brush drawing on plaster from a tomb. Copy the equal lines using watercolour on rough, whitened paper to simplify your drawing. The Egyptians did not use shadows.

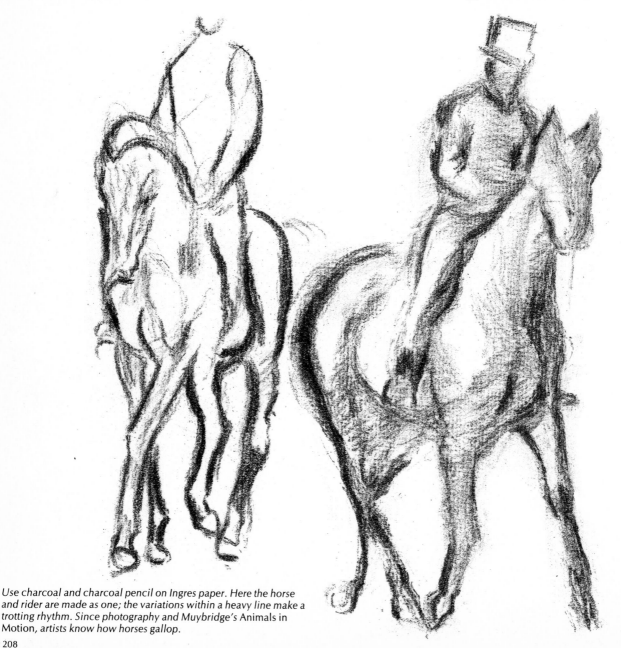

Use charcoal and charcoal pencil on Ingres paper. Here the horse and rider are made as one; the variations within a heavy line make a trotting rhythm. Since photography and Muybridge's Animals in Motion, *artists know how horses gallop.*

After Degas

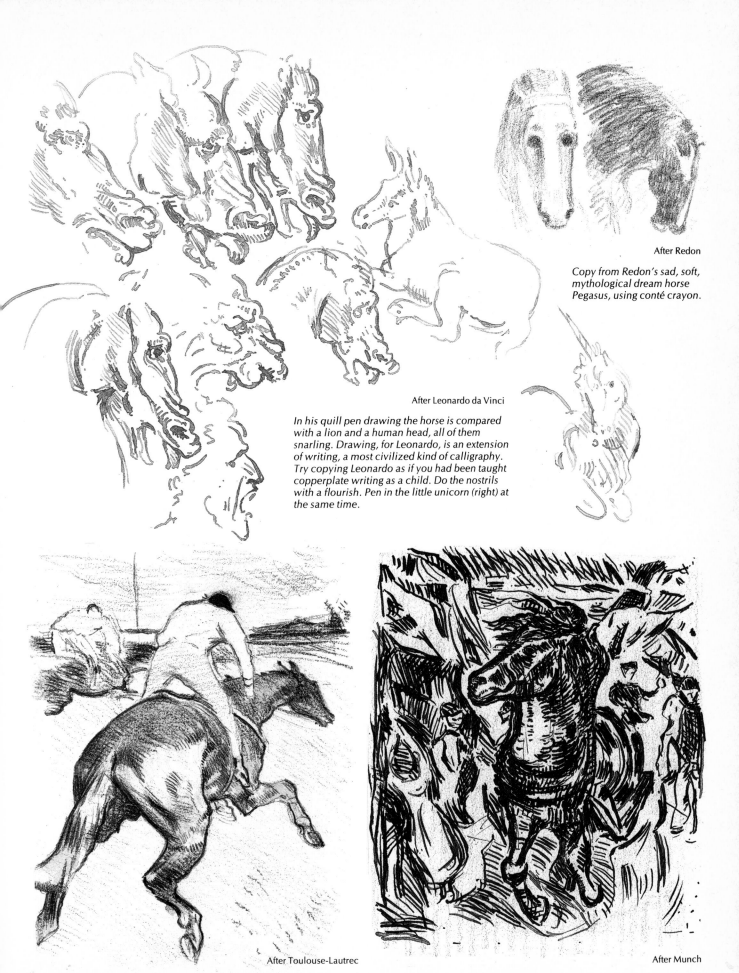

After Redon

Copy from Redon's sad, soft, mythological dream horse Pegasus, using conté crayon.

After Leonardo da Vinci

In his quill pen drawing the horse is compared with a lion and a human head, all of them snarling. Drawing, for Leonardo, is an extension of writing, a most civilized kind of calligraphy. Try copying Leonardo as if you had been taught copperplate writing as a child. Do the nostrils with a flourish. Pen in the little unicorn (right) at the same time.

After Toulouse-Lautrec

The energy of Lautrec's astringent line is used for the gallop into the picture. The nose, foreleg and jockey all spring into the distance, away from the large haunches. Copy the bending perspective.

After Munch

Etched lines are made with a needle and are equal. Bunching in progessions makes them more forceful. Whatever the horsepower of a vehicle, in drawing an artist can make a horse gallop faster.

Cows and Bulls

When we look at animals we anthropomorphize. The prehistoric cave drawings were bulls. Bulls are unlike cows. Fields are full of cows, man-conditioned to be milk producers. Find a bull, solitary in its field. Dare to sit on the gate and draw him. He is the symbolic centre of the Spanish ritual, the bullfight, which exhibits danger, heroism, skill, death, suffering, sexual strut and a butchered mess. Picasso was able to express all this, using the bull with imagination, even combining man and beast to become the Minotaur. Draw the compact, tense bulls from Goya etchings and see how Picasso evolves from them. It is only as you draw the back and neck of the soft-eyed cow that you sense the cow and bull to be the same animal. The bull is a male, lustful, bellowing symbol. Use black ink for the bull, pencil for the cow, Cuyp's dream animal of golden evening stillness.

Cows and bulls fit opposing triangles. Both have square backs. Diagrams help us to see. Then we decide, by looking, what the real shapes are.

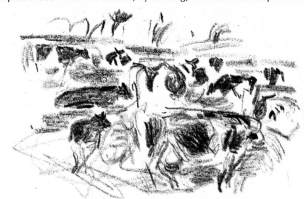

Herds of cows at a distance make patterns in distant fields. Find a suitable thumbnail notation.

A scribble will make a patch on a cow. Strike horizontals for the bony back. Contrasts will make a bright day – light cows will take the sky tone below the horizon, cud-chewing cows merge with the hatched grass.

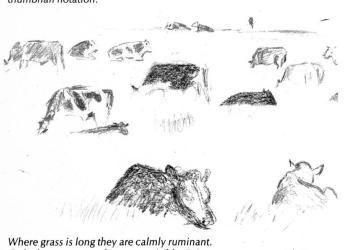

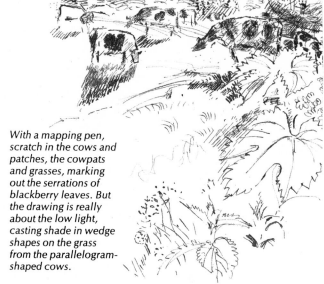

With a mapping pen, scratch in the cows and patches, the cowpats and grasses, marking out the serrations of blackberry leaves. But the drawing is really about the low light, casting shade in wedge shapes on the grass from the parallelogram-shaped cows.

Where grass is long they are calmly ruminant. Only the easy parts of cows are visible. Enjoy drawing their tops, watching the spaces left.

Jersey cows look gentle and these famous cows have gentle names: "Daydream Cow", "Content of Oaklands". They respond to delicate drawing with a hard, sharp pencil. Look at the throats in Egyptian bas-

reliefs. The round eye is harmonic with its concentric incised arcs. Draw keenly as if you were cutting fine lines in marble. Try for a smooth rhythm when you draw these short-haired animals.

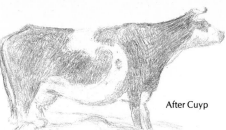

After Cuyp

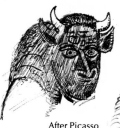

After Picasso

After Picasso

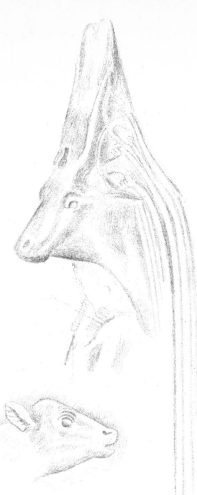

The light area crosses the body. The lightness of the belly lightens the pictorial weight of the cow, making it easier for Cuyp to compose bright golden evening skies.

The Minotaur was half man, half bull. Draw his frown and nostrils in black ink.

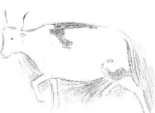

After Brueghel

This delicate, pale animal gives enormous scale to the picture it comes from. Cows are so familiar to us that however small they are drawn they act as clear spatial indicators. Brueghel relates cows to peasants harmoniously – sitting to milk, standing to lead.

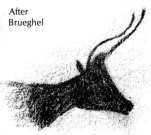

From Lascaux, 13,000 BC. Use charcoal on rock to feel like a prehistoric man drawing a bull.

Picasso was a Spaniard living in Paris. It is almost as if he wanted to assert his Spanish background. Staring, for photographers, as if he was a matador, he even insisted that bicycle handlebars and a saddle could be an equivalent for a bull's head. Here it is shown with a bull's head and a Chimera (obviously a transformed bull). Compared with real Jersey bulls, they obviously come from art.

The ancient Egyptian cow goddess, Hathor. Draw with a hard pencil, as if sculpting the hard rock into a monumental image. She was as benevolent and generous as the long rising rhythms in the stone, so curiously hard for a kind goddess.

After Constable

This copy is life-size. The sketchbook is the size of a hand's palm. There is enough information in it to synthesize a grand painting. Constable said he did not feel at work unless painting a six-foot canvas.

A cow patch from an American quilt. Woof and warp help design a cow.

After Bewick

Draw a little strength from this etched bull by copying it.

After Goya

Even a little bull can be fierce. Draw it tensely with rounded black hatching in ink.

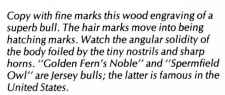

After Bewick

Copy with fine marks this wood engraving of a superb bull. The hair marks move into being hatching marks. Watch the angular solidity of the body foiled by the tiny nostrils and sharp horns. ''Golden Fern's Noble'' and ''Spermfield Owl'' are Jersey bulls; the latter is famous in the United States.

Sheep

At Bodiam Castle beside the moat, sheep graze peacefully. The girl sleeps as the pencil draws. Sheep are fluffy ovals on their hard, thin legs. On Romney Marsh sheep bleat as far as the horizon. Every animal looks sheeplike in a different way. To draw them is not easy. The shorn sheep are as surprising as shorn poodles and have unexpectedly muscular jaws where so much chewing goes on. Shearing alters the natural sheep shape. We feel sorry for sheep: biblically human in their frightened wish to be close to other sheep in this calamitous life, they are sheepdog trialled, dipped, shorn and drenched. Days when the dykes reflect sheep and sky, skies full of sheep-shaped clouds, during summer in Samuel Palmer country – these are the days for drawing sheep. Use soft conté crayon on rough paper. Make wool-soft ovals and draw their legs and noses as sharply as you can.

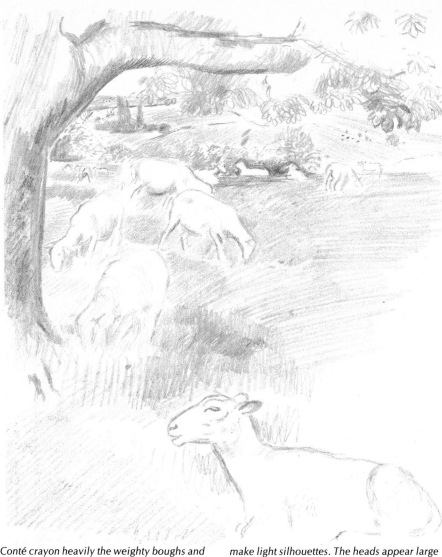

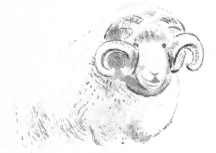

Spirals are always mysterious – the points spiral towards you. Use coloured pencils.

Conté crayon heavily the weighty boughs and tree bole to make a robust contrast with the thinned, shorn animals. The dark shade will

make light silhouettes. The heads appear large with their fleeces gone.

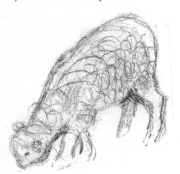

Scribble with a pencil until you have wool, then search for the body shapes.

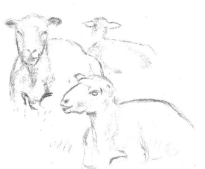

When chewing the cud sheep move less. Use a pencil.

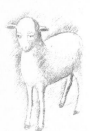

After Petrus Christus

Copy the lamb of Christianity, using it as a standard to depart from.

After Titian or Giorgione

Copy the interlocking jigsaw sheep shapes from ''Moses and the Burning Bush''.

Use black crayon for the wool on rough paper.

Perhaps Bodiam Castle has always been surrounded by sheep. Draw with black chalk. The low viewpoint makes it possible to see the girl shape close to the sheep shapes. The central, vertical cylinder of the tower makes stillness, as does the horizontal modelling gradation of the main sheep. Artists who fear that nostalgia will muddle their message rightly avoid castles, but castles and ancient monuments can be wonderful to draw because great artists such as Turner, Cotman, Corot, Cézanne, Mantegna, Claude and Ingres have drawn them throughout history. Castles need not date drawings. Dufy watercoloured the Tower of London and Picasso lived in a château.

Dark, scavenging crows contrast with the pale wool of the traditionally innocent sheep. Sheep and crows mark out this rounded field with constant visual stimulation. The foreground girl is striped and echoes the lines of the fencing.

213

Birds

A smooth flight of ducks is a popular ceramic wall decoration. We escape by flying imaginatively like birds to realms somewhere over the rainbow, beyond the clouds, beyond the blue. In art, the good birds are white and the bad are black. Ravens go with witches. Bosch's shrike is a death bird. Draw the dawn or evening fly-round of birds. At a distance, draw them as dots and dashes. When they are closer, make equivalents for their movements across the sky. Songbirds and pigeons are rounder than seagulls. Swifts are as sharp as new moons. Draw their flight paths. Hang up bags of peanuts or see what comes to your bird table. Draw some stuffed birds at the museum and correct the taxidermist. Visit aviaries. Linger by a petshop; draw the parrot. The Chinese use feathers to draw with.

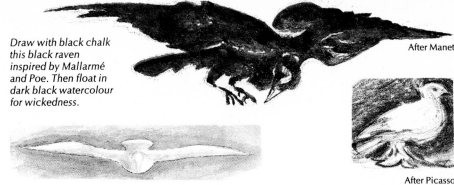

After Manet

Draw with black chalk this black raven inspired by Mallarmé and Poe. Then float in dark black watercolour for wickedness.

After Piero della Francesca

Pale but polished like an icy cirrus cloud, burnished by Brancusi to be pure and holy, it radiates gold lines. Draw it cleanly.

After Picasso

The dove of peace, used for a poster. Picasso kept doves as pets.

Birds are in harmony with the elements — floating like clouds or, like the black-backed gull, undulant like waves. Here, rounded as the egg they are guarding, they are in tune with the pebbles. Draw the nest with black chalk.

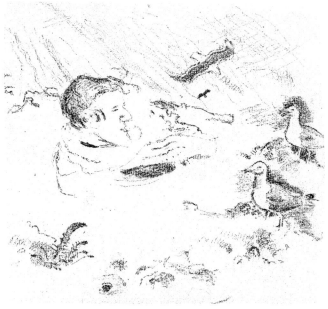

After Picasso

Blood pours. The pale skull is pecked. Fill in the black raven head to echo the pale skull.

After Bewick

Pretend your pen is printing the tiny raised pieces of wood of this engraved duck.

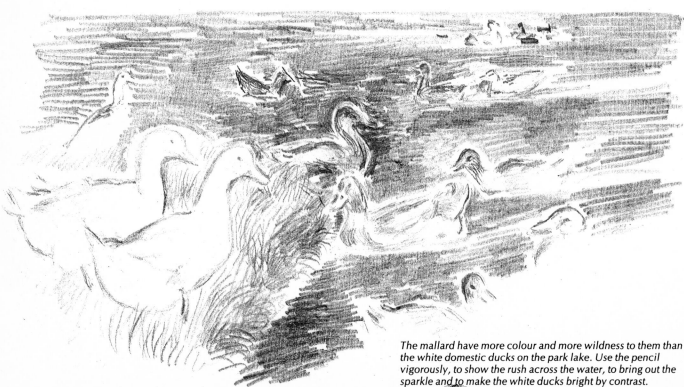

The mallard have more colour and more wildness to them than the white domestic ducks on the park lake. Use the pencil vigorously, to show the rush across the water, to bring out the sparkle and to make the white ducks bright by contrast.

Because Braque's studio was in Normandy where sea birds could be seen daily, his paintings gradually became inhabited by imaginary birds. Draw this shape, light against dark. Seagulls at dawn fly frantically across the sky with extended neck and head, and wings tense. The wings are a moon shape, the tail a triangle.

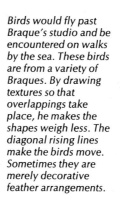

After Braque

Birds would fly past Braque's studio and be encountered on walks by the sea. These birds are from a variety of Braques. By drawing textures so that overlappings take place, he makes the shapes weigh less. The diagonal rising lines make the birds move. Sometimes they are merely decorative feather arrangements.

After Braque

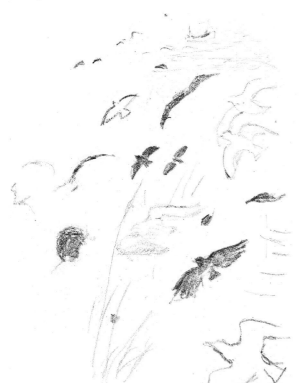

At the cliff edge, currents of rising air will support seagulls and they do not need to move so quickly. It is easier to draw them from a cliff – being on their level you can see them from above and below. The black jackdaws totter, topple and swoop.

After Brancusi

An egg is a bird at its simplest. Inscribe ovals and ovoids to resemble Brancusi's "Penguins".

After Brancusi

Draw with inspiration and aspiration this smooth sculptured bird.

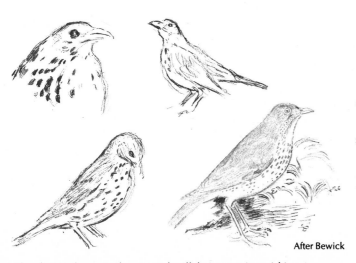

After Bewick

After Klee

Thrushes are happy in the rain and spill their songs in ravishing sequences of notes, their breasts speckled like the notations of medieval music. Draw them cracking snails, dark feathered above and light below for camouflage. Copy them sleekly from Bewick.

Draw with conté crayon the mysterious, rounded Brancusi-like form of a bird sculpted in the Romanesque church at Guebwiller, France.

Ink in, on the ornamental lake, an ornamental swan.

215

Life Cycle

Cats kill starlings. Dead starlings excite flies. Big, shiny bluebottles and mechanical ants quickly move in. The flies, businesslike and buzzing gently, lay their eggs in the soft eye. The ants explore the fine down. Sharpen the conté crayon and draw the beak. Shade the down and sharpen again for the sticklike rigor mortis of the legs and claws. The degree of revulsion we feel can be graded. Consider and look at the yellowish fat, the maggots wriggling, the broken hung dismemberment of bones, feathers and skin, and the buzz and strut of flies. Flies are a part of summer. We can put up with them (if they do not settle on us). We accept them. Do we accept them on flowers? Yes. On leaves? Yes. On dung? No! On a dead bird? No! No!

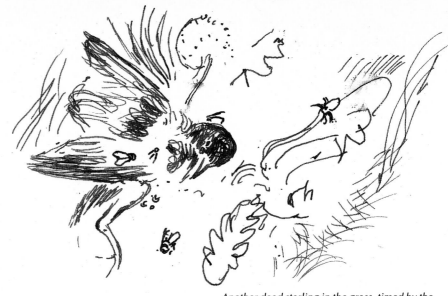

Another dead starling in the grass, timed by the dandelion clock, is only feathers, maggots and smell. Time seems broken. The cleansing process is going on – the fly-blowing, the maggots, the hatching flies, the corpse flesh will be airborne. Eventually only the small bleached bones, dry, fragile and clean, will remain with the feathers. Draw the components: dandelion seeds, flies, grasses and feathers, using a pen and black ink.

After Bewick

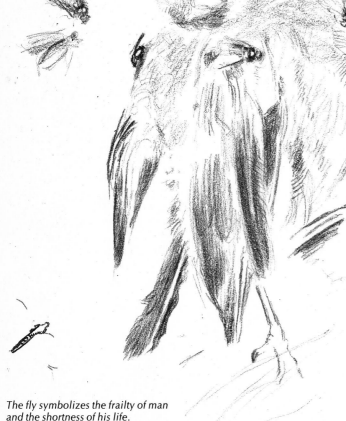

The fly symbolizes the frailty of man and the shortness of his life. Bluebottles shine in the sun. A sharp black crayon will make the shine. Stroke gently for the soft, feathered plumage. The position of the beak shows its predicament.

Like a bourse of excited speculators seizing their shares, each fly has reason to buzz if disturbed. Draw with a full, large pen – fast. This starling corpse is shrike-shaped.

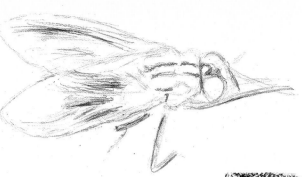

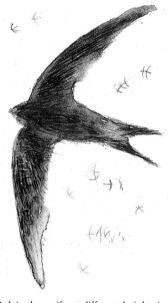

A fly, efficient as a hypodermic. Draw the hairy carapace crispnesses with a sharp pencil and the round, observation-dome, multiple-lensed eyes and the transparent glistening of the wings.

Swifts spend their lives in the air. The wings and bird are streamlined elegance. Draw the tiny beak with a mapping pen sharp enough to catch flies. The forked tail also makes a sharp beak shape from space.

After Bewick

Ink in the swifts at different heights in the air. Flies fly to the sky. The swifts squeal through the skyways, the flies vanish in their paths. Swifts reach speeds of sixty miles per hour and dart over six hundred miles a day.

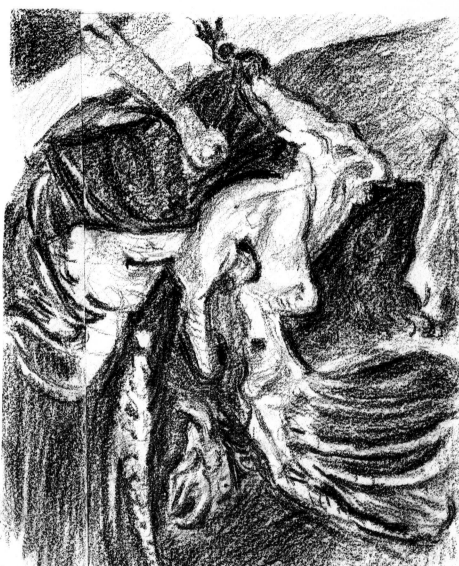

After Soutine

A bird in flight is inspiring. A bird alighting is less dignified. A dead bird is sad. Plucked chickens were etched obscenely by Goya. Draw with black chalk Soutine's tormented, ravishing, paint-basted fowl.

After Chardin

Game has been a frequent still life subject for painters. Chardin, Manet and Courbet found the plumage beautiful and the subject still. This Chardin is arranged to have a falling movement and to be sad like a deposition or pietà.

Draw the cat, rounded and still as a Buddha. The catalyst of this natural cycle will wait in the long grass ready to pounce.

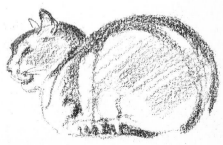

217

STILL LIFE

Grouped objects are called "still life". Stillness is rare in art and life. When a Buddhist meditates he seems still, but blood continues to course through his arteries. Breathing and secretion do not cease. Stillness is always relative. Cézanne required his sitters to be as still as apples, but his apple drawings were done with active strokes. Giacometti's apple drawings consisted of rapid lines. To see how active still life drawings can be, copy apples by Matisse, Picasso, Soutine and Giacometti. The physical processes of focussing and tilting or moving the head induce movement. A still life need not be static. It can include a photograph or picture of a fast event. Chardin put a live cat in a still life, Courbet included distant views, Picasso a view through a window. Fountains, aquaria, candle flames, birds in cages, gerbils, lizards, toads, spiders, coal fires can all be fitted in.

Dutch still life
The flower piece was a commercial invention of the Dutch. It was to sell bulbs and show how beautiful their flowers were. Their amazing technical skill was used to capture dewdrops, delicate petals and the minutiae of butterflies. Vermeer did pictures of possessions with as much skill. His still life paintings included humans.

A still life may involve the body
For some artists, the body was all sufficient. Masaccio, Michelangelo, Rembrandt and Daumier rarely painted objects. For Morandi and Braque, painting and drawing things was absorbing. A bottle is a bottle but by a natural thought process it alludes to the figure (it has a neck). Braque paints apples and guitars, thinking of bodies, girls and breasts. The world consists of humans, nature and man-made objects. They allude to each other in pictures. Blend them as you wish.

The still life as a model theatre, as a world theatre
The city square and a room have corners. A still life can be in a corner of a box. Make a still life in a model-maker's frame of mind. Play with it as a child might play with a model theatre, the items like characters posing as the world. Let it be small enough to look at and draw with ease, almost full size. Do not do a still life at all unless you have a compelling idea about the ingredients. Consider the effect of every component. A Cézanne still life consisted of a plate, a knife and two apples. Draw it to see why it looks so good. It must be because it is a love poem.

Food is associational and makes mouths water
Bonnard drew gorgeously, haphazardly arranged table tops of food which became food for eyes. They work on many levels. To know the degree of power that association exerts in art, draw in watercolour your favourite food. Chardin made a beautiful pile of strawberries. A performance artist dyed eggs turquoise. The effect of Chardin's strawberries would be different if the strawberries were turquoise. When Matisse was given fruit he looked at it, drew it, then ate it. Draw a peach or apple. Hold it in your hand. Think of a circle and draw the fruit well. Thousands of apples are eaten every day; a few are drawn; even fewer are drawn well – only a few in a decade.

An exercise with a juicy grapefruit
You have an idea: a round shape within a rectangle; it is to be crayonned yellow. You see a fine grapefruit at the market. Subject and idea approach each other. Even as you buy it, the idea is getting closer to fruition. Place the grapefruit on the table. Does the wood grain of the table fit your idea? Must you change your idea? No. Embellish it. Feel free. Place it on its lettered brown paper bag. Brown is a low intensity, low-hued, low-toned yellow. The fruit is now part of a family of yellows. The idea evolves. The lettering surprises. Certainly it was not part of the original idea but the red is right. A fly settles near the tiny highlight – it is not in this story. But wait. The blue butterfly which died on the window pane . . . you wanted to draw it. Put it where the fly settled. Now all is coalescing under your fingers, at the end of the crayons! The yellow-as-the-sun grapefruit, the white incandescent highlight, the azure butterfly like the sky, the passionate red lettering and the brown bag, the colour of earth, to hold the family of colours together.

Still life as a style foundry
Many art problems can be worked out in a small still life. Its convenience and permanence make it valuable for experiment. Where a still life is a limited arrangement of two or three objects placed near the artist and close to a background, the intention is probably serious. The onlooker need not expect to be wooed to exotic oases of escape. If he is required to concentrate on a few design relationships, an in-game is afoot, a style change may even be imminent. It was the limited still life which helped Picasso and Braque to make Cubism, helped Mondrian towards abstract art and, in different, wilder ways, started Pop Art with, for example, Stuart Davis' "Egg Beater" and "Lucky Strike" pictures. It also helped in assembling the mad, wild thought-ways of Surrealism – Chirico, Magritte, Dali, Ernst were obsessed by objects and Duchamp drew "Love" as a "chocolate grinder".

The Cubists were still life specialists and followed Cézanne
Braque with Picasso forged a new style. They wanted subject matter close to their Parisian café life which would communicate simply with everyone. They limited colour and texture, then made the table top – a café table top – stand for a world; a pear, jug or guitar for the life of the body; grapes for Bacchus; a knife as a sword for truth and energy; a bottle, violin and apple for wine, women and song; a skull for death. Playing cards, newspapers, pipes, fans, dice, forks, tobacco, jugs, letters, cups, glasses of absinthe and other things might all on occasion be a part of the concentrate.

The Pop still life and Claes Oldenburg
Pop art is art made out of man-made things or from visuals which advertising artists have made to help sell products. Art feeds off art, and sometimes it's a gobble. Claes Oldenburg brought new things into still life. Inflating an idea as much as he enlarges objects, it could be said that he has made the city into a vast still life. Inflating further, the world is his still life. For example, with a grease crayon he thought up a vast baked potato sculpture to be sited in Grand Army Plaza, New York. Enormous lipsticks, razor blades, corks, ironing boards, bottle caps, giant pants, mugs, electric plugs, ray guns, flags, giant pool balls, mammoth hamburgers and foods of plaster and plastic in wild colours are among his transformations. Enlarging objects makes their surroundings look toylike and pompous settings are seen anew. Hard objects, such as portable typewriters, showers, baths and drain pipes, were made in soft vinyl. He has an eye for gigantic billboard cut-outs. "The Store" could be called the all-time super still life. His throwaway style of drawing (which conceals style) is immediately recognizable. It is that of a great engineer, hurriedly scribbling out a new invention to show a friend.

Hyacinths

A potted hyacinth is a still life composition. It is still and alive and it suggests by its upward pointing shapes the rising sap, the new life which will break out in spring. The hyacinth flowers early. Matisse waited through the winter for the first hyacinths, to help him illustrate a book by Aragon. When they arrived, the flowers failed to inspire and he said what he did would be no better than a seed and bulb catalogue. He was wrong, for his pen drawings of hyacinth florets scatter brightly on the paper. Buy a hyacinth in a pot. An asymmetrical plant is best – the bell shapes and stalk form a vigorous, perfumed spike. The strong growth from the bulb is good to behold. The colours move mysteriously from green to violet blue, heralding springtime. Start drawing it before the buds open in a warm room. The movements of its opening mouths are almost visible. Soon the bluebells will be making the blueness of shadows in the woods unbelievable. It will be easier to draw bluebells if you practice with hyacinths. Bluebells are wild hyacinths.

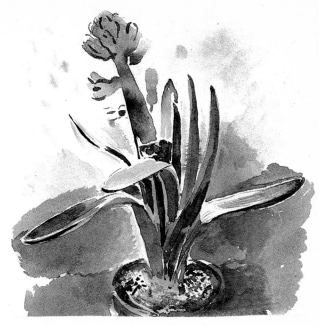

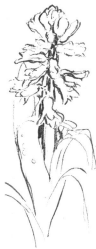

Move round the whole plant, making urgent thick/thin marks for the strong sappy growth.

Each bell-shaped floret resembles the shape of the whole plant. Draw as if you were looking at a dome, a cooling tower, a Sung pot. The bells are balanced against the pull of gravity, becoming more vertical at the top.

Draw with little pen strokes the papery surface of the bulb. Draw the emerging leaves in a different way.

Draw many versions. See as simply as possible. Draw with pale grey water and a sharp sable brush. Then add more Chinese ink while damp. Getting to know the kind of shapes which will portray and equal complex natural history means partially composing, moving within the medium and enjoying the technical flow. It is to some extent a compromise. It could be called "making a study" – all right if one doesn't mistake the bud for the flower.

Suppose a bell was flattened – what would be the shape made? Suppose the space between the bells was solidified – what would be the form? Drawing can make an imagined bell true to the visible bell which is solid.

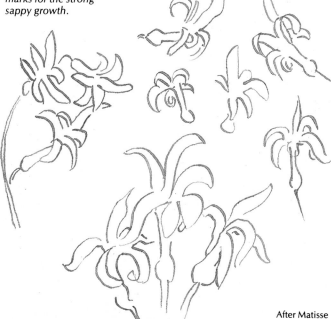

A pressed black-eyed Susan flower drawn with an 0.1mm stylo tip pen. The line being equal and single, the flower can be made flat.

Drawn with a stylo tip pen and a 2H pencil, the pressed flowers suggest the structures from near plan and near elevation. The precision is deceptive. Exact edges and details of this nature convince us the deformed shapes are true.

A live bluebell floret, pressed by a piece of glass. This simple mechanical flattening is interesting, but the shape is mean compared with the creative flat designing of the great artists.

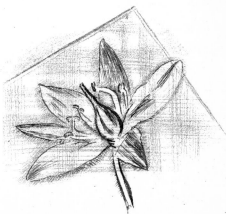

After Matisse

Rather as if he was drawing without lifting the pen, Matisse opens, flattens and displays each blossom. His sculptural experience makes this possible. Pressed flowers are flat but the process maims them. Draw pressed flowers. The dry, papery edges make plain the liquid sap vitality of the growing plant.

Apples Exploded

To draw a circle is to embrace everything. To keep the line alive along all its circumference, think of a snake, tail in mouth, or a ripple on a still pond when a droplet falls in it. The compass-drawn circle is loved by mathematicians for its resemblance to the pure circle which exists only in the mind. Roundness, as I am using it, is different. The compass-drawn circle that Cézanne was found making around his painting of an apple when someone visited him, fitted poorly with his sensation of apple roundness. The apple in the still life by him in the Courtauld Gallery, London is rounder than any circle.

Surface, colour and pattern can be strong and make or break forms. Cézanne, Courbet, Giacometti, Matisse, Klee and Manet made apples help them, as did countless others.

Play with the circle. Pop a moon in it, an iris of an eye, a buttercup, breast or bum, an orange or even an apple.

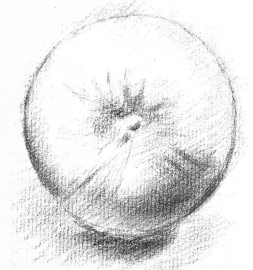

The contour thickens as it turns under. The contour line divides the object from air. The modelling between the near parts and the contour makes the plumpness.

The shading moves round and into the fruit.

Gradated shading up to the edge, as done by Pisanello, gives a bas-relief depth.

Spot out a pure circle. Draw an apple to be as round as it can be experienced – alive and real.

Colour markings which camouflage the solid form may make for important expression on the flat.

Patterns on the skin have an underlying design.

Diagram-draw the universals – an apple in a square above a circle in a square, a waxing/ waning moon, a Yin/ Yang sign and, finally, an apple for the sun with its shadow for the moon. Use conté crayon.

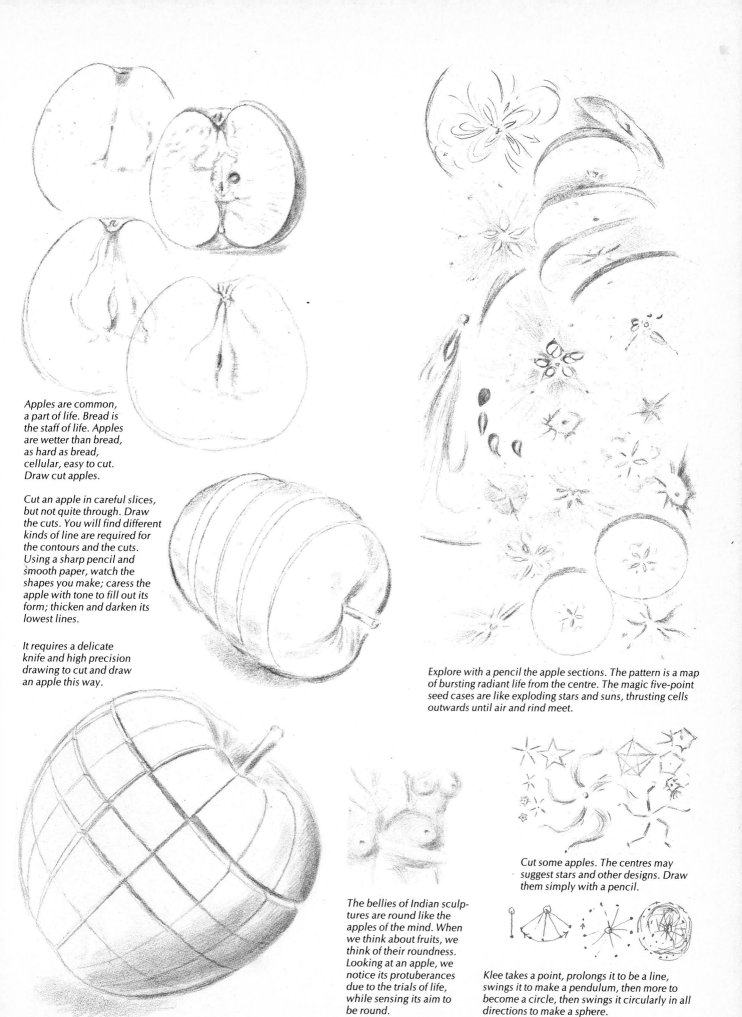

Apples are common, a part of life. Bread is the staff of life. Apples are wetter than bread, as hard as bread, cellular, easy to cut. Draw cut apples.

Cut an apple in careful slices, but not quite through. Draw the cuts. You will find different kinds of line are required for the contours and the cuts. Using a sharp pencil and smooth paper, watch the shapes you make; caress the apple with tone to fill out its form; thicken and darken its lowest lines.

It requires a delicate knife and high precision drawing to cut and draw an apple this way.

Explore with a pencil the apple sections. The pattern is a map of bursting radiant life from the centre. The magic five-point seed cases are like exploding stars and suns, thrusting cells outwards until air and rind meet.

Cut some apples. The centres may suggest stars and other designs. Draw them simply with a pencil.

The bellies of Indian sculptures are round like the apples of the mind. When we think about fruits, we think of their roundness. Looking at an apple, we notice its protuberances due to the trials of life, while sensing its aim to be round.

Klee takes a point, prolongs it to be a line, swings it to make a pendulum, then more to become a circle, then swings it circularly in all directions to make a sphere.

Memory Drawing

At the age of fourteen I took an examination at Lowestoft Art School. Objects were shown me and removed after ten minutes. I was required to draw them from memory. To re-enact the proceedings, I placed an apple, a pear, a carrot, a jug, two roses, a model yacht and spectacles on a tray, as shown below, looked at them for ten minutes and drew them from memory (top picture). When I drew the actual group afterwards (middle picture), I saw clearly that the memory had acted creatively: it had made the components fit more harmoniously together and aligned the apple with the jug. When someone else did the test from memory (bottom picture), they also placed the apple beside the jug. This is an example of how naturally and importantly the creative memory works.

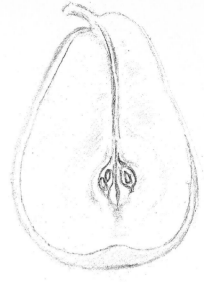

A stamp for embossing letters. It was chosen because, placed on end, it was an unfamiliar shape. It was drawn from memory after ten minutes.

Drawn after a second look

Drawn directly from the object

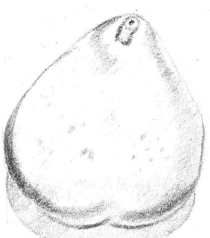

When someone else tried very carefully to draw it from memory, the whole mechanism was reversed.

Draw a pear from memory, or begin it from life and finish it from memory. Some people have prodigious memories; for others the ability to recall may be blocked, protecting them from the massive complications of the good memory. (Cézanne may have been one of the latter.) Lecoq Baudericourt wrote a book and taught his students to copy whole pictures from memory. The results were skilful and of no artistic worth but it does suggest that it might be possible to train the visual memory. The decision to memorize as we draw can help recall.

What is a still life when it is not a group of objects on a table? All categories are arbitrary. A rose with its leaves is still enough and complicated enough – so are five strawberries.

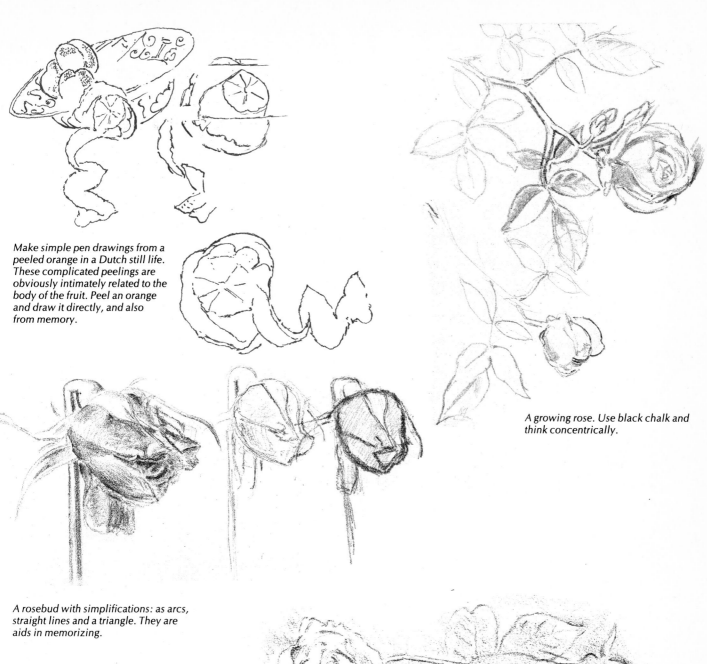

Make simple pen drawings from a peeled orange in a Dutch still life. These complicated peelings are obviously intimately related to the body of the fruit. Peel an orange and draw it directly, and also from memory.

A growing rose. Use black chalk and think concentrically.

A rosebud with simplifications: as arcs, straight lines and a triangle. They are aids in memorizing.

A drawing of a rose pounced (pricked) through for painting. The pale dotted outlines will leave a freedom for the memory and imagination.

Draw a rose with several simplifications. The bud is seen in various ways – as a wild rose, as a spiral, as arcs, as triangles and as rounded triangles.

Fruit, Pots and Pans

Velasquez painted eggs frying in a pan. Gris and Braque painted jugs and lemons. The utensils for preparing and eating food have a worldwide similarity. The common nature of kitchen objects is useful for making extraordinary subjects believable. Their simplicity is engaging and, because they are easy to decipher, they are often used when big style or manner changes are being made or consolidated in art. Certainly the Cubists, and later the Pop artists, knew their value. Picasso painted and drew most things connected with this life. The kitchen was important. The work of his which caused the most fuss in the newspapers was of a hat made of a fish, a fork and a slice of lemon. His wartime pictures were sometimes of everyday objects. A skull, a jug and a candle on a table, or a woman in a chair, were somehow truer to the feelings of fear in wartime than the two murals which were directly titled "Peace" and "War". "The Charnel House" picture actually contains a jug and a saucepan on the table.

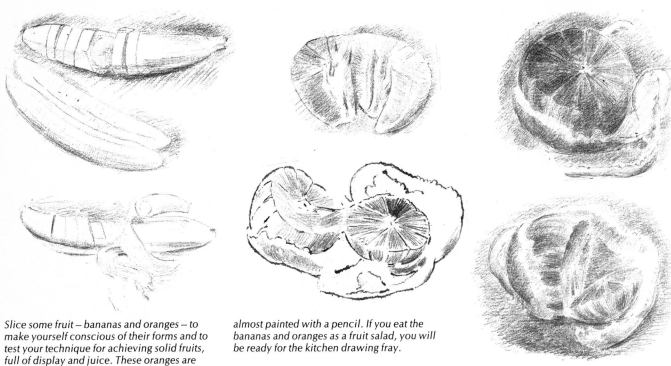

Slice some fruit – bananas and oranges – to make yourself conscious of their forms and to test your technique for achieving solid fruits, full of display and juice. These oranges are

almost painted with a pencil. If you eat the bananas and oranges as a fruit salad, you will be ready for the kitchen drawing fray.

Chardin raised still life into grand art. This crumbly textured body-shaped jug is throbbing in one of the slowest, most affecting movements in painting.

In the flurries of paint it is possible to make out jugs, a teapot and a fish. Braque needed little more than a jug to make poetry.

After Picasso

After Chardin

After Picasso

Above, Picasso's kitchen, partly in plan. He plainly enjoyed designing the gas stove in the two versions copied here. Below them is the still life from "The Charnel House".

After Braque

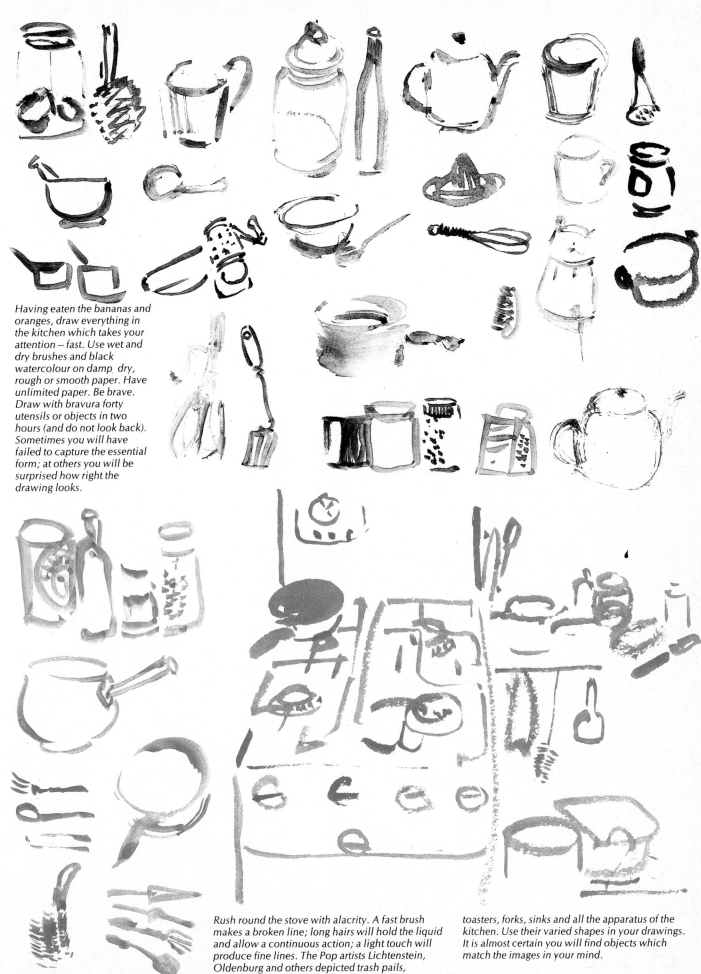

Having eaten the bananas and oranges, draw everything in the kitchen which takes your attention – fast. Use wet and dry brushes and black watercolour on damp, dry, rough or smooth paper. Have unlimited paper. Be brave. Draw with bravura forty utensils or objects in two hours (and do not look back). Sometimes you will have failed to capture the essential form; at others you will be surprised how right the drawing looks.

Rush round the stove with alacrity. A fast brush makes a broken line; long hairs will hold the liquid and allow a continuous action; a light touch will produce fine lines. The Pop artists Lichtenstein, Oldenburg and others depicted trash pails, toasters, forks, sinks and all the apparatus of the kitchen. Use their varied shapes in your drawings. It is almost certain you will find objects which match the images in your mind.

225

Contained Worlds

De Kooning said his painting world was the space experienced between outstretched arms. A still life is within easy grasp and the eye can dwell on it. Here the fitting of shapes in a simple still life group is made obvious by separating the parts. Ultimately, the category still life ceases to be limited. Indeed, the bottom drawing might be termed a portrait. The elements air and water on the right hand page might expand from goldfish bowl and aquaria to a waterfall and a lake.

Any group is complicated. When three objects are placed on a tray, there are over twenty areas to be designed. Adding shadows would increase this number enormously. Examine a painting you have done, by taking it apart in this way, and decide whether each component is doing what you want. This one illustrates analysis, right, and synthesis, below right.

A rectangle *A corner* *With shadow* *With a fruit*

 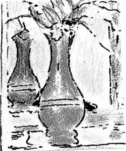

One area *Three areas* *Five areas*

Nine areas

Exploded as separate areas

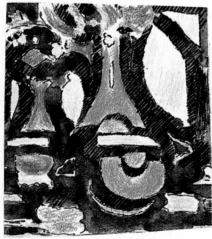

After Vuillard

An apparently simple still life by Vuillard, exploded into its components, is highly complex. One of the areas is the highlight on the vase. Analyzing Intimist painting is intricate.

A clairvoyant's ball of glass – the super-cooled liquid – and a goldfish bowl are objects which expand still life. Their transparent surfaces reflect and transform. Here the format is expanded even further to include Melissa, whose brown eyes contemplate the orange ovals of the setting sun and the scarlet fish. Use pastel pencils sharply and with delicate touches, until you reach the sea's horizon.

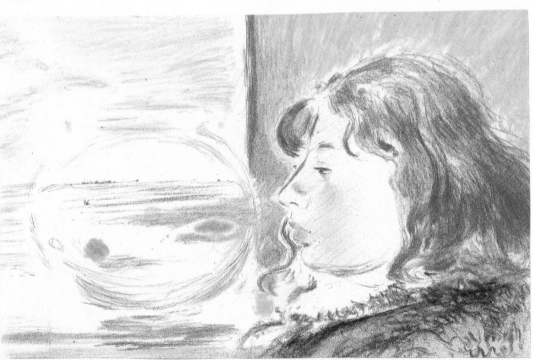

After Taito

Copy the turning, overlapping, counterchanging wave patterns. Be conscious of the leaping penetration up through the bowed water whorls to enlightenment.

The garden expands. The water surface lies flat as watercolour on the surface of the paper. Monet was continually fascinated by this meeting of air and water and waterlily leaves (rather like the meeting of paint with canvas). Using a small sable brush, lay touch against touch. Watch the edges as you sensitively draw the round leaves. Horizontals will flatten.

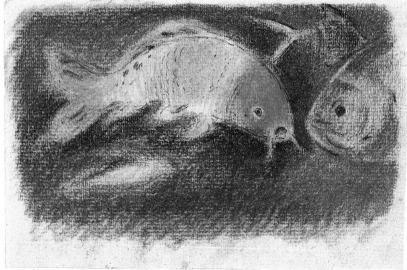

In the darkened aquarium room we seemed subject to the scrutiny of strange eyes. In a dim light, the colours can be written down with a pen, then drawn in pastel afterwards.

After Klee

Fish, water and container are fitted as exactly as a jewelled movement in a watch. The eyes are like the jewels. When copying Klee, be ready to adjust the parts with the precision of a watchmaker.

Drinking, Drawing and Passing Time

Time passes in sips, gasps, long breaths and heartbeats. Grasses grow, erections come and go, measured by the swing of the pendulum. Some wish to squander time, others fear its passing. Sand falls in the hourglass, clock hands revolve. Our sense of time passing is always changing. Combine drinking and drawing and time will pass. A glass of beer takes time to drink and draw. The froth requires a delicate touch. The golden liquid lowers at each sip. The foam retreats as the topaz bubbly liquid, full of company, disappears. Drawing as you drink means you draw at a good pace. Draw the cigarette and its ash. Whatever the effects of nicotine or alcohol, the faces of clocks hold us spellbound and confront us continually.

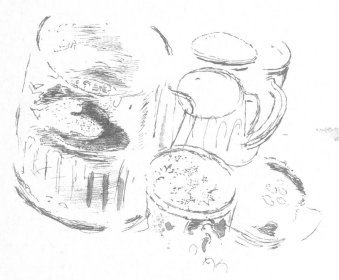

With a sable brush and watercolour, make an oval for the rim of the glass and for the eye. The cuts on the glass make rounded squares and hexagons into transparent patterns as the girl drinks. Watch the dabs accrue.

With a fountain pen, dot the foam into circles and oval islands. Stroke the surface of the dark liquid horizontally. Only drink it when you have drawn enough. Manet painted glasses of beer. Sickert and Burra painted pubs.

A glass of stout with the trails of foam as it empties. Crayon and pencil it.

With a fountain pen, draw the ashtray before it fills.

A cigarette burns away. Draw the textures of tobacco, ash and smoke.

Scribble, hatch, fill with wet ink. Draw the glass full, then empty. Flick in the cigarette ends. In the end, it's only ash and empties.

After Chirico

A clock by Chirico. Surrealist time moves forwards and back in dreams.

After Chagall

A winged Russian clock by Chagall – time flies.

After Dali

A melting Surrealist watch with a fly. Time falls and stretches. Diagram-draw the melting. The disorientation is greater because the deformed subject is familiar.

An egg timer. The fascination lies in the narrowness, the infinitely small now between past and future.

The faceless digital watch does not display the passage of time.

The Roman numerals radiate from the centre. The hour hand of these clocks is heavier than the minute hand. Draw the intervals and concentric bands which make time almost visible.

After Lowry

A sad, time-worn clock

A cup of coffee is drunk. Turn it on its side, spilling its grounds for a last drawing. Hatch horizontally with a fountain pen and, thinking in terms of a cloudy evening sky, move the shading from side to side until its blackness spreads.

Big Ben is a world-famous, poorly designed clock.

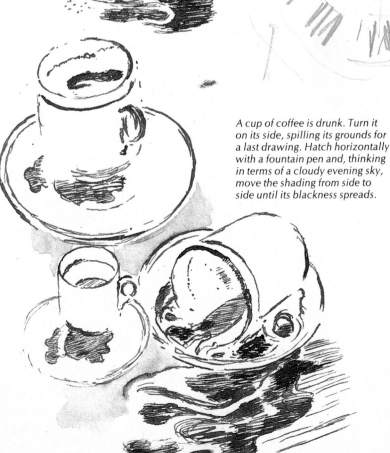

With white conté pencil on black paper, draw wreaths of cigarette smoke writhing to a temporal pattern.

Equivalence and Translation

Cézanne made considerable intuitive departures from the natural appearance of the subject. He could do it in the presence of the motif or subject. He called it "realizing his little sensation" and I think this ability is rare. It may be that people remember visual information too well for the touches to be so thoroughly transformed by the imagination. Picasso and Braque had gifts of a different kind. Their work was more consciously styled. They felt African sculpture to be important and found deformations which gave them confidence in distorting for their own purposes. The excitement was considerable in 1910. It is as simple in essence as when a child plays with a broom or hobbyhorse, pretending it to be a horse. Whittling, collaging, model-making, modelling, carving puppets – all make equivalents to some extent, with varying degrees of resemblance to the subject. We believe in a horse by Stubbs but a child finds a hobbyhorse exciting.

After van Gogh

A figure whittled from firewood by Jim, a fifteen-year-old fisherman. The extreme simplification requires that four holes stand for eyes, nose and mouth.

A lugger made by Jim from odds and ends of firewood. The components assemble to be a convincing boat, grainy like planks and waves. Boats are made of wood and so is firewood.

The two famous chairs were "stand-ins", true to the moods and personalities of the two artists – violet, green and orange for Gauguin and yellow, red and blue for Vincent.

An Art Nouveau chest of drawers which is female and covered with shark skin.

After Picasso

African sculpture helped to make styles which were more synthetic than Impressionism. Diagram-draw from African sculptures, synthesizing. With the box as a head, Picasso was seeing how far he could go without losing the idea of a head.

Colours translated into movement by arrows. Klee made colour changes as arrows.

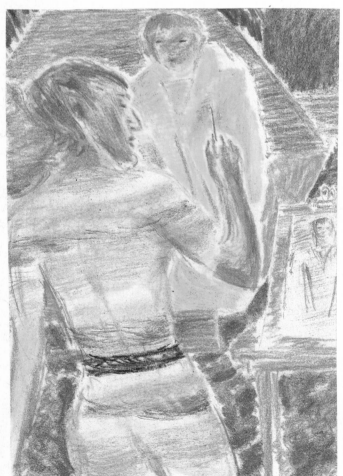

Pastel pencils were used to make a drawing of Laetitia at an easel, translating from the drawn linear equivalent of a fisherboy to make an oil painting. Drawing and painting are about equivalence and translation.

Firework rockets falling over Venice are translated by TV into a strange area of film colour. The screen is seen against a nocturnal sea through a window at Hastings. Play is made of balancing the two artificial textures.

230

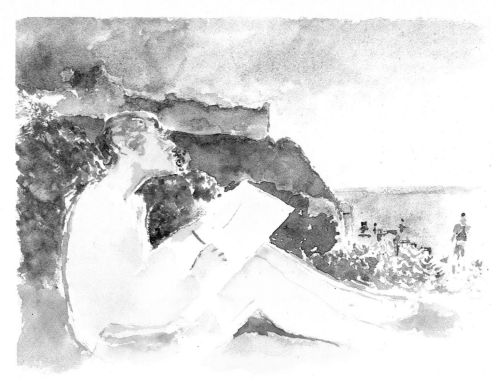

The sun, Beachy Head and the light-house, suggested by a sequence of marks from blue to yellow. With confidence, a rub with a finger and a few dots will make a whole environment. A tiny scribble by Bonnard shows this.

Laetitia in front of Hastings Castle, making equivalent marks for a sky. The magic is that little splodges of watercolour will become a person and a world.

After Kitaj

A section through the complex sequence of colours which follows the labyrinthine thought of R. B. Kitaj.

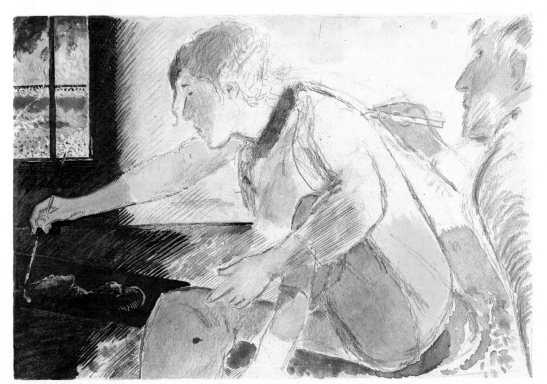

Pen and pastel and watercolour dots and hatchings are used as equivalents. The author is translating Laetitia portraying Laetitia on the floor. Believe it will happen sufficiently and almost any blotch or line will equal the subject.

This Cycladic Greek carving is a marble, wandlike equivalent for a human figure. As you draw it, the rectangular forms become surprisingly believable.

231

Scales, Highlights and Armour

With a conté crayon, draw a face looking at a fish. Think of forms which resemble those of a fish. Fish have bones and scales. Insects have no bones but possess horny carapaces. Humans are boned but soft outside, and made armour using plates of metal. We are drawn by a sensual curiosity to the way stuffs fit the body – plates of steel forged to enclose the figure, corsetry; the wet suits of skin-divers, leathers, helmets, body stockings, tights, jeans and patches. As I copied Giorgione's St Liberale (facing), I thought of fish scales, armadillo plates, insect wing cases, the shells of tortoises, beetles, scorpions and woodlice. Fish lie on the fishmonger's slab, still but vital, flashy as when they were alive, the light glistening on their bodies. The general shape, mouth, tail and scale shapes resemble each other. In the drawing below, the round eye like a jewel gleams darkly, surrounded by nacreous scales. The subtle markings are irridescent and re-semble the patterns left by wavelets on the sand. The shadow below the fish flows like water. A fly symbolizes the frailty of man's life and a fish is a resurrection symbol.

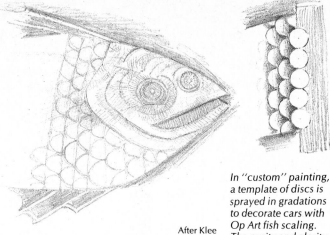

After Klee

Draw precisely this timeless, hard-scaled fish.

In "custom" painting, a template of discs is sprayed in gradations to decorate cars with Op Art fish scaling. The purity and clarity of these and the Klee scales seem bright compared with the scaling of the fish drawn below.

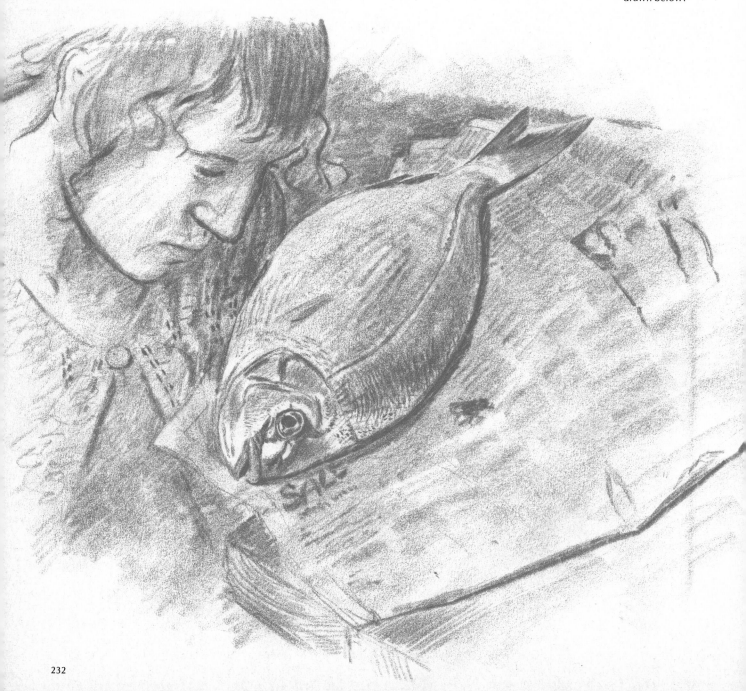

A tortoise shell is in six- and five-sided shapes. Some of these expand to become attenuated stars.

The tortoise's shell is fitted together most finely. The plates are like shallow ziggurats of thinnest scales, which are so slow-growing and geometrical in appearance that they could almost be taken for mineral rock formations. As so often in natural history, the small formations, such as the scaly head or legs, resemble the larger forms.

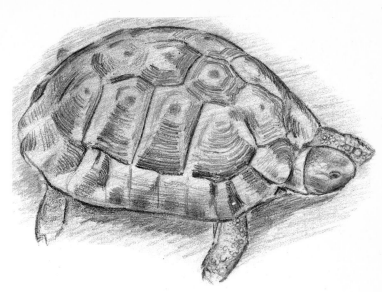

Mantegna and Piero's soldiers' armour is close-fitting. Here they are compared with a stag beetle, corsets and underwear which is sewn in panels to fit the body. Drawing seams will often build the subject. Stretch fabrics make revealing areas of light. The darks collect at the contours, making a super highlighting on the plump parts. Satins and silks reflect beautifully. Lindner made pictures which included tailors' pattern shapes. Draw them sheer or shiny. Armour provided Tintoretto, Uccello and others with an excuse for painting sharp darks and highlights, which contrasted well with the soft areas of flesh.

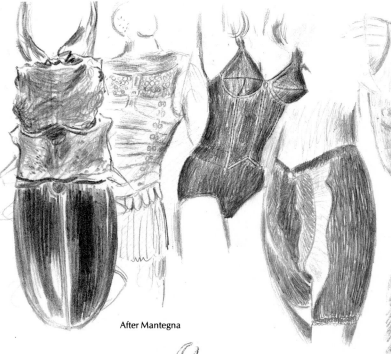

After Mantegna

After Piero della Francesca

Draw the pure, sharply designed burnish of St Liberale's helmet and shoulder plates. Like all apparel, there is a relationship between the form of the body and the metal parts which cover it.

After Giorgione

Use horrible black stabs with shiny Indian waterproof ink for a scorpion.

Draw neatly with a crayon the well-fitting plates of an earwig.

Use a fountain pen to build the spherical eye, hairs and horny divisions of this dragonfly's head.

A stag beetle, black as shiny ink. Draw pincers which can pinch.

IMAGINATION

For those who are sensitive and aware, to live from one breath to another is mysterious, and nothing could be more mysterious. We live for years, and each year we become more accustomed and adjusted to the world which surrounds us. The surprises of everyday life become fewer, the further we move from childhood. The more habitual and ordered the way of life, the greater the shock of any departure from the expected. Magritte painted a man whose reflection, as he looked in a mirror, was the back of his head. This was fundamentally no more surprising than a man looking in a mirror and finding his face reflected. Existence is a great mystery! If this is accepted, we will quickly agree that there are mysterious pictures of everyday life. "Las Meninas" or a Bonnard bathroom will do as examples.

Mysteries come of their own accord

I cannot tell you to draw a mystery. Mysteries come upon us. Some of us daydream. For some, the dream is always with us as we draw. For some, the night dream can be remembered. When Sigmund Freud took our minds seriously, we had uneasy, squeamish feelings, rather like our first intimations of sex – a feeling that someone was tampering with our intimate being. Lady Macbeth had walked in her guilty sleep; Ophelia had lain in the stream. Shakespeare could have analyzed Freud and elucidated his motivations. Freud's ideas were made public during a prudish period when the energy of the body was taboo. He became the most exciting personage of the age. A Victorian young lady wore more clothes than six girls would wear today – which meant there were more to take off. As with clothes, our taboos are fewer now. It is difficult to know the degrees of daring one hundred years ago. The coy raising of an elbow, clothed in black, by a music hall beauty might have been more provocative in that restricted world than any specialized performance today. The bonds of taboo had to break. The First World War had been so revolting that a different revolt was inevitable. If Dada was foreplay and prophecy, Surrealism was the act where every inhibition was uncovered and displayed. Marcel Duchamp could really shock, by placing a male urinal at the entrance to a Surrealist exhibition. Today, there is little which can shock verbally. All the four letter words have been sterilized and there is only about one which might still shock. The visual arts can shock more easily than the other arts. For this, as painters, we should be grateful. It shows the power at our disposal. The power to shock is at the heart of mystery. It can take many forms, and the Surrealists explored some of them. They searched the past, looking at the monsters by Bosch and Brueghel, Gothic hells and gargoyles, primitive and outsider art, pornography and medical engravings. They loved forensic science, spiritualism, folklore, fairy tales, Lautréamont, "penny dreadfuls", black magic and all extreme acts. Amongst all this wildness and a mass of vulgar rubbish, some great art was made and a good magazine, *Minotaure*, was produced. There is hardly a living artist who does not owe something to Surrealism (even if it only helped him expunge from his work the symbolic and surreal).

A flame is an intimate token of the distant sun

Prometheus stole fire from heaven. The mystery is entrancing. Every time we light a match, firework or candle, the fire appears. Draw the flickers, flames and fluctuations, the glows of Georges de la Tour and the candle flames in Titian, and see the flames from Heaven in El Greco's "Pentecost". The sun close to its zenith is a disc which, if we dare to look at it at all, flashes with overbright rays, then as a black disc and then flashes in colour – like counters, tiddlywink after-images. Like Turner, we must be at sun-up and dab pencil and watercolour mementos to compare with other dabs done at sundown. See the sketchbooks of Turner to know what sun worship means. Van Gogh created a sun from solid lines until it beamed. The Impressionists mainly depicted the sun's effects, with no trace of Surrealism.

The Impressionists rarely painted rot

The Impressionists were selective, rarely painting decay. Apples can be mystery-loaded or plain fruit. The fine-looking fruit which, when cut, is seen to be a labyrinth of worm paths and decay, is a disturbing quick-change act. To draw the apple whole and then demolished is revelatory. Rock strata are history-layered, like memories in the mind. Our earliest memories are crushed, compressed deep down into thin seams overlaid by recent experiences. To look at a rock face is to be brought face to face with a temporal mystery. To draw from a Cézanne of Bibemus Quarry, to contemplate the sheer mass deposit of chalk at Beachy Head, or to see the multiple details in a mosque, can baffle us wonderfully. Although all is mysterious, some items are more intensely, manifestly mysterious than others. Like alembics, they distil the essences of mystery and are special. Tantric egg-shaped sculptures, the Sphinx, Redon lithographs. Rembrandt's Phoenix ... the items are countless. I have no space to list the vessels which contain the essences of the great mysteries of art, for the list would wind around the world. Throughout this book on drawing, parallels are made with other arts. Indeed, the subject is so short of words that vocabulary has frequently had to be borrowed from that used in the other arts. Words like harmony, dissonance, tonality, colour, vitality, tenderness, measure and many others can be used successfully among the arts – in music or poetry, for example. But others have confusing resemblances: mode, module, modulate, the tenor (of a drawing). Then there are the specialist in-words of painting, like space, presence, Gestalt, equivalence, action or even hairy.

Cubism was a misleading name

Cubism was a word thrown at the movement by a newspaper critic. Impressionism was an equally superficial name. To write about any art is a struggle with an inadequate vocabulary. To write about Cubism is a lost battle. Fortunately, it is there to be seen. To copy by diagramming and drawing a path through the stages of Picasso's development is very rewarding. The word Cubism is a nuisance. If it could have been called "Perceptions Creatively Presented as Design", this might have been helpful!

Copy a Picasso

When you have explored Cubism, copy Picasso's "Ulysses and the Sirens" (facing). His findings in Analytic and Synthetic Cubism (he never admitted to searching) led him towards a free new language which would serve his prodigious invention and realize his sensuous subject matter. Start by drawing a circle in the middle, using a carbon pencil. Modify its circularity to make a sun, grey and white. It is not a sun, it is Ulysses' face and he is bound to the mast. Those are not brown, fucoid thongs – he is a brown, horned faun. The mast is vertical and grey-white, like the cloudy, snow-capped, harpy-faced, malevolent Sirens of the blue sky, luring and leering over a distant bar hemming a far horizon. There, dancing like a fish, like a boat in the foam, is Ulysses trying to be free. His body is like a fish, his limbs like seagulls and mackerel and at the edges of the picture, the bars for foam become bars for bones which scatter the island. At the bottom right, the Siren, part-woman, part-bird, lures in fierce frustration. Whatever your interpretation of the picture as you make your copy, it is plain that the Cubist language could grow under the hand of Picasso eloquently, and it lasted his lifetime. To copy Picasso is to think of Goya. The marriage of perception and invention was natural to both. Imagination and mystery movingly haunt the pages of Goya's last sketchbooks. It is right to conclude a drawing book by dwelling on mystery. I believe the arts (and therefore drawing) are the only bastions we have against a climate of absurdity and a sense of loss.

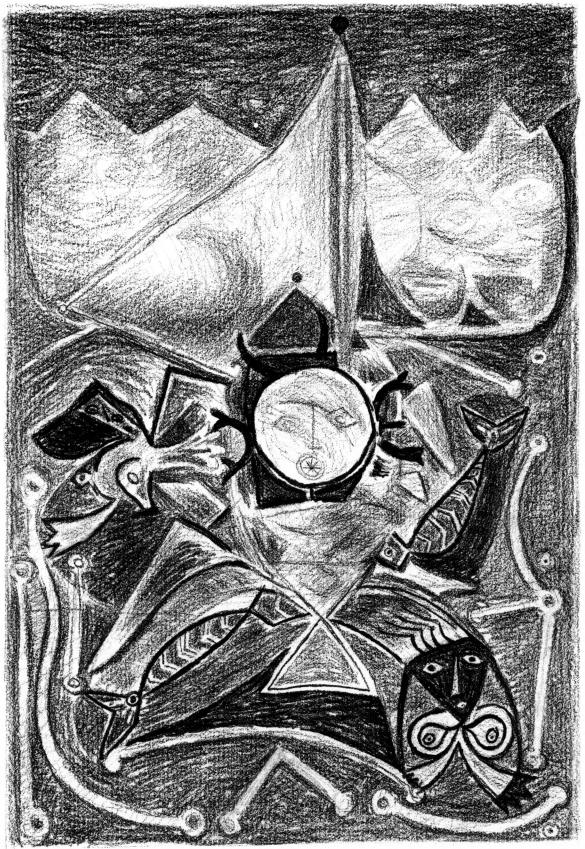

After Picasso

Mountains and Transformation

Mountains lure us and inspire us. Snow-covered, they shine with clear air around Chamonix. Mountaineers' towns have glamour. The mountains are immense. To achieve this scale, we need to make tiny marks. Brueghel and Turner worked like ants to make pinprick-sized marks build rocky masses. Brueghel was delicate with a pen. To go on a copy-dot with him is like a long climb — but the views are beautiful. Look at the central drawing on the facing page. Shall we say it's an old man and a tiger? It's a mountain with a snow-covered peak! No, it's a sage with a tiger. Twenty splashes of ink and, if you want it to be, it will be either a sage and a tiger, or a mountain, just as the rudimentary drawing is a hare or a duck or, if you want it hard enough, a hare-duck. A hare-duck is difficult to believe in. Conceive, if you will, a figure having the head of a man, ram or hawk. Such a transmogrification was the Sphinx of ancient Egypt. The Surrealists and Symbolists, such as Chirico and Magritte, worked with strange transformations. In Lewis Carroll's *Alice in Wonderland*, the Cheshire Cat appears and disappears and finally appears as only its smile. To understand transformation, try drawing the smile with a brush and diluted ink.

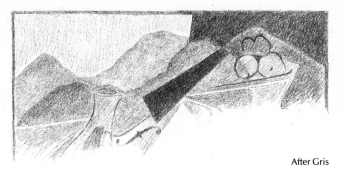

After Gris

In this still life, Gris paints the mountain to enter the window and continue as a napkin. He enjoyed economizing in this way, to make poetry.

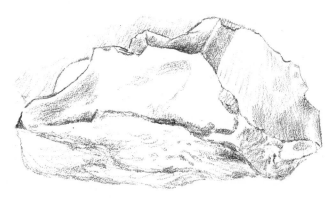

Draw a flint and think of it as a mountain. It needs tiny marks to make its edges sharp. Drawing lumps of coal was a common art lesson at one time. Coal might suggest Tolkien's black mountains.

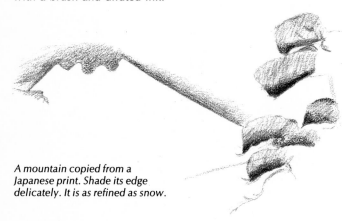

A mountain copied from a Japanese print. Shade its edge delicately. It is as refined as snow.

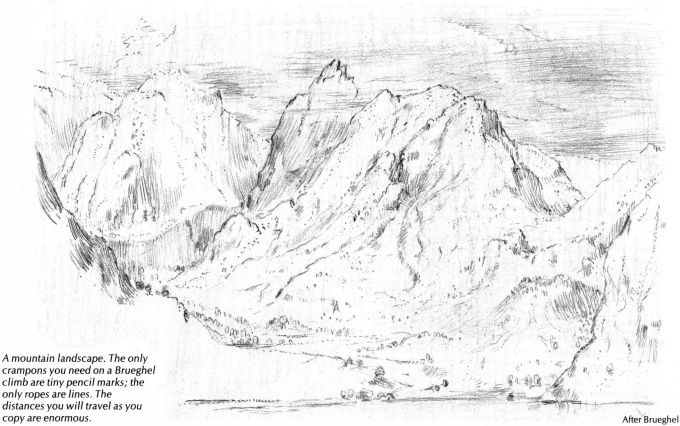

A mountain landscape. The only crampons you need on a Brueghel climb are tiny pencil marks; the only ropes are lines. The distances you will travel as you copy are enormous.

After Brueghel

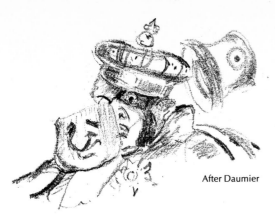

After Daumier

The evil face of the king is seen when his benevolent mask slips. Draw the mask against the face to understand a good political drawing.

After Picasso

"The Dream and Lie of Franco". With a sharp nib, using snake venom as ink, copy this hate drawing of Franco.

After Klee

"Angry Kaiser". Using a pen even sharper than Picasso used for Franco, with nervous lines of loathing, draw the Kaiser.

"A Chinese Patriarch and a Tiger." This fine drawing, done with a trailing eloquent brush, is what these pages are about: the instant transmutation of one form into a completely different one or the ability we sometimes have of seeing a subject in two completely different ways at once. Draw with Chinese ink and a Chinese brush a Chinese sage so that he is also a Chinese mountain. The tiger will support your efforts.

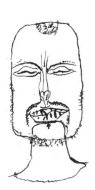

After Klee

The distorted forms of Klee's self portraits are not caricatures. The difference between distortions of this kind and caricature is subtle, but generally it might be said that exaggeration is not involved.

Seeing the hare-duck diagram as both animals at once is considered psychologically difficult. This ability to appear in various guises at once is a characteristic of many works of art.

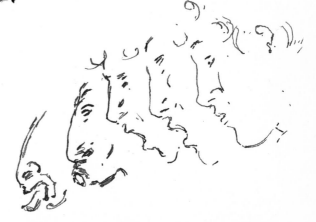

Laetitia transformed into a horse. Draw your best friend becoming by degrees an animal or an animal becoming a friend. The animal will stay your friend.

237

Fire and Sun

Prometheus stole heavenly fire. Light a small piece of newspaper – news is always worth a burn! With sharpened charcoal and your fastest fingers, race-draw the flames. Be quick as sparks. Make more fire and draw some more. Burn some matches. Wallow in a candle flame's beauty. Draw it soft at the top, hard and bright low down, with a parabola of blue-grey rainbow above the wick. Tongues of flame attend many mysteries.

Turner, Delacroix and El Greco are romantic artists with flaming imaginations. Van Gogh drew flame-shaped foliage. The sun is of blinding brightness. The imagined sun is the only sun we stare at. It is almost in the realms of imagination before it vanishes behind low clouds. We can only see it sinking over the horizon a few times a year. Be there as a witness with a sable.

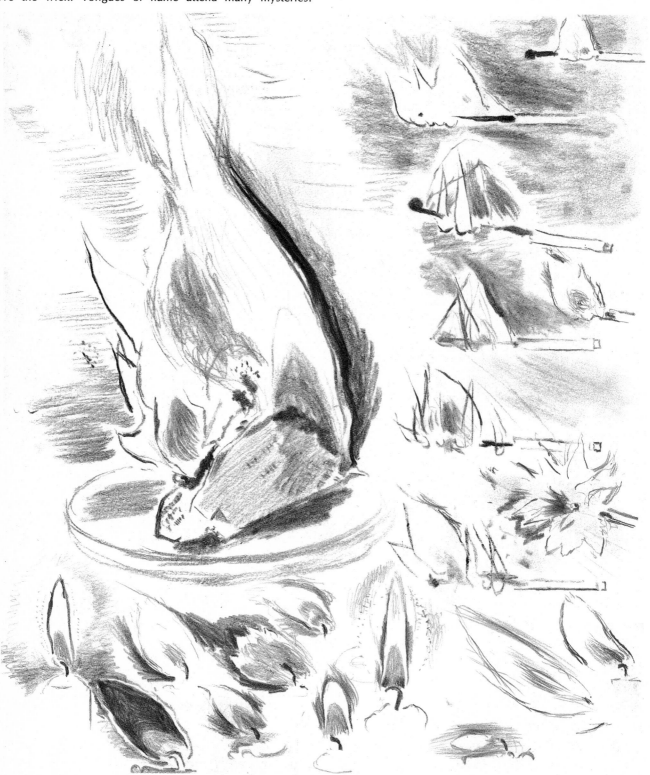

The lower candle flames were drawn with a pencil, the rest with charcoal. Charcoal needs a virtuoso's touch. If you use it with fairy delicacy, it is like using soft brushes filled with the lightest powders.

The lowest of the match drawings was done with a spent match. Draw fast. The one above it, just struck, flares with energy. Black flames would be fire from Hell.

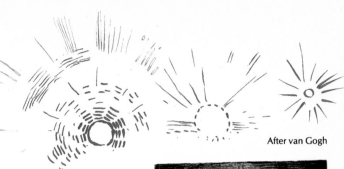

Draw with little dashes which move concentrically. Leave blank channels to radiate. Then radiate lines. Van Gogh was the sun specialist; he invented many pen-drawn models for the sun.

After van Gogh

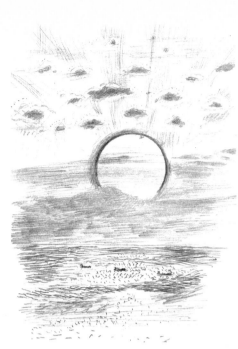

Scribble and dash staccato sparks and rays with a mapping pen to make cloud-covered suns and after-images.

After O'Keefe

Georgia O'Keefe always communicates directly. The image is as strong as the last shot in many a Western. The title is "Red Hills and the Sun".

The sun setting over the sea seems to become immense. It changes shape as it goes down. Make hesitant scratchings with half-shut eyes and memorize the dazzle. Use a pen.

The primal light is painted gold and is from the Deccan Plateau, India.

A cosmic sun from Tanjore near Madras, India. It is a solid ring.

After Dove

Far from making an astronomically accurate sun, Arthur Dove has burned his way through to a completely new and convincing image of Phoebus. Its title is "High Noon".

After Picasso

The sun from the mural painting "Peace". Copy it and it may become clear why this Phoenix-feathered, leafy, facetted sun is not round.

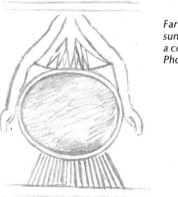

An ancient Egyptian creation of the sun. Copy it delicately in fine pencil. Follow the fine rays.

A Yaure tribal mask in dyed African hardwood. Its blackness somehow implies the brightness of the sun. It is rewarding to shade a copy.

After Picasso

The rayed sun is a diamond.

After Fludd

A conventional sun with a face

After a seven-year-old child. Earth, sun and moon as eggs of the cosmic dragon.

Drawn from the Red Book of the Lanâpé Indians. Above left, the firmament is made to move in harmony. Above right shows the creation of the sun, moon and stars.

239

Decay

Whether in orchards, hand held, crushed, fermented as cider or baked in pies, apples are healthful and their mushy autumnal perfume engenders a beautiful sadness. The maggot at the core seems less benign. Perhaps it was an apple with a worm which Eve gave to Adam, bitter at the centre and golden to behold. But Eve's apple may have been a pomegranate from the Tree of Knowledge of Good and Evil. Imagine a worm within an apple which grows to encircle it as a snake. Find ways of drawing the pulpy corruption, skulls, orifices of decay, Stiltons and old and new fungi. Differentiate between the smooth life of a healthy apple and the still deadness of bone and soggy pulp.

The branches and roots of a tree make up the form of an apple.

A brain labyrinth from India. Copy it with nervous touches of the pen.

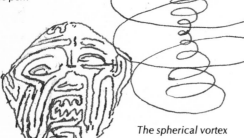

The spherical vortex

The entrail demon Humbaba is, again, mysteriously labyrinthine.

With a well-sharpened point, charcoal-draw an apple actually hanging from a tree. With the darks in the right places, the outlines are less necessary. It is good to draw an apple the right way up, as it grows.

The spiral peelings of an apple, as mysterious in their own way as the wrappings of an Egyptian mummy.

A Yin/Yang sign with spirals – the beginning and the end elaborated.

The Mexican feather serpent shows the union of heaven – as a bird – and earth – as a snake.

A spiral in perpetual motion

The cut apple with its grub is like a map of the forces at work within it. In its own way, the story looks as tragic as the fall of man. Caress the decay with conté crayon, drawing clearly the happy grub, obviously in paradise.

Draw a double spiral, thinking of snails and Celtic carved stones.

A decayed apple – brush it with broken dabs of watercolour.

An apple, sodden with decay. Draw the breaking up, Make its rhythms weak.

Draw this fine, healthy apple – full, round and smooth – with pencil, until it shines brightly.

A skull seen from above, with a circle cut out of the top. This aperture makes the hollowness visible. Push a little brush full of ink around it. Touch the sutures delicately.

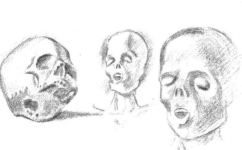

After Carpaccio

Decaying heads with a skull – they were victims of the dragon. Copy from Carpaccio paintings in the Scuola di San Giorgio degli Schiavoni, Venice.

A skull with no teeth, jawbone or spine – an image of decay. Blend the dark hollows of a Yorick. It is too dry and dead to interest a dog. Below it are diagrammed the cavities of the skull.

A howling, pulpy head – decay can begin before death. The orifices are on display. Plump it up with black chalk; blend into the maw.

After Grünewald

Marks for Eternity

There is a strange excitement which enters your whole being when you copy ancient Egyptian art. The proportional geometry binds vast buildings, ruling them with the same exact measure that divides a sculptured jewel. When we copy the bas-relief below, is it the clarity, the hardness of the stone or the stone-hard rendering of the soft flesh of the girl, so simple and clear, that baffles us? Is it that we know nothing of the frame of mind of the artist? Or is it that its appearance has not changed for thousands of years? There are not many art works as changeless as those of Egypt. The negative areas are built as certainly for eternity as the positive. Every touch we make as we copy must be a monumental pain-borne incision decision, close to a tomb – a kind of threshold mark. Copy as if the stern eye of the Pharoah's architect were on you and the Pharoah's eye was on him! Mysterious are the spreading, sunbaked surfaces, the counter-changing sunlightings and silhouetting shades. In 1923, Paul

Klee visited Egypt and Egypt changed him and charged him with energy. He found ways of drawing which resembled hiero-glyphics, and he evolved cartouche-like forms, ballooning without speech, elaborately and mysteriously telling of stomach aches and angels, the human comedy, life and death. He was possessed by the idea of blocks of rock laid as floors, walks or pyramids, closely seamed and engineered precisely so as to lie like perfected man-made strata. Like simple structural systems, the tiny sheets of paper were made into walls of colour, laid with the thinnest mortar. Klee's lines for doing this are of all kinds possible, from gossamer to rich pastel. The visit to Egypt elicited bright, clear stripes like levels, the verticals slipped in like faults or cracks in rock. The strata lines are also used to make lines on faces, signifying worry, ageing and time. Cracks are tears in the fabric of time. Klee's appointment at the Bauhaus was as weaving instructor. He was aware of the fates and the loom of life.

After Klee

Deep-cut stone gives this Egyptian bas-relief a dramatic chiaroscuro, as the sun casts the shadow of the edge on the rounded body. The torso is lotus-like and vase-like and seems to rise upwards. Draw sharply. The parts of the body are displayed clearly. The navel is pulled round to appear as a circular hole on the left and the buttock is pulled round to be visible at the same time on the right. The Cubists found themselves making similar mixtures of frontal and profile views.

Copy a piece of a Klee. The thickness of each horizontal bar doubles each time it meets a vertical interruption. It is called "Monument on the Edge of Fertile Country". It was done at the time when Schoenberg was using a twelve tone series in music. The idea of measure was very attractive in the strong light of Egyptian mystery mathematics.

Model by gradating to the edges the smooth, mysterious, present-day Tantric lingam with the vital snake Kundalini coiled around it.

The Shri Yantra is the most important of all Tantric yantras. Draw its marvellous sequence of triangles meditatively with a charcoal pencil. The hypnotic design expands and contracts.

The universe symbolized by a circle, a square and a triangle. As with the Zen universe on the facing page, the idea is to be simple. The Minimalist idea was to reduce the complex ganglia of existence to simple perfection, with an extreme reduction of means.

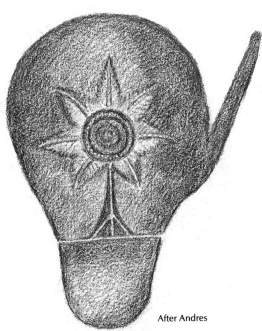

After Andres

Gradate darkly with black chalk, making a skull-shaped retort containing ashes, from which springs a seven-pointed alchemical flower.

A sphere called "The Globe of the Unfolding World" from Orissa, India. To copy this is an absorbing experience. The rings, buildings and petal shapes are very mysterious.

Flattening and Cubism

However magnificently the artists of the past used patterns of marble, carpets, stylized folds of fabric, aleatoric gold or map-covered walls (as in Vermeer) to maintain the flat or decorative surfaces in pictures, this was not sufficiently thorough for the early twentieth century, when every element in the substance of art was being tested. Seurat believed in hollowing canvasses, but not in making holes in them. Using pointillist dots, he often painted the edges in pictures with increased contrast, to prevent them from receding. These are called "forced" edges. Strict control of the picture surface was important to Cézanne. His style included straight lines that asserted the flatness of the canvas. Such lines are called "tie lines" and are left free (they do not join orthogonals and therefore do not form disruptive solids). The lines in a Cézanne are modified by patches of tone which do not model disruptively. His pictures suggest three dimensions but are primarily and assertively coloured surfaces. This was difficult to do in front of nature, but not so hard when away from it. Picasso, Braque and Gris were able to be more schematic; the scaffolding of lines and their attachments of tone were emphatically declared. This was Cubism, the last major style in painting. It was really more about dismantling cubes than about making them. All subsequent painting owed something to Cubism. Chirico, Chagall, Nicholson, Modigliani and Willem De Kooning used it for their own purposes, as did Mondrian on his path towards pure abstraction.

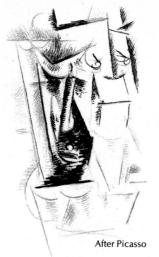

After Picasso

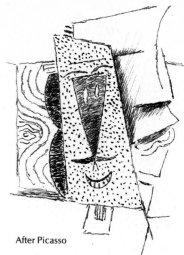

After Picasso

Analytical Cubism was more optical than Synthetic Cubism. Pictures were hollowed more deeply than in the later Cubism.

Synthetic Cubism became more and more decorative as urgency became less. The patterned surfaces are flat, in spite of having angled edges.

This shows the forced edges, tie lines flattened by lettering, and the dismemberment of the absinthe glass on the right. Some of the most beautiful Cubist pictures were made in ovals. Perhaps the corners of rectangles have an intrinsic vanishing effect. Certainly, the corners sometimes appeared difficult for Braque to fill.

After Picasso

Braque's father was a painter–decorator and Braque knew how to use graining combs and many other skills of the trade. Graining is done as if seen from above. The playing cards are also seen almost as if in plan.

After Braque

Draw a postcard, the same size as the original. Gradually, you will know what it is like to work actually on the picture plane. It is an eerie feeling, because enlarging, reducing or changing what we see is so habitual. Use ink and water. The position of postmarks, stamps and bruisings happens by chance. Chance plays a part in most drawings.

After van Gogh

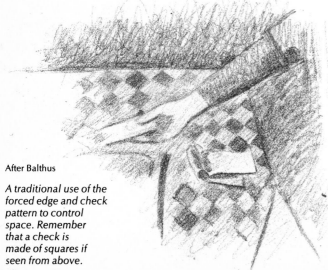

After Balthus

A traditional use of the forced edge and check pattern to control space. Remember that a check is made of squares if seen from above.

A letter from Theo recedes in perspective. The deformation of the rectangular envelope suggests spatial recession. Van Gogh controls the picture plane with thickly applied paint. Use ink and water.

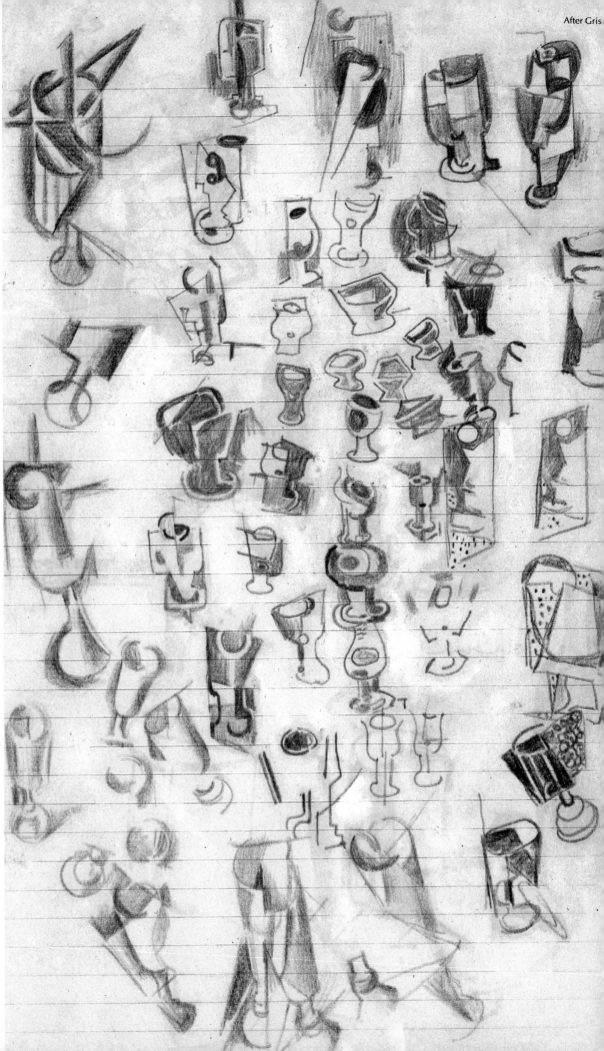

Some of the countless
variations made on an
absinthe glass (a
liqueur glass) by Juan
Gris. Never has a
simple object been
made beautiful in so
many different ways.
Diagram-copy the
drawings and paintings.
The later the work, the
simpler his glass
becomes. Where
objects are naturally
flat, Cubism includes
them whole or cuts
them to shape. Paper
collage and assemblage
were also aspects of the
style. Schwitters used
trash. The materials
with which a Cubist
work was made were
always clearly
declared. Charcoal was
made to look like
charcoal, pencil like
pencil. Lettering was
used as a flattening
device and could be
used for special or witty
meanings. Newspaper
would maintain
flatness.

After Picasso

The sculptured
absinthe glass, spoon
and cube of sugar with
two early pre-Cubist
glasses make clear the
amount of distortion
involved in Gris.
Picasso has always
done sculpture to make
his images concrete,
sculpting from the
drawings and drawing
from the sculptures.
Here, the sculpture has
even been dotted. With
a small discarded jar
and some plaster or
modelling paste, make
your own version of a
liqueur glass or other
simple object. Then
draw from it.

CONCLUSION

This book begins with Rembrandt's late self portrait. It is an example of a central image with presence – like having the painter standing opposite you in the gloom. Our reflection in a mirror is the nearest thing we have to being present in a frame. Colour films and projected colour slides can also come close to doing this, but Vermeer, Bonnard, Rembrandt and Velasquez were able to achieve presence in other ways. A Rembrandt figure sits beyond the frame, half length. Bonnard peers at you at chest level through a bathroom mirror. Francis Bacon throws you to the ground as rudely as a wrestler. The glass comes up like a transparent mirror, shielding you from the presence beyond. The water-gilded frame, like a Savile Row suit, the deep pile of the carpet on both sides of the frame, are all part of a presentation which makes every Bacon like a one-way mirror. The Bacon presence is directed as carefully as a film. There is a turmoil of thrown paint, wide brandish-brushings and long brushed lines. Some are like signwriters' lines. They are fashioned on a New York-style coloured canvas. The imaginatively remembered friend, perhaps Lucien Freud, appears as the brushings accrue. Chance is valued but the theatre of activity is highly skilful. Bacon's brush drawing works like the strokes in the pastels of the aged Degas and shows how drawing and painting can be the same activity.

Tangible presence is not a general aim for drawing
Drawing is a special language, full of suggestion beyond the concrete presence of its lines. Clean line drawing can probe the very engines of the universe, stroke an eyelid and express and explore. Drawings can be concise. When we do not wish to see anything, we do not usually shut our eyes – we just cease paying attention. Yet seeing goes on, and a kind of daydreaming goes on. It is good not to tamper with our natural ways of apprehension. The mind is a natural transformer and we can never be sure what it is doing. For instance, we can try and describe a close friend. Does he have a large earlobe – does he have one at all? Probably we do not know, yet in a large crowd we can pick him out instantly. All the time we are looking, we are transforming. We can only prevent it happening if we try to, and this is a strain. Transforming is fundamental to creativity.

Limiting transformation
The influential Euston Road school (1937–1939), in a reaction to the Parisian fashion of the time, made objective painting a goal. This entailed limiting the transforming action of the mind by measuring. (Plumb-lines were used and a pencil was held at arm's length – see p. 144.) In the hands of the original practitioners – Graham Bell, Coldstream, Gowing, Pasmore and Claude Rogers – the limitations on transformation or free expression actually turned out to be safer than might be expected, as they were usually ready to yield slightly rather than follow rules slavishly. The example of Degas, Seurat and Sickert helped them to see in ways which made art possible within their chosen limits. Certainly, some beautiful drawings and paintings were done using their objective method.

Catharsis and the nasty
Pain often instigates art. Dostoevsky, Nono and Titian achieve cathartic art. Where then are the Beethoven Fidelios and the Bartok Miraculous Mandarins of drawing? Certainly, Titian's "Flaying of Marsyas" is an example of a painful subject and one that is copied in this book. Crivelli's "St Roch" shows his wound, Francis Bacon demonstrates an interest in wounds, and wounds can be found in Mexican painting. Copy from Grünewald's "Crucifixions" (powerfully cathartic) or from Otto Dix (less cathartic but often horrible) to appreciate the difference. Some artists leave the blood visible. Others turn the knife in the wound gently, so that at first you hardly notice that the blade has entered

your body. Goya did beautiful drawings of every kind of pain. How is it that works of the greatest beauty can depict events of the most gruesome agony? War horrors and open heart operations are the spectaculars available on television, unassuaged by art. Everything is news and all is shown, inside and out – the wounds, warts, acne and pus. Catharsis is difficult to achieve when all you are using is a skin condition, but drawing is all-embracing.

Photographs are incomplete
Photographs are slices of nature and if the slice is right and you are a very experienced, stylish artist and good at drawing, limited information can be extracted from them. Colour slides projected in the dark are best. Sickert and Degas had strong styles and occasionally used the camera. Photographs can be imitated on smooth paper using pencil. It merely involves exchanging the darkness, caused on the photographic paper by the natural action of light, for a rubbing of graphite. Photorealists seem to like doing it. It is less like drawing than most activities. Even the direct use of a camera is more fun. A photograph is a one-lensed, fast, muddled mass of (for art) irrelevant information, a petrified slice of nature. We love its gloss, its wealth of associations and ego support, its sexy paraphernalia, its flash and click. But we must beware lest it kills our dreams with slimy negatives. In the early days, photographs were expensive and subjects were carefully arranged. Today, photographs are mass-exposed, almost without thought. Cameras are motor-driven. There is no time for reflection. The slow process of drawing allows an image to build in the mind. Put simply, a photograph has a lot of information the artist does not need for his art and only a little that he does. A drawing, if it is the right sort of drawing, contains the information the artist can use and nothing he does not need.

Copy for long-term rewards
I believe copying is necessary for learning to draw. But copying without desire or commitment, for a weak desire for security or as a hobby entailing meticulous detailing – such show-off copying is not the kind of copying I mean. It is astonishing to me how many feel it is possible to build art entirely from themselves and derive confidence from being a part of a narrow contemporary art clique. I know lionized artists who never look at art before their own time. For them, a national gallery is a collection of frames full of yellowing varnish. Their narrow, in-bred, extravagant manner is a part of the fashion climate and is a requirement for promotion by dealers and galleries. The money for art is in the hands of people who spend so much time making it that none is left for discovering art's true nature. Dealers know this and foster easily recognizable batch art. There are people whose lives are spent surrounded by great art, who still have poor taste. Others seem intuitively to know the good. Obviously, discrimination is more secure where there is wide knowledge.

Fashionable art may not be the most moving
In looking around for material to put in this book, I searched in a special way. I needed "big names" because I wanted a wide audience to understand me. On the other hand, works by "small names" often moved me and were more apposite. And, just as the predellas of large altarpieces can often be more surprising and full of life than the important works above them, I found small and unpretentious works were beautiful. The international art set and the directors of grand museums exhibit what they designate "public pictures". I found more and more, as I copied and searched in art, that the art of today was better when not done for these promotions. Drawings are rarely "public pictures" and I would rather look at a ten-centimetre Bonnard drawing or a twenty-centimetre Rembrandt etching than at many recent "inflated" public pictures.

I tried but failed to copy a Titian drawing. First I blamed the paper, then the chalk. The first marks were too cautious and accurate, the next too powerful, the next underworked and without the image. Instead, I copied Goya's "Feline Pantomime" (right) and "Raging Lunatic" (below). His chalk marks were easier to follow. Here again were ease of execution and strange subject matter. Both artists were making great images with the sort of gestures people use for writing shopping lists. In old age, Titian and Goya did rough marks with chalk as memoranda of their visions. To copy them is more difficult than drawing a bear by looking only at its tracks.

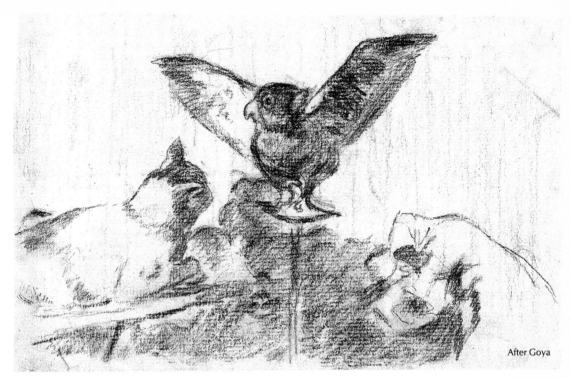

After Goya

After Goya

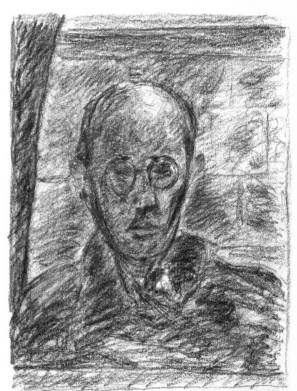

After Bonnard

The last self portraits of Munch are tragic visions, as he sees himself reflected in mirrors, lonely in the house at night. This late self portrait by Bonnard is also poignantly moving. It looks as if, while he was groping to remove shaving soap from the bathroom mirror, the looking glass had become transformed into a painting. Use conté crayon if you dare to draw it.

249

Some recent artists to copy and admire

Bonnard, Vuillard, Sloan, Bellows, Hopper and Eakins loved their subject matter. Smile at Ardizzone's boy, cuddling his girl in a special way, brush-marked as in Daumier. Stiffen to Euan Uglow's still, thin-stalked daisy. Use a pen and look at Harold Gilman's drawing of his mother, pillowed in a brass bed of the kind Sickert would fill with a stolid nude. Look carefully at the sharply detailed sea urchins, lemons, quinces, squids (sometimes on copper) which Lucien Freud painted several years ago – and painted as precisely as the meeting of vipers' lips. See how the same thin paint is used to touch in the minutely veined eyes of a bed portrait or the white muzzle of a dog, a tiny portrait of Francis Bacon or the discoloration on a hand holding a rose. London painters are intimist. "Intimist" means with close affection. Value the touch of Graham Bell or the probing drawing of Haldane by Claude Rogers. Where in the world today is there a better brushed mouth than in the portrait of Christopher Isherwood by Coldstream? Where do eyes flash with such clear beauty as in the golden-black portraits by Craigie Aitchison? Intimist too is the art of Leonard McComb as he strokes measures of pale grey watercolour to define a portrait's throat. Frank Auerbach scours and scours between redrawings, until a well-known face settles. Draw with a fat pencil, with absolute concentration, from an Auerbach. Learn to see and draw London. Leon Kossoff draws crowded subways and swimming pools – and when he paints a portrait, the expression almost breaks the frame. Look, as William Roberts draws cockney subjects with "Bow Bells clarity" and a toy maker's affection, or as Edward Burra sardonically watercolours the denizens of a London pub – intimists both. Carel Weight looks at the dark bricks of London and paints them true. Cavafy-intimate are the boys in Hockney's etchings. Lawrence Gowing in London looked at Clement Attlee, the Prime Minister, and painted him true. Humanly attached are the sea-inspired paintings by Christopher Wood, Eric Ravilious and Norman Adams (the master painter of the Atlantic Ocean and "The Sound of Scarp"). Kokoschka painted the Thames, but copy instead his earliest, nervy portraits. John Davies makes refined sculptures. Examine his minutely marked drawings of figures in white spaces, nervous as whey-faced clowns on a high wire. R. B. Kitaj is a transatlantic artist. His picture "Across the Pacific" is a good work to end on. The colour is most carefully balanced. It is drawn razor sharp – I would have been unwise to attempt a copy.

The survival of a language

Drawing continues to live in the present polyglot art world – a world of tree-marking, bondage, sound-operated quivers of metal rods, magnets, photographs, walk maps, turf lifts, body drags, marine rock spirals, computer tracings, holograms, laser moon-bouncings and neon tubes. Is a pencil line on paper not stranger than any of these? A young artist, holding his pencil firmly, said, "Drawing is what you do".

I live in Hastings, where the forces of nature are visible. In London, tower blocks surround the Slade School where I teach. They seal off much of the land and sky and I do not like large areas of concrete. The coast near Hastings is varied. The sandstone rocks, the fissures, caves and cliffs, make sharp encounters with the sea and interesting leaps of scale. Beyond the rocks lie the flat, sheep-filled fields of Romney Marsh and a few miles behind me are the high chalk headlands of Beachy Head.

Index to Illustration Sources

l = left; *r* = right; *c* = centre; *t* = top; *b* = bottom

Acknowledgments

Author's Acknowledgments
I thank first David Hockney for a marvellous
beginning to my book, full of vitality and every word
is true. I consider myself very fortunate. I am grateful
to Laetitia Yhap for being present in so many
drawings – wherever the writing is serious it derived
from our discussions; to Peter Kindersley for
initiating the book and for the infection of his
boundless enthusiasm and flair; to Christopher
Davis for gentle humour and a grand surveillance; to
Christopher Dorling for kind encouragement; to
Bridget Morley, Sheilagh Noble and Valerie Nelson
for their early work with indigestible material. My
thanks to Pauline Davidson, an unaided wrestler
with my much crossed out, illegible longhand and
contorted syntax, who yet produced immaculate
typed copy to fit with Mark Richards' ingenious,
elegant layouts, done with craft and skill. The
accolade, the extra thanks are due to Lucy Lidell,
who helped expunge all "studio shop" when
obscure, kept fancy within bounds, yet allowed
imagination to flower. Extolling her virtues I name
her "Lucy Elucidator, the Good Editor." My thanks to
Joss Pearson and Stuart Jackman for generous,
practical support. Finally, I owe most to the artists I
have copied.

Dorling Kindersley would like to extend special
thanks to the following for their help in producing
this book: Susan Wallington and Anabel Thomas (for
research and assistance with the index), Sheilagh
Noble, Roz Gendle, Verity Anne Meldrum, Lesley
Gilbert, Steve Collingwood, Michael Burman of
F. E. Burman Ltd and Steve Burden of
Tradespools Ltd.